陳澄波全集
CHEN CHENG-PO CORPUS
第十七卷·修復報告（III）
Volume 17 · Selected Treatment Reports（III）

策劃／財團法人陳澄波文化基金會

發行／財團法人陳澄波文化基金會
中央研究院臺灣史研究所

出版／藝術家出版社

感 謝
APPRECIATE

文化部 Ministry of Culture

嘉義市政府 Chiayi City Government

臺北市立美術館 Taipei Fine Arts Museum

高雄市立美術館 Kaohsiung Museum of Fine Arts

台灣創價學會 Taiwan Soka Association

尊彩藝術中心 Liang Gallery

吳慧姬女士 Ms. WU HUI-CHI

陳澄波全集
CHEN CHENG-PO CORPUS

第十七卷 · 修復報告（Ⅲ）
Volume 17 · Selected Treatment Reports（Ⅲ）

目 錄

Contents

榮譽董事長 序

　　家父陳澄波先生生於臺灣割讓給日本的乙未（1895）之年，罹難於戰後動亂的二二八事件（1947）之際。可以說：家父的生和死，都和歷史的事件有關；他本人也成了歷史的人物。

　　家父的不幸罹難，或許是一樁歷史的悲劇；但家父的一生，熱烈而精采，應該是一齣藝術的大戲。他是臺灣日治時期第一個油畫作品入選「帝展」的重要藝術家；他的一生，足跡跨越臺灣、日本、中國等地，居留上海期間，也榮膺多項要職與榮譽，可說是一位生活得極其精彩的成功藝術家。

　　個人幼年時期，曾和家母、家姊共赴上海，與父親團聚，度過一段相當愉快、難忘的時光。父親的榮光，對當時尚屬童稚的我，雖不能完全理解，但隨著年歲的增長，即使家父辭世多年，每每思及，仍覺益發同感驕傲。

　　父親的不幸罹難，伴隨而來的是政治的戒嚴與社會疑慮的眼光，但母親以她超凡的意志與勇氣，完好地保存了父親所有的文件、史料與畫作。即使隻紙片字，今日看來，都是如此地珍貴、難得。

　　感謝中央研究院翁啟惠院長和臺灣史研究所謝國興所長的應允共同出版，讓這些珍貴的史料、畫作，能夠從家族的手中，交付給社會，成為全民共有共享的資產；也感謝基金會所有董事的支持，尤其是總主編蕭瓊瑞教授和所有參與編輯撰文的學者們辛勞的付出。

　　期待家父的努力和家母的守成，都能夠透過這套《全集》的出版，讓社會大眾看到，給予他們應有的定位，也讓家父的成果成為下一代持續努力精進的基石。

　　我が父陳澄波は、台湾が日本に割讓された乙未（1895）の年に生まれ、戦後の騒乱の228事件（1947）の際に、乱に遭われて不審判で処刑されました。父の生と死は謂わば、歴史事件と関ったことだけではなく、その本人も歴史的な人物に成りました。

　　父の不幸な遭難は、一つの歴史の悲劇であるに違いません。だが、彼の生涯は、激しくて素晴らしいもので、一つの芸術の偉大なドラマであることとも言えよう。彼は、台湾の殖民時代に、初めで日本の「帝国美術展覧会」に入選した重要な芸術家です。彼の生涯のうちに、台湾は勿論、日本、中国各地を踏みました。上海に滞在していたうちに、要職と名誉が与えられました。それらの面から見れば、彼は、極めて成功した芸術家であるに違いません。

　　幼い時期、私は、家父との団欒のために、母と姉と一緒に上海に行き、すごく楽しくて忘れられない歳月を過ごしました。その時、尚幼い私にとって、父の輝き仕事が、完全に理解できなっかものです。だが、歳月の経つに連れて、父が亡くなった長い歳月を経たさえも、それらのことを思い出すと、彼の仕事が益々感心するようになりました。

　　父の政治上の不幸な非命の死のせいで、その後の戒厳令による厳しい状況と社会からの疑わしい眼差しの下で、母は非凡な意志と勇気をもって、父に関するあらゆる文献、資料と作品を完璧に保存しました。その中での僅かな資料であるさえも、今から見れば、貴重且大切なものになれるでしょう。

　　この度は、中央研究院長翁啟惠と台湾史研究所所長謝国興のお合意の上で、これらの貴重な文献、作品を共同に出版させました。終に、それらが家族の手から社会に渡され、我が文化の共同的な資源になりました。基金会の理事全員の支持を得ることを感謝するとともに、特に総編集者である蕭瓊瑞教授とあらゆる編輯作者たちのご苦労に心より謝意を申し上げます。

　　この《全集》の出版を通して、父の努力と母による父の遺物の守りということを皆さんに見せ、評価が下させられることを期待します。また、父の成果がその後の世代の精力的に努力し続ける基盤になれるものを深く望んでおります。

<div style="text-align:right">

財團法人陳澄波文化基金會
榮譽董事長　陳重光

</div>

Foreword from the Honorary Chairman

My father was born in the year Taiwan was ceded to Japan (1895) and died in the turbulent post-war period when the 228 Incident took place (1947). His life and death were closely related to historical events, and today, he himself has become a historical figure.

The death of my father may have been a part of a tragic event in history, but his life was a great repertoire in the world of art. One of his many oil paintings was the first by a Taiwanese artist featured in the Imperial Fine Arts Academy Exhibition. His life spanned Taiwan, Japan and China and during his residency in Shanghai, he held important positions in the art scene and obtained numerous honors. It can be said that he was a truly successful artist who lived an extremely colorful life.

When I was a child, I joined my father in Shanghai with my mother and elder sister where we spent some of the most pleasant and unforgettable days of our lives. Although I could not fully appreciate how venerated my father was at the time, as years passed and even after he left this world a long time ago, whenever I think of him, I am proud of him.

The unfortunate death of my father was followed by a period of martial law in Taiwan which led to suspicion and distrust by others towards our family. But with unrelenting will and courage, my mother managed to preserve my father's paintings, personal documents, and related historical references. Today, even a small piece of information has become a precious resource.

I would like to express gratitude to Wong Chi-huey, president of Academia Sinica, and Hsieh Kuo-hsing, director of the Institute of Taiwan History, for agreeing to publish the *Chen Cheng-po Corpus* together. It is through their effort that all the precious historical references and paintings are delivered from our hands to society and shared by all. I am also grateful for the generous support given by the Board of Directors of our foundation. Finally, I would like to give special thanks to Professor Hsiao Chong-ruy, our editor-in-chief, and all the scholars who participated in the editing and writing of the *Chen Cheng-po Corpus*.

Through the publication of the *Chen Cheng-po Corpus*, I hope the public will see how my father dedicated himself to painting, and how my mother protected his achievements. They deserve recognition from the society of Taiwan, and I believe my father's works can lay a solid foundation for the next generation of Taiwan artists.

Honorary Chairman, Chen Cheng-po Cultural Foundation
Chen Tsung-kuang

Chen, Tsung-kuang

院長 序

　　嘉義鄉賢陳澄波先生，是日治時期臺灣最具代表性的本土畫家之一，1926年他以西洋畫作〔嘉義街外〕入選日本畫壇最高榮譽的「日本帝國美術展覽會」，是當時臺灣籍畫家中的第一人；翌年再度以〔夏日街景〕入選「帝展」，奠定他在臺灣畫壇的先驅地位。1929年陳澄波完成在日本的專業繪畫教育，隨即應聘前往上海擔任新華藝術專校西畫教席，當時也是臺灣畫家第一人。然而陳澄波先生不僅僅是一位傑出的畫家而已，更重要的是他作為一個臺灣知識份子與文化人，在當時臺灣人面對中國、臺灣、日本之間複雜的民族、國家意識與文化認同問題上，反映在他的工作、經歷、思想等各方面的代表性，包括對傳統中華文化的繼承、臺灣地方文化與生活價值的重視（以及對臺灣土地與人民的熱愛）、日本近代性文化（以及透過日本而來的西方近代化）之吸收，加上戰後特殊時局下的不幸遭遇等，已使陳澄波先生成為近代臺灣史上的重要人物，我們今天要研究陳澄波，應該從臺灣歷史的整體宏觀角度切入，才能深入理解。

　　中央研究院臺灣史研究所此次受邀參與《陳澄波全集》的資料整輯與出版事宜，十分榮幸。臺史所近幾年在收集整理臺灣民間資料方面累積了不少成果，臺史所檔案館所收藏的臺灣各種官方與民間文書資料，包括實物與數位檔案，也相當具有特色，與各界合作將資料數位化整理保存的專業經驗十分豐富，在這個領域可說居於領導地位。我們相信臺灣歷史研究的深化需要多元的觀點與重層的探討，這一次臺史所有機會與財團法人陳澄波文化基金會合作共同出版陳澄波全集，以及後續協助建立數位資料庫，一方面有助於將陳澄波先生的相關資料以多元方式整體呈現，另一方面也代表在研究與建構臺灣歷史發展的主體性目標上，多了一項有力的材料與工具，值得大家珍惜善用。

<div align="right">

臺北南港／中央研究院
院長
2012.3

</div>

10

Foreword from the President of the Academia Sinica

Mr. Chen Cheng-po, a notable citizen of Chiayi, was among the most representative painters of Taiwan during Japanese rule. In 1926, his oil painting *Outside Chiayi Street* was featured in Imperial Fine Arts Academy Exhibition. This made him the first Taiwanese painter to ever attend the top-honor painting event. In the next year, his work *Summer Street Scene* was selected again to the Imperial Exhibition, which secured a pioneering status for him in the local painting scene. In 1929, as soon as Chen completed his painting education in Japan, he headed for Shanghai under invitation to be an instructor of Western painting at Xinhua Art College. Such cordial treatment was unprecedented for Taiwanese painters. Chen was not just an excellent painter. As an intellectual his work, experience and thoughts in the face of the political turmoil in China, Taiwan and Japan, reflected the pivotal issues of national consciousness and cultural identification of all Taiwanese people. The issues included the passing on of Chinese cultural traditions, the respect for the local culture and values (and the love for the island and its people), and the acceptance of modern Japanese culture. Together with these elements and his unfortunate death in the post-war era, Chen became an important figure in the modern history of Taiwan. If we are to study the artist, we would definitely have to take a macroscopic view to fully understand him.

It is an honor for the Institute of Taiwan History of the Academia Sinica to participate in the editing and publishing of the *Chen Cheng-po Corpus*. The institute has achieved substantial results in collecting and archiving folk materials of Taiwan in recent years, the result an impressive archive of various official and folk documents, including objects and digital files. The institute has taken a pivotal role in digital archiving while working with professionals in different fields. We believe that varied views and multi-faceted discussion are needed to further the study of Taiwan history. By publishing the corpus with the Chen Cheng-po Cultural Foundation and providing assistance in building a digital database, the institute is given a wonderful chance to present the artist's literature in a diversified yet comprehensive way. In terms of developing and studying the subjectivity of Taiwan history, such a strong reference should always be cherished and utilized by all.

President of the Academia Sinica
Nangang, Taipei
Wong Chi-huey
2012. 3

總主編 序

作為臺灣第一代西畫家，陳澄波幾乎可以和「臺灣美術」劃上等號。這原因，不僅僅因為他是臺灣畫家中入選「帝國美術展覽會」（簡稱「帝展」）的第一人，更由於他對藝術創作的投入與堅持，以及對臺灣美術運動的推進與貢獻。

出生於乙未割臺之年（1895）的陳澄波，父親陳守愚先生是一位精通漢學的清末秀才；儘管童年的生活，主要是由祖母照顧，但陳澄波仍從父親身上傳承了深厚的漢學基礎與強烈的祖國意識。這些養分，日後都成為他藝術生命重要的動力。

1917年臺灣總督府國語學校畢業，1918年陳澄波便與同鄉的張捷女士結縭，並分發母校嘉義公學校服務，後調往郊區的水崛頭公學校。未久，便因對藝術創作的強烈慾望，在夫人的全力支持下，於1924年，服完六年義務教學後，毅然辭去人人稱羨的安定教職，前往日本留學，考入東京美術學校圖畫師範科。

1926年，東京美校三年級，便以〔嘉義街外〕一作，入選第七回「帝展」，為臺灣油畫家入選之第一人，震動全島。1927年，又以〔夏日街景〕再度入選。同年，本科結業，再入研究科深造。

1928年，作品〔龍山寺〕也獲第二屆「臺灣美術展覽會」（簡稱「臺展」）「特選」。隔年，東美畢業，即前往上海任教，先後擔任「新華藝專」西畫科主任教授，及「昌明藝專」、「藝苑研究所」等校西畫教授及主任等職。此外，亦代表中華民國參加芝加哥世界博覽會，同時入選全國十二代表畫家。其間，作品持續多次入選「帝展」及「臺展」，並於1929年獲「臺展」無鑑查展出資格。

居滬期間，陳澄波教學相長、奮力創作，留下許多大幅力作，均呈現特殊的現代主義思維。同時，他也積極參與新派畫家活動，如「決瀾社」的多次籌備會議。他生性活潑、熱力四射，與傳統國畫家和新派畫家均有深厚交誼。

唯1932年，爆發「一二八」上海事件，中日衝突，這位熱愛祖國的臺灣畫家，竟被以「日僑」身份，遭受排擠，險遭不測，並被迫於1933年離滬返臺。

返臺後的陳澄波，將全生命奉獻給故鄉，邀集同好，組成「臺陽美術協會」，每年舉辦年展及全島巡迴展，全力推動美術提升及普及的工作，影響深遠。個人創作亦於此時邁入高峰，色彩濃郁活潑，充份展現臺灣林木翁鬱、地貌豐美、人群和善的特色。

1945年，二次大戰終了，臺灣重回中國統治，他以興奮的心情，號召眾人學說「國語」，並加入「三民主義青年團」，同時膺任第一屆嘉義市參議會議員。1947年年初，爆發「二二八事件」，他代表市民前往水上機場協商、慰問，卻遭扣留羈押；並於3月25日上午，被押往嘉義火車站前廣場，槍決示眾，熱血流入他日夜描繪的故鄉黃泥土地，留給後人無限懷思。

陳澄波的遇難，成為戰後臺灣歷史中的一項禁忌，有關他的生平、作品，也在許多後輩的心中逐漸模糊淡忘。儘管隨著政治的逐漸解嚴，部份作品開始重新出土，並在國際拍賣場上屢創新高；但學界對他的生平、創作之理解，仍停留在有限的資料及作品上，對其獨特的思維與風格，也難以一窺全貌，更遑論一般社會大眾。

以「政治受難者」的角色來認識陳澄波，對這位一生奉獻給藝術的畫家而言，顯然是不公平的。歷經三代人的含冤、忍辱、保存，陳澄波大量的資料、畫作，首次披露在社會大眾的面前，這當中還不包括那些因白蟻蛀蝕

而毀壞的許多作品。

　　個人有幸在1994年，陳澄波百年誕辰的「陳澄波‧嘉義人學術研討會」中，首次以「視覺恆常性」的角度，試圖詮釋陳氏那種極具個人獨特風格的作品；也得識陳澄波的長公子陳重光老師，得悉陳澄波的作品、資料，如何一路從夫人張捷女士的手中，交到重光老師的手上，那是一段滄桑而艱辛的歷史。大約兩年前（2010），重光老師的長子立栢先生，從職場退休，在東南亞成功的企業經營經驗，讓他面對祖父的這批文件、史料及作品時，迅速地知覺這是一批不僅屬於家族，也是臺灣社會，乃至近代歷史的珍貴文化資產，必須要有一些積極的作為，進行永久性的保存與安置。於是大規模作品修復的工作迅速展開；2011年至2012年之際，兩個大型的紀念展：「切切故鄉情」與「行過江南」，也在高雄市立美術館、臺北市立美術館先後且重疊地推出。眾人才驚訝這位生命不幸中斷的藝術家，竟然留下如此大批精采的畫作，顯然真正的「陳澄波研究」才剛要展開。

　　基於為藝術家留下儘可能完整的生命記錄，也基於為臺灣歷史文化保留一份長久被壓縮、忽略的珍貴資產，《陳澄波全集》在眾人的努力下，正式啟動。這套全集，合計十八卷，前十卷為大八開的巨型精裝圖版畫冊，分別為：第一卷的油畫，搜羅包括僅存黑白圖版的作品，約近300餘幅；第二卷為炭筆素描、水彩畫、膠彩畫、水墨畫及書法等，合計約241件；第三卷為淡彩速寫，約400餘件，其中淡彩裸女占最大部份，也是最具特色的精采力作；第四卷為速寫（Ｉ），包括單張速寫約1103件；第5卷為速寫（ＩＩ），分別出自38本素描簿中約1200餘幅作品；第六、七卷為個人史料（Ｉ）、（ＩＩ），分別包括陳氏家族照片、個人照片、書信、文書、史料等；第八、九卷為陳氏收藏，包括相當完整的「帝展」明信片，以及各式畫冊、圖書；第十卷為相關文獻資料，即他人對陳氏的研究、介紹、展覽及相關周邊產品。

　　至於第十一至十八卷，為十六開本的軟精裝，以文字為主，分別包括：第十一卷的陳氏文稿及筆記；第十二、十三卷的評論集，即歷來對陳氏作品研究的文章彙集；第十四卷的二二八相關史料，以和陳氏相關者為主；第十五至十七卷，為陳氏作品歷年來的修復報告及材料分析；第十八卷則為陳氏年譜，試圖立體化地呈現藝術家生命史。

　　對臺灣歷史而言，陳澄波不只是個傑出且重要的畫家，同時他也是一個影響臺灣深遠（不論他的生或他的死）的歷史人物。《陳澄波全集》由財團法人陳澄波文化基金會和中央研究院臺灣史研究所共同發行出版，正是名實合一地呈現了這樣的意義。

　　感謝為《全集》各冊盡心分勞的學界朋友們，也感謝執行編輯賴鈴如、何冠儀兩位小姐的辛勞；同時要謝謝藝術家出版社何政廣社長，尤其他的得力助手美編柯美麗小姐不厭其煩的付出。當然《全集》的出版，背後最重要的推手，還是陳重光老師和他的長公子立栢夫婦，以及整個家族的支持。這件歷史性的工程，將為臺灣歷史增添無限光采與榮耀。

<div align="right">
《陳澄波全集》總主編

國立成功大學歷史系所教授　蕭瓊瑞
</div>

Foreword from the Editor-in-Chief

As an important first-generation painter, the name Chen Cheng-po is virtually synonymous with Taiwan fine arts. Not only was Chen the first Taiwanese artist featured in the Imperial Fine Arts Academy Exhibition (called"Imperial Exhibition"hereafter), but he also dedicated his life toward artistic creation and the advocacy of art in Taiwan.

Chen Cheng-po was born in 1895, the year Qing Dynasty China ceded Taiwan to Imperial Japan. His father, Chen Shou-yu, was a Chinese imperial scholar proficient in Sinology. Although Chen's childhood years were spent mostly with his grandmother, a solid foundation of Sinology and a strong sense of patriotism were fostered by his father. Both became Chen's Office impetus for pursuing an artistic career later on.

In 1917, Chen Cheng-po graduated from the Taiwan Governor-General's Office National Language School. In 1918, he married his hometown sweetheart Chang Jie. He was assigned a teaching post at his alma mater, the Chiayi Public School and later transferred to the suburban Shuikutou Public School. Chen resigned from the much envied post in 1924 after six years of compulsory teaching service. With the full support of his wife, he began to explore his strong desire for artistic creation. He then travelled to Japan and was admitted into the Teacher Training Department of the Tokyo School of Fine Arts.

In 1926, during his junior year, Chen's oil painting *Outside Chiayi Street* was featured in the 7th Imperial Exhibition. His selection caused a sensation in Taiwan as it was the first time a local oil painter was included in the exhibition. Chen was featured at the exhibition again in 1927 with *Summer Street Scene*. That same year, he completed his undergraduate studies and entered the graduate program at Tokyo School of Fine Arts.

In 1928, Chen's painting *Longshan Temple* was awarded the Special Selection prize at the second Taiwan Fine Arts Exhibition (called"Taiwan Exhibition"hereafter). After he graduated the next year, Chen went straight to Shanghai to take up a teaching post. There, Chen taught as a Professor and Dean of the Western Painting Departments of the Xinhua Art College, Changming Art School, and Yiyuan Painting Research Institute. During this period, his painting represented the Republic of China at the Chicago World Fair, and he was selected to the list of Top Twelve National Painters. Chen's works also featured in the Imperial Exhibition and the Taiwan Exhibition many more times, and in 1929 he gained audit exemption from the Taiwan Exhibition.

During his residency in Shanghai, Chen Cheng-po spared no effort toward the creation of art, completing several large-sized paintings that manifested distinct modernist thinking of the time. He also actively participated in modernist painting events, such as the many preparatory meetings of the Dike-breaking Club. Chen's outgoing and enthusiastic personality helped him form deep bonds with both traditional and modernist Chinese painters.

Yet in 1932, with the outbreak of the 128 Incident in Shanghai, the local Chinese and Japanese communities clashed. Chen was outcast by locals because of his Japanese expatriate status and nearly lost his life amidst the chaos. Ultimately, he was forced to return to Taiwan in 1933.

On his return, Chen devoted himself to his homeland. He invited like-minded enthusiasts to found the Tai Yang Art Society, which held annual exhibitions and tours to promote art to the general public. The association was immensely successful and had a profound influence on the development and advocacy for fine arts in Taiwan. It was during this period that Chen's creative expression climaxed — his use of strong and lively colors fully expressed the verdant forests, breathtaking landscape and friendly people of Taiwan.

When the Second World War ended in 1945, Taiwan returned to Chinese control. Chen eagerly called on everyone around him to adopt the new national language, Mandarin. He also joined the Three Principles of the People Youth Corps, and served as a councilor of the Chiayi City Council in its first term. Not long after, the 228 Incident broke out in early 1947. On behalf of the Chiayi citizens, he went to the Shueishang Airport to negotiate with and appease Kuomintang troops, but instead was detained and imprisoned without trial. On the morning of March 25, he was publicly executed at the Chiayi Train Station Plaza. His warm blood flowed down onto the land which he had painted day and night, leaving only his works and memories for future generations.

The unjust execution of Chen Cheng-po became a taboo topic in postwar Taiwan's history. His life and works were gradually lost to the minds of the younger generation. It was not until martial law was lifted that some of Chen's works re-emerged and were sold at record-breaking prices at international auctions. Even so, the academia had little to go on about his life and works due to scarce resources. It was

a difficult task for most scholars to research and develop a comprehensive view of Chen's unique philosophy and style given the limited resources available, let alone for the general public.

Clearly, it is unjust to perceive Chen, a painter who dedicated his whole life to art, as a mere political victim. After three generations of suffering from injustice and humiliation, along with difficulties in the preservation of his works, the time has come for his descendants to finally reveal a large quantity of Chen's paintings and related materials to the public. Many other works have been damaged by termites.

I was honored to have participated in the"A Soul of Chiayi: A Centennial Exhibition of Chen Cheng-po"symposium in celebration of the artist's hundredth birthday in 1994. At that time, I analyzed Chen's unique style using the concept of visual constancy. It was also at the seminar that I met Chen Tsung-kuang, Chen Cheng-po's eldest son. I learned how the artist's works and documents had been painstakingly preserved by his wife Chang Jie before they were passed down to their son. About two years ago, in 2010, Chen Tsung-kuang's eldest son, Chen Li-po, retired. As a successful entrepreneur in Southeast Asia, he quickly realized that the paintings and documents were precious cultural assets not only to his own family, but also to Taiwan society and its modern history. Actions were soon taken for the permanent preservation of Chen Cheng-po's works, beginning with a massive restoration project. At the turn of 2011 and 2012, two large-scale commemorative exhibitions that featured Chen Cheng-po's works launched with overlapping exhibition periods —"Nostalgia in the Vast Universe"at the Kaohsiung Museum of Fine Arts and"Journey through Jiangnan"at the Taipei Fine Arts Museum. Both exhibits surprised the general public with the sheer number of his works that had never seen the light of day. From the warm reception of viewers, it is fair to say that the Chen Cheng-po research effort has truly begun.

In order to keep a complete record of the artist's life, and to preserve these long-repressed cultural assets of Taiwan, we publish the *Chen Cheng-po Corpus* in joint effort with coworkers and friends. The works are presented in 18 volumes, the first 10 of which come in hardcover octavo deluxe form. The first volume features nearly 300 oil paintings, including those for which only black-and-white images exist. The second volume consists of 241 calligraphy, ink wash painting, glue color painting, charcoal sketch, watercolor, and other works. The third volume contains more than 400 watercolor sketches most powerfully delivered works that feature female nudes. The fourth volume includes 1, 103 sketches. The fifth volume comprises 1, 200 sketches selected from Chen's 38 sketchbooks. The artist's personal historic materials are included in the sixth and seventh volumes. The materials include his family photos, individual photo shots, letters, and paper documents. The eighth and ninth volumes contain a complete collection of Empire Art Exhibition postcards, relevant collections, literature, and resources. The tenth volume consists of research done on Chen Cheng-po, exhibition material, and other related information.

Volumes eleven to eighteen are paperback decimo-sexto copies mainly consisting of Chen's writings and notes. The eleventh volume comprises articles and notes written by Chen. The twelfth and thirteenth volumes contain studies on Chen. The historical materials on the 228 Incident included in the fourteenth volumes are mostly focused on Chen. The fifteen to seventeen volumes focus on restoration reports and materials analysis of Chen's artworks. The eighteenth volume features Chen's chronology, so as to more vividly present the artist's life.

Chen Cheng-po was more than a painting master to Taiwan — his life and death cast lasting influence on the Island's history. The *Chen Cheng-po Corpus*, jointly published by the Chen Cheng-po Cultural Foundation and the Institute of Taiwan History of Academia Sinica, manifests Chen's importance both in form and in content.

I am grateful to the scholar friends who went out of their way to share the burden of compiling the corpus; to executive editors Lai Ling-ju and Ho Kuan-yi for their great support; and Ho Cheng-kuang, president of Artist Publishing co. and his capable art editor Ke Mei-li for their patience and support. For sure, I owe the most gratitude to Chen Tsung-kuang; his eldest son Li-po and his wife Hui-ling; and the entire Chen family for their support and encouragement in the course of publication. This historic project will bring unlimited glamour and glory to the history of Taiwan.

Editor-in-Chief, *Chen Cheng-po Corpus*
Professor, Department of History, National Cheng Kung University
Hsiao Chong-ray

Chong-ray Hsiao

澄緣──由修復牽引出的故事

一、前言

約莫在2011年初吧！學校高層通知我們說，將有重要的貴賓來訪，參觀本中心的修復和科學檢驗的作業流程，這會是我們藝術科學保存修復組（本中心的前稱）創立以來所接觸到最具份量的單位──財團法人陳澄波文化基金會。一接收到訊息，我的內心又是興奮又是惶恐，這臺灣最具代表性的先輩藝術家其後代所成立的基金會的到來，若能受到他們的青睞，我們中心無論在學術研究或是未來發展，應都會邁向另一個里程碑；相反的，如果這次我們表現的不好，除了需虛心檢討改善外，可能也無法參與到這臺灣藝術修復保存最高殿堂的相關工作，對中心甚或學校皆為莫大的損失。基金會參訪當天，兩位重要人物映入眼簾的身影至今難忘；時任基金會董事長的陳重光先生，也就是陳澄波老師的長子，慈眉善目中流露著堅毅，是位令人感覺到溫暖的長者；現任董事長陳立栢先生帶著略顯嚴肅的表情，舉手投足間充滿著對其父之尊重，對任何事務的提問，也讓我感受到他實事求是的精神，這部分在後來的合作中，更有確切的體認，也讓我們中心的運作系統品質有了大幅度的提升。

所幸，在當日的參訪後，基金會願意將部分作品的修復作業交由本中心執行，在此之前，我們鮮少有機會能接觸到臺灣如此重量級藝術家所創作的作品，為了能完善的處理好這些畫作，基金會給了我們相當充分的時間，由於在託予我們修復之前，基金會已有委託其他單位修復的經驗，甚至在十幾二十年前，前董事長就曾帶作品遠赴日本進行修復，所以他們堅信，被時間所擠壓出來的修復，對作品而言絕對不是好事，還可能弄巧成拙的讓作品受到傷害。

說也有趣，當初這批畫作送進修復室的時候，常常看到我們的首席油畫修復師尤西博（Dr. Ioseba）望著作品發呆，一望就望了半餉，有一回我湊過去，問他究竟看著什麼看得這麼入神，他回答道：「我在和作品對話，如果沒有深切的了解它，就可能在修復時忽略了一些蛛絲馬跡，而這些資訊，很可能決定未來修復作業的重要關鍵或成敗與否。」當下的我五分佩服五分質疑，佩服的是他面對畫作修復投入的態度，質疑的是這種作法在降低油畫修復效率的同時，是否真能如他所言，提出對研究陳澄波的相關學者有所助益的發現，但後來他在這些作品修復過程所得的研究能量，證實了在修復過程中與作品對話的重要性。

除了作品的修復外，修復完成後作品的保存與管理也是不容忽視的議題，為配合2014年陳澄波百二誕辰東亞巡迴大展，專業的運輸包裝、保險及佈展等相關的問題，必須依不同國家及展覽空間條件的需求量身定製，每件作品從裝箱前的檢視紀錄，再到展場開箱檢查、佈置及卸展後的檢視等，基金會每個環節無不考慮到非常周詳，也因為基金會秉持著嚴謹的態度看待每個細節，讓每一個參與工作的夥伴，不分你我的想讓每一次的展出都是完美的呈現，這樣的心情與態度，促使橫跨三個國家五個地區的陳澄波百二東亞巡迴大展，能夠在掌聲中順利的圓滿落幕。

二、油畫作品修復

在2014年陳澄波百二誕辰東亞巡迴大展前，於2011年至2013年三年的期間，我們中心的油畫組總共修復了35件作品，包含了20件布質及15件木板畫作，這些作品曾受與未受修復的比例約為2:1，三年來的作業過程，除了審

慎的進行各件作品的修復外，更重要的，我們透過了觀察這些畫作的劣化方式，找出了一些相當有趣的資訊，也摘取了其中8件具代表性的修復案例於本書中呈現；譬如〔綠幔裸女〕這件作品，在多年前曾被修復過，由畫布的狀況可得知，在修復之前相當脆弱，所以那時的修復師使用歐洲地區傳統加強畫布支撐力的手法——蠟托裱，試圖加強畫布的支撐力，這種手法確實能達到上述功效，但取而代之的，則會讓畫布失去它自然的彈性，整體繪畫層即變得僵硬，而無法抵禦外力或溫濕度劇烈的變化，一遇到這些狀況，就會讓繪畫層產生逆裂、起翹或缺損的可能；蠟托裱在歐洲等氣候帶也許是一種可行的修復手法，可惜的是，在高熱高濕的臺灣反而容易會加劇作品的劣化。也許是經過時空的轉換吧，我們在作品背面的畫布上發現了部分殘蠟，有些還由繪畫層裂縫中熔出，檢視到這些狀況，修復師們決定先將對作品具不良影響的蠟托裱移除，而這程序卻也是這件作品修復中最耗時的步驟，經過數次的測試，後來我們找到了最有效率的作法，這程序也獲得了我國的發明專利。修復之前的科學檢視對每張作品而言都是不可或缺的，譬如我們在X光的檢視下察覺此幅作品畫面下隱藏著另一幅畫——一位裸女斜坐著雙手環抱膝蓋，而綜合X光與紫外線一系列的檢測結果，也發現部分的補筆畫到缺失處周圍原有繪畫層上，而在原繪畫層缺損處填料刻劃的細緻度，與陳澄波的筆觸也有所差異，所幸之前修復師所使用的材料具可移除性，故我們可以在儘量不損及原創的情況下將之前所受的修復補筆處全面移除。最後一個步驟是在上保護凡尼斯再次塗佈與否的取決，這部分Dr. Ioseba下了很大的工夫去調查，他發現所有陳澄波未曾修復的作品皆沒有上保護漆，有上保護凡尼斯的大部份都是受過修復的畫作，或是家屬授權陳澄波學生等人塗佈的，基於尊重原創且以保留藝術家創作原貌的修復倫理基礎，他決定還原各件作品的本相，也就是不再在陳澄波的畫作上保護凡尼斯。

與上述相似的狀況也同樣出現在陳澄波的其他作品上，如〔臥躺裸女〕這件畫作，比繪畫層缺失面積大上許多的補筆痕跡，狂肆的滿佈在作品之上，並覆蓋了其原有的筆觸；在紫外線下，厚重的凡尼斯所散發出來螢光，幾乎將原創的繪畫層色澤吞噬殆盡；從側光的拍攝角度，明顯的能觀察到它因自然劣化或保存環境所限而逆散的龜裂紋，仿若畫中的裸女被密密麻麻的絲線所困縛住，這件作品更大的問題，在於右下方偌大的摺痕缺失，一個因保存環境而烙在作品上的傷痕。若說每件畫作都有其自己的故事，那科學研究則可稱為開啟這一連串密碼的鑰匙，在〔臥躺裸女〕的X光檢視圖中，我們深刻體認到「凡走過必留下痕跡」的事實，從X光檢視圖中，掛著畫的背景顯然更為複雜，若隱若現的在掛畫下方及其左側，可觀察到正常光下所看不到的構圖，除了背景的修改之外，裸女頸背下方的綠色毯子，也具有與繪畫層不盡相似的構筆，而這些資訊都是仰賴現今科技的進步才得以窺探。

在〔貯木場〕一畫所觀察到的現象，像是一道道長者臉上的皺紋（圖1），每一條都有它的故事。這作品龜裂的狀況沒有前兩件嚴重，但除了裂紋外，作品繪畫層還存在著其他問題，一般的裂痕是因畫布的張力的改變所造成的，所以雖然裂了，卻不會有繪畫層起翹或剝離等狀況，但〔貯木場〕的表面充斥了山型的裂痕，這種劣化是因顏料層遭到擠壓所致，擠壓的力道使繪畫層脫離了畫布，稍一不慎即會造成顏料層的剝離，面對這樣的狀況，首要之事就是進行繪畫層的保護，透過這樣的程序讓顏料層回歸到它原有的位置，另外，在這張作品中，除了與前述作品同樣的具有補筆及全色不當的狀況之外，還具有許多顏料層被壓扁的壓痕、被其他畫布疊放其上而留下的印痕及畫心中央附近的指紋等情形（圖2），這些現象因為都是發生在繪畫層上，而不是在之前修復時所加上的凡尼

斯層中，所以可能是在那之前就已經存在的了，除了那枚指紋未去驗明正身外，顏料層的壓痕及畫布印痕，則可能是在創作完成而顏料未乾時所留下的，當然這種狀況也可能是因長時間以堆疊的方式存放畫作所導致。〔貯木場〕最有趣的地方，在於它的X光檢視結果，其表層繪畫層的底下，另具有一半身的裸女，而且原裸女是以畫布直立的方式進行創作的，這類在肖像畫上改變方向重新繪圖的狀況，在我們所發現陳澄波不同底層構圖作品的比例上算是不低，尤其最常見的，就是在肖像畫上重新繪製風景畫，這也讓我們確定，陳澄波在創作時，除了如〔臥躺裸女〕一般會對畫面構圖進行調整外，也會重新利用已具繪畫層的畫布進行創作。

圖1.〔貯木場〕作品局部圖

圖2.畫面上疑似指印的壓痕

　　關於畫布重新繪製的部分，我們也花了許多心力進行研究，這些大多是經由從X射線所得到的結果。在東京美術學校期間，陳澄波之所以會重新使用畫布，可能是受迫於當時處於學生身份下的經濟和教育因素的影響，但當我們將陳澄波一生中主要創作的三段時期：東京、上海和臺灣的作品全面檢視時，就不能夠只把經濟因素當成陳澄波重覆使用同一張畫布的唯一理由，因為在各個階段，尤其當陳澄波成為一位正職的藝術家之後，我們都發現了他重覆利用畫布創作的作品，所以我們必須也要從「藝術欣賞」的觀點來考量這些因素，也就是說，當畫家改變一幅作品或者修改一幅作品的時候，很有可能表示他並不想再接受其所「不喜歡的」，而且也已經「被覆蓋的」畫作。

　　我最喜歡把〔上海碼頭〕修復前後的差異比喻為戰後和戰前的表徵了，而實際上，在第二次世界大戰之後，畫作中的雕像紀念碑也已成為歷史而不復存在了。第一次見到〔上海碼頭〕這張畫作時，灰暗的天空和街景仿若陷在解不開的迷霧中，**豎**立著雕像的孤獨氣息帶著幾分沈鬱，它鑽入我的心中，是一股壓抑著的氣氛，但隨著修復師一抹一抹的揭除它的陰霾後，呈現在我們眼前的，是陳澄波對上海外灘碼頭的榮景所進行的描繪（圖3），連

陳董事長都說道，他從來不知〔上海碼頭〕的天空是如此的明亮，而事實上，讓我們誤解這張作品所傳達意境的最大元兇，就是繪畫層表面已黃化劣化的厚重凡尼斯層，這個現象在紫外線的下更加的明顯，尤其是凡尼斯層劣化的部分，猶如戰火的煙硝迷漫著整個上海碼頭的天空，建築物上的補筆痕跡，更如同飽受摧殘後而沾滿了灰燼。回到作品本身，在基質上的劣化，係因畫布基底材的老化及其織紋樣式而造成相當細小的裂痕，但這些裂痕上卻堆積了大量的塵埃及髒污物，另外，這張作品的基底材是以一經二緯的方式所織成的畫布，這並非陳澄波常使用的類型。在創作後，這張畫作曾經於顏料未乾時就與其他作品重疊置放，所以在它彩繪層之上有其他畫布所壓印的痕跡。於前手修復後，我們發現加諸於畫面上的凡尼斯層塗佈並不均勻，而這也是造成作品表面陰晦不均的原因之一。在〔上海碼頭〕這件作品的修復過程中，與內框相關的作業是較為特殊的，由於在內框上，有著以鉛筆書寫的「上海外灘碼頭」字樣（圖4），所以框條上可利用來繃畫布的部分材料有所缺損，但我們還是以填料的方式補強它，並在以無酸背膠帶進行畫布收邊時，避開此區域且使之顯露出來。

紫外線的檢視是修復師用來判斷作品是否經過修復補筆的重要工具之一，以〔淑女像〕而言，由其檢視結果得知它是一件從未經修復的畫作，但由於久置於庫房中，且從來沒有被修整過，所以繪畫層上具有一些昆蟲排遺（圖5），並積了厚重的塵垢及其他物件的壓痕。這件作品較不好處理的地方，在於經年累月在筆觸間所堆疊的髒污，它是極為細小且難以處理的，如同油污一沾上衣服時，如果立即清潔就非常容易將它移除，但若隔了一段時間再去處理它的時候，油污就會滲入衣服的纖維中而難以洗淨，〔淑女像〕就像是遇到這種情形，而且在清理這些塵垢時，一不小心都很有可能破壞了繪畫層的完整。在修復中，我們使用了兔膠與硫酸鈣調和而成石膏漿填補繪畫層缺損處，再塑造出畫作原有的肌理狀態；全色時則以水性可逆專業顏料進行，並秉持著保留自然色澤之最高準則進行全色作業，讓大家可以觀賞到這件作品樸實中所散發的光采。

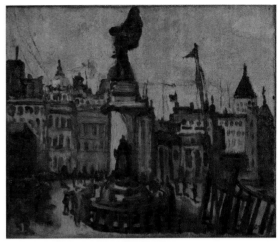

圖3.〔上海碼頭〕描繪上海外灘碼頭的榮景

圖4.背面內框書寫「上海外灘碼頭」字樣

圖5.〔淑女像〕繪畫層上昆蟲的排遺

〔船艙內〕一圖和〔淑女像〕的狀況相當類似，根據紅外線光、紫外線及X光拍攝檢視結果，發現畫作並無底稿、舊補筆、凡尼斯或隱藏的繪畫層的反應，由此可知此畫作並沒有被修復過，同樣的，因為這張圖亦屬繪製木板上的油畫，所以較為顯著的劣化就是多年以來沈積的髒污及塵埃，免不了在部分繪畫層上還是會發現昆蟲排遺，及因在繪畫層未完全乾燥時與其他木板疊放，導致厚塗處顏料部分有被壓扁的狀況等。在修復這件作品時，Dr. Ioseba發現了一個很有趣的現象，就是〔船艙內〕畫作的各個角落，都存在著一個圓狀壓印痕跡，而且中間還有一個孔洞（圖6），四個角落的壓痕與孔洞的大小都是一致的，這「先天」的損傷，揭露出陳澄波將畫作從創作處攜回工作室時所用的方法。怎麼說呢！一般藝術家在戶外創作時，會盡可能使用最安全的運送方式及合適的畫布畫板攜帶器具，來將未乾的畫布移動到工作室，以避免因攜帶運送時對作品造成毀壞，由上述的這些壓痕和孔洞，我們可以得知陳澄波所使用的工具就是畫布針（圖7），他會將這金屬畫布針的兩端頭針釘入畫布內框或是木板上當作撐具，把二件大小相近的畫作正面對正面的固定住，使之能一起運送，而且較不容易讓外在因素傷害到作品表面的繪畫層，只是無法避免的，一定會在作品上留下上述的痕跡，雖然理論上它並不屬於創作的一部分，但也算是在這作品於創作時所一起留下的，所以我們都會選擇保留它而不執行修復。

圖6.畫作四週圍的孔洞及壓痕

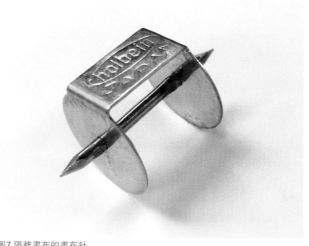

圖7.隔離畫布的畫布針

當我們談論陳澄波的美術成就時，通常不願意提及他敏感的身份，以免模糊了純粹的美學觀點，但他部分的作品，卻的確受二二八事件所影響，以不得不的方式進行保存而造成嚴重的損傷，如〔上海郊外〕這件作品上的龜裂紋，就如同這段不堪歷史的印記。當〔上海郊外〕送到我們中心時，狀況大致上並不佳，由於它的畫布曾經被捲曲著收藏，所以畫面上佈滿大量垂直且同方向的裂痕（圖8-9）。當初，在陳澄波遭受當權者迫害而逝世後，其家人認為畫作應該保護並藏匿起來以避免被政府發現，因為一旦被搜出，可能會將之沒收並破壞這些畫作，陳家本著保護陳澄波遺物的決心而展現出來的勇氣，讓臺灣人能保有這些珍貴資產，因此畫面上的捲曲裂痕展現出的

圖8.因捲曲方式收藏而出現的垂直龜裂紋　　　　　　　　　　　　圖9.因畫布收縮造成的折痕

是他們的勇氣和文物保存的象徵，並告知世人這幅畫作的自身的生命歷史與傷痕。

在〔上海郊外〕身上，除了歷史的印記外，我們也發現了和〔船艙內〕一圖相同的圓孔與壓痕，這也說明這張圖應是在戶外所創作的，此外，基於修復倫理，我們通常都會盡可能保留任何屬於原作的物件，包括已脫線的布邊，仍會利用各種加固的手段復原之。在內框的部分，由於〔運河〕原本使用的是固定式的，其狀況對作品保存而言並不合適，所以修復師即以新的可調整式樺接木製內框替換，並裝上畫框調整器，以在畫布張力太大或變鬆時可以適時的調整之，減少這些讓作品可能受損的因素。最後，由於這張畫布對繪畫層的承載力已有不足，所以我們以新的畫布在其後方重新托裱，期望在「救回」這件作品後，能盡可能的延續它的生命。

〔含羞裸女〕是陳澄波創作的一張半身裸女肖像畫，它在送來我們修護中心之前從未曾受到修復，但由於之前存放它的環境並不是相當的好，所以〔含羞裸女〕的狀況並不佳，繪畫層都佈滿了嚴重的龜裂紋，尤其上半部的龜裂更為顯著，以強光從畫的背面檢視時，女子的上半身即有如被絲網纏繞著似的，除了一樣有髒污沈積在裂紋上外，在裸女左胸的部分，還有一處面積不小的繪畫層缺失；也許是緣份吧，這半截小指頭大小的缺損，竟然讓我們找到了；這幾年有幸得基金會的青睞，委託我們進行這35件油畫作品的修復，當初我們在進行另一張靜物畫作〔早餐〕的修復工作時，在其畫布後面有發現到一塊油畫繪畫層殘片，因為它對油畫的保存狀況不會產生影響，所以進行修復的時候並沒有把它移除，而將之當成是作品的一部分，而在修復〔含羞裸女〕的時候，Dr. Ioseba想起〔早餐〕背後的那塊殘片（圖10），其大小和形狀為相似，謹慎的比對之後，我們確認它就是〔含羞裸女〕左胸所遺失的那塊繪畫層（圖11），這驚人的發現，要剛好兩件作品皆由同一個人進行修復，而修復師也得對畫作完全的尊重並觀察入微，才有可能得到令人滿意的結果，使〔含羞裸女〕一圖在多年後得以回到其原始被創作時的本貌；根據我們的推測，這種狀況是因為在顏料未完全乾透時，即將兩張畫布疊壓存放所造成的，但發現歸

圖10.〔早餐〕背後沾黏的殘片

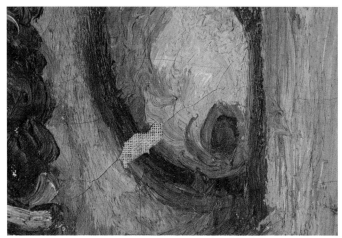

圖11.〔含羞裸女〕繪畫層缺損處

發現，要將黏於靜物畫背面的易碎彩繪層色塊從畫布上完整的分離並拼合黏回原處是一項相當精細的步驟，必須先以可被移除的紙張及黏膠黏附於色塊背面把它固定，以預防色塊在剝離及復原修復中碎裂，小心取下後，再以動物膠將色塊黏回〔含羞裸女〕上原缺失處。

　　〔含羞裸女〕一圖的修復，也運用了較為少見的手法——透明托裱法。由於這張作品有許多龜裂及媒材不穩定的狀況，因此有必要針對畫作施行全面性托裱以加固繪畫層，同時也可以幫助畫作基底材更平整，一般所採取的，是以新的畫布直接在背面托裱，但由於這件作品的背面有陳澄波的親筆簽名（圖12-13），所以修復師使用透明材質進行托裱，一來可維持藝術家簽名處可見度以保留畫布的歷史，二來可讓畫作整體結構更加穩定，而為了選擇適當的材料，油畫組的同仁們可是翻遍了大大小小的布莊呢！

圖12.畫布托裱前簽名處

圖13.透明托裱後簽名處

三、紙質作品修復

　　陳澄波在美術上的展現，除了油畫作品外，也有為數甚為可觀的東、西方紙質作品；其中，東方紙質作品，是指以樹皮之韌皮纖維、大麻、藤類與禾本科的竹類、草類等作為基底材主要構成原料所製出的紙，存在在這類紙質之上的媒材，則以水墨、彩墨、書法、膠彩作品為大宗。在西式紙材作品的部分，主要則以機製紙為基底材，藝術家通常使用炭筆或鉛筆畫素描，亦有鋼筆速寫或色鉛筆速寫參於其中，這兩類材質，最常發生的劣化狀況即包含了褐斑、清痕、蟲害及微生物所造成的損傷。在紙類作品的修復作業中，基金會自2011起至2015年以來，係委託本中心進行11件東方紙質（含膠彩鏡片1件、水墨鏡片1件、彩墨鏡片1件、彩墨掛軸4件、水墨掛軸1件、書法對聯一組2件及扇面1件等）與302件西方紙質（含炭筆素描12張、素描簿3本、地圖1張、水彩1張與最大宗的單頁速寫285張）作品，而在本全集中，即挑選了六項較具代表性的修復成果呈現於內。

　　〔百合花〕為東方紙質膠彩作品，一般而言此類作品多以鏡面裝裱或製成卷軸來保存，但此作品卻未以這些方式處理，而僅以直接捲收的方式存放，加上紙張酸化的狀況相當嚴重，造成基底材甚為脆弱，需經過小心的加濕攤平與背面加固後才得以展開，一窺畫作原貌（圖14）；此幅作品除了畫心之外，背面還包含一層命紙與一層大小與畫心一致的加托紙，但經年累月的劣化，其脆弱的程序和畫心相差無幾，不僅黃化髒污嚴重，原裝裱的紙力也不勝負荷，造成多處橫向的摺痕、裂痕等，為了讓畫作能長久保存，在解決紙力脆弱問題的部分，修復師係移除原有的背紙，以去除紙張的酸性來源，而後即選用性質較佳的修復級紙張加托，並且改善日後的保存方式與環境。雖然紙張基底材劣化嚴重，所幸百合花畫意保留的相當完整，尤其從背面觀察時，可發現清晰的百合花貌，且其顏色較鄰近的紙張白上許多（圖15），這表示本作品所使用的繪畫材料有效的保護紙張，降低了其酸化和黃化的狀況。在修復前的各項光學檢測，我們發作品背景除了顏色較不均勻外，亦有紙張缺損、水漬、髒污等問題，而下方紙張

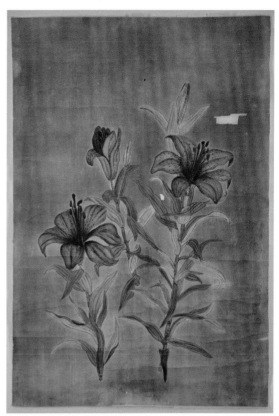

圖14.〔百合花〕修復前正面

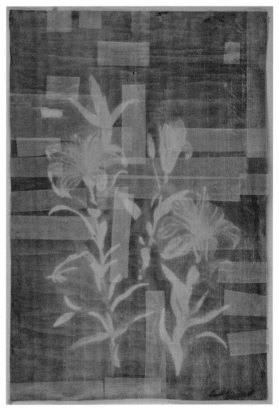

圖15.作品背面清晰的百合花貌

邊緣厚薄不均的問題，也是日後需要調整的對象。酸性物質一向是紙質作品最大的殺手，其會使紙張產生褐斑，嚴重時則會全面的黃化劣化，等到紙張進入到粉化的階段時，其修復作業就非常難以進行。

此〔百合花〕作品已進入上述的第二回階段，畫心全面都呈現嚴重的黃化，針對這類需全面去酸的作品，通常修復師會以最溫和安全的方式處理，因為紙張已甚為脆弱，所以會在不添加任何的藥劑的情況下以純水進行全面的淋洗，避免去挑戰紙張對任何試劑的耐受度，就算是用純水淋洗，我們也是讓它扮演「過客」的角色，以能帶走酸性物質的最短停留時間留駐在紙中，故在淋洗時，即以人造纖維紙襯住畫心並放置於壓克力板上，將RO純水以淋洗方式緩緩將紙張髒污洗出，並隔著人造纖維將汙水刷出。在紙張缺失及全色的部分，與油畫的處理方式就大不相同，紙質作品缺失處的處理，需選用與畫心相似性較高的中性手工紙作為命紙，以排筆刷染紙張的方式挑選顏色最適合的樣本進行小托，全色時更是馬虎不得，由於油畫的全色若失手，仍可以清潔的方式移除顏料，但紙質作品則否，一不小心紙張就會將顏料吸附，所以進行全色時皆需先塗佈隔離層來避免顏料暈染。

〔牽牛花〕是陳澄波少見的水墨作品，而且自它被完成後就未曾進行裝裱；此作品畫心紙張邊緣參差不齊且帶些許裂痕，圖中遍佈多處摺痕，最重要的，由於年久失修，整個畫面上佈滿褐斑而嚴重干擾畫意，所幸紙張酸化的狀況還不致影響結構。修復師在處理這件作品時，所採取的首要手段是先進行全面清洗與淡化褐斑，大面積的髒污處全面以溫水清洗，其他不易去除的局部褐斑，則使用稀釋後的過氧化氫（雙氧水）進行淡化清潔，以盡量回復到其原始畫意，在淡化褐斑後，我們以淋洗的方式將紙張中髒污及藥劑洗出，避免藥劑殘留在基底材及顏料層中；另外，在邊緣不齊的部分，為了保留原畫的完整性與欣賞時的協調性，修復師係將命紙先行染色後再進行小托，命紙則選用與畫心性質較相近的中性手工紙為之，並以延展邊緣的方式全色，補足缺失的部分，使畫心在視覺上較為方正，為兼顧紙張的支撐力及後續作品的保存，在第二層的加托係選用中性手工美栖紙，這類紙張含有碳酸鈣，可用以調節畫作的酸鹼值，提升基底材的保存性及壽命。另外，由於本作品已有逐漸酸化之跡象，所以修復師採用無酸蜂巢板作為背板，並將之框裱以作為日後保存維護與展示的形式。

如果對臺灣美術史有所涉獵的話，應該都會同意在民國初期日治的臺灣，其美學藝術發展之蓬勃，恐怕較現今還來得熱絡，最近的一齣連戲劇「紫色大稻埕」即以當時美育發展與交流作為該戲的背景，其中有一幕，我竟然瞥見了我們曾修過的畫——〔淡水寫生合畫〕，而這張畫也真稱得上是1941年前後各藝術家熱烈交流的代表作，此作品是由陳澄波等六人共同合畫的水墨淡彩畫，陳重光先生依據陳澄波的口述紀錄，得知六位藝術家分別畫了哪些部分：陳澄波畫山腳房屋、周圍草地、小帆船、天空與鳥群；楊三郎（楊佐三郎）先生畫觀音山；林玉山畫大船；李梅樹畫左邊大樹；郭雪湖畫前面陸地；陳敬輝（中村敬輝）畫淡水河中沙地等 (圖16-17)，這張以日本厚紙板為基底材的作品，具白色的正面及淺褐的背面，紙張的四周立邊有鑲金，也許這在那個時代屬難得的紙材，才會誕生出如此的珍品，這樣的夢幻組合不但不容錯過，更要極力將之好好保存，留下那一段美學交流巔峰的見證，而這張圖會交由陳澄波保存，也足見當時他在臺灣藝壇的地位。和前幾張紙質作品相較之，此畫作的狀況顯為和緩，即便如此，其修復前狀況，仍具有畫心表面黃化、多處佈有褐斑、邊緣髒污和蟲蛀及四個邊角具有摺痕等狀況。

在紙質作品的修復領域中亦適用「上善若水」一詞，一般大眾對紙質作品的印象，是最好別讓它接觸到水

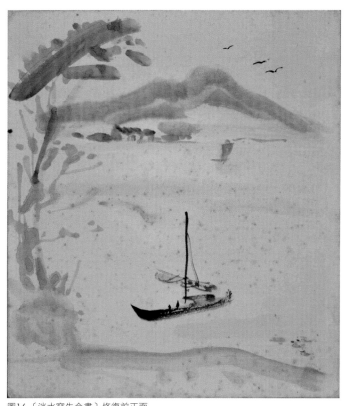

圖16.〔淡水寫生合畫〕修復前正面

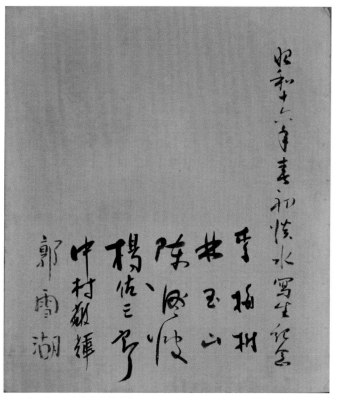

圖17.作品背面六人簽名落款字樣

分或水汽，以避免造成形變及漬痕，但在修復領域的作法就不一樣了，我們通常把水（這裡是指純水，自來水因雜質太多而不適用以下說法）當作緩解酸化的第一選擇，而且以水去處理紙質作品，是最不會造成日後問題的作法，只有水處理不了的時候，才會使用其他藥劑，所以針對這件作品，修復師先以溫水將其中的酸性有害物質帶出，之後以過氧化氫來淡化嚴重的褐斑。〔淡水寫生合畫〕除了正面，背面的簽名也是學者們研究欣賞的目標之一，鑑於這種狀況，修復師係以雙面夾裱的方式處理之，以讓畫作兩面皆可供人研究觀賞；此外，因應這類的裝裱方式，修復師係設計製作了一透明壓克力立式臺座裝裱，將框裱部分將設計成兩面都能以站立的方式被觀賞，處理完之後的效果非常好，常常在展出時，這件作品就成為觀眾目光的焦點。

在西方紙質修復的部分，我們分別摘錄了炭筆素描、水彩、單頁速寫和素描簿等四類作品於全集中呈現，以〔水源地附近〕這張水彩作品為例，此圖是1919年陳澄波所繪之水彩風景寫生，除了繪圖內容外，其左下方有簽名、印章、文字註記等共六處（圖18），且背面亦有中日文交雜的文字標註，可供研究之處相當豐富，這件作品較可惜的，是因前人以較厚的長纖維紙張從背後托裱，導致背面的字跡難以辨認；本圖全幅的畫意完整，紙力穩固，惟在作品劣化部分，其畫心具全面性的黃化，尤其邊緣顏色暗沉、髒污嚴重，且褐斑顏色較深，上方有一處之缺口較大，而缺口邊緣有許多昆蟲排遺，表示該缺口應為蟲害所致。

本作品修復最重要的步驟，就是揭掉原托裱紙張，保留紙張背面文字的可辨識性，並移除夾紙內的膠帶，以加濕壓平方式恢復紙張原貌。另有別於其他的水彩作品，我們在裝裱時特別複製了背面的文字，將之與畫心共同

圖18.〔水源地附近〕作品右下方作者簽名、印章及文字註記處

展示於無酸夾裱中，讓觀眾在欣賞畫作的同時，能閱讀藝術家當時在背後所註記之文字。

此批炭筆素描作品為約在1925年到1930年間完成的12件裸體人物，每件作品陳澄波都有紀錄其完成的年代和日期，而經由透光檢視我們有觀察到紋路清晰的浮水印，且每張基底材的厚薄、紋路、質地皆不盡相同，對相關學者專家而言，這些結果都是可供研究的題材。這批作品的原始狀態皆無任何裝裱，而且從作品的狀況，可得知當初係以重疊捲曲方式收藏。舉例而言，〔坐姿裸女素描-27.2（16）〕、〔坐姿裸女素描-27.11.24（26）〕、〔立姿裸女素描-27.10.20（25）〕等3件作品在左下角同一位置都有一形狀大小相似的缺失，應是收藏時重疊而同時造成的缺損。就所有畫作的劣化狀況，其基底材方面，多有表面黃化嚴重、紙張邊緣焦脆缺損及畫心顏色不均勻等問題，同時也多帶有輕微髒污及些許異物或昆蟲排遺，其中以〔坐姿裸女素描-30.5.3（30）〕之黃化不均的狀況最為顯著，該作品在人物及簽名部分皆有明顯黃化，且其下方兩處方型的區域則呈色較白，依此我們推測紙張表面黃化嚴重部分，可能是噴膠變質後所導致，白色部分則是當初被紙膠或是其他膠帶所遮蔽住，故未因沾染到噴膠而劣化變色；這批作品中，紙力最脆弱的為作品〔立姿裸女素描-28.10.19（32）〕，因其紙張較薄，且下方有兩條大範圍的橫向折痕和一處垂直裂痕，故需要進行嵌折處理以強化紙力；此外，在作品〔坐姿裸女素描-25.6.11（4）〕中，因為該紙張形狀上窄下寬且邊緣不齊，為保留邊緣的簽名與印章，所以我們在製作夾裱時，係以邊緣外加紙張的方式讓畫心往外延伸，以便展示簽名的部份。最後，為了兼顧展示及保存等功能，修復師選用白色無酸卡紙板製作活動式窗型夾裱，依據作品實際尺寸進行開窗，並使用無酸聚酯片與卡紙板製作壓條，以無膠的方式將作品固定於同一尺寸的夾裱背板上，如此一來，這些作品在展示時即可配用相同的系統框，而未展示時也可統一以無酸盒保存以節省貯藏空間並便於管理。

相較於其他類型的紙質作品，單頁速寫的保存本身就是一項艱困的課題，這批包含1張街景、24張山景、260張人物與靜物等共285件的速寫，多年來就被整疊的收藏，用牛皮紙袋簡單的包著，座落在角落，在這種環境下，牛皮紙帶來的厚重酸氣，沈甸甸的被紙張完全吸收，所以幾乎每張速寫邊緣，都有焦黃脆化的狀況，暗沈的褐斑，隨著時間的積累，暈化開在漸黃化的紙體，並具有皺摺、破損、撕裂、漬痕，乃至蟲蛀排遺等劣化狀況。由於這批速寫雖個別狀況有些許差異，但主要劣化狀況大同小異，所以在修復過程中，除了依個別狀況制訂處理細節外，在進行清洗、除漬痕、褐斑或補紙等動作時，則需以相同程序執行。在這批作品的修復程序中，同樣的，我們以純水來帶走紙張纖維內部的有害物質與色素，但由於各速寫紙張的原始顏色並不相同，老化後差異更大，故清洗過後雖可縮小彼此間顏色的差異，惟實無法將之調整至完全相同，另在整體的修復策略，畫心的缺損將其補齊，但邊緣則不多作修整，保留原有的缺失，因這部分也是屬於此批作品的故事，而最後的保存問題，係以輕便、穩固與持拿的便利性為優先考量，故除了26張山景速寫由活動式的窗型無酸夾裱存放外，其餘259張作品修復

師則將其編號後以無酸瓦楞紙保護盒存放之。

　　相對於完整的作品，藝術家的素描簿更常是學者專家所珍愛的文史資料，從藝術者的視野與創作邏輯，也可以尋找完整作品的前身，故其可供研究之價值不容小覷。本次於全集中列示修復過程的素描簿，為陳澄波所繪的寫生草圖，內容包括了各地的實景描繪、練習和記錄，素描簿中所記載的，雖然只是鉛筆與鋼筆的簡單線條，但透過圖畫和部分的文字記錄，仍能了解當時陳澄波的生活情景與感受。在作品劣化的部分，因該素描簿係以金屬釘針裝幀，歷經數十年之後，原先的金屬釘早已氧化鏽蝕，所產生的鐵鏽不僅成為紙張的汙染源，也無法穩定的固定書頁而失去原本的功能，所以修復之當務，即為移除原本的金屬釘，並使用楮皮紙製作紙釘取代，以避免對作品造成傷害，而為了保護作品抵禦酸性物質的侵蝕，故以製作無酸保護盒的方式收藏該素描簿。

四、結論

　　這幾年來與基金會之配合，除了具體的作品修復作業外，學術論文亦有所產出，我們除了將重要的修復成果與其發現於國內外研討會發表外，在藝術品科學檢測分析的部分也獲得國際期刊的肯定與刊登，而在2015年底，本校藝文處也針對本中心利用X光所檢視到的各項結果，配合陳澄波的原作，策劃了「澄現・陳澄波X射線展」，難得的以藝文類的新聞報導登上部分報紙的頭版，並以該展覽結合同年11月底由本校協辦之「第四屆亞太地區熱帶氣候藝術保存研究組織（APTCCARN）年會」與文化部「挑戰與對策──2015文化資產保存年會」等國內外重要學術研討會，尤其是APTCCARN的年會，更是2012年與陳董事長共同參與第三屆會議後所催生出來的成果，而這些也是基金會一直以來對美學教育及修復觀念推廣所投諸之心力。除了向上發展外，基金會對向下扎根信念的實踐更是不遺餘力，在2015至2016年間，大大小小或到偏鄉或至城市的教育推廣活動本中心就參與了20餘場，而且對象多為資源相對弱勢的東部地區小學學生們，為了完成這些理念，基金會也不計成本的將全數作品進行數位典藏，並把一部分的作品以複製畫的方式（正確來說，已可算是數位版畫了）在東部多數國小內辦理展覽，這樣程度的體現美學教育推廣，讓身處教育界的我們也感汗顏。不可諱言，財團法人陳澄波文化基金會絕對是目前最活躍的藝術家基金會，而不論榮譽董事長和董事長的親力親為，在在都讓人感受到，他們為了實現陳澄波畢生最想推動的事的那份純粹，我只能說，這些年來有幸能受基金會青睞而有配合之機會，有幸學校不計成本支持中心辦理所有事項，有幸我們能擁有這個團隊，也有幸能參與實踐這麼多深具意義的美事，此一段路於願足矣！

【註釋】
* 李益成：正修科技大學藝文處文物修護中心主任。

Dependent Originating——Stories between Chen Cheng-po's Artworks and Conservation

I. Introduction

In early 2011, I received information from the principal that there would be some important guests to come to visit our conservation center. They were from Chen Cheng-po Cultural Foundation which was the greatest institution I had ever get contact with since our center established. I was excited and also got nervous knowing that the descendants of one of the most typical artists in Taiwan planned to come over. Regardless of academic research or future development, conservation center would be on the way to another milestone if we won their recognition. On the contrary, we could not be involved with any conservation work if we lose them. It meant that we needed to take it seriously. I still remember all the things about that day clearly. It was my first time to meet them. Chen Tsung-kuang, the ex-chairman of Chen Cheng-po Cultural Foundation and the eldest son of Chen Cheng-po, is an elder with kind personality and makes others feel the warmth. Chen Li-po, the current chairman of the foundation and the son of Chen Tsung-kuang, is so down-to-earth that doing anything with a serious and respectful attitude.

Fortunately, we got the opportunity for implementing a part of artworks after the visiting. We seldom have a chance to approach artworks which were made by the great artist of Taiwan before. For a perfect and completed restoration, the foundation asked us to make it by a comfortable margin. Because the foundation had entrusted another conservation departments to do the restoration before, even the ex-chairman had brought some artworks to Japan more than 10 years ago, they believe that a quick restoration will never be good for artworks and could hurt them fatally.

When these part of artworks sent to our studio, I used to see Dr. Ioseba who is in charge of the team of oil painting in our center were gazing at the artworks quite a while. There was one time that I looked at him and asked him "What are you gazing at?" and he replied "I'm talking to the works. If you didn't understand them deeply, you may ignore some key points while restoring and those can conclude the restoration work". At that moment, I took his words with a pinch of salt. I admired his attitude but also confused that could it really find the helpful key points in a way like dropping the work efficiency? But after this project, the research results testified his words.

In addition to restore the artworks, the preservation is also an important issue. For the"Chen Cheng-po's 120th Birthday Anniversary Touring Exhibition 2014", the foundation had planned in detail from professional transport, packing, insurance, installation, inspections before packing to examinations after exhibition. Also because of this kind of attitude, everyone who had participated in this work shown their best and paid with selflessness. Therefore, the exhibition could be presented in three countries, five areas and all ended in a perfect way.

II. Conservation in oil painting

During 2011 to 2013, our team of oil painting had restored 35 pieces of works in total, including 20 pieces of canvas and 15 pieces of wood. The ratio of ever to never been restored is 2:1. In these three years, in addition to restore every piece of works carefully, the most important of all, we found something quite interesting via the way of degradation in these works. We also

captured 8 typical cases to show in this corpus. To take *Nude Female Against Green Curtain* for example, this work had been restored many years ago. It was fairly fragile before the first restoration, so the conservator decided to use the Wax-lining which is a traditional technique for preventing paintings from moisture damage and strengthening the support force of canvas. This technique can bring the effects above into full play without doubt; nevertheless, the canvas will lose its nature elasticity and the whole painting will be too stiff to accept the dramatic change of temperature and humidity. Then the painting may crack, bent up or defect. The wax-lining may be a workable technique in the climate area like Europe, but regrettably, it will aggravate the degradation of works in Taiwan where is humid all year long.

We found some wax remained on the back of canvas, some of them even dissolved out to the flaws on the painting. Conservators decided to remove the wax-lining first after seeing these condition, but this step is the most time-consuming in the whole procedure. After numerous experiments, we found out the most efficient method which also got an invention patent in Taiwan. Science inspection is an essential step before any restoration. For example, we discovered an under layer shows a nude seated and leaned with hands surrounding her keens throughout the X-ray. Furthermore, we combined the results which were from X-ray and UV, found out that some part of retouch were drawing directly on the original color. Luckily, those can be removed completely because they were using reversible materials. The last step is applying varnish. In this part, Dr. Ioseba took a lot of work on it. He investigated all the artworks of Chen Cheng-po which were never been restored, and found out that all of them had never applied any varnish. Those artworks with varnish were those had been restored. Based on the respect and retaining to original creativity, Dr. Ioseba determined on keeping the original appearance of the artworks which means do not ever apply varnish in Chen Cheng-po's painting.

The situation above also happened to other paintings of Chen Cheng-po. Such as *Nude in lying posture*, the retouch area were bigger than the lost area and full of the painting. Under the UV light, the thick varnish was shining like fluorescence and almost mantled the original color. To shoot form the sidelight, we can obviously see the flaws were caused by the environment of preservation or by naturally. Just looked like dense silk threads fettered the nude. There was one more serious problem, the biggish line made by folding where was on the lower right corner of the painting. Every artworks has its own secrets, and the science research will be the key of a succession of code to reveal them. In the X-ray picture of *Nude in lying posture*, we truly feel the saying "Footprints in the sand surely show where you have been". The background were so complicated and we can see the composition touch appeared indistinctly on the bottom left of painting. In addition to amend the background, Chen also changed the green blanket under the neck of nude. We need to thanks to technology nowadays for making us to obtain these information.

In *A Lumberyard*, we also can see a lot of flaws just like wrinkles on an elder's face (Fig. 1), every one of it has its own story. The condition of chap was slighter than the two artworks which I've mentioned above. But expect the chap, the first layer still had another problems. The general flaws were caused by the changing of tension of the canvas which means that although the painting had chapped, the first layer wouldn't bent up or peel off. However, the appearance of *A Lumberyard* was full of flaws that look like an outline of mountains. This kind of degradation was caused by squeezing of painting layer. The strength of squeeze made

the painting layer took apart from the canvas, and the color will be lost if touch it without careful. To face a condition like this, the first step is to protect the painting layer. Let the painting layer get back to the place where it should be through this procedure. Further, except the inappropriate retouch, this painting also had numerous impresses which were caused by pressing from the others and fingerprint where was situated in the center of painting (Fig. 2). These conditions were all happened on the painting layer instead of on the varnish, so we can say that maybe those damages were just there since before. Except that fingerprint, all the impresses might be caused while the pigment was not completely dry or by preserving in a stack way. The most interesting part of *A Lumberyard* is the result of the X-ray examination. There is a layer which painted with a half nude woman under the first layer, moreover, that half nude woman was painted vertically which was opposite to the first layer. The cases of changing the direction for re-painting were not rare in the artworks of Chen Cheng-po. Especially in the landscape paintings. All of these results verified that Chen Cheng-po not only revised the composition of painting, but also reused the canvases which were already painted.

About the part of reusing canvas, we also put a lot of efforts to do the research. Most of the results were from the

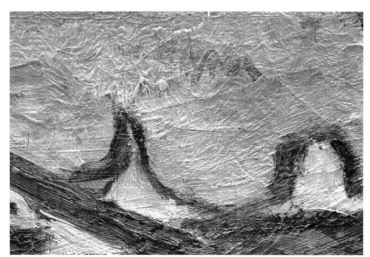

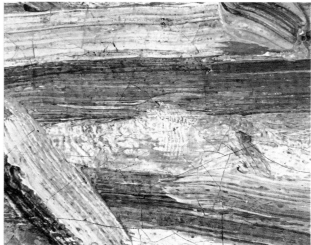

Fig.1: A part of *A Lumberyard*

Fig. 2: The impress of fingerprint

experiment of X-ray. In Tokyo period, the reason of reusing canvas might due to the education and economy. But after inspected all the artworks of Chen Cheng-po's major periods which were in Tokyo, Shanghai and Taiwan, we cannot take economy as the only factor into reusing canvas. Because in every stage of his life, we can find artworks that had indication of reusing canvases. Therefore, we need to ponder what made him to do that from another viewpoint such as "the esthetics". That is to say, when an artist change or revise his artwork, it may means that he doesn't like it anymore.

I like to take the *Shanghai Dock* as a metaphor of the difference of before and after war. Also in reality, the monument in the painting were no longer there anymore due to the World War Ⅱ. The first time I saw *Shanghai Dock*, I felt a lonely atmosphere. The sky and street were so dark as though deeply sank into the heavy fog. However, with the conservator cleaned it little by little,

what shows to us is a prosperous scenery of The Bund, Shanghai (Fig. 3). Even the current chairman of the foundation didn't know that the sky in this painting was supposed to be bright. What is the reason to make us to misunderstand this artwork? It's the heavy varnish which was already yellowing and flawing. We can clearly see all these conditions via UV lights, especially the flawing of varnish, just looks like smokes that caused by the war full of the sky; and the retouching on buildings were stained with dust. Get back to the painting; there were tiny flaws that caused by the degradation of ageing and grain of the canvas, so that many dust and dirt were piled up on those flaws. Besides, the canvas of this painting was knitted by a special way and is not the usual type Chen Cheng-po used, also when Chen finished this painting, he laid another paintings on it right away so the painting layer has impresses of other canvases. We found out that the varnish were applied in an uneven way that caused the appearance looked dark. In the restoration procedure of *Shanghai Dock*, the most particular step is about the inner frame by reason of that there is a hand script of Chen writing with pencil which says "The Bund, Shanghai Dock（上海外灘碼頭）" (Fig. 4). So the available frame strips for tighten up canvas were defective, but we wadded it to enhance it and used acid-free tape to trim the canvas. In this manner, the hand script can be seen obviously.

UV light is one of the important tool for ascertaining whether the artworks had been restored before. Taking *Portrait of a Lady* for example, we found out that it's a painting which have never been restored via the UV light examination. Due to storing for a long time in warehouse and never being restored, there were some flyspecks of insect (Fig. 5), thick dust and dirt and impresses from another objects on the painting layer. The part of dust and dirt where in the strokes over a series of years were tiny and hard to remove, like the situation that when oil spilt on a cloth, it's easy to clean at that moment; but time after time, it will be hard to clean. *Portrait of a Lady* just had the situation above. In addition, the completeness could be destroyed if we cleaning those dirt

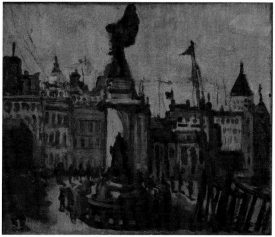

Fig. 3: Drawing of the prosperous scene of The Bund, Shanghai.

Fig. 4: The hand script of *Shanghai Dock* on the back side of inner frame.

Fig. 5: The insect flyspecks on *Portrait of a Lady*.

without carefulness. In the restoration process, we used gypsum liquid which blended with rabbit glue and calcium sulfate to fill in the loss part, then made the original physical texture. When doing inpainting, we used water-based and reversible pigments and uphold the highest standard in this step for retaining the nature color. Thus every one of us can enjoy the specialties in this simple artwork.

The condition of *Inside the Cabin* and *Portrait of a Lady* were quite similar. According to the results of IR, UV light and X-ray, showing that there is no manuscript, old retouch, varnish or concealment layer. That we could know that this painting had never been restored. Identically, *Inside the Cabin* is also an oil painting on wood, so the most obvious degradation part is the dirt and dust were deposit by time after time. But unavoidably, there were also insects flyspecks and some parts were flattened by piling up with other wood boards when the canvas was still wet. While restoring *Inside the Cabin*, Dr. Ioseba discovered an interesting thing which is that there is a hole in each corner of this painting and the sizes are equal (Fig. 6). This "original" problem revealed the transportation manner for paintings that Chen Cheng-po used. To avoid painting damage, usually when artists are painting outdoors, they will choose the most safety way to transport canvas and other materials from outdoor to indoor. We can know that Chen used to transport wet canvases with canvas pin from the impresses and holes (Fig. 7). He pushed the metal pins into each corner on the wetside of the canvas and made sure the pins go fully into the stretcher bar. Then place another canvas which has the similar size face down on the pins protruding from the first canvas and push down gently at each corner to secure the pins into the second canvas. This way can transport wet canvas easily and without smearing the pigment. But what is inevitable is that will certainly remain some holes on paintings. Even though the holes are not a part of creation, we will still keep them there instead of restore them because those are also made by artists while creating.

When we talk about the art achievements of Chen Cheng-po, we seldom mention his political identity, lest be out of focus

Fig. 6: The hole and impress in the corner of canvas.

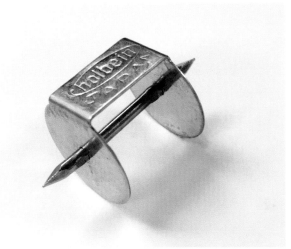

Fig. 7: Canvas pin for separating two wet canvas.

in the pure esthetics. But some part of his artworks were truly damaged by the 228 Incident. Those flaws on *Shanghai Outskirts* were the marks of this horrible history. When *Shanghai Outskirts* sent to our studio, the condition were not well in general. The appearance were full of vertical flaws as a result of storage by rolling (Fig. 8-9). At first, the family of Chen thought that those painting should be hidden after Chen was killed by the government and they might destroy his painting once discovered, so the family decided to protect his relics. Thanks to his family that Taiwanese can possess these valuable properties until today. The flaws which were caused by rolling show the courage of Chen's family and also tell the painful history to every one of us.

In *Shanghai Outskirts*, except the mark of history, we also found the holes in each corner just like those in *Inside the Cabin*,

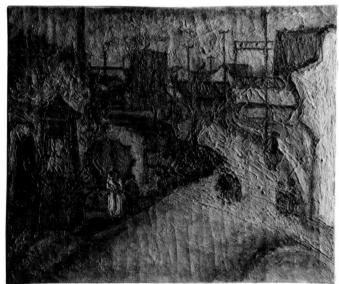

Fig. 8: Vertical flaws caused by rolling Fig. 9: Creases caused by the shrink of canvas

which means this painting might be painted at outdoor. Besides, base on the conservation theory, we usually remain every objects that belong to original creation including recover detached threads by variety consolidation methods. In the inner frame part, the original inner frame were immovable type and that's not suitable for preserving, so conservators change a new one with mortised type and put frame adjusters in to make the canvas has flexibility when environment altered. At last, the original canvas couldn't afford the painting layer, so we lining a new canvas behind. Hope this painting can extend its life after we "save" it.

A Bashful Nude is a portrait of a half-naked woman created by Chen Cheng-po. It was never been restored before sent to our studio. However, the condition was not good because the storage environment was bad. The painting layer were covered with a lot of flaws, especially those where in the upper part are more significant. When checking from the back side of the painting with strong light, the woman's body looked like being entwined with many silk threads. In addition to the deposited dirt on the flaws, there was a small area of the painting layer was missing on the left chest part of the naked female. In these years, we did the

restoration treatment to 35 pieces of artworks. Maybe you can call this "destiny", because we found the missing part of *A Bashful Nude* while doing the restoration to the other painting which called *Breakfast*. A piece of oil painting and was found behind the canvas of *Breakfast*, but because it did not affect the preservation, so we regarded it as a part of the artwork and remained it. After some days, when we were restoring *A Bashful Nude*, Dr. Ioseba remembered the piece of oil painting which was behind the *Breakfast* (Fig. 10), the size and shape are so similar. Then after a serious comparison, we confirmed that it was exactly the loss of *A Bashful Nude* (Fig. 11). Because the conservator who does restoration to these two paintings is the same person, this surprisingly thing could happened. Also the conservator needs to respect and observe the painting with lots of circumspection. According to our speculation, this condition were caused by stacking two canvas when the pigment was still wet. But there came the most difficult part. To remove the fragile piece of oil painting from the back side of canvas then stick it back into the original place was a complicated step. You must first use a removable paper to adhere the piece of oil painting from back for fixing and preventing it become splintered while take it apart from the canvas. Then adhere it back with animal glue.

In the restoration process of *A Bashful Nude*, we used a rare way of lining which called "transparent lining". As this work

Fig. 10: The small piece which remained on the back of *Breakfast*

Fig. 11: The small loss of *A Bashful Nude*

had many flaws and the condition of materials was unstable, it was necessary to consolidate the painting layer by overall lining, and also make the supports being flat. Usually we line in the back of oil painting with a new canvas, but there is an autograph of Chen Cheng-po on the back (Fig. 12-13), so we chose transparent materials to do the lining. In this way we not only keeps the autograph but also consolidate the structure. But the materials is so hard to find in Taiwan, our team members of oil painting had walking almost whole the city round just for choosing the suitable materials!

Fig. 12: The autograph of Chen before lining.

Fig. 13: After the treatment of transparent lining.

III. Conservation in paper painting

Except oil paintings, Chen Cheng-po also created a lot of paper artworks in eastern paper and western paper. Eastern papers are made from bast fiber of coretex, hemp, rattan and grass fiber and the materials that including Chinese ink, Chinese color ink, calligraphy, glue color. Western papersare made from machine and the materials such as charcoal pencil, pencil, fountain pen or color pencil. The most degradation will happen in these two kinds of paper are like foxing, tide line, insect and germ damages. Chen Cheng-po Cultural Foundation had entrusted 11 pieces of orient paper artworks (including 1 glue color plate picture, 1 ink painting plate picture, 1 color ink plate picture, 4 color ink hanging scrolls, 1 ink hanging scroll, 1 calligraphy mounted hanging couplet and 1 folding fan) and 302 pieces of western artworks (including 12 charcoal sketches, 3 sketch books, 1 map, 1 watercolor and 285 pieces of single-sheet sketches) to us for restoration from 2011 to 2015. We captured restoration results of 6 typical artworks in this corpus.

Lilies is an eastern glue color paper work. Most of the preservation methods of this kind of artwork are panel framed mounting or hanging scroll. But *Lilies* didn't preserved in either these ways but only with rolling. Moreover, the acidification were quite acute so that the supports were fragile. Needed to humidify, flattening and consolidate from the backside, then this painting could be opened completely (Fig. 14). Except the main painting, the back of this artwork also came with a layer of first lining paper and a lining paper which had the same size with the main painting. Year by year, those lining paper became extremely brittle, not only had yellowing condition, but also lost the support from the original paper, and that caused a lot of horizontal creases and flaws. To preserve this artwork for a long time, conservators removed the original back paper for extirpating the acid and used high quality paper to do the lining work, then improved the method and environment of preservation. Luckily, although the paper was gravely deteriorated, the lilies on the painting were still distinct especially observing from the backside, and so was the color (Fig. 15). That means the pigment which was used in this painting can protect papers with effect and also ease off the

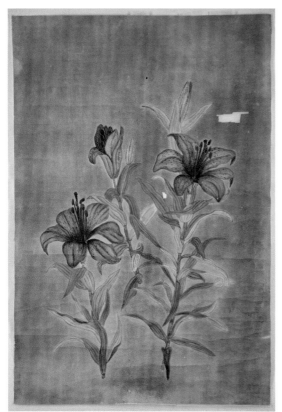

Fig. 14: Front of *Lilies* before restoration

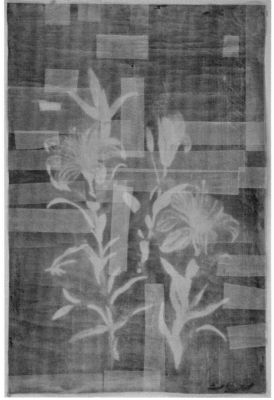

Fig. 15: The obvious outline of lilies to see from the back.

condition of acidification and yellowing. In every science examination before restoration, we found out some conditions that the colors in the background were uneven, paper loss, liquid stain and dirt…etc., and the problem of the uneven thickened paper edge also need to be resolved. Acid substance is always the biggest problem to paper, it will make papers have foxing, yellowing even become brittle. When papers become powdering, the conservation work will be too difficult to carry out.

The main painting of *Lilies* was gravely yellowing, and for these kind of work that need to de-acidify completely, conservators will use the safest way to restore it in general. Since the paper was quite brittle, we washed it only with pure aqua. But even the pure aqua didn't play a main role in this cleaning process, because the painting couldn't soak in aqua for a long time. Thus in this process, we used an artificial fiber paper to line the main painting, put it on an acrylic board, rinsed the dirt out by pure aqua then brushed the dirty water from the artificial fiber paper. The way of loss solving and inpainting of paper are widely different. For the loss part, conservators need to select a neutral manual paper that has a similar quality with main painting as the first lining paper, then brush the paper to see which one is more suitable for lining test. For the inpainting, they need to be more careful in this step. Because papers are easy to absorb the pigment, it will be hard to remove if something happened accidentally. Therefore, before inpainting to a paper work, a buffer layer to prevent the pigment dyes is strongly necessary.

Morning Glory is an artwork of ink painting, and it had never been mounted after he finished this painting. The paper of this painting was ragged and had some flaws on it, even was full of creases. Most important of all, due to it was out of restoration for a long time, the foxing almost covered the whole painting. But fortunately, the acidification were not that serious to alter the structure. For restoring *Morning Glory*, the first step was cleaning in complete and removing the foxing. Using warm water to clean the big area of dirt and diluted hydrogen peroxide (H_2O_2) for the other area of foxing. After removing the foxing, conservators

rinsed the dirt and chemical solvent away to avoid them remained in the supports and the painting layer. Besides, in the part of uneven edge, in order to keep the completeness and the esthetics of the painting, conservators began with dyed the first lining paper which the quality is similar with the main painting to do the relining, then inpainting in a way of extending the edge to repair the loss. These steps can make the main painting looks more centrally located in vision. Second, for making the paper stronger and healthier, conservators chose the neutral handmade Misu paper (美栖紙) to do the lining of second layer. Misu paper has calcium carbonate, not only adjust the pH but also increase the life of painting. At last, as the painting already had a little bit acidification condition, conservators decided to change the backboard with acid-free honeycomb board and mount with panel for preserving and demonstrating in a better way.

If you have ever cultivated in Taiwanese art history, you may agree with that the art development in the early year of the Republic Era was more prosperous than today. There is a Taiwanese drama named "Purple Dadaocheng" are playing on TV recently, the setting is just the early year of the Republic Era. I saw a painting named *Tamsui Collaboration* which was restored by our team in one of the scene. This painting can be considered as a classic artwork in 1941 because it was created by six famous artists including Chen Cheng-po. According to the record of his son, we can know how they finished this work by painting apart. Chen Cheng-po painted the foot of mountain, field around, little sailing boat, sky and birds, Yang San-lang made the part of mountain Guanyin, Lin Yu-shan painted the big boat, Li Mei-shu created the tree on the left, Kuo Hsueh-hu made the land and Chen Jin-hui painted the sand in the middle of Tamsui River (Fig. 16-17). The paper of this painting was rare in that era. Japanese cardboard with white front and light brown back, gold inlaid around. Plus the creation of those six artists, this painting should be conserved with lots of efforts, to keep the highest moment of art communication. Moreover, this painting was stored by Chen and we can know Chen was playing an important role in Taiwanese art field from this. Compare with the other paper works, the condition of this painting is more stable before restoration. But still, there are some foxing, yellowing, dirt on the edge, insect damage and creases in the four corners.

There is a Chinese saying of "The top virtue is like water, benefitting all", and it's also a good description in the paper conservation field. Generally, the public always has an impression of that paper needs to be distant from water for preventing distortion and stain; nevertheless, water is an essential material in conservation process. We usually take pure aqua (tap-water has too much impurities so it's not suitable) as the first choice to lysis the acidification. Further, using pure aqua to clean artworks is the best method which is safer than any chemical solvents. Hence, for making *Tamsui Collaboration* better, conservators first washed the acid substances out with warm pure aqua then removed the foxing by hydrogen peroxide. In addition to researching the front of *Tamsui Collaboration*, the autographs of artists on the back side are focal points for researchers. Therefore, conservators mounted this painting with double-sided window mat in consideration of being able to view the both side. In addition, conservators designed "transparent acrylic standing mounting" in response to making the frame stands. It often catch the public's eyes while being exhibited.

In the part of western paper, we captured 4 works (charcoal sketch, watercolor, single-sheet sketch and sketch book). For

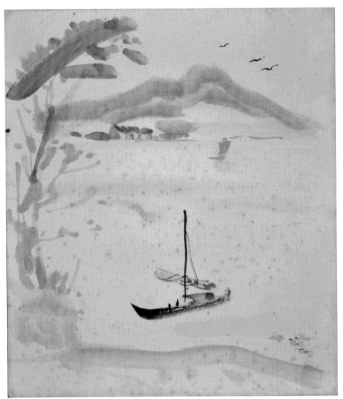

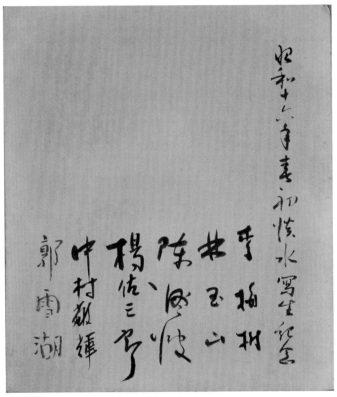

Fig. 16: Front of *Tamsui Collaboration* (before restoration)　　Fig. 17: The autographs of six artists on the back.

example, *Near the Water Source* is painted with watercolor by Chen in 1919. Except the main painting, there are autograph, stamp, hand scripts...and more interesting objects on the left part of front (Fig. 18); the back side also have some handwritings in Chinese and Japanese. These could make us know more about his history by making researches. However, the predecessor used a thick fiber paper to line from the back and it caused the handwritings became hard to recognize. The condition before restoration of *Near the Water Source* was quite stable, the color and touches were still clear to see. But also there were yellowing, dirt, foxing, darkening and loss on the upper edge. There were insect flyspecks around the loss, so it might be insect damage.

The most important restoration steps of *Near the Water Source* are removing the original lining paper and keeping the words which are on the backside visible. Then removed the tape that was inside the ply paper. After that, flatten the painting by humidification. Unlike other watercolor artworks, we copied the backside words and demonstrated those in acid-free matting with the main painting. Making the public can read the artist's words; meanwhile, enjoy the painting.

The 12 charcoal pencil sketches are sketch of nude women that were finished between 1925 to 1930. Chen had recorded the complete date of each work. Via light, we observed distinct watermarks and the thickness, grain and texture of every sketches are different. To scholars and experts, these are source materials for research. These batch of sketches had never been mated and we can know that these sketches were stored by stacking up and rolling together from its condition. For example, there were similar losses on the bottom left part of *Sitting Nude Sketch-27.2 (16)*, *Sitting Nude Skethch-27.11.24 (26) and Standing Nude*

Sketch-27.10.20 (25), that might be caused by stacking up together while storing. In terms of the degradation of all paintings, surfaces yellowing, brittle edges of paper and uneven colors of painting were problems which had been observed. Meanwhile, we also found some dirt and insect flyspecks. Especially the condition of uneven yellowing was more visible in *Sitting Nude Sketch-30.5.3 (30).* On the parts of figure of nude and autograph were seriously yellowing, also there were two square part lower of the painting which were whiter. Hence we conjectured that the yellowing might caused by spraying glue, and the whiter part might be covered by paper tapes

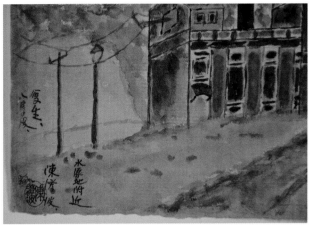

Fig. 18: The autograph, stamp and handwritings on the bottom of *Near the Water Source.*

or other kinds of tape. In these batch of sketches, the paper of *Standing Nude Sketch-18.10.19 (32)* were brittler than others. Because of that, there were one big transverse crease and one large vertical flaw on the paper. Therefore we need to strengthen the paper by mending. Besides, in results of the paper of *Sitting Nude Sketch-25.6.11 (4)* had a shape with narrow top and wide bottom and the edge was uneven, we extended the edge paper when making the mat for remain the stamp and autograph visibly. At last, we chose white acid-free cardboards to make moveable window type matting to give consideration to display and preservation. Do the matting depends on the real dimension of works and make buffer layer with acid-free MYLAR polyester films and cardboards, then fix the works on same dimension matting backboards without tape. In this manner, these works can fit in frames which in same size while displaying; while not displaying, all of them can also be preserved in an acid-free box and will be easy to manage.

Conservation of single-sheet sketches is always a difficult thing if compare with another type of paper works. These 285 single-sheet sketches, including 1 street scene, 24 mountain scenes and 260 figures and still lives, had been preserved by piling up and packed by kraft paper bag in a corner of room for many years. In this environment, the papers had absorbed all the acid which liberated from kraft paper. Therefore, the edges of all single-sheet sketches became brittle and yellow. The dark foxing had feathered on the paper which are gradually yellowing with time goes by. Further, there were creases, breakages, tears, stains and insect flyspeck...etc. The condition of every single-sheet sketches were similar and only had some bit of special differences, so the conservators in addition to implementing the same cleaning work to all sketches such as removing stain and foxing, also need to solve those special conditions one by one. Equally, in this restoration process, conservators washed out the harmful substances which were stocked inside the fiber by using pure water. However, due to the paper's original color of each single-sheet sketches were different, washed by pure water could only narrow down the color differences of every paper instead of adjust to the same color. Besides, conservators decided to compensate the loss but remain the damaged edge without any restoration in the entire process. In the last, conservators in addition to make window type acid-free mat to 26 single-sheet sketches of mountain scene, also number the other 259 single-sheet sketches and preserve them into an acid-free corrugated paper box for a light, stable and convenient handling.

In comparison with complete works, some scholars and experts prefer artists' sketch books. Sketch books can help them to find the forerunners of artworks from artists' viewpoint and logics of creation. Thus they can obtain more research results from those. The sketch books that had been captured in this corpus are outdoor scenes sketches including locating paintings, practices and records. Although those sketches were only composed with simple lines by pencil and pen, we can still understand the former life of Chen through those sketches and some simple words. Those sketch books were bound in metal staples, after years, the original metal staples were already oxidative and rusty, not only couldn't fix books anymore, even the rust polluted papers. So the first step would definitely be removing metal staples and replacing by paper staples made by bast fiber paper to prevent any further damages. Moreover, we made acid-free paper boxes for storing those sketch books to fend off acid substances.

IV. Conclusion

Up to now, we have cooperated with Chen Cheng-po Cultural Foundation for many years. Except the results of restoration work, we also have results in academic field. Not only present the result of restoration on international conferences, but also carry in a worldwide publication with results of science analysis. In the end of 2015, the office of art of Cheng Shiu University planed an exhibition named "Looking Through X-Ray: The Unknown Chen Cheng-po" with all the outcomes of X-ray examination. What's more, this was published on the headline of some newspapers. At the same time, we held "2015 APTCCARN 4th Meeting: Embracing cultural materials conservation in the tropics" with The University of Melbourne and "2015 Cultural Heritage Conservation Annual Meeting: The Challenges and Our Strategies" with Bureau of Cultural Heritage of Taiwan. Especially thanks to the current chairman, Chen Li-po, we got the chance to undertake the APTCCARN Meeting with his supports. In addition to upward development, the foundation make more efforts on rooting down the beliefs of art. Between 2015 to 2016, from cities to counties, our center had participated in more than 20 courses of spreading the conception of conservation and most of the objects are those students of elementary schools who obtain less education resources. In order to complete these ideas, the foundation made a digital collection of all the works of Chen and copied some of them out then held a tour exhibition in a lot of elementary schools which located in eastern Taiwan. Even us, who are working in educational field, esteem this kind of aesthetic education spreading. It can't be denied that Chen Cheng-po Cultural Foundation is the most active artists foundation in Taiwan, every things they do, making people feel their heart of achieving Chen Cheng-po's aspiration in all his life. In the end, having opportunity to cooperate with Chen Cheng-po Cultural Foundation, having strong supports from our university, having this conservation team and having a place in all these meaningful activities are all I ask for.

Li-cheng *

* Li I-cheng: Supervisor of Conservation Center of Cheng Shiu University.

油畫作品
Oil Paintings

專文
Essays

正修科技大學文物修護中心
Cheng Shiu University Conservation Center

珍藏陳澄波：臺灣第一位西畫家油畫作品修復計畫[1]

尤西博[2]、吳漢鐘[3]、李益成[4]

摘要

　　本次修復計畫，第一階段總共修復陳澄波一生當中，三段不同時期的二十四幅畫作。在修復計畫中，利用X射線（X-ray）、紫外線、和紅外線等化學分析技術，以深入了解陳澄波繪畫的技巧。藉由畫作的修護，使我們更了解陳澄波如何使用畫布和一幅畫作被創作完成的過程，以及陳澄波的家人如何在獨裁政策的統治之下，保護他的作品免於遭受損毀。同時，也發現陳澄波如何將畫布從作畫時的地點移至畫室的方式。藉由科技保存的研究，促使我們深入了解陳澄波創作的技術和方法。

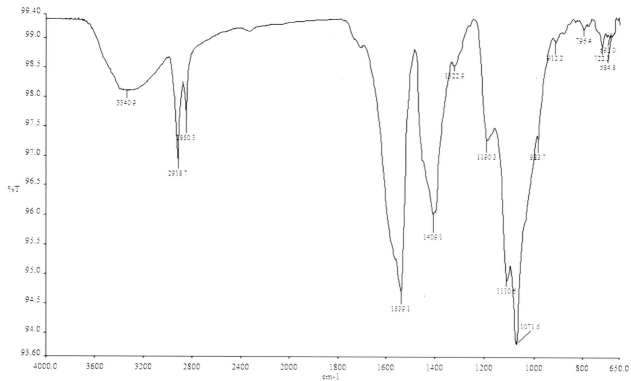

圖1. 從陳澄波油畫顏料碎片的FTIR圖譜中，可觀察到位於3400cm-1的氧—氫（O-H）鍵結、2919 cm-1及2850 cm-1的一級碳—氫（C-H）鍵結、1100 cm-1的碳—氧（C-O）鍵結的吸收峰，因此推測其顏料樣品主為長碳鏈飽和脂肪醇類化合物。

一、緒論

　　1895年，陳澄波出生於日治時代的臺灣嘉義。1913年，進入臺灣總督府國語學校公學師範部就讀，接受石川欽一郎（日本水彩畫家）的指導，對西洋美術獲得初步的認識與了解。1917年畢業後任職於嘉義公學校，開始了之後六年的教學生涯。但是，之後卻執意前往日本繼續深造，1924年，陳澄波以將近三十歲的高齡考入東京美術學校圖畫師範科就讀，是早期留學日本的臺灣學生之一。1926年陳澄波以一幅〔嘉義街外（一）〕入選第七回日本帝展，是臺灣以西畫進入日本官方展覽的第一人，其後又多次入選帝展及其他各項展覽。1929年東京美術學校研究科畢業後，赴上海新華藝專、昌明藝專任教。在上海期間，畫了許多與中國南方景色相關的畫作。1933年，因為中國、日本兩個國家政治局勢對立，時局愈來愈不穩定，所以毅然決定返回臺灣。回臺之後，即使政治局勢也是動盪不安，陳澄波並沒有放棄作畫，表現出一位積極的藝術家典範。1947年二二八事件[5]爆發後，時任嘉義市議員的陳澄波與柯麟、潘木枝、盧鈵欽等六人擔任和平代表前往水上機場與軍方協商，不料卻遭受拘捕，在未經審判的情形下，被羈押到嘉義火車站前，槍斃示眾。之後，陳家長期遭到情治單位的監控，但家屬仍在艱難中盡力保存陳澄波畫作，才有今日為數可觀的作品呈現在世人眼前。

　　能夠執行陳澄波修復計畫，必須要感謝財團法人陳澄波文化基金會（以下簡稱陳澄波文化基金會）和正修科技大學文物修護中心的合作。這是件非常緊迫而密集的修復研究計畫，但是也因為如此，卻帶來出人意料之外的結果。這次的合作計畫，主要著眼於藝術家對於藝術工作的保存。然而，修復工作也促使我們發掘有別於以往對創作過程的觀感。「修復」讓我們了解藝術家創作每件藝術品的方式，並且以科技研究的方式獲取最有價值的資訊。

二、材料和技術

　　在修復每幅畫作之前，我們都會竭盡所能地以各種研究方式，獲取完整的繪畫手法。我們使用的研究方法包括化學分析、X射線、紫外線、紅外線和可見光檢測等。經由上述的檢測結果，我們可以得到每幅畫作的材料分析資料、作畫的技術手法和畫作的保存狀況。

　　這個計畫是第一次用一套完整的判斷方法，來分析藝術家所使用的顏料成分。圖1是一張傅立葉轉換紅外線光譜儀（Fourier Transform Infrared, FTIR）的掃描圖譜。從圖譜上所呈現出的掃描結果可以證實，陳澄波是使用「油」當作結合劑。同時，我們也以截面分析（cross-section analysis）、掃描式電子顯微鏡 （Scanning Electron Microscope, SEM）、能量散佈分析儀（Energy Dispersive X-ray Spectrometer, EDX）等儀器分析畫作上的顏料成分。圖2是分析〔背向坐姿裸女〕畫作上的一小塊顏料的橫截面圖。由圖2可以觀察到，這塊顏料包含九個不同的顏料層（分析結果如表1）。圖3是一張陳澄波在1921年12月向東京美術用品供應商店購買水彩顏料的訂購單局部。[6]我們將估價單上顯示的顏料訊息與圖2成分分析結果作比對，於顏色的比較上是非常有用的。此張訂購單為修復計畫帶來非常有利用價值的資訊。此外，訂購單上的資料，也對於我們將來想拿來用在畫作顏色的比對以及用於統整陳澄波作畫所使用的材料成分資料庫，都能提供非常有用的訊息。

　　從X射線的分析結果，可發現陳澄波習慣重覆使用同一張畫布。他在東京美術學校時期的創作通常都會在同一張畫布上面繪畫多次；而且前一次畫作的圖像，也能夠藉由X射線分析顯示出來。在一幅沒有註明日期的畫作〔橋畔〕中，我們觀察到有一塊區域並沒有被覆蓋完全，也因為如此才讓我們瞭解到下面那一層畫作的筆觸和手法。推測這些沒有被後續畫作覆蓋完全的區域，是因為當時這幅作品必須要趕在學校展覽之前完成，所以缺乏充足的繪畫時間所造成的結果。在東京美術學校期間，之所以會重新使用

圖2.〔背向坐姿裸女〕畫作上的一小塊顏料的橫截面圖。

No.	顏料
9	鋅白、翡翠綠、赭紅
8	鋅白、赭紅
7	鋅白、赭黃、鉛黃
6	鉛白
5	鉛黃、鉛白
4	鉛白、赭黃
3	翡翠綠、硃砂、鉛白
2	鉻綠、鉛白
1	鉛白

表1.〔背向坐姿裸女〕可能使用之主要顏料。

畫布，可能是受迫於當時處於學生身份下的經濟壓力。[7] 此外，從畫作〔背向坐姿裸女〕中，也觀察到重覆使用畫布的現象。〔背向坐姿裸女〕的X射線影像圖顯示（圖4），不僅重覆使用畫布一次，而是兩次。第一次作畫時，所畫的是一幅人物像，但是當他決定再次使用這張畫布時，卻改以裸女的圖像取代原先的人物像。之後，又再次使用這一張畫布，才完成最後這幅〔背向坐姿裸女〕。前兩次在使用這一張畫布的時候，將畫布擺放成垂直方向來作畫，但是到了第三次作畫時，卻將畫布改以水平方向擺放。在這張畫作的左下角，也觀察到陳澄波用鉛筆寫著「未了」這兩個字，意思就是「尚未完成」。我們認為他想表達的意思是，不知道將來會在這張畫布上畫出哪一幅畫作。

　　陳澄波在東京求學時期重覆使用畫布，或許是受迫於經濟和教育因素的影響。然而在他生命中的三個

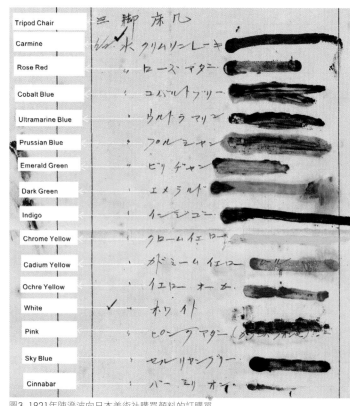

圖3. 1921年陳澄波向日本美術社購買顏料的訂購單

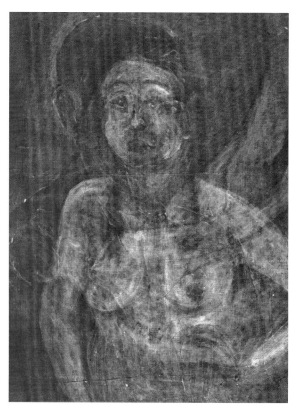

圖4.〔背向坐姿裸女〕的X射線圖顯示陳澄波重覆使用畫布。

時期—東京、上海、臺灣中重覆使用畫布的情形已經變成常態，特別是當他成為一位專職的藝術家之後，作品也都有顯示出底層繪畫的現象。所以不能夠只把經濟因素當成陳澄波重覆使用同一張畫布的唯一理由，同時也要從「藝術欣賞」的觀點來考量這些因素。也就是說，當畫家改變或修改一幅作品時，很可能表示並不想再接受那些他「不喜歡的」，而且也已經「被覆蓋的」畫作，因此他多次重覆使用畫布。

而且一旦決定重覆使用畫布時，他會將新的顏料直接畫在畫布上，並不會以打底層來將新的顏料和原先畫作做區隔。而當他使用一張全新的畫布時，也不會事先塗上一層白色的打底層。所以，不論是紡織品或木頭等這些陳澄波準備要拿來作畫的支撐物上面，都沒有白色打底層。但是，如果在畫作上觀察到打底層的時候，可能是因為用到了工業製造的標準畫布。陳澄波不使用白色打底層的原因，是受到東京美術學校教育的影響，那個時期東京美術學校的藝術深深受到法國印象派主義運動（French Impressionist Movement）的影響，法國印象派畫家拒絕傳統的以及學術的規定。這些藝術家是第一批迴避使用底層[8]的藝術家，同時他們也是致力於尋求屬於個人風格的藝術家。[9]陳澄波就是受到法國印象派主義運動的影響，所以不使用打底層。

三、修復

陳澄波第一階段修復計畫主要針對二十四件畫作的修復。早期保存這些畫作的環境並不是非常妥善，所以畫作受損的情形都相當地嚴重，畫作的損毀狀況也不盡相同。我們修復的目的是為了要保存畫作，但是這些作品具有變形、斷裂、顏料缺損、髒汙等等各種不盡相同的狀況，所以，必須先針對畫作各種損傷的狀況，謹慎地將畫作修復，之後才能夠將它們妥善地保存下來。在這二十四幅畫作中，有一種獨特的損毀狀況強烈地引起我們的注意，那就是畫作上都顯現出一種與「方向」相關的損毀狀況。畫作〔運河〕的X射線檢測圖中所顯示平行方向的裂痕（圖5），是因為捲繞畫作所造成的結果。陳澄波死於獨裁政權的統治，其家人認為必須保護和藏匿這些畫作，以免被政府沒收和損毀。因此，毅然決定保藏這些陳澄波的遺物，他們勇敢的舉動也讓這些被視為珍貴的臺灣遺產免於消失。這些捲繞的裂痕正是一種「無懼的象徵」，而保存畫作的舉動更見證了這道曾經存在於歷史上的傷口。

當獲得所有畫作的材料資訊以及畫作的保存狀況之後，我們便著手開始進行修復畫作的工作。首先，修復師會在畫作表面塗抹一層魚膠、並且覆蓋一張日本紙（Japanese paper）來保護畫作、並且鞏固畫布表層上面的顏色。接著，修復師會再將畫布翻轉至背面，以進行後續的清潔步驟和修復程序。隨後，修復師會將畫布上撕裂的地方小心地黏合起來。等到畫布背面的修復工作全部完成之後，修復師才會開始針對畫作不同的受損情形進行托裱。大部分的畫作中，我們都觀察到陳澄波習慣在他所使用的畫布背面用鉛筆簽名，而且簽名的風格隨著時代不同而改變。因此，修復師在進行托裱的時候，必須避免畫布背面的簽名被覆蓋和隱埋。所

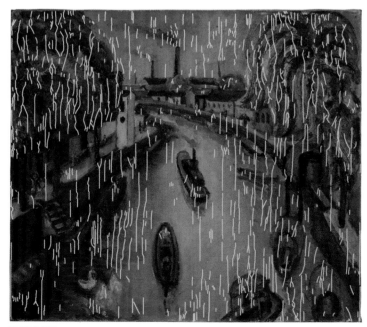

Rolling Crack

圖5.〔運河〕裂痕出現一致的方向，作品被捲起存放和隱藏是為了在專制時代不被沒收或破壞。

圖6.〔含羞裸女〕的背面圖，呈現在作品上的透明托裱能夠加固原有基底材，同時能夠看到藝術家的簽名。

以，介於托裱強度以及表現顯示畫家簽名的衡量之下，我們在這次修復計畫中，實行了如圖6所示之透明托裱（transparent lining）的方式。

當畫作托裱完成之後，修復師將畫作固定在一個全新的框架上，這個將畫布固定的程序，有利於後續清洗畫布和修補畫作的工作。首先，在框架的四個角落個別鎖上一個金屬調整器，這些調整器可以用來調整框架，因此才能把畫布繃緊，接著才開始清潔畫面。修復師都必須以極為謹慎、細膩的態度和方式來執行這工序。然在畫面清潔之前，均需先選取一小塊區域進行溶劑測試，也就是要尋找能夠清除灰塵和汙垢，但是又不會損傷畫布的最佳成份。整體而言，都使用了特製的專用清潔劑徹底清除畫面上的灰塵，但是又能夠保護繪畫層的成份。當畫面清洗完成之後，修復師才會開始在顏料缺損的區域進行填補、補筆等步驟，使畫作回復原來的樣子。

值得注意的是，在修復計畫中，所有的修復過程最後都要在畫作上顏料缺損的區域全色。因為陳澄波是一位喜歡以無光澤及乾燥呈現畫作的藝術家，所以在他一生當中都沒有使用凡尼斯。因此，如果有畫作上呈現出光亮的外表，我們認為並非陳澄波所為，而是後人塗抹凡尼斯所造成的結果。另外，不使用凡尼斯原因之一，也可能是陳澄波在日本東京美術學校時期受到印象派運動（Impressionist Movement）影響。印象派運動是一項由法國藝術家所興起的運動，在運動中，所有的畫家都不使用凡尼斯。這些畫家就是利用這種方式來避免凡尼斯改變畫作上的顏色。印象派運動正是畫家們突破傳統的繪畫理論，並向當時的社會大眾表達現代藝術的一種方式。綜上所述，在這次的修復計畫中，我們也不使用凡尼斯來修復畫作，就是想用這種「不使用凡尼斯」的方式，來表達對陳澄波這位偉大畫家本人及其藝術思想的敬重。

四、保存和處理

修復研究計畫中，可深入瞭解陳澄波繪畫的技法以及構圖方式。其中從畫布上觀察到的損傷特徵，幫助我們找到陳澄波是如何將畫作從作畫時的地點帶回他個人工作室的方法。陳澄波習慣在郊外作畫，但是經常會遇到畫布上的顏料還沒乾燥完全，就必須將畫布帶回工作室的時候。考量到安全性、便利性和乾淨性，他使用如圖7所示的畫布針來當作搬運裝置。金屬畫布針的兩側分別設計有長度為6毫米的釘子，這個凸出的釘子可以將兩張畫布以面對面的方式釘鎖住。也就是利用這種方式，讓他在往返郊外作畫時，能夠同時搬運兩幅畫作。另外，圖8也證實了陳澄波利用了釘鎖畫布的方式，來搬運畫作。也就是因為要將畫布釘鎖住，所以才會形成畫布表面那些刮傷的痕跡。

在畫作上觀察到的孔洞，是陳澄波將畫布運送往返於作畫地點與住處的結果。第一階段修復計畫中的二十四幅畫作主要分為城鎮風景和大自然景觀。陳澄波生平作畫的三個時期：日本、上海和臺灣，都會使用畫布針。如圖8所示，在〔二重橋〕中也觀察到使用畫布針的結果。畫作上損傷的狀況，除了畫

圖7. 向日本東京美術品供應商店所購買的畫布針。

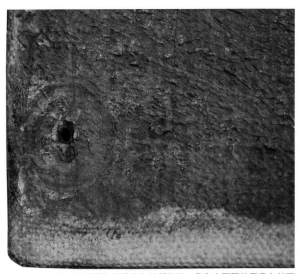

圖8. 作品上的孔洞是因為使用畫布針所留下，畫作表面因使用畫布針而有擦傷的痕跡。

布針形成孔洞留下的凹痕之外，畫作上部分區域也會受到壓力或磨擦力的作用而產生裂痕以及變色的狀況。一般而言，畫布針應該要設置在畫作的四個角落，但是在部分畫作的畫布中間也觀察到了孔洞，推測這是因為陳澄波往返郊外與住處作畫時，為了固定不同尺寸的畫布所造成的結果。

我們必須強調，在這次的修復計畫中，並不填補這些觀察到的孔洞或對這些孔洞作補筆等修復工作。將這些孔洞的原始狀況保存在畫作上，能讓我們瞭解陳澄波的作畫方式，更重要的是，這些孔洞是他在戶外寫生的證明，同時也象徵一段屬於陳澄波的人生。

陳澄波在戶外寫生前後，釘鎖畫布可以避免搬運畫作時，碰觸到被釘在相反方向的畫作。但是，當畫布上的顏料未乾的時候，或者兩張畫作並沒有以最適當的距離被釘住的時候，可能會造成畫布上顏料對調的情形。在許多陳澄波的畫作中，都可以明顯地觀察到顏色對調或顏料沾染的現象。

當一天的寫生工作結束，陳澄波將畫作帶回住處後，他會將畫作倚靠在家裡的柱椿上面，並且一件一件地堆疊起來。受迫於狹小的居住空間，陳澄波必須以水平方向擺放畫作，同時他在存放這些畫作時也沒有畫框可以使用。〔含羞裸女〕和〔早餐〕這兩幅畫作就是在畫布上的顏料還沒乾透的情形之下，被相繼擱放在住處的柱子旁。在〔早餐〕的背面觀察到一層淺淺的顏料，經由縝密的顏料比對和化學成分分析，發現〔含羞裸女〕上顏料缺損的區域與〔早餐〕背面那層顏料的成分分析結果完全吻合。而且，這層顏料在〔早餐〕背面的位置與〔含羞裸女〕上顏料缺損位置的顏色完全吻合。在分析結果輔助之下，修復師以極為細膩的手法，先將〔早餐〕背面那一層顏料從畫布上移除，隨後再搭配化學分析的結果，修補畫作〔含羞裸女〕。

另外，將畫作以堆疊的方式保存起來的習慣，會對畫作表面產生許多不同的損毀狀況。因為疊放畫作所產生的壓力，會壓碎畫作上的顏料層，並且改變顏料的體積大小。顏料如果被壓碎後，會徹底改變畫作所呈現出來的藝術觀感；而且堆疊產生的壓力也可能把較厚的顏料壓平（圖9）。如果畫布上的顏料還沒有完全乾的時候，就將畫作儲存起來，也可能會造成畫作上的顏料變形或者產生畫布被擠壓的紋路。在陳澄波的畫作上，幾乎都可以觀察到這種被擠壓的紋路，甚至有一些畫作被擠壓出來的紋路更是相當地嚴重。這些受壓擠所產生的紋路，正是陳澄波這位藝術家工作的寫照，更是專屬於他的獨特風格的象徵。

圖9.〔上海郊外〕畫作上的壓痕和紋理就是接觸到其他畫的背面所留下。

五、結論

　　這次的修復計畫，第一階段總共修復陳澄波二十四幅畫作。這二十四幅畫作正是代表陳澄波人生當中三段不同時期的畫作。修復工作的進行，讓我們了解陳澄波作畫的方式，例如：重複使用畫布的習慣、搬運畫作和收藏畫作的方式等。不僅揭開陳澄波的作畫方式，更重要的是揭開每幅畫作的創作歷程。另外，畫作上因捲繞產生的裂痕也告訴我們，哪些畫作曾經躲避過當時混亂的政治局勢，並且免於遭受當下獨裁政府的毀損。

　　修復計畫中，不僅保存了畫作的布料、畫布上的顏料等有形的材質，同時也珍藏了畫作最初想表達出來的藝術觀感。更重要的是，修復計畫揭開了每幅畫作的創作歷程，同時也藉由這次修復計畫的執行，讓我們再次展現出每幅畫作最佳的原始風貌。而經由這次的修復計畫，臺灣的人民以及社會大眾才能夠盡情地欣賞、完整地理解、並且由衷地感謝陳澄波的藝術創作成果以及一段陳澄波所代表的歷史紀錄。

【註釋】

1. 本文於2012年4月24日泰國藝術大學主辦之「第三屆亞太地區熱帶氣候藝術保存研究組織（APTCCARN）年會」中發表。

2. 尤西博（Dr. Ioseba I. Soraluze）：西班牙瓦倫西亞綜合大學藝術文化資產保存暨修復學系博士學位。2006年，獲聘到臺灣高雄正修科技大學藝文處之文物修護中心，負責油畫修復工作。

3. 吳漢鐘：國立成功大學分析化學博士。2008年起，於正修科技大學藝文處的文物修護中心著手進行藝術品的科技檢測與分析，並擔任藝術修復保存與科學研究實驗室的負責人。

4. 李益成：西班牙瓦倫西亞綜合大學藝術學院博士。2005年起擔任高雄正修科技大學藝文處的文物修護中心主任。

5. 二二八事件是臺灣於1947年2月28日發生的事件，事件中，臺灣各地民眾大規模反抗，國民政府暴力鎮壓，這次事件造成超過千名以上的民眾死亡。

6. 劉長富，2012。

7. 經多次與藝術家的家人訪談，證實陳澄波於東京求學時期有經濟困難的問題。

8. Mazzoni, Tiziana, 1994, p. 30.

9. Soraluze, Ioseba, 2006, p. 61-65.

【參考文獻】

1. Mazzoni, Tiziana, 1994, 'All' origine del problema conservative dell' arte contemporanea, la pittura del XIX secolo. Materiali, techniche, alterazioni', in Sergio Angelucci（ed）, Arte contemporanea conservazione e restauro, Nardini, Firenze.

2. Ioseba I. Soraluze, 2006, La conservación de los objetos artísticos contemporáneos: Degradaciones, criterios de actuación y tratamientos de restauración, PhD thesis, Universidad Politécnica de Valencia, Valencia.

3. 尤西博（Ioseba I. Soraluze）〈論陳澄波作品──修復過去‧建構未來〉《再現澄波萬里：陳澄波作品保存修復特展》頁51-60，2012.4，高雄：正修科技大學文物修護中心。

4. 吉田千鶴子〈陳澄波と東京美術学校の教育〉《檔案‧顯像‧新「視」界──陳澄波文物資料特展暨學術論壇論文集》頁13-19，2011.12.7，嘉義：嘉義市政府文化局。

5. 李淑珠〈陳澄波（1895～1947）の編年について──三つの履歴書を中心に〉《京都美學美術史學》第1號，頁135-166，2002.3。

6. 林育淳《油彩‧熱情‧陳澄波》1998.5，臺北：雄獅圖書股份有限公司。

7. 林育淳〈陳澄波生命之旅的現實地與桃花源圖像〉《行過江南──陳澄波藝術探索歷程》頁6-15，2012.5，臺北：臺北市立美術館。

8. 邱函妮〈陳澄波「上海時期」之再檢討〉《行過江南──陳澄波藝術探索歷程》頁32-49，2012.5，臺北：臺北市立美術館。

9. 吳漢鐘、李益成、陳怡萱、黃婉真〈畫中有化──陳澄波作品的化學密碼〉《再現澄波萬里：陳澄波作品保存修復特展》頁61-73，2012.4，高雄：正修科技大學文物修護中心。

10. 黃冬富〈陳澄波畫中的華夏美學意識──上海任教時期的發展契機〉《檔案‧顯像‧新「視」界──陳澄波文物資料特展暨學術論壇論文集》頁27-44，2011.12.7，嘉義：嘉義市政府文化局。

11. 陳重光〈我的父親陳澄波〉《台灣美術家2 陳澄波》頁86-95，1979.12，臺北：雄獅圖書公司。

12. 傅瑋思〈認同、混雜、現代性：陳澄波日據時期的繪畫〉《行過江南──陳澄波藝術探索歷程》頁50-63，2012.5，臺北：臺北市立美術館。

13. 顏娟英〈勇者的畫像──陳澄波〉《臺灣美術全集（一）：陳澄波》頁27-48，1992.2.28，臺北：藝術家出版社。

14. 劉長富〈探索畫家陳澄波的「用筆」與「設色」〉《再現澄波萬里：陳澄波作品保存修復特展》頁21-28，2012.4，高雄：正修科技大學文物修護中心。

Preserving the Legacy of Chen Cheng-po : Restoration Project of the First Western Style Painter of Taiwan[1]

Dr. Ioseba I. Soraluze[2] , Wu Han-chung[3] , Li Yi-cheng[4]

Abstract

This project has restored 24 paintings of Chen Cheng-po that include the three period of the artist. The restoration used chemical analyses, X ray, ultraviolet and infrared light to be able to go deeper in understanding of the artist's technique. The conservation has allowed us to know the way the artist used the canvas and the history of the canvas itself, and how the artist's family protected the paintings from the dictatorship to avoid to be destroyed. At the same time we have also discovered how the artist transported the canvas where he painted, from the outdoor location to the studio. The technical conservation research carried out has provided us with a better understanding about the technique and the way Chen Cheng-po created his works of art.

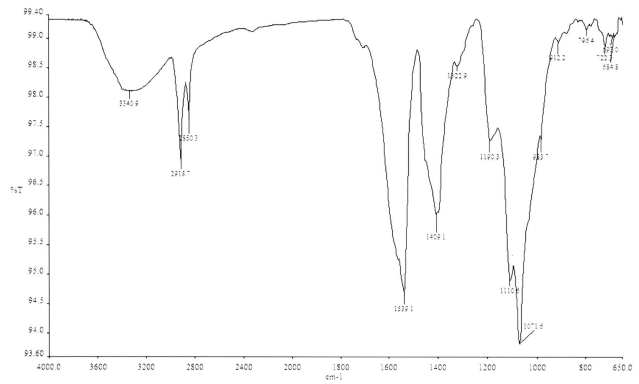

Fig.1: From the FTIR analysis result of Chen's oil paint fragment, some absorption peaks as the broad O-H band centering between 3400 cm-1, medium alkane stretch peaks in 2919 and 2850 cm-1, and a strong C-O peak about 1100 cm-1 were observed, suggesting that the main sample composition are long-chain saturated fatty alcohols.

I. Introduction

Chen Cheng-po was born in Chiayi City, Taiwan in 1895 during the Japanese colony period. In 1913 he started to learn with Kinichiro Ishikawa, a Japanese watercolour painter which gave him his initial contact with western art. After his graduation, he started to teach in Chiayi Public School for six years. However, he decided to embark to Japan to pursuit his artistic career dream. In 1924 at the age of 30 he was admitted to study at the Tokyo School of Fine Arts. In 1926 his *Chiayi Street Scene* (嘉義街外) was the first western style Taiwanese oil painting selected to the 7th Imperial Exhibition in Tokyo. Later it would be selected several times again. After graduating in 1929 Chen went to China then was teaching art in Xinhua Art School and Chang Ming Art School in Shanghai. During his Shanghai period he was already fascinated with the scenery of southern China. In 1933 doubt to the situation between Chinese and Japanese forces, he decided to return to Taiwan. Chen was an active artist even a politician. When the 228 Incident occurred in 1947[5], he and others city council members were shot dead in the Chiayi train station by militaries. Afterwards, Chen's family started to be monitored by the intelligence agency for a long period. Nevertheless, his family still had preserved his paintings with a lot of efforts no matter how hard was the situation of society. Thanks to that, today we could still view and admire his great artworks.

The Chen Cheng-po conservation project has been carried out thanks to the collaboration between the Chen Cheng-po Foundation and the Cheng Shiu Conservation Center. It has been a very intensive research and restoration, but it has led us to get impressive results and to preserve heritage. The collaboration project has been focused on the preservation of the artistic works of the artist. However, the restoration has allowed us to uncover different aspects of the creative process. The restoration has achieve to understand how the artist worked, obtaining valuable information for the technical understanding of his art.

II. Materials and techniques

Before starting a restoration treatment we needed to gain as much information as possible to obtain a complete technique understanding of the paintings, so different studies were carried out. These studies involved chemical analysis, X-rays, ultraviolet (UV) light, infra-red (IR) light and visual examination, which provide invaluable knowledge about materials, techniques and conservation.

It was the first time that artist's materials were investigated from a compositional point of view. Several Fourier Transform Infrared (FTIR) scans were undertaken to confirm that the binder used was oil, see Fig.1. At the same time, cross-section analysis and Scanning Electron Microscopy SEM / Energy Dispersive X-ray (EDX) were implemented to determine the pigments. The cross-section of *Back of Sitting Nude Female* (背向坐姿裸女), see Fig. 2 reveals nine different layers and the pigments are listed as table 1. The pigment study was completed and compared with the colors that the artist ordered from the Tokyo art supply store in December of 1921[6]. The quotation form of the color purchased by the artist are available at the Chen Cheng-po Foundation, and they were very useful to compare the colors to begin compiling a pigment database of Chen, see Fig. 3.

Using X-ray imaging we found out that artist Chen Cheng-po had a tendency to reuse canvases. The works he created at the University of Tokyo were usually painted over more than once and images

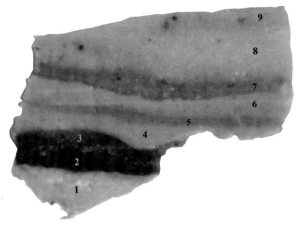

Fig. 2: Cross-section of paint sample from *Back of Sitting Nude Female*

No.	Pigments
9	Zinc White, Emerald Green, Ochre Red
8	Zinc White, Ochre Red
7	Zinc White, Ochre Yellow and Litharge
6	Lead White
5	Litharge, Lead White
4	Lead White, Ochre Yellow
3	Emerald Green, Minium, Lead White
2	Chrome Green, Lead White
1	Lead White

Table 1: List of pigments used in *Back of Sitting Nude Female*

often appear below. This is the case *Bridge* Side (橋畔) undated, which was painted so quickly because we appreciate the rush in those areas that are not well covered, letting us see underlying brush strokes. These well not covered areas were probably due to the lack of time prior to submission as a school subject. The reuse of canvases during his Tokyo period was caused by economic pressures given to the artist's student status[7]. Another example with the characteristic to reuse the canvas at the University of Tokyo is found in *Back of Sitting Nude Female*. The x-ray image shows that Chen did not reuse the canvas once, but twice, see Fig. 4. The first time he used it, he painted a portrait. When he decided to

Fig. 3: Chen Cheng-po's proforma invoice for supplies ordered from a Tokyo art supplier in 1921.

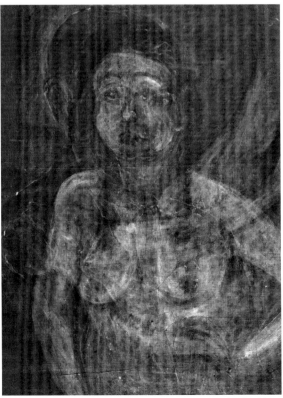

Fig. 4: X-ray image of *Back of Sitting Nude Female*. The X-ray shows how the artist reused the canvas several times.

reuse it again, the portrait was replaced with a nude female figure. Later it was reused one more time to paint the final *Back of Sitting Nude Female*. The first two times the canvas was painted vertically, while the third time the format is horizontal. On the bottom of the left side of this painting is a note writing in pencil, 未了, meaning unfinished. It is not clear which painting was being referred to.

The tendency Chen had for reusing canvases in his Tokyo period could be considered a tendency for economic and educational reasons. However, it was a trend that he repeated in the three periods of his life, Tokyo, Shanghai and Taiwan. All the artistic periods of Chen present underlying paintings. Thus, we must not considerer only the economic reasons as the motive of to reuse the canvases again, but aesthetic reasons too. When artist changed or modified the composition, he was manifesting his unconformity to accept a painting he did not like, and those paintings were always covered. Chen repainted his canvases many times.

Once he decided to reuse a canvas again, no coating layer was employed as separation and he applied the new color directly on the painting. The lack of a white ground layer was not only when he decided to reuse canvases, but also when painted them for the first time. The support whether of textile or wood prepared by the artist himself has no initial white coating. However, the paintings that have coating layer are due the artist's use of industrially produced standard canvases. The reason for not employing the white coating was due to the teaching received at the Tokyo School of Fine Arts. In that time the Tokyo School of Fine Arts was greatly influenced by the French Impressionist movement, and the French artists were the first to avoid using the ground layer[8] because they rejected the traditional and academic rules. They also looked for a personal style to make difference with others[9]. Thus, Chen did not employ it either.

III. Restoration

The Chen Cheng-po project was mainly focused on the restoration of paintings, particularly a group of 24 works of art. The conservation condition it was not the most appropriate and the paintings showed significant damages. The works of art were at risk but not all of them presented the same degradation. Commonly they had deformations, cracks, losses, stains··· that made the restoration inevitable for the future conservation. Nevertheless, a special damage drew attention to a specific crack. There was a characteristic in many of the paintings that contained the same kind of degradation, and it was corresponded to a directional crack. The cracking that went in a parallel direction was due to the canvas sometimes being rolled, see Fig.5. As Chen Cheng-po was killed by the

■ **Rolling Crack**

Fig. 5: The painting named *Canal* (運河) , was rolled to be protected from the dictatorship. The damage mapping shows the directional cracks caused by being rolled.

Fig. 6: The back of *A Bashful Nude* (含羞裸女), undated. The transparent lining allows the artist's signature to remain visible.

dictatorship, his family thought that the paintings had to be protected and hidden from the government. If they had found the paintings they would have probably confiscated and destroyed them. In that sense, the Chen's family had determination to preserve the artist's legacy and they showed courage to avoid the loss of this Taiwanese heritage. So, the rolling cracking is a symbol of bravery and preservation that display to us the wound of history that the painting lived.

Once all the information about the work was obtained and conservation condition analyzed, the restoration process itself was begun. Initially the paintings were faced with fish glue and Japanese paper to protect and consolidate the color surface. Thus, the reverse of the canvas was accessible to work on and clean. Tears in the canvas support were welded by threads. After the back was finished, we continued with the lining of some paintings that required this treatment step. In the case of Chen Cheng-po, the artist had the habit of signing with a pencil at the back of the canvas even though not all paintings present this. Through the years the artist changed the signature's style. When a signature was present at the back of a canvas, the lining required to take it into account as the lining would cover and hide it. The lining would have to be strong enough and allow the signature's display, so a transparent lining was done, see Fig. 6.

Following lining the paintings were mounted in a new stretcher. At the corners were placed four metal keys to allow the expansion. Then the cleaning would begun, a very sensible process that requires care and attention. To do this, small cleaning test were done to find the most suitable product that could remove dust and stains and not damage the painting. Generally special soaps were used to take off the dust and maintain the patina. Finally the lost paint areas were filled and retouched, recovering the unity of the art work.

It should be noted that the restoration process of the works of Chen ends with the retouching of the paint losses. Chen Cheng-po is an artist who liked the matt and dry finish and throughout his life never used varnish. The paintings that show a glossy finish had varnish applied by others, not by the artist. The reason he did not use varnish is also a direct consequence of teachings at the Tokyo School of Fine Arts and its influence by the Impressionist movement. This French artistic movement was the first time to avoid using varnish due to the chromatic changes of colors, and also as a way to break with traditional academic painting, showing to society a modern art. Therefore, in any painting restored no varnish was applied in order to respect the aesthetic and the artist's intention.

IV. Storing and handling

The restoration study carried out on the paintings let us know technical and organizational aspects of the artist. A damage analysis demonstrated how Chen Cheng-po moved the canvas from the place he painted to his studio. The artist had the habit to paint outdoor, so he needed to bring the canvas back to the workshop when it was still damp. He had to use a transportation system or a canvas carrier to be able to move them as safely as possible. Transporting a freshly painted canvas required a tool to make it portable without mess, and the artist started to use canvas pins, see Fig. 7. The metallic canvas pin had two nails of 6mm to drive into the stretchers to be able to move two canvases at the same time placed face to face, so it is a system that drills the paintings and scratches the surfaces.

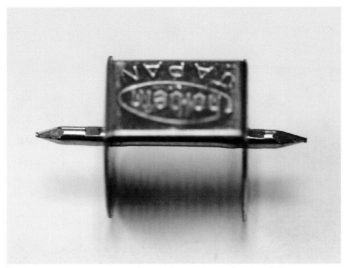

Fig. 7: A new canvas pin purchased in an art supplies store in Tokyo.

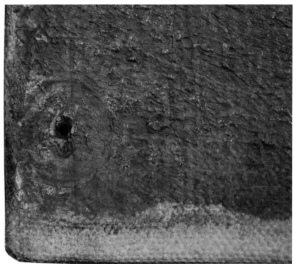

Fig. 8: The hole was caused by using the canvas pin. The pin was also printed in the paint surface.

The paintings which have holes are those that were painted outdoors and were subsequently brought back to the studio. The paintings are mainly urban landscape and nature, and the pin was used in the three periods of the artist's life, in Tokyo, Shanghai and Taiwan. An example of consequences of using the canvas pin is noted in the painting *Nijubashi Bridge* (二重橋), undated, see Fig. 8. The pin left an impression on the paint surface and sometimes the color suffered scratches and tone changes due to the pressure and friction provoked by it. The canvas pin were generally placed at the corners but in some cases the holes appeared at the center of the canvas, probably due to putting different sized canvas face to face.

It should be mentioned that none of the holes of the canvas pin were filled and retouched. The holes were kept in the original form because they let us know and visualize the artist's way of work. Furthermore, the holes are a sign of painting outdoors and represent a part of painting's history.

The canvas pin, despite protecting the painted surface from outside, allowed the paint to come into contact with another painted surface placed against it. As the paintings were still damp and the space between placed canvases was not enough to avoid contact, some transfer of paint occurred between canvases. The paint transfer or paint stains are clearly visible in many paintings of Chen Cheng-po.

Once the artist came back to the studio with the paintings, he usually piled them on top of each other. Due to the lack of space he was forced to stack them horizontally, also he stored them together even without the stretcher. This is the case of *A Bashful Nude* (含羞裸女), undated, and *Breakfast* (早餐), undated, that were piled one after the other while still tacky. Consequently, a huge paint loss of *A Bashful Nude* was discovered and recovered as a flake of paint fixed to the back of the *Breakfast* painting, and the flake was removed and consolidated in its original place.

The habit to stack and storage canvases together provoked several damages in the painting surfaces. The pressure exerted caused crushed impasto, changing the volume of the paint material. The crushed impasto altered completely the aesthetic of the painting, reducing the impasto to an entirely flat surface. Simultaneously, the storage of paintings which had not fully dried also produced deformations and fabric texture imprints, see Fig. 9. Most of the paintings of Chen Cheng-po contain this kind of texture imprints all around the surface, with some more severe than others. It could be said the fabric texture imprints are a characteristic of the works of art of the artist and conferred a singular sign.

V. Conclusions

The project carried out has had the aim of restoring 24 paintings of the collection of Cheng Cheng-po Foundation that include the three periods of the artist. The restoration has led us to know

Fig. 9: Detail of a huge fabric texture imprints in *Shanhai Outskirts* (上海郊外). Similar imprints have occurred throughout the painting.

and understand the artist's way of work, such as his reuse of canvas many times and how he moved and stored paintings. We have not only discovered about the creation, but the canvas history itself. The cracking of the rolled paintings tell us which of them were hidden from the dictatorship.

At the same time, the restoration project in addition to preserving the materials and aesthetic of the paintings, has allowed us to recover the past and display it in the best possible condition. In this way, the Taiwanese and the public in general will be able to enjoy, understand and appreciate Chen Cheng-po's works of art and the history he represents.

1. 3rd meeting of APTCCARN (Asia Pacific Tropical Climate Conservation Art Research Network), *The conservation of material culture in tropical climates*, Sipalkorn University, Thailand, 2012.

2. Ioseba I. Soraluze has a doctor's degree in Fine Art specialized in painting conservation at Universidad Politécnica de Valencia. Since 2006 he is responsible of oil painting restoration at Conservation Center, Cheng Shiu University, Kaohsiung.

3. Wu Han-chung has a doctor's degree in Analysis Chemistry at National Cheng-Kung University now. Since 2008 he is responsible of scientific examination at Conservation Center, Cheng Shiu University, Kaohsiung.

4. Li I-cheng has a doctor's degree at Universidad Politécnica de Valencia. Since 2005 he is the Head of the Conservation Center, Cheng Shiu University, Kaohsiung.

5. The 228 Incident also knows as 228 Massacre was an anti-government uprising in Taiwan that occurred in 1947, which was violently repressed by the Nationalist Government. More than 10000 persons were killed.

6. For more information see also Liu, Chang-Fu, 2012.

7. Several conversation with the artist family confirmed that Chen Cheng-Po had economic difficulties in Tokyo.

8. Mazzoni, Tiziana, 1994, p. 30.

9. Soraluze, Ioseba, 2006, p. 61-65.

【 References 】

1. Burke Mathison, Christina S.W., 2012, "Identity, hybridity, and modernity: The colonial paintings of Chen Cheng-po", *Journey through Jiangnan - A pivotal moment in Chen Cheng-po's artistic quest*, Taipei Museum of Fine Arts, Taipei, p.50-63.

2. Chen Tsung-kuang, 1979, "Chronology of Chen Cheng-po", *Chen Cheng-po – A naïve painter from the Academy*, Taiwan Artists 2, Hsiung Shih Art Books, Taipei, p.86-95.

3. Chiu Han-ni, 2012, "Reappraising Chen Cheng-po's 'Shanghai Period' ", *Journey through Jiangnan - A pivotal moment in Chen Cheng-po's artistic quest*, Taipei Museum of Fine Arts, Taipei, p.32-49.

4. Chizuko Yoshida, 2011, "Chen Cheng-po and the education at the Tokyo School of Fine Arts", *Archive, Visualitation, New Vision - Special Exhibition and Seminar on Chen Cheng-po*, Cultural Affairs Bureau, Chiayi, p.13-19.

5. Huang Tung-fu, 2011, "Chinese aesthetics in Chen Cheng-po's painting style. Turning point of development while teaching in Shanghai", *Archive, Visualitation, New Vision - Special Exhibition and Seminar on Chen Cheng-po*, Cultural Affairs Bureau, Chiayi, p.27-44.

6. Li Su-chu, 2002, "On the chronology of Chen Cheng-po (1895-1947) based on three curriculum vitae", *Kyoto Studies in Aesthetics and Art History*, p.135-166.

7. Lin Yu-chun, 1998, *Oil paint, Passion, Chen Cheng-po*, Hsiung Shih Art Books, Taipei.

8. Lin Yu-chun, 2012, "The real scenes and images Utopia in Chen Cheng-po", *Journey through Jiangnan - A pivotal moment in Chen Cheng-po's artistic quest*, Taipei Museum of Fine Arts, Taipei, p.6-15.

9. Liu Chang-fu, 2012.4, "Explore the painter Chen Cheng-po 'brush strokes' and 'colour application'", *Exhibition of conservation and restoration of Chen Cheng-po's work*, Cheng Shiu Art Center, Kaohsiung , p.21-28.

10. Mazzoni, Tiziana, 1994, "All' origine del problema conservative dell'arte contemporanea, la pittura del XIX secolo. Materiali, techniche, alterazioni", in Sergio Angelucci (ed), *Arte contemporanea conservazione e restauro*, Nardini, Firenze

11. Ioseba I. Soraluze, 2006, *La conservación de los objetos artísticos contemporáneos: Degradaciones, criterios de actuación y tratamientos de restauración*, PhD thesis, Universidad Politécnica de Valencia, Valencia

12. Ioseba I. Soraluze, 2012, "Chen Cheng-po: Restaurando pasado, construyendo futuro", *Exhibition of conservation and restoration of Chen Cheng-po's work*, Cheng Shiu Art Center, Kaohsiung, p.51-60.

13. Wu Han-chung, Li I-cheng, Chen I-shuan and Huang Wan-jin, 2012, "The chemistry codes of Chen Cheng-po's paintings", *Exhibition of conservation and restoration of Chen Cheng-po's work*, Cheng Shiu Art Center, Kaohsiung, p.61-73.

14. Yen Chuan-ying, 1992, "Portrait of a brave man: Chen Cheng-po", *Taiwan Fine Arts Series 1*, Artist publishing Co., Taipei, p.27-48.

陳澄波畫作之非破壞性檢測[1]

吳漢鐘、尤西博、黃平志[2]、桂椿雄[3]

摘要

　　本研究主要以非破壞性的方法分析及檢視臺灣先輩藝術家陳澄波的作品，以了解這些作品的受損狀況與陳澄波的創作習性。以紫外線檢視數十件需執行修復的作品，由螢光特性的差異發現部分油畫作品曾受補筆，藉此可區分出原作與補筆的區塊；以紅外線檢視這些作品，發現陳澄波未以炭筆或鉛筆繪製底稿，而是以油畫顏料直接在畫布上作畫；綜合前兩項檢視技術觀察紙類素描作品，發現因保存方式所沾附到的其他殘留稿件的主要原因，是炭筆上的有機物質而非碳粒；由X光檢視結果，發覺在數件作品的表層之下還存在著其他創作；以X射線螢光光譜儀進行顏料的非破壞性元素分析，其結果與陳澄波訂購顏料的手稿相符，也歸納出其可能之調色習慣。整體而言，本研究在顏料鑑定方面得到相當多的資訊，並建立了陳澄波作品慣用顏料的資料庫。

一、緒論

　　近幾十年來藝術品修復保存領域漸漸重視到科學方法的參與可解決許多問題，並可以幫助修復師得到更多藝術品的資訊。於此部分，Lahnier等學者[4]針對藝術品、古蹟、歷史建築及自然景觀等文化資產提出「理想」分析檢視技術的需求如下：

(1) 非破壞性：意即保持材料或物體的物理完整，理論上此分析程序對標的物件不應產生任何可見的損壞，通常指完全不取樣或者進行相當少量（數µg至mg以下）的取樣，適用於高價值物件的調查研究。

(2) 快速：可在短時間分析大量性質類似的樣品，或可在物件表面上進行多點或多樣性的調查研究，此方法的價值在於能辨識出非常態的標的物檢視處或數據取樣點。

(3) 可通用性：指分析檢視儀器能在最低樣品前處理程序下對不同型態／尺寸的材料／標的物進行分析。

(4) 多功能性：指同一技術能得到文物均化的資訊，但也可獲得非均質材料小面積（如µm至mm的範圍）的局部資訊。

(5) 高靈敏度：具此特性的分析程序除了可得到標的物的主要元素組成外，也能得知微量元素的分佈以建立文物指紋資料庫。

(6) 多元素分析：以同一儀器分析時可同時得到多種元素的資訊，更重要的是在分析前不必假設樣品所含元素為何。

目前這些研究方向以光譜學應用為主，並分為物理檢視與化學分析兩大領域。物理檢視方面，紫外線（UV）常應用在藝術品表面狀況的檢視，是藝術修復保存領域中最普遍的方法。在UV-A（320-400 nm）、UV-B（280-320 nm）及UV-C（180-280 nm）中，UV-A（長波長）和UV-C（短波長）是博物館內最常用來檢視藝術品的紫外線源。[5]在紅外線（IR）部分利用礦物顏料不吸收近紅外線（Near Infrared, NIR）的特性可檢視到塗層後面的炭筆底稿。X射線的應用與NIR檢視相近，不同的是它利用對不同元素的穿透能力，可檢視到表面畫作下的其他繪畫結構。[6]化學分析部分，針對無機顏料非破壞性元素分析以攜帶式X射線螢光光譜儀（X-ray fluorescence, XRF）的應用最廣。[7]根據得到的元素成分種類和比例，可定義出畫家使用的礦物顏料成分。統整上述各種檢視和分析方法所得到的結果，就可以推測出陳澄波的創作習性和慣用顏料的組成成分。

油畫最早起源於歐洲，蓬勃發展了數百年之久後，才在1世紀多以前傳入東亞地區，包含當時仍屬日本殖民地的臺灣。19世紀初，臺灣開始有藝術家前往日本學習繪畫技巧，並將這些技術帶回臺灣，陳澄波（1895-1947）就是首批東進的藝術家之一。1926年，他以畫作〔嘉義街外（一）〕入選日本第七回「帝國美術展覽會」，成為第一個以油畫作品入選該展覽的臺灣人，之後也持續入選各個國際大展。陳澄波除了忠於自己的創作外，他積極的組辦美術學會，以推廣增進臺灣藝術能量為己任，並為此走入政壇欲完成畢生志業，卻也因二二八事件而殉命。陳澄波的一生就如同20世紀初臺灣社會及人民的縮影，而他的藝術成果更受到世人所肯定。2002年，陳澄波的〔嘉義公園（二）〕油畫作品，在香港的拍賣場以高於估價四倍的2仟6百多萬台幣成交，創下臺灣畫家的最高拍賣價格記錄。2006年在香港蘇富比「中國當代藝術品」拍賣會上，他的〔淡水〕以約1億4千8百萬台幣賣出，2007年〔淡水夕照〕拍出約2.12億元台幣，都一再刷新臺灣畫家拍賣記錄。

本次研究藉由財團法人陳澄波文化基金會的協助，才得以完成了這數十件作品的檢測分析，由於陳澄波作品的重要性和價值都相當高，所以本研究所進行的各項分析皆屬於非破壞性的檢測，即使以此類檢測方式所得到的資訊難以窺探各項物質確切成分之組成，但對臺灣的藝術修復保存界、美術界及學術界而言，卻是第一次有這種完整蒐集這些資料的機會。

二、檢測方法及對象

本研究針對財團法人陳澄波文化基金會委託正修科技大學藝文處藝術科技保存修復組執行修復的作品，執行紫外線表層檢視、紅外線底稿檢視及X射線穿透檢視等項目，包含了32件油畫作品及14件紙質作品等，受檢視的畫作與項目如表1所示；化學分析部分以攜帶式XRF至財團法人陳澄波文化基金會檢測，共計72件及3件紙類作品，各作品及分析顏料一覽表如表2所示。

表1. 檢視對象與檢視項目一覽表

次序	作品名稱	年代	媒材	紫外線檢視	紅外線檢視	X光檢視
1	北回歸線地標	1924	畫布油彩	✓		✓
2	背向坐姿裸女	1926	畫布油彩	✓	✓	
3	杭州古厝	1928	畫布油彩	✓	✓	
4	陽台上的裸女	1928	畫布油彩	✓	✓	
5	甕	1929	畫布油彩	✓	✓	
6	小弟弟	1931	畫布油彩	✓	✓	✓

次序	作品名稱	年代	媒材	紫外線檢視	紅外線檢視	X光檢視
7	八月城隍祭典	1932	畫布油彩	✓	✓	
8	林中戲水裸女	1932	畫布油彩	✓	✓	✓
9	上海碼頭	1933	畫布油彩	✓	✓	
10	玉山暖冬	1934	畫布油彩			✓
11	抱肘裸女	1940	畫布油彩	✓	✓	✓
12	貯木場	年代不詳	畫布油彩	✓	✓	
13	有芭蕉樹的人家	年代不詳	木板油彩			✓
14	橋畔	年代不詳	木板油彩	✓	✓	✓
15	屋頂	年代不詳	密底板油彩	✓		✓
16	上海郊外	年代不詳	畫布油彩	✓	✓	✓
17	運河	年代不詳	畫布油彩	✓	✓	✓
18	西湖塔景	年代不詳	畫布油彩	✓	✓	✓
19	潭前山景	年代不詳	畫布油彩	✓	✓	
20	二重橋	年代不詳	畫布油彩	✓	✓	✓
21	厝後池邊	年代不詳	畫布油彩	✓	✓	✓
22	綠幔裸女	年代不詳	畫布油彩	✓	✓	✓
23	側坐裸女	年代不詳	畫布油彩	✓	✓	
24	綠面具裸女	年代不詳	畫布油彩	✓		✓
25	側臥閱讀裸女	年代不詳	畫布油彩	✓	✓	✓
26	臥躺裸女	年代不詳	畫布油彩	✓	✓	✓
27	含羞裸女	年代不詳	畫布油彩	✓	✓	
28	群眾	年代不詳	木板油彩	✓	✓	
29	淑女像	年代不詳	木板油彩	✓	✓	✓
30	紅與白	年代不詳	畫布油彩	✓	✓	
31	花（一）	年代不詳	畫布油彩	✓	✓	✓
32	早餐	年代不詳	畫布油彩	✓	✓	✓
33	淡水寫生合畫	1941	紙本水彩	✓		
34	百合花	1924-1925	紙本膠彩	✓		
35	炭筆素描12張	1925-1930	紙本炭筆	✓	✓	

表2. 元素分析檢測作品與顏料一覽表

次序	畫作名稱	年代	媒材	檢測顏色
1	有藍色瓶子的靜物	1924	木板油彩	綠、藍、褐、紅（簽名）
2	北回歸線地標	1924	畫布油彩	綠、藍、紅（簽名）
3	荒城	1924	木板油彩	綠、藍、褐
4	街道	1925	木板油彩	藍、橘、褐、紅（簽名）
5	日本橋（一）	1926	畫布油彩	黃、綠、藍、紅（簽名）
6	自畫像（一）	1928	畫布油彩	褐、黃
7	朝陽洞	1929	畫布油彩	綠、藍
8	少年像	1929	木板油彩	藍
9	普陀山群驢	1929	畫布油彩	綠、藍、黑

次序	畫作名稱	年代	媒材	檢測顏色
10	半身裸女	1931	畫布油彩	藍、褐、紅（簽名）
11	水畔臥姿裸女	1932	畫布油彩	藍、褐、紅（簽名）
12	陽台遙望裸女	1932	畫布油彩	白、藍、褐、紅（簽名）
13	畫前坐姿裸女	1932	畫布油彩	白、紅、膚、綠、藍、褐
14	上海江南製船所	1933	畫布油彩	藍、褐、黑、紅（簽名）
15	河岸	1934	畫布油彩	綠、藍、紅（簽名）
16	綠蔭	1934	畫布油彩	綠、藍
17	嘉義公園一景	1934	畫布油彩	褐、綠
18	遠眺玉山（二）	1935	畫布油彩	白、綠、藍、紅（簽名）
19	嘉義郊外	1935	畫布油彩	白、紅、黃、綠、藍、褐、紅（簽名）
20	杜鵑花	1935	畫布油彩	綠
21	雲海	1935	木板油彩	白、綠
22	椰林	1938	畫布油彩	褐、綠
23	濤聲	1939	畫布油彩	綠、藍
24	夏之朝	1940	畫布油彩	綠、藍
25	新樓庭院	1941	畫布油彩	綠、藍、白、紅（簽名）
26	碧潭	1946	畫布油彩	綠、藍
27	玉山積雪	1947	木板油彩	白、綠、藍、紅（簽名）
28	吳鳳廟	年代不詳	木板油彩	綠、藍
29	廟頂眺望	年代不詳	木板油彩	綠、藍、黃、褐
30	有芭蕉樹的人家	年代不詳	木板油彩	白、綠、藍、褐
31	紅毛埤	年代不詳	木板油彩	紅、綠
32	林中閣樓	年代不詳	木板油彩	綠、藍
33	阿里山	年代不詳	紙本油彩	綠、藍
34	川邊少女	年代不詳	木板油彩	綠、藍、白、紅、褐
35	河邊山坡	年代不詳	紙本油彩	紅、綠
36	教堂	年代不詳	木板油彩	紅、綠
37	山腳下	年代不詳	木板油彩	褐、藍
38	溪畔人家	年代不詳	畫布油彩	褐、綠
39	八卦山（二）	年代不詳	畫布油彩	綠、藍
40	二重橋	年代不詳	畫布油彩	白、藍、綠、淺紫、紅（簽名）
41	運河	年代不詳	畫布油彩	紅、綠、藍、紅（簽名）
42	溪畔	年代不詳	畫布油彩	黃、綠、藍
43	渡船頭	年代不詳	畫布油彩	白、紅、綠、藍、褐、灰
44	海灣	年代不詳	畫布油彩	綠、藍、紅（簽名）
45	夕陽	年代不詳	畫布油彩	黃、藍、褐
46	睡蓮	年代不詳	三合板油彩	白、褐、綠、紅（簽名）
47	城門	年代不詳	三合板油彩	藍、褐
48	屋頂	年代不詳	木板油彩	藍、褐
49	橋下戲水	年代不詳	木板油彩	藍、紅（簽名）
50	觀音山下	年代不詳	木板油彩	黃、藍

次序	畫作名稱	年代	媒材	檢測顏色
51	屋頂遙望	年代不詳	畫布油彩	綠、藍
52	斜坐矮凳裸女	年代不詳	木板油彩	膚、黑
53	綠幀裸女	年代不詳	畫布油彩	白、膚、黑
54	紅巾裸女	年代不詳	畫布油彩	膚、紅、黑
55	綠面具裸女	年代不詳	畫布油彩	膚、黑
56	臥躺裸女	年代不詳	畫布油彩	膚、黑
57	坐姿冥想裸女	年代不詳	畫布油彩	膚、黑
58	裸女靜思	年代不詳	畫布油彩	膚、黑
59	高腳桌旁立姿裸女	年代不詳	木板油彩	膚
60	紅氈裸女	年代不詳	木板油彩	膚、紅
61	仰臥裸女	年代不詳	畫布油彩	膚、綠
62	畫前立姿裸女	年代不詳	畫布油彩	膚、紅
63	立姿擺態裸女	年代不詳	木板油彩	褐、黑、膚
64	林中戲水裸女	年代不詳	畫布油彩	白、膚、黑
65	倚窗裸女	年代不詳	木板油彩	膚、紅
66	側面裸女	年代不詳	木板油彩	膚、黑
67	早餐	年代不詳	畫布油彩	白、藍
68	花（一）	年代不詳	畫布油彩	褐、綠
69	靜物	年代不詳	木板油彩	綠、藍
70	花瓶與石榴	年代不詳	木板油彩	白、紅
71	雌伴雄武	年代不詳	紙本油彩	藍
72	驢	年代不詳	木板油彩	綠、藍

（一）紫外線表面特性檢視

紫外線表面特性檢視是修復領域中最常用的一門技術，此技術儀器操作技巧簡易，設備費用較其他科學分析儀器為低，且可即時得到文物表面狀況、受損形態、受損來源、保護層狀況、修復痕跡等資訊。紫外線檢視方法，是以紫外線照射在待測物件上，照射區域中可吸收紫外線的物質會將其吸收，經由分子內能量的轉移，部分能發射螢光的物質即會產生螢光反應，且會因為不同物質而發射不同波長或強度的螢光，分析人員即可藉此判斷其表面狀況。此技術最大的特點，即為觀察藝術品表面是否受有機物質及黴菌的侵入破壞，而曾經修復或補筆的痕跡，也會因其材質不同而在紫外線的照射下一覽無遺。雖然作品長時間曝露在紫外線下會產生劣化現象，但因檢視過程所需時間不會太長，故一般仍將其歸類於非破壞性檢視方法。本次研究所使用的紫外線光源為雙燈管光源，波長皆為長波長的352 nm，功率各為40 W，記錄方式為數位相機拍攝，並視作品狀況輔以450 nm之濾光鏡以去除不必要的藍、紫色螢光。

（二）紅外線檢視

在各項物理性的檢視技術中，紅外線檢視主要可提供表層下的炭筆或墨筆痕跡等資訊，創作者若有以炭筆繪製底稿之習慣，即可藉紅外線檢視觀察到，除了油畫作品外，在臺灣，一般的廟宇彩繪構件多以墨筆為稿，若其受煙害或保護層劣化而無法觀察到其底層圖樣時，紅外線檢視即可提供相當有用之資訊，甚或在表面塗層甚為模糊而難以辨視的狀況下，有了紅外線檢視技術的輔助，即可觀察到墨筆滲入基底材後的原稿構

圖。紅外線屬於熱光源，在晴天的正常日光已含足夠的紅外線，但若在室內，像日光燈或LED等冷光源即無法提供足夠的紅外線以符合影像擷取界面的需求，故需以紅外線光源輔助之，由於可見光的強度一般都較紅外線強，所以進行紅外線檢視時，皆需於鏡頭前加裝濾鏡以濾除可見光。本次紅外線檢視所使用的紅外鏡攝影機適用波長範圍為400-1100 nm，可見光濾視應用波長範圍為400-720 nm，紅外線濾視應用波長範圍則為720-1100 nm；在紅外線光源部分，係由48顆紅外線LED所組成，光源波長為850 nm，有效照射距離約在20至25米之間。

（三）X射線檢視與螢光光譜分析

　　X射線，又稱為倫琴射線或X光，是波長範圍在0.01 nm到10 nm間的電磁輻射波，為一對人體有危害的射線。X射線最初用於醫學成像診斷和X射線結晶學，由於其穿透力強，故在藝術品修復領域中，也用以檢視畫作表層底下，是否存在其他圖層畫面。X射線光子的產生，是利用加速後的電子撞擊金屬靶，撞擊過程電子減速損失的動能，即以光子形式放出而形成連續的X光光譜，此類型的光可為X光的光源；另若以較高能量將原子內層電子撞出形成內層空穴，由外層電子躍遷回內層填補空穴而放出的光子，其波長會集中在某些特定的狹窄範圍，而為該原子的特徵X光譜線，在無機材料分析中，即是以此特性輻射為判斷元素種類的主要依據。

　　藝術品修復保存領域中，科學測試方法的選用極受限制，其主要原因，係為大部分測試方法多無法避免由文物上採取樣品而會對文物造成傷害，故非破壞性、取樣量少或靈敏度佳的分析方法遂為目前此領域科學分析所首重，因此，非破壞性放射線分析技術即日漸受到重視。在藝術品修復保存領域中，最常用到的放射線分析技術為X射線螢光光譜法（XRF）及電子顯微鏡-能量散佈光譜儀（SEM-EDX），其中，XRF更已有攜帶式的機型，對於不方便遷徙的文物可在其所在處進行分析。這兩種技術的主要用途，皆是為了進行無機物的元素分析，惟元素分析實驗本身難度並不高，較為困難之處，乃為由元素分析結果判斷測試樣品材料或顏料的成分，否則所得結果對修復工作者而言助益不大。雖然SEM-EDX與XRF屬於半定量分析方法，對分析物含量分析的準確度沒有非常高，但由於在藝術品修復保存的應用上，分析標的物多屬樣品中的主要成分元素，所以其提供的資訊已可敷使用。

三、結果與討論

（一）紫外線及紅外線檢視結果

　　本次研究針對陳澄波的32件油畫作品進行紫外線與紅外線檢視，由檢視的結果可知財團法人陳澄波文化基金會對這些作品的管理及保存環境甚為注重，作品的狀況尚屬良好，產生黴菌的狀況並不常見，值得注意的是，在紫外線下卻觀察到了部分作品有曾被以修復或補筆的方式介入。圖1為〔綠幔裸女〕、〔抱肘裸女〕及〔上海碼頭〕等作品的局部區域在正常光與的紫外線下之比較，照片中紅色虛線圈選處以較深的顏色顯現，但這些區域在正常光下觀察並沒有顯著的差異。這些區域吸收了大部分的紫外線，表示其基質與畫作上的其他位置不同，故判定為由修復師所補筆（retouched）的。基於修復倫理，為了保留畫作原本的美學價值，修復師必須使畫作在被肉眼觀賞時看不出被修復處。而為了讓後來的修復師能夠區分出被修復的部位，當未來有更適當的材料或修復技術能取代時，能夠針對被修復處而保留作者原來的創作，這些被加上去的物質和原畫作的基質則需完全不同。畫作的紫外線檢視就像是它的病歷，能夠讓畫作的醫生——修復師清楚的了解這張畫的哪些位置曾經出現問題，即使它在一般狀況下看起來是健康的。而我們對其中28件作品進行完整的紅外線檢視，所有油畫作品的檢視結果皆沒有發現與表層畫面明顯不同處，表示陳澄波沒有以炭筆繪製底稿的習慣，這也和以研究畫風為主的專家所下的結論一致。

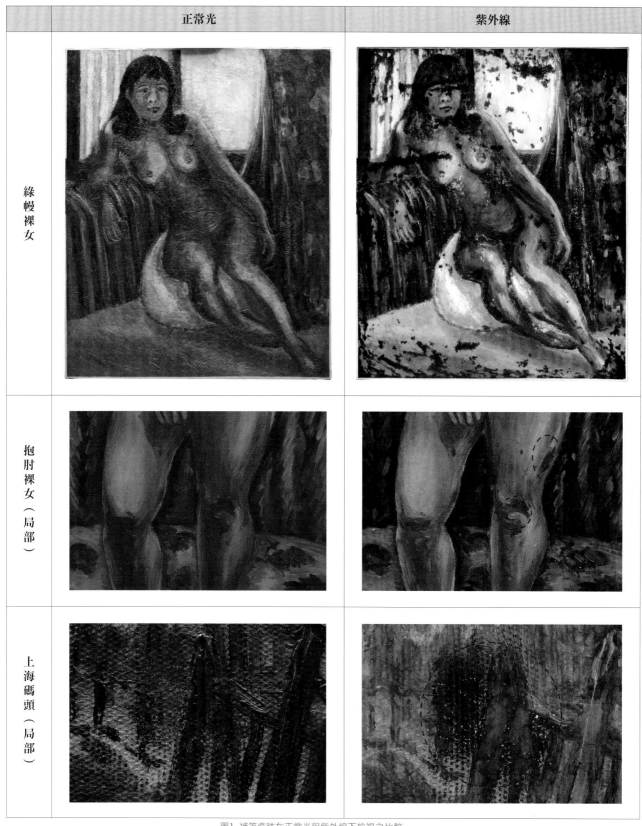

正常光	紫外線
綠幔裸女	
抱肘裸女（局部）	
上海碼頭（局部）	

圖1. 補筆痕跡在正常光與紫外線下檢視之比較

　　我們以同樣的方式檢視了陳澄波的14件紙質作品，在〔淡水寫生合畫〕（陳澄波、楊三郎、李梅樹、廖繼春）的部分，在紫外線的照射下使作品受損而產生褐斑的區域更容易被定義（圖2）。另外，在12張炭筆素描作品正、背面的紫外線及紅外線檢視結果，也獲得了令人感到興趣的資訊。早期因為藝術家儲藏室的空間不足，或尚未建立正確的作品保存觀念時，是以平放堆疊的方式儲存作品，日積月累下畫作背面多有沾附

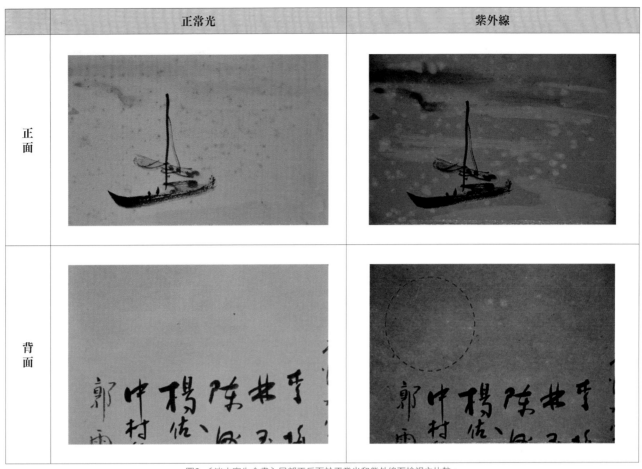

	正常光	紫外線
正面		
背面		

圖2.〔淡水寫生合畫〕局部正反面於正常光和紫外線下檢視之比較。

到其他作品的模糊構圖。依據經驗，原本推測沾附上去的會是炭筆的粉末，以紅外線檢視應該可以得到更為清楚的堆疊構圖，但實際檢視的結果，出乎意料的這些模糊的構圖反而在紫外線下更為清晰（如圖3），而且線條外圍有暈開的狀況，由此結果可以知道，堆疊所得構圖主要成因為炭筆成分中的有機物質，這些物質揮發後即吸附在前張畫作，粉末的物理性沾附只是其中的一小部分，另外，也可知道陳澄波在創作這些素描作品時，可能並沒有進行固定炭色的動作。

（二）X射線檢視結果

　　不同於紅外線檢視，X射線主要以透視的方式檢視作品表層下是否具有其他資訊，如作者因為不滿意原有創作或其他因素，而在其上層重繪等狀況。在陳澄波油畫作品的X射線檢視中，的確發現了有這種現象，且最多有觀察到在作品表層下另有其他2件畫作的存在。總計對陳澄波26件油畫所進行的X射線穿透檢視中，有9件作品觀察到其下層仍存在其他畫作，如：〔西湖塔景〕的X射線檢視圖（如圖4）可明顯觀察到表層下存在另一正面裸女圖；〔橋畔〕的X光檢視結果也與其表層大不相同，雖然因為其X射線透視圖的畫面較為複雜，而難以判斷在表層下存在幾件作品，但仍可明顯的觀察到其底下至少存在二個與畫面不同的建築物。

（三）顏料檢測結果

　　本次研究係以攜帶式XRF執行非破壞性元素鑑定分析，總計進行了72件布質、木板油畫及紙質作品共327個樣品數的分析，檢測對象及分析結果如表2所示，主要針對人物畫的膚色及黑色；風景畫的綠色、藍色及褐色；及靜物畫之紅色、綠色、褐色等顏色進行檢測。由根據各顏料之元素含量分佈圖與油畫顏料化合

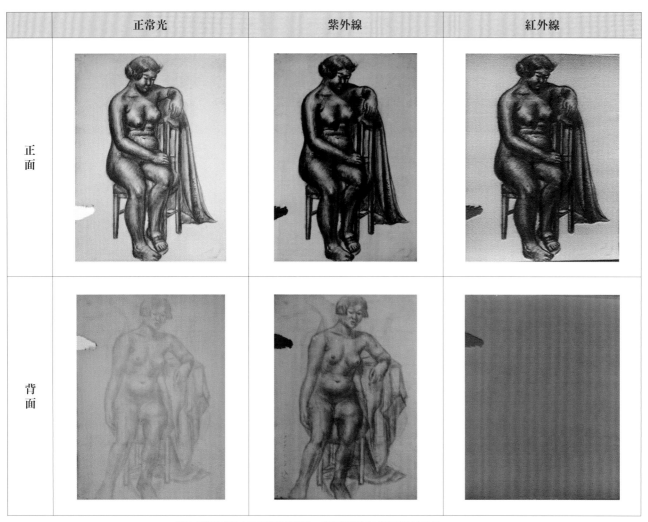

	正常光	紫外線	紅外線
正面			
背面			

圖3. 炭筆素描作品正反面於正常光、紫外線與紅外線下檢視之比較。

物資料庫來比對這些檢測結果，可篩選出陳澄波可能使用的顏料種類，值得注意的是，本研究所得到的結果，如表3所示，在白色系部分，陳澄波以鋅白（ZnO）及鉛白（$2PbCO_3 \cdot Pb(OH)_2$）為主要使用顏料，其中又以鋅白比例較高，而鈦白（TiO_2）則主要用於調色；黃色系部分以鎘黃（CdS）使用頻率最高，且會使用鉻黃（$PbCrO_4$）及那不勒斯黃（$Pb_2Sb_2O_7$）進行其他顏色的調色；紅色系主要使用的顏料為朱紅（HgS）及赭石（Fe_2O_3），其中在單純紅色系以朱紅使用頻率最大，赭石則多用於調色，但不常與朱紅混合使用；藍色系部分，陳澄波主要以鈷藍（$Co(AlO_2)_2$）進行創作，其他顏料雖有使用但頻率較低；綠色系中，其最喜愛使用鮮豔的鉻綠（Cr_2O_3）及翡翠綠（$Cu(CH_3COO)_2$、$3Cu(AsO_2)_2$）創作，橄欖色系則多以調色的方式呈現；在褐色部分會使用赭石（Fe_2O_3）創作，亦有相當的比例是由紅色系顏料調色而得。

以XRF檢測結果進行統計分析時，往往會以顏色為資料解析的基礎，本次針對陳澄波藍色顏料的研究，選定30幅畫作計101個測點進行分析，這些作品包含了12幅木板油畫（OW）及18布質油畫，並在布質油畫部分，區分成3類，分別為OCJ、OCS及OCT。由檢測結果，可發現陳澄波畫作的藍色顏料，無論在不同時期或油畫及木質等基質中，元素分析結果分布的專一性甚高，但其中最值得探討的部分，應該是鈦（Ti）及鉻（Cr）在不同時期中含量分布的差異，由圖5-8呈現的結果，可得知此兩元素在日本時期（OCJ）作品藍色顏料中的含量，顯然較其他時期為高，但因鈦及鉻皆不是藍色顏料的主要元素，故可能是陳澄波在不同時期混色顏料使用上的差別，而這科學檢測的結果，也可作為藝術史學家再深入探討的線索。

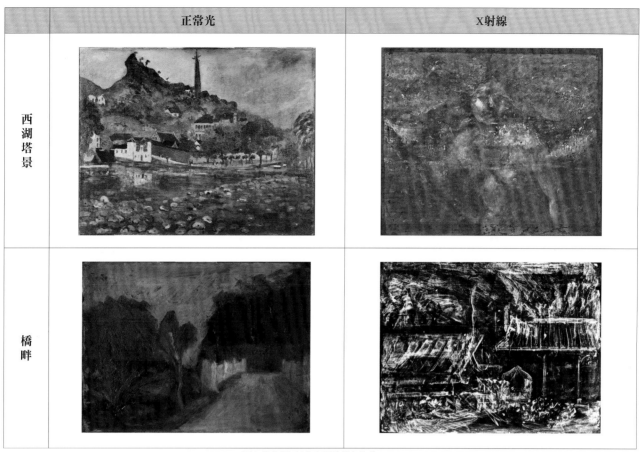

	正常光	X射線
西湖塔景		
橋畔		

圖4. 畫作與X射線穿透檢視之比較

四、結論

由本次對陳澄波作品之非破壞性研究，可窺探出這些作品的整體狀況與其創作之可能習性。在紫外線檢視中，觀察到部分作品曾受修復，也釐清了素描作品背面沾附其他作品的原因；由紅外線和X射線的檢視結果，可得知陳澄波的習慣，他在創作時不會以炭筆或鉛筆繪製底稿，但是有可能因為當時物資缺乏，或他對舊作品不滿意，所以會在畫過的作品上面進行新的創作。在顏料的元素分析中，結果符合與他的訂購單，我們也整理出不同顏色中相關性非常高的元素及其含量比例。整體而言本次研究已得相當多可用資訊，未來我們研究團隊也將再針對如陳澄波先生等前輩藝術家之作品執行深入剖析，以非破壞且快速的分析方法建立各項數據資料庫。

表3. 陳澄波可能使用之主要顏料種類

次序	英文名字	主要化學式／化學名稱
白色	Chinese White	鋅白ZnO
	Lead white	鉛白$2PbCO_3 \cdot Pb(OH)_2$
	Titanium white	鈦白TiO_2
黃色	Chrome Yellow	鉻黃$PbCrO_4$, $Al_2(CrO_4)_3$
	Cadmium Yellow	鎘黃CdS
	Ochre Yellow	赭石黃$FeO(OH) \cdot xH_2O$
紅色	Ochre Red	赭石Fe_2O_3
	Cinnabar	朱紅HgS
	Cadmium red	鎘紅CdS + CdSe
藍色	Cobalt Blue	鈷藍$Co(AlO_2)_2$
	Prussian Blue	普魯士藍$Fe_4[Fe(CN)_6]_3$
	Ultramarine Blue	群青SiO, Al_2O_3, S, Na_2S
	Sky Blue	天空藍$CoSnO_3$
	Azurite	石青$2CuCO_3 \cdot Cu(OH)_2$
綠色	Viridian	鉻綠Cr_2O_3
	Cobalt green	鈷綠Co_2O_3 及 ZnO
	Emerald Green	翡翠綠$Cu(CH_3COO)_2 \cdot 3Cu(AsO_2)_2$
	Malachite	石綠$CuCO_3 \cdot Cu(OH)_2$
褐色	Ochre	赭石Fe_2O_3

圖5. 油畫（OCJ）XRF檢測分析（Mining mode）

圖6. 油畫（OCS）XRF檢測分析（Mining mode）

圖7. 油畫（OCT）XRF檢測分析（Mining mode）

圖8. 木板畫（OW）XRF檢測分析（Mining mode）

【註釋】

1. 本文於2013年9月曾發表於《JOURNAL OF THE CHINESE CHEMICAL SOCIETY》第60卷第9期，後因資料新增，文章略有修正。

2. 黃平志：正修科技大學化妝品與時尚彩妝系副教授。

3. 桂椿雄：國立成功大學化學系教授。

4. Lahanier Ch., Preusser F. D., Zelst L. Van, "Study and conservation of museum objects: Use of classical analytical techniques", *Nucl. Instrum. Methods Phys. Res. B*, 14, 1-9, 1986. Janssens K., Vittiglio G., Deraedt I., Aerts A., Vekemans B., Vincze L., Wei F., Deryck I., Schalm O., Adams F., Rindby A., Knochel A., Simionovici A., Snigirev A., "Use of Microscopic XRF for Non-destructive Analysis in Art and Archaeometry", *X-Ray Spectrom.*, 29, 73-91, 2000.

5. 參考文獻1-6。

6. 參考文獻1和7。

7. 參考文獻8-14。

【參考文獻】

1. F. D. P. a. L. V. Z. Ch. Lahanier, *Nuclear Instruments and Methods in Physics Research Section B: Beam Interactions with Materials and Atoms*, 1986, 14, 1-9.

2. G. V. K. Janssens, I. Deraedt, A. Aerts, B. Vekemans, L. Vincze, F. Wei, I. Deryck, O. Schalm, F. Adams, A. Rindby, A. Knochel, A. Simionovici and A. Snigirev, *X-Ray Spectrometry*, 2000, 29, 73-91.

3. S. Daniilia, D. Bikiaris, L. Burgio, P. Gavala, R. J. H. Clark, Y. Chryssoulakis, *Journal of Raman Spectroscopy*, 2002, 33, 807-814 10.1002/jrs.907.

4. M. S. Grant, in *Book The Use Of Ultraviolet Induced Visible-Fluorescence In The Examination Of Museum Objects, Part II*, ed., ed. by Editor, National Park Service, City, 2000, Chap. Chapter.

5. M. S. Grant, in *Book The Use Of Ultraviolet Induced Visible-Fluorescence In The Examination Of Museum Objects, Part I*, ed., ed. by Editor, National Park Service, City, 2000, Chap. Chapter.

6. C. B. Tragni, in *Book The use of ultraviolet-induced visible fluorescence for examination of photographs*, ed., ed. by Editor, *International museum of photography* and film & image permanence institute, City, 2005, Chap. Chapter.

7. A. Mounier, C. Belin, F. Daniel, *Environmental Science and Pollution Research*, 2011, 18, 772-782 10.1007/s11356-010-0429-5.

8. M. Thoury, J. P. Echard, M. Refregiers, B. Berrie, A. Nevin, F. Jamme, L. Bertrand, *Analytical Chemistry*, 2011, 83, 1737-1745 10.1021/ac102986h.

9. D. Naegele, *Ra-Revista De Arquitectura*, 2009, 15-+.

10. N. M. Ahmed, M. M. Selim, *Pigment & Resin Technology*, 2011, 40, 4-16 10.1108/03699421111095883.

11. S. Akyuz, T. Akyuz, G. Emre, A. Gulec, S. Basaran, *Spectrochimica Acta Part a-Molecular and Biomolecular Spectroscopy*, 2012, 89, 74-81 10.1016/j.saa.2011.12.046.

12. O. Chiantore, R. Ploeger, T. Poli, B. Ferriani, *Studies in Conservation*, 2012, 57, 92-105 10.1179/2047058411y.0000000003.

13. T. Li, Y. F. Xie, Y. M. Yang, C. S. Wang, X. Y. Fang, J. L. Shi, Q. J. He, *Journal of Raman Spectroscopy*, 2009, 40, 1911-1918 10.1002/jrs.2340.

14. I. Nakai, Y. Abe, *Applied Physics a-Materials Science & Processing*, 2012, 106, 279-293 10.1007/s00339-011-6694-4.

15. F. M. V. Pereira, M. Bueno, *Chemometrics and Intelligent Laboratory Systems*, 2008, 92, 131-137 10.1016/j.chemolab.2009.02.003.

16. S. Y. Wei, Q. L. Ma, M. Schreiner, *Journal of Archaeological Science*, 2012, 39, 1628-1633 10.1016/j.jas.2012.01.011.

17. 《陳澄波百年紀念展》1995.6.26再版，嘉義：嘉義市文化中心。

18. 黎中光〈倒在血泊中的「和平使」〉《台灣史料研究》第3期，1994.2，臺北：吳三連台灣史料基金會。

Using Non-destructive Analysis Techniques to Examine the Artworks of Taiwanese Artist Chen Cheng-po (1895-1947)[1]

Wu Han-chung, Dr. Ioseba I. Soraluze, Huang Ping-chih[2], Kuei Chun-hsiung[3]

Abstract

This study employed the non-destructive techniques to analyze and examine the artworks of the Taiwanese artist Chen Cheng-po (1895-1947) for disclosing the damage to Chen's artworks and determine his creation habits. Ten pieces of artworks that required restoration were examined using ultraviolet examination techniques. Based on the differences in their fluorescence characteristics, various parts of these works were shown to have been retouched, thus, original and retouched regions were distinguished. Examining these works using Infrared instrument revealed that Chen did not use charcoal to prepare drafts, and he directly applied oil paint to the canvases. Subsequently, these two examination techniques were adopted to examine sketches. The results showed that residues imprinted on them cause of storage methods were organic materials from charcoal and not carbon granules. The X-ray examination identified numerous creations beneath the surface of several artworks. The X-ray fluorescence spectrometer was used for elemental analysis of the pigments. The results corresponded with the pigments listed in Chen's purchase form, thus, we summarized the composition of palettes used by Chen. In general, this study acquired a considerable amount of information from the pigment examinations and established a database of the pigments that Chen commonly employed in his artworks.

I. Introduction

In the past few decades, the inclusion of scientific approaches has been valued by conservators and restorers because these methods provide solutions to numerous problems and facilitate restorers to acquire more information on artworks. According to Lahanier et al.[4] an ideal method for analyzing objects of artistic, historic or archaeological nature should be:

(a) **Non-destructive:** i.e. respecting the physical integrity of the material/object. Often valuable objects can only be investigated when the analysis does not result in any (visible) damage; usually this completely eliminates sampling or limits it to very small amounts;

(b) **Fast:** so that large numbers of similar objects may be analyzed or a single object investigated at various positions on its surface; this property is very valuable since this is the only way of being able to discern between general trends in the data and outlying objects or data points;

(c) Universal: so that by means of a single instrument, many materials and objects of various shapes and dimensions may be analyzed with minimal sample pretreatment;

(d) Versatile: allowing with the same technique average compositional information to be obtained, but also local information of small areas (e.g. millimeter to micrometer-sized) from heterogeneous materials;

(e) Sensitive: so that object grouping and other types of provenance analysis can be done not only by means of major elements but also by means of trace-element fingerprints; and

(f) Multi-elemental: so that in a single measurement, information on many elements is obtained simultaneously and, more importantly, so that also information is obtained on elements which were not initially thought to be relevant to the investigation.

This type of research primarily adopts the application of spectroscopy, partitioning the research into fields of physical examinations and chemical analyses. In physical examinations, the use of ultraviolet (UV) lights is the most commonly applied method in the art restoration and conservation field to examine the surface conditions of artworks. The UV portion of the electromagnetic spectrum can be divided into the following regions: UV-A (320-400 nm), UV-B (280-320 nm), and UV-C (180-280 nm). Among these three regions, UV-A (long-wave) and UV-C (shot-wave) are the most useful in examining museum objects.[5] The Infrared (IR) examination technique employs the characteristics of mineral pigments, which do not absorb near IR radiation (NIR), to examine charcoal-based materials beneath the surface of an artwork. Although similar to the NIR examination technique, the X-ray technique differs by examining compositions beneath the surfaces of works based on the different penetration levels of various elements.[6] In chemical analyses, a portable X-ray fluorescence (XRF) spectrometer is the non-destructive elemental analytical technique that is most frequently used for the analysis of inorganic pigments in painting or cultural heritage.[7] The composition of mineral pigments utilized by painters can be defined according to the types and proportions of the elemental compositions. By integrating the results of the above examination and analytical techniques, we can then know the creation habits and pigment compositions typically adopted by artists.

Oil painting spread across East Asia, including Japanese-occupied Taiwan in the early twentieth century. Chen Cheng-po (1895-1947) and several Taiwanese artists were among the first to learn painting skills in Japan, and they subsequently brought back this technique. In 1926, Chen was the first Taiwanese person to have an oil painting (i.e., *Outside Chiayi Street* (1)), selected for the seventh "Empire Exhibition" of Japan. Afterwards, he continuously participated in various international exhibitions. In addition to his devotion to creation, Chen entered politics in hopes of promoting people's dedication to Taiwan's artistic energy, but was murdered during the 228 Incident. The life of Chen Cheng-po is an epitome of society and people in early-twentieth-century Taiwan, and his artistic achievements have been recognized worldwide. In 2002, Chen's oil painting *Chiayi Park* (2) was sold at a Hong Kong auction for over NTD$ 26 million, setting a record for the highest auction price for a Taiwanese artist. In 2006, his *Tamsui* painting sold for approximately NTD$ 148 million at Sotheby's "Contemporary Chinese Art" auction in Hong Kong. In 2007, Chen's *Sunset in Tamsui* was auctioned for approximately NTD$ 212 million, breaking the auction record among Taiwanese artists yet again. With the support of the Chen Cheng-po Cultural Foundation, we were able to comprehensively examine and analyze numerous examples of Chen's artworks. Because of the extreme importance and value of his works, most analyses and examinations conducted on these artworks were non-destructive.

Much information about the using materials in each piece was obtained through this study, and it was the first opportunity of acquiring a complete data set for the fields of art restoration and conservation in Taiwan.

Table 1: Overview of the Works and Examination Techniques

No.	Artworks	Year	Materials	UV	IR	X-Rays
1	Tropic of Cancer Landmark	1924	Oil on canvas	✓		✓
2	Back of Sitting Nude Female	1926	Oil on canvas	✓	✓	✓
3	Ancient Houses in Hangzhou	1928	Oil on canvas	✓	✓	
4	Nude on a Balcony	1928	Oil on canvas	✓	✓	✓
5	Jug	1929	Oil on canvas	✓	✓	
6	Little Boy	1931	Oil on canvas	✓	✓	✓
7	Town God Sacrificial Rites in September	1932	Oil on canvas	✓	✓	
8	Nude Female Kicking Water in Forest	1932	Oil on canvas	✓	✓	✓
9	Shanghai Dock	1933	Oil on canvas	✓	✓	
10	Mild Winter at Mt. Jade	1934	Oil on canvas			✓
11	Nude Female Holding Elbow	1940	Oil on canvas	✓	✓	✓
12	A Lumberyard	unknown	Oil on canvas	✓	✓	✓
13	Houses with a Banana Tree	unknown	Oil on wood			✓
14	Bridge Side	unknown	Oil on wood	✓	✓	✓
15	Rooftop	unknown	Oil on MDF	✓		✓
16	Shanghai Outskirts	unknown	Oil on canvas	✓	✓	✓
17	Canal	unknown	Oil on canvas	✓	✓	✓
18	Tower Scene at West Lake	unknown	Oil on canvas	✓	✓	✓
19	Mountain View in Front of a Pond	unknown	Oil on canvas	✓	✓	
20	Nijubashi Bridge	unknown	Oil on canvas	✓	✓	✓
21	Pondside at the back of Houses	unknown	Oil on canvas	✓	✓	✓
22	Nude Female Against Green Curtain	unknown	Oil on canvas	✓	✓	✓
23	Nude Female Sitting Sideways	unknown	Oil on canvas	✓	✓	
24	Nude Female with a Green Mask	unknown	Oil on canvas	✓	✓	✓
25	Reclining Nude Reading Book	unknown	Oil on canvas	✓	✓	
26	Nude in Lying Posture	unknown	Oil on canvas	✓	✓	✓
27	A Bashful Nude	unknown	Oil on canvas	✓	✓	✓
28	Inside the Cabin	unknown	Oil on wood	✓	✓	✓
29	Portrait of a Lady	unknown	Oil on wood	✓	✓	✓
30	Red and White	unknown	Oil on canvas	✓	✓	✓
31	Flowers (1)	unknown	Oil on canvas	✓	✓	✓
32	Breakfast	unknown	Oil on canvas	✓	✓	✓
33	Tamsui Collaboration	1941	Watercolor on paper	✓		
34	Lilies	unknown	Glue color on paper	✓		
35	12 pieces of charcoal sketches	unknown	Charcoal on paper	✓	✓	

II. Experimental

Using the restored works that were entrusted by the Chen Cheng-po Cultural Foundation to the Art Technology Conservation and Restoration Group (Cheng Shiu University Art Center), we examined 32 oil paintings and 14 paper-based artworks using the following techniques: UV lights for surface examination, IR lights for charcoal-base material examination, and X-ray penetration examinations. The artworks and items under study are shown in Table 1. The chemical analyses were conducted at the Chen Cheng-po Cultural Foundation with a portable XRF spectrometer to examine Chen's works. A total of 72 oil paintings and 3 paper-based artworks were examined, and their titles and analyzed colors are summarized in Table2.

Table 2: Overview of the Artworks and Colors Examined Through Elemental Analysis

No.	Artworks	Year	Materials	Colors
1	Still Life with Blue Bottle	1924	Oil on wood	green, blue, brown, red (signature)
2	Tropic of Cancer Landmark	1924	Oil on canvas	green, blue, red (signature)
3	Deserted City	1924	Oil on wood	green, blue, brown
4	Street	1925	Oil on wood	blue, orange, brown, red (signature)
5	Nihonbashi Bridge Scene (1)	1926	Oil on canvas	yellow, green, blue, red (signature)
6	Self-Portrait (1)	1928	Oil on canvas	brown, yellow
7	Chaoyang Cave	1929	Oil on canvas	green, blue
8	Portrait of a Teenage Boy	1929	Oil on wood	blue
9	Donkeys at Putuo Mountain	1929	Oil on canvas	green, blue, black
10	Helf-length Portrait of Nude Female	1931	Oil on canvas	blue, brown, red (signature)
11	Nude Female Lying Waterside	1932	Oil on canvas	blue, brown, red (signature)
12	Nude Female Looking out	1932	Oil on canvas	white, blue, brown, red (signature)
13	Nude Seated Before a Painting	1932	Oil on canvas	white, red, skin, green, blue, brown
14	Shanghai Jiangnan Shipyard	1933	Oil on canvas	blue, brown, black, red (signature)
15	Riverside	1934	Oil on canvas	green, blue, red (signature)
16	Foliage	1934	Oil on canvas	green, blue
17	A Scene at Chiayi Park	1934	Oil on canvas	brown, green
18	Overlooking Mt. Jade (2)	1935	Oil on canvas	white, green, blue, red (signature)
19	Chiayi Countryside	1935	Oil on canvas	white, red, yellow, green, blue, brown, red (signature)
20	Azalea	1935n	Oil on canvas	green
21	Sea of Clouds	1935	Oil on wood	white, green
22	Coconut Grove	1938	Oil on canvas	brown, green
23	Crashing Waves	1939	Oil on canvas	green, blue
24	Summer Morning	1940	Oil on canvas	green, blue
25	Courtyard in Sin-Lau	1942	Oil on canvas	green, blue
26	Bitan	1946	Oil on canvas	green, blue
27	Accumulated Snow on Overlooking Mt. Jade (2)	1947	Oil on wood	white, green, blue
28	Wu Feng Temple	unknown	Oil on wood	green, blue
29	Distant View from Temple Top	unknown	Oil on wood	green, blue
30	Houses with a Banana Tree	unknown	Oil on wood	white, green, blue, brown

No.	Artworks	Year	Materials	Colors
31	Hongmao Lake	unknown	Oil on wood	red, green
32	A Storied Building in the Woods	unknown	Oil on wood	green, blue
33	Ali Mountain	unknown	Oil on paper	green, blue
34	Riverside Girl	unknown	Oil on wood	green, blue, white, red, brown
35	Mountain Slope at a River	unknown	Oil on paper	red, green
36	Church	unknown	Oil on wood	red, green
37	At a Mountain Foot	unknown	Oil on wood	brown, blue
38	Stream-side Cottage	unknown	Oil on canvas	brown, green
39	Bagua Mountain (2)	unknown	Oil on canvas	green, blue
40	Nijubashi Bridge	unknown	Oil on canvas	white, blue, green, violet, red (signature)
41	Canal	unknown	Oil on canvas	red, green, blue, red (signature)
42	Creekside	unknown	Oil on canvas	yellow, green, blue
43	Ferry	unknown	Oil on canvas	white, red, green, blue, brown, grey
44	Bay	unknown	Oil on canvas	green, blue, red (signature)
45	Sunset	unknown	Oil on canvas	yellow, blue, brown
46	Sleeping Lotus	unknown	Oil on plywood	white, brown, green, red (signature)
47	City Gate	unknown	Oil on plywood	blue, brown
48	Rooftop	unknown	Oil on wood	blue, brown
49	Playing Water under a Bridge	unknown	Oil on wood	blue, red (signature)
50	At the foot of Guanyin Mountain	unknown	Oil on wood	yellow, blue
51	View from a Rooftop	unknown	Oil on canvas	green, blue
52	Nude Female Sitting Reclined on Low Stool	unknown	Oil on wood	skin, black
53	Nude Female Against Green Curtain	unknown	Oil on canvas	white, skin, black
54	Nude Female Against Red Towel	unknown	Oil on canvas	skin, red, black
55	Nude Female with a Green Mask	unknown	Oil on canvas	skin, black
56	Nude in Lying Posture	unknown	Oil on canvas	skin, black
57	Back of Sitting Nude Female in Meditation	unknown	Oil on canvas	skin, black
58	Seated Meditating Nude	unknown	Oil on canvas	skin, black
59	Nude Standing Next to a High-foot Table	unknown	Oil on wood	skin
60	Nude on a Red Carpet	unknown	Oil on wood	skin, red
61	Nude Lying on her Back	unknown	Oil on canvas	skin, green
62	Nude standing Before a Painting	unknown	Oil on canvas	skin, red
63	Nude Female Posting in Stance	unknown	Oil on wood	brown, black, skin
64	Nude Female Kicking Water in Forest	unknown	Oil on canvas	white, skin, black
65	Nude Leaning Against a Window	unknown	Oil on wood	skin, red
66	Side View of Nude Female	unknown	Oil on wood	skin, black
67	Breakfast	unknown	Oil on canvas	white, blue
68	Flowers (1)	unknown	Oil on canvas	brown, green
69	Still life	unknown	Oil on wood	green, blue
70	Vase and Pomegranates	unknown	Oil on wood	white, red
71	Female Accompanying a Valiant Male	unknown	Oil on paper	blue
72	Donkey	unknown	Oil on wood	green, blue

1. Ultraviolet examination of surface characteristics

UV light is the most commonly used technique in the conservation field to examine surface characteristics. The equipment adopted in this technique is easy to operate, affordable compared to other scientific analytical instruments, and data from the object (e.g. surface conditions, types and sources of damage, conditions of the protective layer, and any restoration) can be obtained rapidly. The UV examination technique entails the radiation of UV lights directly on the surface of an object. When UV radiation is absorbed by reactive materials on the surface (i.e., materials that absorb UV radiations), a portion of the fluorescent materials undergo a reaction because of intermolecular energy transfer, thereby emitting fluorescence of differing wavelengths or intensity depending on the material. From this, the analysts can determine the surface conditions of an object. Another crucial aspect of this technique is its ability to determine whether the surface of the artwork was damaged by organic substance and mold, and restored or retouched regions, because various materials react differently under UV lights. Although long-term exposure to UV lights deteriorates artworks, the time needed for an examination is brief. Therefore, the use of UV lights is categorized as a non-destructive examination method. For this study, UV lights from a dual-lamp, operating at a wavelength of 352 nm and a power of 40 W, was adopted as the light source. The information was captured using a digital camera with a filter (wavelength of 450 nm) placed in front of the camera lens to eliminate the blue and purple fluorescence.

2. Examining which beneath the surface of artwork with Infrared

Of all the physical examination techniques, the IR primarily provides information regarding traces of charcoal or ink beneath the surface of artworks. Furthermore, this technique enables the detection of whether the artist was accustomed to creating charcoal-based underdrawings. Besides oil paintings, temples in Taiwan typically use ink for underdrawings. If underlying patterns are unobservable because of fire-related damage or protective layer deterioration, or when the surface is unrecognizable, the IR examination technique can provide useful insights or can detect the original patterns of ink-based underdrawings. IR lights that are sufficiently present in normal sunlight during sunny days are a heat source. In contrast, IR light from indoor, cold light sources, such as daylight lamps or LEDs, are inadequate for satisfying the requirements of video capturing interfaces. This necessitates supplementary IR lights. Because the intensity of visible light is generally stronger than that of IR light, a filter must be placed in front of the lens to filter out visible light when conducting IR examinations. In this study, an IR camera with a wavelength range of 400 to 1100 nm was employed in the IR examination. Depending on the application, the wavelength for the visible light filter ranged from 400 to 720 nm and the IR light filter ranged from 720 to 1100 nm. The IR light was sourced from 48 IR LEDs, operating at a light wavelength of 850 nm and capable of emitting to a distance of 20 to 25 m.

3. X-radiography examination and fluorescence spectral analysis

X-radiations (i.e. Roentgen rays or X-rays) are electromagnetic radiation waves with wavelengths between 0.01 and 10 nm and are hazardous to humans. X-rays, initially applied in medical imaging for diagnostics and X-ray crystallography, are characterized by their strong penetrability. Thus, it is applied in art restoration fields to determine the existence of sub-surface patterns. X-ray spectrums are generated in the form of photons, which represent the kinetic energy lost because of electron deceleration during the collision of accelerated electrons on metal objects. This type of photon is

the light source of X-rays. Furthermore, the X-ray spectral line of an atom is the key characteristic in determining elemental compositions during the analysis of inorganic materials. This characteristic entails the specific narrow wavelength range of a photon that is liberated during the transition of outer electrons to fill the inner hole, which is formed when a high energy causes the collision of electrons in the inner layer of an atom.

In the art restoration and conservation field, the selections of analysis methods are limited because most analytical methods inevitably damage works during sampling. Therefore, non-destructive and high-sensitivity analyses that only require small sample sizes are preferred in the art restoration and conservation field. Consequently, the non-destructive radiation analytical technique has gradually become valued. The most prevalent radiation analytical techniques in the art restoration and conservation field are the XRF and the scanning electron microscope – energy dispersive x-ray (SEM-EDX) spectrometers, of which the XRF spectrometer is a portable device that can analyze art that cannot be easily moved. These techniques are primarily used for the elemental analysis of inorganic materials. Although the experimental difficulty of elemental analyses is low, the results of these analyses are not useful to the restorers if the sample materials or pigment compositions cannot be identified from the results of the analysis. Although SEM-EDX and XRF spectrometers are semi-quantitative analytical methods, their accuracy in determining the quantity of analytes is low. However, the information produced is adequate for art restoration and conservation applications because the majority of the analytes are the key elemental compositions of the samples.

III. Results and discussion

1. Results of ultraviolet and infrared examinations

In this study, we conducted UV light and IR examinations on 32 oil paintings of Chen Cheng-po. The results showed that these works were extremely well maintained and preserved by the Chen Cheng-po Cultural Foundation. The conditions of the artworks were not so stable, with few molds. Noticeably, under the UV light, we found traces of restoration or retouching on some of the works. Fig. 1 comparatively show the partial regions of the paintings (*Nude Female Against Green Curtain, Nude Female Holding Elbow and Shanghai Dock*) under normal and UV lights. The regions circled in red dashed lines were darker in color; however, no significant differences where observed under normal lights. This region absorbed most of the UV light, indicating that the materials differed from those on the other regions of the painting because of retouching by a restorer. According to the code of ethics for conservation, areas of restoration retouching should preserve the original aesthetic value of the artwork. For future restorers to distinguish the restored region, the supplemented material must differ from the original material. Therefore, in the future, the restored region can be replaced by a more suitable material or restoration technique to maintain the originality of the artwork. The UV light examination results from an artwork are equivalent to a medical history, from which the doctor (i.e., the restorer) can identify the regions where problems have occurred, even if the condition of the artwork appears to be normal. Similarly, we examined these 28 pieces of artwork using IR and identified no significant differences between the foundation and surfaces, suggesting that Chen did not have a habit of adopting charcoal-based underdrawings. This finding was consistent with the conclusion made by specialists with expertise in research related to painting styles.

	Normal lights	UV lights
Nude Female Against Green Curtain		
Nude Female Holding Elbow (detail)		
Shanghai Dock (detail)		

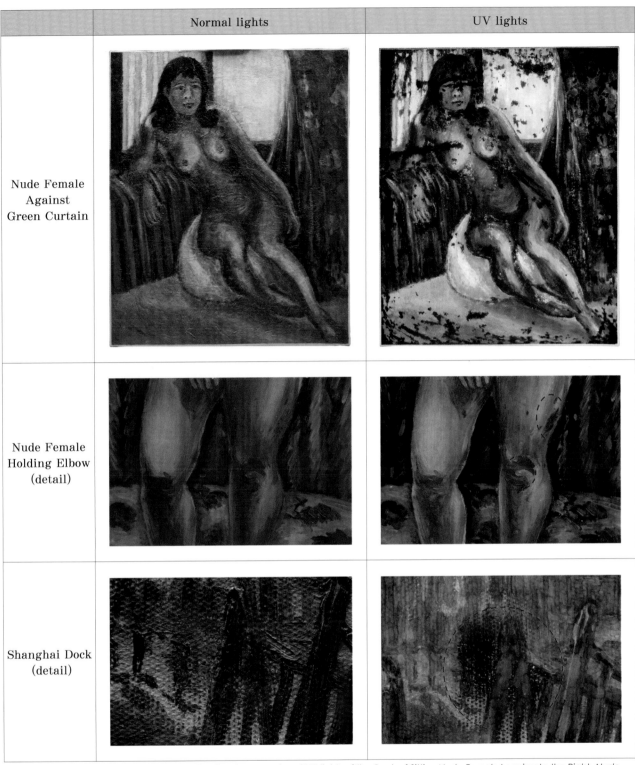

Fig. 1: Comparison of retouchings examined under normal and UV lights of the *Back of Sitting Nude Female* Leaning to the Right, *Nude Female Holding Elbow*, and *Shanghai Dock*

Subsequently, we examined 14 pieces of paper-based artwork using the same method. In *Tamsui Collaboration* (painted by six artists, including Li, M. S., Lin, Y. S., Chen, C. P., Yang, S. L., and Kuo, S. H.), the regions with brown spots resulting from damage were easily identified by the radiation of UV lights (Fig.2.) Furthermore, the UV light and IR examination of the front and backs of the 12 sketches presented interesting findings. In the past, when artists had insufficient storage space or lacked correct concepts for artwork conservation, works were stored by stacking them on top of each other. Thus, blurry images

	Normal lights	UV lights
Front	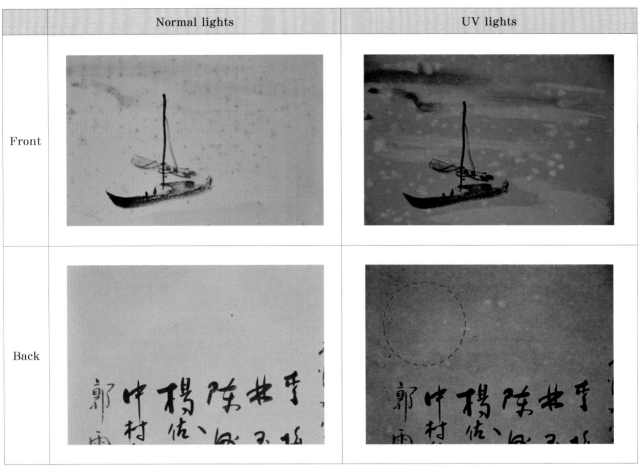	
Back		

Fig. 2: Comparative images of the partial regions of the front and back sides of *Tamsui Collaboration*.

were imprinted on the back of artworks. Based on experience, the imprints were initially deduced as charcoal powder, and a clearer stacked image can be obtained using IR examination. However, the examination results showed that the blurry images were more apparent under UV lights (Fig. 3), and that the outer linings were slightly smudged. Based on these results, the primary composition of the imprints was organic materials that exist in charcoal. These materials volatilized and attached to the back of the artwork stacked on top. Thus, the physically imprinted powders were only a small portion of the organic material. We also discovered that Chen presumably did not perform charcoal fixation when he was working on these sketches.

2. Results of X-radiography examination

Compared to the IR examination, the X-ray examination is based on a perspective method to determine whether additional information is present beneath the surface of an artwork. For example, artists repaint over their creations because they are dissatisfied with the original creation or because of other factors. This phenomenon was observed in the X-ray examination of Chen's oil paintings, which showed up to two additional paintings beneath the surface of the works. Of the 26 pieces of Chen's oil paintings that underwent X-ray examination, five presented underneath paintings. Examples included that shown in Fig. 4, in which the X-ray examined painting, *Tower Scene at West Lake*, distinctively showed the view of a nude woman. Similarly, the X-ray examination of the *Bridge Side* showed beneath pattern significantly different from that of the surface. Although the number of sub-surface artworks

	Normal lights	UV lights	IR lights
Front			
Back			

Fig. 3: Comparative images of the front and back sides of the sketches examined under normal, UV, and IR lights.

cannot be determined because of the complexity of the X-ray perspective, at least two buildings that differed from the surface painting were evident.

3. Results of the pigment examination

Applying a portable XRF spectrometer, this study conducted non-destructive elemental analyses on 327 samples, including 72 canvas and wood board oil paintings and paper-based paintings. The artworks and analytical results are tabulated in Table 2. The following colors of the artworks were examined: skin-tones and black (portraits); green, blue, and brown (scenery); and red, green, and brown (still life paintings). The results of the examination were compared with the distribution graph of the elemental compositions for each color and the pigment compound database of oil paint was established to identify various pigments possibly used by Chen. As shown in Table 3, Chen adopted Chinese white (ZnO) and lead white ($2PbCO_3 \cdot Pb(OH)_2$) as the primary white pigments. The proportion of Chinese white was comparatively higher, and titanium white (TiO_2) was chiefly employed for color mixing. Cadmium yellow (CdS) was chiefly used for the yellow series, and chrome yellow ($PbCrO_4$) and Naples yellow ($Pb_2Sb_2O_7$) were utilized as mixing pigments for the formation of other pigments. The pure red series primarily comprised cinnabar, whereas ochre red was dominantly applied as a mixing color, but was not frequently used with cinnabar. Regarding the blue series, Chen chiefly adopted cobalt

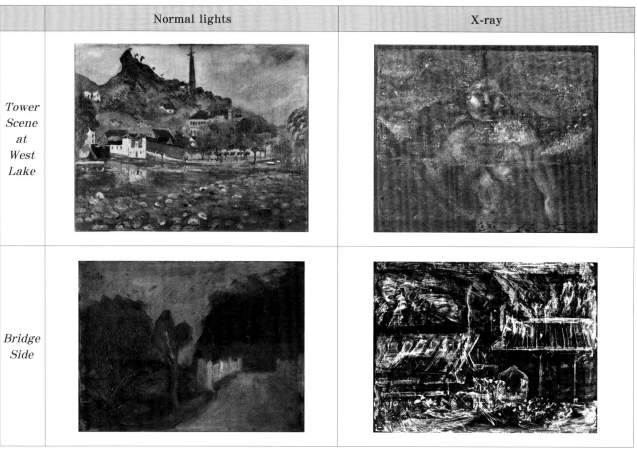

	Normal lights	X-ray
Tower Scene at West Lake		
Bridge Side		

Fig. 4: Comparison of the painting and X-ray perspective examination.

Table 3: Primary pigment possibly used by Chen

Color series	English Names	Primary Chemical Formula/Name
White	Chinese White	ZnO
	Lead White	$2PbCO_3 \cdot Pb(OH)_2$
	Titanium White	TiO_2
Yellow	Chrome Yellow	$PbCrO_4, Al_2(CrO_4)_3$
	Cadmium Yellow	CdS
	Ochre Yellow	$FeO(OH) \cdot xH_2O$
Red	Ochre Red	Fe_2O_3
	Cinnabar	HgS
	Cadmium red	$CdS + CdSe$
Blue	Cobalt Blue	$Co(AlO_2)_2$
	Prussian Blue	$Fe_4[Fe(CN)_6]_3$
	Ultramarine Blue	SiO, Al_2O_3, S, Na_2S
	Sky Blue	$CoSnO_3$
	Azurite	$2CuCO_3 \cdot Cu(OH)_2$
Green	Viridian	Cr_2O_3
	Cobalt Green	Co_2O_3 and ZnO
	Emerald Green	$Cu(CH_3COO)_2 \cdot 3Cu(AsO_2)_2$
	Malachite	$CuCO_3 \cdot Cu(OH)_2$
Brown	Ochre	Fe_2O_3

blue ($Co(AlO_2)_2$) in contrast to the other blue pigments. In the green series, Chen favored bright viridian green (Cr_2O_3) and emerald green ($Cu(CH_3COO)_2 \cdot 3Cu(AsO_2)_2$), and used an olive green series as mixing pigments. Finally, ochre brown (Fe_2O_3) was employed in Chen's work, but a considerable portion was derived from red pigment mixtures.

The results derived from this statistics by X-Ray Fluorescence used as pigments data for understanding of basic data. A total of 101 measuring area of 30 oil paintings, 12 on wood (OW) and 18 on canvas, were collected in

this study. We can divide into OCJ, OCS and OCT from the oil paintings. From our study, we also found that the blue pigment from Chen's paintings were consistency for element analysis. However, There were some points that Ti and Cr in different periods were worth a discussion in this study (Fig. 5-8). We also understand that the concentration of Ti and Cr more than other period in OCJ, but Ti and Cr were not the main element of blue pigment. The possible causes include used mix-pigments in different periods and the scientific detection action as further study by art historian.

Fig. 5: Detection of OCJ by X-Ray Fluorescence

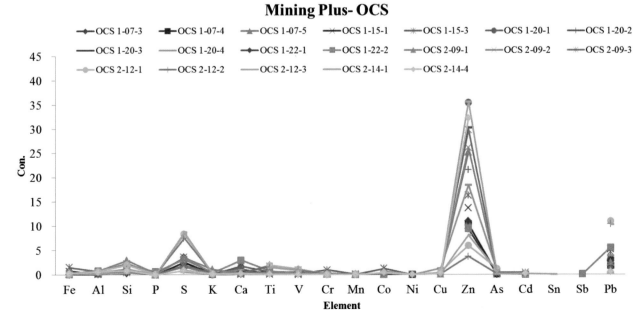

Fig. 6: Detection of OCS by X-Ray Fluorescence

Mining Plus- OCT

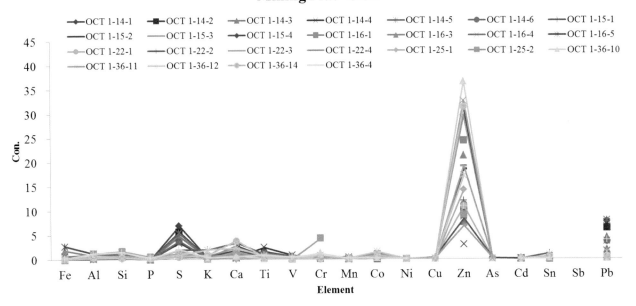

Fig. 7: Detection of OCT by X-Ray Fluorescence

Mining Plus- OW

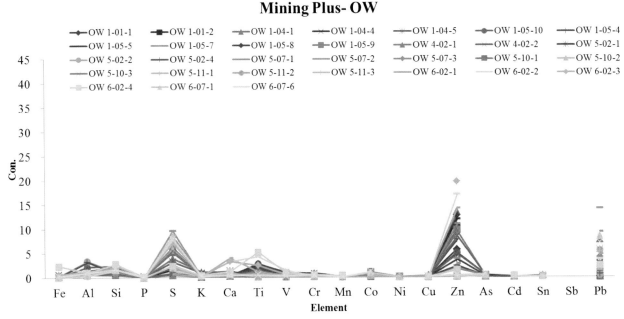

Fig. 8: Detection of OW by X-Ray Fluorescence

IV. Conclusions

In this study, a non-destructive analysis of Chen Cheng-po's paintings presented the overall conditions of his artworks and the possible creation habits he possessed. The UV light examination not only revealed that some of Chen's works have been restored, but elucidated the reasons for the presence of imprints on the backs of his sketches. Based on the results of the IR and X-ray examinations,

we identified Chen's creation habits, specifically, he did not use charcoal or pencils for underdrawings and he repainted over his paintings, possibly because the lack of resources at the time or a dissatisfaction with certain pieces. Based on the pigment elemental analysis, the results were consistent with the pigments purchased by Chen. In addition, we found high correlations among the elements and the proportions of various pigments used in Chen's artworks. In general, a considerable amount of useful information was obtained in this study. We plan to further explore the works of various artists such as Chen Cheng-po using this rapid, non-destructive analytical method to establish a database.

1. This paper had published in *JOURNAL OF THE CHINESE CHEMICAL SOCIETY* (Volume 60, Issue 9, September, 2013). And the article has modified it from the new data.

2. Huang Ping-chih: Department of Cosmetics and Fasion Styling, Cheng Shiu University, Kaohsiung

3. Kuei Chun-hsiung: Department of Chemistry, National Cheng Kung University, Tainan

4. Lahanier Ch., Preusser F. D., Zelst L. Van, "Study and conservation of museum objects: Use of classical analytical techniques", *Nucl. Instrum. Methods Phys. Res. B, 14*, 1-9, 1986. Janssens K., Vittiglio G., Deraedt I., Aerts A., Vekemans B., Vincze L., Wei F., Deryck I., Schalm O., Adams F., Rindby A., Knochel A., Simionovici A., Snigirev A., "Use of Microscopic XRF for Non-destructive Analysis in Art and Archaeometry", *X-Ray Spectrom.*, 29, 73-91, 2000.

5. See References 1-6。

6. See References 1 and 7。

7. See References 8-14。

[References]

1. F. D. P. a. L. V. Z. Ch. Lahanier, *Nuclear Instruments and Methods in Physics Research Section B: Beam Interactions with Materials and Atoms*, 1986, 14, 1-9.

2. G. V. K. Janssens, I. Deraedt, A. Aerts, B. Vekemans, L. Vincze, F. Wei, I. Deryck, O. Schalm, F. Adams, A. Rindby, A. Knochel, A. Simionovici and A. Snigirev, *X-Ray Spectrometry*, 2000, 29, 73-91.

3. S. Daniilia, D. Bikiaris, L. Burgio, P. Gavala, R. J. H. Clark, Y. Chryssoulakis, *Journal of Raman Spectroscopy*, 2002, 33, 807-814 10.1002/jrs.907.

4. M. S. Grant, in *Book The Use Of Ultraviolet Induced Visible-Fluorescence In The Examination Of Museum Objects, Part II*, ed., ed. by Editor, National Park Service, City, 2000, Chap. Chapter.

5. M. S. Grant, in *Book The Use Of Ultraviolet Induced Visible-Fluorescence In The Examination Of Museum Objects, Part I*, ed., ed. by Editor, National Park Service, City, 2000, Chap. Chapter.

6. C. B. Tragni, in *Book The use of ultraviolet-induced visible fluorescence for examination of photographs*, ed., ed. by Editor, *International museum of photography* and film & image permanence institute, City, 2005, Chap. Chapter.

7. A. Mounier, C. Belin, F. Daniel, *Environmental Science and Pollution Research*, 2011, 18, 772-782 10.1007/s11356-010-0429-5.

8. M. Thoury, J. P. Echard, M. Refregiers, B. Berrie, A. Nevin, F. Jamme, L. Bertrand, *Analytical Chemistry*, 2011, 83, 1737-1745 10.1021/ac102986h.

9. D. Naegele, *Ra-Revista De Arquitectura*, 2009, 15-+.

10. N. M. Ahmed, M. M. Selim, *Pigment & Resin Technology*, 2011, 40, 4-16 10.1108/03699421111095883.

11. S. Akyuz, T. Akyuz, G. Emre, A. Gulec, S. Basaran, *Spectrochimica Acta Part a-Molecular and Biomolecular Spectroscopy*, 2012, 89, 74-81 10.1016/j.saa.2011.12.046.

12. O. Chiantore, R. Ploeger, T. Poli, B. Ferriani, *Studies in Conservation*, 2012, 57, 92-105 10.1179/2047058411y.0000000003.

13. T. Li, Y. F. Xie, Y. M. Yang, C. S. Wang, X. Y. Fang, J. L. Shi, Q. J. He, *Journal of Raman Spectroscopy*, 2009, 40, 1911-1918 10.1002/jrs.2340.

14. I. Nakai, Y. Abe, *Applied Physics a-Materials Science & Processing*, 2012, 106, 279-293 10.1007/s00339-011-6694-4.

15. F. M. V. Pereira, M. Bueno, *Chemometrics and Intelligent Laboratory Systems*, 2008, 92, 131-137 10.1016/j.chemolab.2009.02.003.

16. S. Y. Wei, Q. L. Ma, M. Schreiner, *Journal of Archaeological Science*, 2012, 39, 1628-1633 10.1016/j.jas.2012.01.011.

17. Chen, *Chen Cheng-po Centennial Memorial Exhibition*, Editor: Cultural Affairs Bureau of Chaiyi City, Chaiyi City, Taiwan, 1995.

18. L. Z. G, in *Book Lying in a Pool of Blood: The Peacemaker*, ed., ed. by Editor, Wu San-Lin Foundation for Taiwan Historial Materials, City, 1994, Vol. 3, Chap. Chapter.

澄現——X射線下的陳澄波

尤西博、李益成

摘要

　　X射線檢視技術在修復領域中被廣泛使用，主要用來檢視畫家的創作技巧與習慣。本文將深入探討臺灣畫家—陳澄波先生的創作技巧，與他畫作下隱藏的故事。本研究分析了74幅油畫作品，透過X射線檢視，發現其中的25幅作品表面另有底層存在，且底層的畫多為陳澄波先生在日本留學時，課堂習作所畫的裸女。因著三成多的作品藏有另幅畫作，陳澄波先生變成臺灣最標新立異的畫家之一。本文亦將探究是為了什麼原因，陳澄波先生會決定修改畫作呢？可能是出於經濟上的考量抑或是對原來的畫作不滿意？另外，為什麼被修改的畫作大多是在工作室內創作的作品而非在戶外創作的呢？

一、前言

　　雖然X射線早在19世紀80年代被一位德國物理學家發現，卻直至20世紀30年代才將其應用在畫作檢視上。自此，X射線檢視法便成為藝術科學研究的重要工具之一。無論是修復師、科學家或歷史學者，皆利用此法來鑑定畫作與查找藝術家於創作過程中的軌跡。當X射線照射在畫布上時，我們能清楚的看見包括作品底層、微小的顏料缺失、畫作的媒材組合、藝術家的原稿及修改痕跡，但最重要的還是想探測畫作底下是否另有創作存在。

　　「澄現——X射線下的陳澄波」已不僅於研究藝術家的創作技巧，且更深入的探究其創作過程與習慣。本研究檢視了74件陳澄波先生的作品，且發現其中25件曾經被部分或完全的修改過，高達三成的作品藏有底層。在此特別感謝財團法人陳澄波文化藝術基金會與正修科技大學文物修護中心的合作，使本研究得以用展覽的方式呈現給大眾。

　　陳澄波先生是臺灣油畫家先驅之一，他的作品大致上依居住地而分為三個時期，分別為日本、上海及臺灣，但無論是哪個時期的作品皆被發現有畫中畫存在。然而，藝術家決定部分或完全修改畫作另有其因。陳澄波先生一生中持續的將本應為裸女圖與風景圖的畫作進行修改；此外，有些作品的底下也發現藏有底稿與素描搞。

二、裸女系列

　　陳澄波先生的創作生涯中，「裸女」始終為創作主題之一，並於1925年在東京求學時創作了第一個裸

女作品。學生時期的他為了完成學校的作業與研究，以油彩完成了許多裸女圖。在他的三大創作時期的作品中皆不乏裸女圖的出現，而且，我們能夠在各個時期的作品下發現隱藏圖層的存在；這代表著他時常修改畫作，決定重新使用畫布的原因也不盡相同。

我們將裸女圖分為兩類，分別為日本時期與其他求學時期；日本時期的裸女圖大多是為了學校作業而練習創作，此時期的畫布皆被重新使用至少兩次以上。以〔背向坐姿裸女〕這幅作品來說，經X射線檢視後發現該作品共有三個圖層，第三個圖層為坐姿背面裸女，第二個圖層為一名女子左手插腰半身像，第一個圖層為一名男子肖像，且第一與第二個圖層是將畫布垂直創作，而第三個圖層則是以水平方向創作；再以1926年時創作的〔側身坐姿裸女〕（圖1-2）舉例，透過X射線顯示出該作品共有兩個圖層，而兩個圖層非常相似，甚至連女性模特兒的的臉部、身形輪廓也極為相像，且兩個圖層的背景都沒有加以點綴；由此可推測兩個圖層的創作時間非常相近，很可能是為了同一堂課而創作的。

在上海與臺灣期間，陳澄波先生持續不斷地創作裸女圖，其中亦有許多作品被發現藏著底層。在X射線的照射下，我們更能瞭解藝術家決定重複使用畫布的原因，且在很多時候，最初的圖層會左右藝術家最後決定呈現在世人眼前的圖像。以〔側臥閱讀裸女〕舉例，我們發現畫中的棕色抱枕是為了覆蓋第一個圖層裡的身體及臉部，而值得一提的是，該作品的第一個圖層則是另一幅作品〔臥躺裸女〕（參見本卷122頁）的構圖，在這種情況下，我們無從得知該二圖層是否為同一系列之創作。

陳澄波先生重複使用畫布創作的原因也有時期的分別；在東京時期，我們可以歸因於經濟與教育的問題，做為一位在大城市裡求學且沒有太多預算的學生，重複使用畫布可以替他省下一筆可觀的金額；而在臺灣期間，其中一個原因則變成了取得畫布的難易度，因當時的臺灣屬日本殖民地，藝術材料大多仰賴日本或一線城市中的指定美術社進口，但進口作業相當耗時，導致創作靈感湧現時手邊沒有全新的畫布，才會使用既有畫布將靈感記

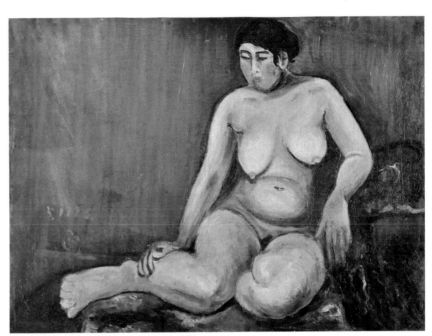

圖1.陳澄波　側身坐姿裸女　1926　畫布油彩

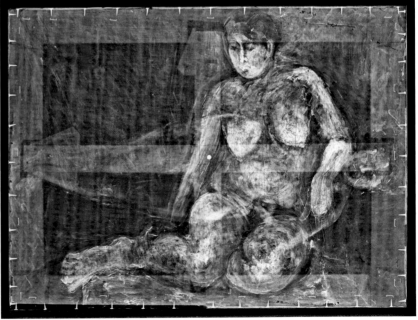

圖2.〔側身坐姿裸女〕X光檢視圖。

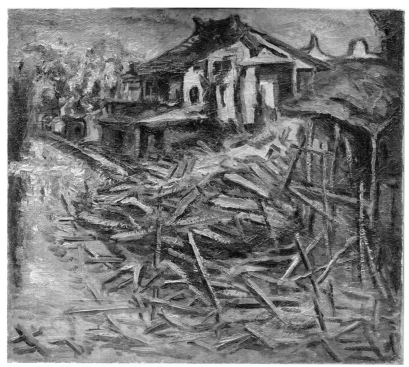

圖3.陳澄波　貯木場　年代不詳　畫布油彩

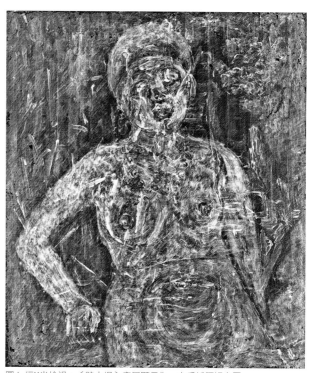

圖4. 經X光檢視，〔貯木場〕底層顯示為一右手插腰裸女圖。

錄下來。

三、風景系列

　　除了裸女系列外，風景描寫亦是陳澄波先生創作的另一大主題。學生時期的他時常繪畫自然景色與郊外風景；不僅如此，我們也發現許多他創作的風景圖底下有著裸女圖的存在，其中〔貯木場〕（圖3-4）是最廣為人知的作品之一；另外還有一幅作品〔西湖塔景〕也發現藏著裸女底層。值得一提的是，該二幅畫作底下所描繪的裸女圖，無論是姿勢還是髮型皆極為相似，但並無法因此而評斷該二裸女是否為同一人或同一系列之創作。

　　陳澄波先生經常以風景圖覆蓋於裸女圖上，其中最主要的原因可能是畫布取得不易。裸女圖通常會在室內被創作，而風景圖則是在戶外寫生時所產生；如前文提及，該時期的美術材料大多仰賴日本進口，但進口作業耗時，導致有時藝術家有靈感想至戶外寫生時，無奈手邊沒有新畫布，只好帶著已畫有裸女圖的舊畫布到戶外，再將風景畫於之上。也因為如此，陳澄波先生的作品中沒有風景圖被裸女圖覆蓋的例子。

　　另一幅極具代表性的畫作〔嘉義公園一景〕（圖5），創作於1934年，透過X光亦檢視出底層藏有雙裸女圖，是陳澄波先生的創作中少數罕見同時出現兩位裸女的作品之一（圖6）。然而，是為了什麼才決定將獨特的雙裸女圖以風景畫覆蓋住呢？也許是不滿意該作品，抑或是歸咎於畫布的取得不易。另外，該雙裸女圖曾經被構圖在一片乾淨的小木板上，與畫布上的圖進行比對後，我們發現女模特兒們、椅子與窗簾都在同樣的位置，卻少了窗戶（圖7）。

　　由於至戶外寫生需要帶著畫布四處走，加上當時交通較不便，所以陳澄波先生通常會選擇攜帶尺寸較小的舊畫布，也因此，大部分藏有底層的風景畫都是尺寸較小的作品。話雖如此，繪於1940年的〔夏之朝〕卻打破常規，此幅作品尺寸偏大且底下隱藏了另一個有趣的景觀；底層顯示出陳澄波先生於1939年描

圖5.陳澄波　嘉義公園一景　1934　畫布油彩

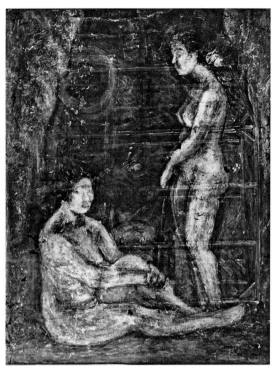

圖6.〔嘉義公園一景〕經X光檢視後，底層為雙裸女圖。

繪的龜山島風景（位於臺灣東北方），該幅作品也是我們研究中唯一一張藏有底層的大尺寸作品。由陳澄波先生當時素描本來看，可以證明其創作程序。〔夏之朝〕底層裡所繪的龜山島輪廓、山與船隻皆和素描本上的手稿相同，因此可推測，陳澄波先生可能是在他的工作室裡，依著當時在戶外的手稿來完成，而非直接在戶外寫生。

四、人像系列

除了裸女系列與風景系列，人像也是陳澄波先生偶爾描繪的主題之一。以下所舉的例子皆為臺灣時期的作品，且都被覆蓋在風景圖或是另一個人像圖的下方。陳澄波先生於西元1935年創作的〔遠眺玉山（二）〕下方藏著一名女子的人像圖，此幅作品是我們研究中第一幅以橫向表現出女人像的作品，該女子以側臉示人，身著洋裝，且她在右肩上用了一個圓形的飾品以襯托服裝。

圖7.雙裸女圖手稿。

此外，也發現另一個非常有趣的案例：〔小弟弟〕（圖8）這幅作品繪於西元1931年，畫的正是陳澄波先生的兒子，透過X射線檢視後，發現畫作下方是一位身著丁字褲的持刀男子像（圖9）。雖然目前尚未證實畫中男子來自哪裡，但他在那段期間的確畫了許多穿丁字褲男子的速寫（圖10）。然而，現存的油畫作品中卻沒有任何一幅與著丁字褲男子相關。至於陳澄波先生為什麼決定以兒子的肖像覆蓋在男子像上呢？原因也許就如同前文所提及，對原畫作不滿意或是畫布取得的難易度使然。

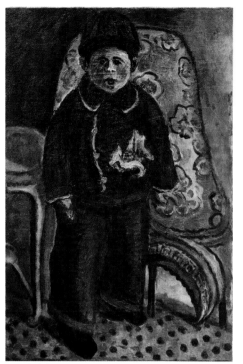
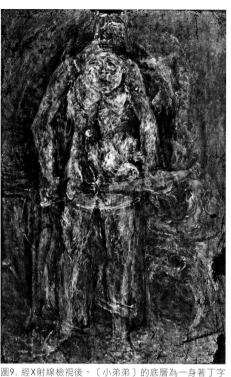

圖8.陳澄波 小弟弟 1931 畫布油彩

圖9. 經X射線檢視後，〔小弟弟〕的底層為一身著丁字褲的持刀男子像。

圖10. 1930年4月2日繪製的手稿。

五、修飾痕（筆畫再現）

　　「修飾痕」一詞，指的是畫作上用顏料覆蓋的地方，重新顯露出底下原本的部分，表示出藝術家在創作時改變心意的過程。修飾痕的發現，讓我們可以看見藝術家最原始的構圖，而不再只是單單欣賞最終的成品。陳澄波先生有部分作品也被發現有修飾痕，但僅限於風景系列；其中一個例子為臺灣時期的作品—〔廟頂遠眺〕，在該幅圖的第一層圖層上可以看見左邊天空畫有一棟中國式的建築物，但在第二層圖層時則被天空所覆蓋，由此可見，陳澄波先生當時改變了該作品的構圖。此外，也可推測出第二層圖層是於室內完成的，因藝術家習慣在戶外寫生，必須先等第一層的顏料乾燥後才可進行修改。

　　陳澄波先生於西元1924年所創作的〔北回歸線地標〕經過X光檢視後，亦發現原圖和底層構圖的差異（圖11-12），而依據該作品的創作年代可推測出陳澄波先生開始有了改變原創作的習慣，並一直持續到最後。

六、結語

　　本研究藉由探究X射線下的陳澄波畫作，使我們更深入了解藝術家本人。自學生時代開始，陳澄波先生就有著改變、創新原有構圖與重複使用畫布的習慣，並始終持續著；然而，造成此習慣的主因則依生平中的三個居住地而有所不同。東京時期係因經濟拮据，上海與臺灣時期則是因為美觀與畫布取得不易。

　　陳澄波先生生前喜愛至戶外寫生，且習慣帶著畫布與繪畫材料四處找尋景色，卻無奈因材料進口作業耗時導致手邊沒有新畫布，加上交通不便，只好帶著尺寸較小且已畫有裸女圖的舊畫布到戶外，再將風景畫於之上；因此，也一解了「為什麼被改變的畫作通常都是原本在室內創作的作品呢？」之疑惑。

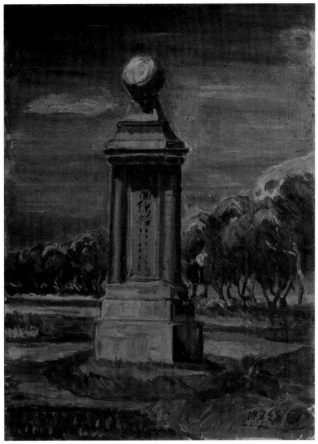 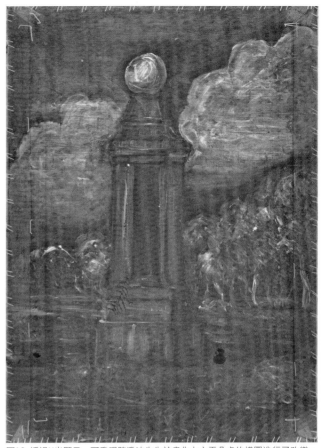

圖11. 陳澄波　北回歸線地標　1924　畫布油彩　　　　　　　　　　圖12. 透過X光顯示，可發現陳澄波先生於畫作上方雲朵處的構圖進行了改變。

【註釋】

1. 本文曾於2015年11月25日正修科技大學主辦之「第四屆亞太地區熱帶氣候藝術保存研究組織（APTCCARN）年會——面對熱帶地區文物材保存的挑戰」中發表。

【參考文獻】

1. Ioseba I. Soraluze〈論陳澄波作品—修復過去・建構未來〉《再現澄波萬里：陳澄波作品保存修復特展》頁51-60，2012，高雄：正修科技大學藝文處。

2. 吉田千鶴子〈陳澄波與東京美術學校的教育〉《檔案・顯像・新「視」界-陳澄波文物資料特展暨學術論壇論文集》頁13-19，2011，嘉義：嘉義市政府文化局。

3. 李淑珠〈陳澄波（1895~1947）の編年について一三つの履　書を中心に〉《京都美學美術史學》頁135-166，2002。

4. 林育淳《油彩・熱情・陳澄波》1998，臺北：雄獅圖書股份有限公司。

5. 林育淳〈陳澄波生命之旅讀現實地與桃花源圖像〉《行過江南——陳澄波藝術探索歷程》頁6-15，2012，臺北：臺北市立美術館。

6. 邱函妮〈陳澄波「上海時期」之再檢討〉《行過江南——陳澄波藝術探索歷程》頁32-49，2012，臺北：臺北市立美術館。

7. 吳漢鐘、李益成、陳怡萱、黃婉真〈畫中有化——陳澄波作品的化學密碼〉《再現澄波萬里：陳澄波作品保存修復特展》頁61-73，2012，高雄：正修科技大學藝文處。

8. 吳漢鐘、Ioseba I. Soraluze、李益成〈Using non-destructive analysis techniques to examine the artworks of Taiwanese artist Cheng-Po Chen（1895-1947）〉《Journal of the Chinese Chemical Society》第60期，2013.9，頁1127-1134，臺北：中國化學學會。

9. 陳重光〈陳澄波生平年表〉《學院中的素人畫家—陳澄波》頁86-95，1979，臺北：雄獅圖書股份有限公司。

10. 黃冬富〈陳澄波畫風中的華夏美學意識——上海任教時期的發展契機〉《檔案・顯像・新「視」界——陳澄波文物資料特展暨學術論壇論文集》，頁27-44，2011，嘉義：嘉義市政府文化局。

11. 顏娟英〈勇者的畫像——陳澄波〉《臺灣美術全集（一）：陳澄波》頁27-48，1992，臺北：藝術家出版社。

12. 傅瑋思〈認同、混雜、現代性：陳澄波日據時期的繪畫〉《行過江南——陳澄波藝術探索歷程》頁50-63，2012，臺北：臺北市立美術館。

13. 劉長富〈探索畫家陳澄波的「用筆」與「設色」〉《再現澄波萬里：陳澄波作品保存修復特展》頁21-28，2012，高雄：正修科技大學藝文處。

Looking through X-Rays:
The Unknown Chen Cheng-po[1]

Dr. Ioseba I. Soraluze, Li I-cheng

Abstract

X-ray photography has stated as an essential tool for the understanding of the artist's technique as well as creation habits. This paper will contribute with the analysis of the way of work of Cheng Chen-po and go deeper in knowledge of his artworks. This research has studied 74 oil paintings, and 25 of them have revealed underneath layers. Having 34% of the artworks with underneath paintings, Chen Chen-po becomes one of the most nonconformist painters of Taiwan. This study will also focus on the reasons that why the artist decided to modify partially or completely the paintings, being the nude female the topic most changed while landscapes are almost unaltered. Economic, aesthetic and unpleasant results are the main reasons why the paintings were changed during his Japan, Shanghai and Taiwan periods. Furthermore, the reasons why the canvases that were painted in the studio were more modified rather than the ones painted outdoors will also discuss.

I. Introduction

Although X-rays were discovered in the 1880s by a German physicist it was not until the 1930s that they were used for the examination of paintings and since then X-ray technology has become an important tool for scientific research and the study of paintings. Art conservators, scientists and historians utilize X-rays to obtain information that helps them to authenticate paintings and find new clues about the artworks' creative process. X-rays applied to easel paintings show the details of the canvas, such as if there is a hidden lining, paint loss that is not visible, painting's material composition, pentimenti or modifications, but most importantly if there is underlying painting.

Looking through X-rays: the unknown Chen Cheng-po has been an art project to extend and develop the studies of the artist's way of work as well as deepen into his creative process and habits. The research project has led to organize an exhibition showcasing the results obtained and it has been carried out with thanks to the collaboration between the Chen Cheng-po Cultural Foundation and Cheng Shiu Conservation Center. They have been studied 74 paintings by Chen which 25 of them have modifications or completely new paintings. 34% of the cases researched have underneath layers.

Cheng Cheng-po was one of the first generation of Taiwanese artist that started using oil based colors and his artworks are divided into three artistic periods depending where he lived; Japan, Shanghai and Taiwan. In all of these periods underneath paintings have been found and there is no one period that dominates another. However, there are different reasons why the artist decided to modify the paintings either partially or completely. The main subjects to alter or change were nudes and landscapes and it was a constant in his life. Furthermore, some of the paintings that have been found underneath also exist as drawings and sketches.

II. Nudes

The female nude has been a repeated theme in all Chen Cheng-po's career. He started painting nudes when he was a student at the Tokyo School of Fine Arts in 1925. During this period many nudes were painted with oil-colours and were done as a student; they were works and studies made for the school. In the three artistic periods of his life he continued painting nudes and we are able to see underneath nude paintings from all the periods. He used to modify them very often, so the reasons for deciding to re-use the canvases also vary.

In this way, the nudes could be divided into two categories: the school works of Japan period and the others. The Japan period nude paintings was a resource for learning in the school of art and the canvases were re-painted twice or more by the artist. This is the case of *Back of Sitting Nude Female* that have appeared another female nude and a male portrait as underneath paintings. The first two times the canvas was painted vertically, while the third time was painted horizontally. Other cases of nudes painted as student are *Back of Sitting Nude Female* and *Nude Female in Sideway Sitting Posture* (Fig. 1-2) of 1926. The final and underneath paintings are very similar and even show the same chubby female model, rounded shapes and identical painted faces. The backgrounds of both paintings are equally empty and it could be said the time frame of them being painted is very narrow. They were probably created for the same class of the school.

The tendency Chen Cheng-po had for re-using canvases in his Tokyo period could be considered due to economic and educational reasons. The budget the artist had as student in Tokyo was tight and re-using canvases would have been a way of saving money.

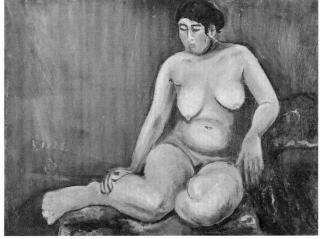

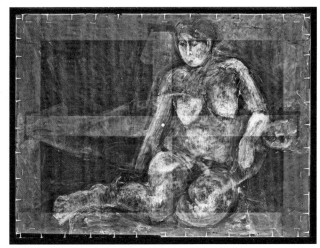

Fig. 1: Chen Cheng-po, *Nude Female in Sideway Sitting Posture*, 1926, oil on canvas.

Fig. 2: X-rays of *Nude Female in Sideway Sitting Posture*.

During the Shanghainese and Taiwanese periods he kept painting nudes and several other nudes were discovered as underneath layers. The X-rays show us how the artist when he decided to reuse a canvas again, sometimes the second representation was determined by the first one. This is the case of *Reclining Nude Reading Book* that was created on another lying down nude. The brown cushion was done to cover the body and face of the underneath painting. However, this underneath can be found as an identical foreshortening nude looking at us with her arms behind the head in *Nude in Lying Posture*. In this case, we are not able to know if both paintings belonged to the same model or series.

One of the main reasons that Chen Cheng-po re-used canvases was the availability of them. Taiwan being a Japanese colony, the artist needed to import art-supplies from the metropolis, and there are proforma invoices that show the materials he ordered. Probably the desire to paint a new work but not having a canvas available and the time consuming effort of getting them, was one of main factors to often re-use canvases.

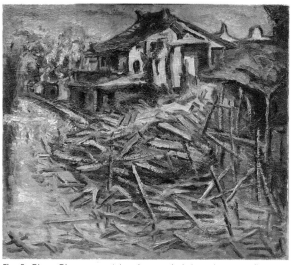
Fig. 3: Chen Cheng-po, *A Lumberyard*, date unknown, oil on canvas.

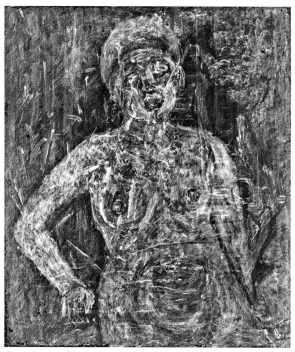
Fig. 4: X-rays of *A Lumberyard* showing a female nude with the arm on her waist.

III. Landscapes

One of the main subjects of Chen was the landscape and since student he usually painted nature and urban sceneries. In that way, many of X-rays have revealed other paintings underneath of nudes and landscapes from all of his periods. An example of this is *A Lumberyard* (Fig. 3-4) that presents a female nude underneath. Furthermore, another Shanghai period painting *Tower Scene at West Lake* also shows an underlying female nude with the same position and short hair but we could not assess if it is the same model, or whether they were painted as a series or a study.

Chen Cheng-po changed many times nude paintings and he used to re-paint them with landscapes. The reason of changing the nude most often is probably because the canvases were painted indoors. As the artist had the habit of painting landscapes outdoors, the effort of transporting all the materials to the county side for example, was too great, so he would decide to cover a nude that was painted indoors. Moreover, as of yet, no female nude covering a landscape has been found.

The X-rays of *A Scene at Chiayi park* (Fig. 5) of 1934 has been a revelation. It is the only known composition that Chen painted with two female nudes, whilst all other existing paintings are composed with only one female nude. (Fig. 6) Why the artist decided to repaint this uncommon representation could

only be explained from the point of view that he wasn't pleased and due to the lack of available canvases. However, the Two female nudes has its own sketch drawn in another small wood panel that was never painted. The underneath painting as the sketch has the curtains and the chair, but not the windows. (Fig. 7)

Almost all the landscape canvases that have underneath paintings are small size works. Due to the artist painting outdoors and the need to bring the canvases to everywhere, he would decide to cover the small ones rather than big ones. This decision could be based upon transportation convenience because the big canvases that have being studied don't have underneath paintings. Nonetheless, there is an exception with *Summer Morning* that was painted in 1940 in Chiayi County. This big canvas hides another interesting landscape and it has been the only big painting we have found with underneath layers. The first time the canvas was painted in 1939 on Guishan Island or Turtle Island, situated in the north-eastern cost of Taiwan. The sketch book testifies its procedure. Chen Cheng-po drew and painted the characteristic mountain of Turtle Island with several boats as the same way he took the notes. Probably the canvas was painted in his studio rather than outdoors because the painting was originated from the sketch book.

IV. Portraits

Another common subject that Chen Cheng-po used to paint is portraits but not as often as nudes and landscapes. The underneath portraits that have been found belong to the Taiwan period and they were covered to paint new landscapes or portraits. The *Overlooking Mt. Jade (2)* of 1935 covers a female portrait. The canvas was first painted in horizontal representing a woman that doesn't look at the viewers. But in this case, the woman is wearing a dress and some details of the dress's decoration may be seen. In the right shoulder she even presents a rounded accessory that compliments the dress.

A very interesting case has been found with X-rays in *Little Boy*.(Fig. 8) This portrait displays the son of the artist

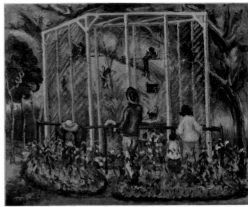

Fig. 5: Chen Cheng-po, *A Scene at Chiayi Park*, 1934, oil on canvas.

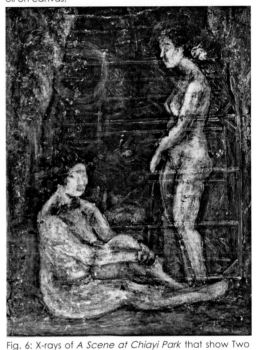

Fig. 6: X-rays of *A Scene at Chiayi Park* that show Two female nudes.

Fig. 7: Sketch on wood of Two female nudes.

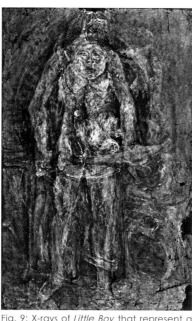

Fig. 8: Chen Cheng-po, *Little Boy*, 1931, oil on canvas.

Fig. 9: X-rays of *Little Boy* that represent a male holding a knife and wearing thong (underwear).

Fig. 10: Sketch of 1930 April 2.

and it was painted in 1931. The studies have revealed another male portrait underneath that is holding a knife and he is wearing thong (underwear)(Fig. 9). Although it is still unverified where the male is from, but there are many sketches of these males from that time(Fig. 10). However, there isn't any oil-painting known with this subject. The reasons the artist decided to cover the warrior would be the same as other times, i.e., the artist was not pleased with the result and the lack of canvas availability.

V. Pentimenti

Pentimenti is a change in a painting showing that the artist has modified his mind as to the composition during the process of painting. The pentimenti exposes that a composition originally had a component or a detail but it is no longer in the final painting. Some works of Chen Chen-po present pentimenti but especially in the landscapes. This is the case of *Distant View from Temple Top* that belongs to the Taiwanese period where it can be seen through the X-rays how some Chinese architectures have disappeared. As Chen used to paint his landscapes outdoors, the pentimenti, however, had probably been made indoors because the first oil paint layers needed to be dried first.

Tropic of Cancer Landmark of 1924 is the oldest painting of the artist. Since the beginning Chen Cheng-po started to modify his works that didn't please him as can be noticed with the sky and clouds. (Fig. 11-12) The feature of changing his creations was a constant in all his life either partially or completely. The changes were also probably done in the artist's studio.

VI. Conclusions

The research of X-rays that have been done to the paintings of Chen Cheng-po highlights some conclusions. Since the artist was a student decided to change, modify and create new works reusing canvases. He continued this habit during all three of his artistic periods. However, the reasons why

the artist covered his paintings vary depending on the period he lived. Thus, economical reasons would be the motivation of reusing canvases in Japan as a way of saving money, while new canvas availability and aesthetic desires would be the major reasons of deciding to repaint his works in the Shanghai and Taiwan periods.

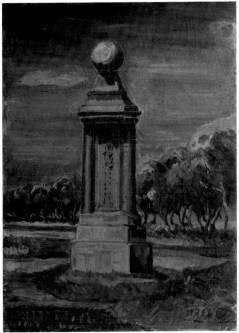

Fig. 11: Chen Cheng-po, *Tropic Cancer Landmark*, 1924, oil on canvas.

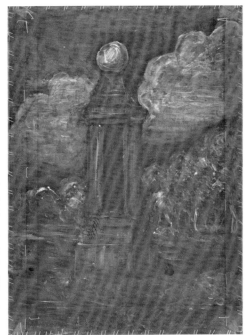

Fig. 12: X-rays of *Tropic Cancer Landmark* that show how the artist changed his mind with the sky.

Chen Cheng-po liked to paint outdoors and he used to bring the canvases and materials everywhere. With this effort and discomfort he probably didn't wish reusing these canvases and it would explain why the painting works done indoors are the most changed.

1. This paper was presented at 4th meeting of APTCCARN (Asia Pacific Tropical Climate Conservation Art Research Network), Embracing cultural materials conservation in the tropics, Cheng Shiu University, 2015.

[References]

1. Burke Mathison Christina S.W., 2012, "Identity, hybridity, and modernity: The colonial paintings of Chen Cheng-po", *Journey through Jiangnan – A pivotal moment in Chen Cheng-po's artistic quest*, Taipei Museum of Fine Arts, Taipei, p.50-63.
2. Chen Tsung-kuang, 1979, "Chronology of Chen Cheng-po", *Chen Cheng-po – A naïve painter from the Academy*, Taiwan Artists, Vol.2, Hsiung Shih Art Books, Taipei, p.86-95.
3. Chiu Han-ni, 2012, "Reappraising Chen Cheng-po's Shanghai Period", *Journey through Jiangnan – A pivotal moment in Chen Cheng-po's artistic quest*, Taipei Museum of Fine Arts, Taipei, p.32-49.
4. Chizuko Yoshida, 2011, "Chen Cheng-po and the education at the Tokyo School of Fine Arts", *Archive. Visualitation. New Vision*, Special Exhibition and Seminar on Chen Cheng-po, Cultural Affairs Bureau, Chiayi, p.13-19.
5. Huang Tung-fu, 2011, "Chinese aesthetics in Chen Cheng-po's painting style. Turning point of development while teaching in Shanghai", *Archive. Visualitation. New Vision*, Special Exhibition and Seminar on Chen Cheng-po, Cultural Affairs Bureau, Chiayi, p.27-44.
6. Li Su-chu, 2002, "On the chronology of Chen Cheng-po (1895-1947) based on three curriculum vitae", *Kyoto Studies in Aesthetics and Art History*, p.135-166.
7. Lin Yu-chun, 1998, *Oil paint – Passion – Chen Cheng-po*, Hsiung Shih Art Books, Taipei.
8. Lin Yu-chun, 2012, "The real scenes and images Utopia in Chen Cheng-po's journey of life", *Journey through Jiangnan. A pivotal moment in Chen Cheng-po's artistic quest*, Taipei Museum of Fine Arts, Taipei, p.06-15.
9. Liu Chang-fu, 2012, "Explore the painter Chen Cheng-po 'brush strokes' and 'colour application' ", *Exhibition of conservation and restoration of Chen Cheng-po's work*, Cheng Shiu Art Center, Kaohsiung, p.21-28.
10. Soraluze Ioseba I., 2012, "Chen Cheng-po: Restaurando pasado, construyendo futuro", *Exhibition of conservation and restoration of Chen Cheng-po's work*, Cheng Shiu Art Center, Kaohsiung, p.51-60.
11. Wu Han-chung, Li I-cheng; Chen I-shuan; Huang Wan-jin, 2012, "The chemistry codes of Chen Cheng-po's paintings", *Exhibition of conservation and restoration of Chen Cheng-po's work*, Cheng Shiu Art Center, Kaohsiung, p.61-73.
12. Wu Han-chung, Soraluze Ioseba I., Li I-cheng, 2013, Using non-destructive analysis techniques to examine the artworks of Taiwanese artist Cheng-po Chen (1895-1947), *Journal of the Chinese Chemical Society*, vol. 60, Issue 9, 1127-1134.
13. Yen Chuan-ying, 1992, Portrait of a brave man: Chen Cheng-po, *Taiwan Fine Arts Series*, vol.1, Artist publishing Co., p.27-48.

陳澄波畫作的再修復與保存領域之探討[1]

尤西博、李益成

摘要

　　本文將藉由陳澄波先生曾被不當修復的一批畫作來探討複雜的修復程序及不正確的修復行為將如何造成藝術品的物理結構與美學改變；那些不適當的修復手法，不僅破壞了該批畫作的結構，也改變了其美觀程度。為了將不當修復的地方再次進行修復，因而著手進行此研究，透過許多化學檢測，如X射線螢光光譜分析（XRF）、掃描式電子顯微鏡X光能量散佈分析（SEM-EDX）、傅立葉紅外線光譜分析（FTIR）及其他跨領域的檢測作業，建立完整的畫作基本資料。

　　另外，我們發展出使用真空加熱桌且不使用任何化學溶劑就可移除蠟托裱的新方法；以該方法進行修復時，被移除的蠟都以公克為單位。也藉此進而進行比色研究，了解熱處理將會如何影響畫作色彩。

　　第一次修復中的補筆與使用凡尼斯的方法，完全改變了陳澄波先生作品的美觀程度，原作上有一大部分面積被不當補筆，且破壞了畫作的品質。因此，二度修復時必須移除不當補筆的部分，再重新以正確且不影響原作為前提的方法填補畫作缺損，同時也須研究原作所使用的顏料以及藝術家的創作想法。

　　本研究揭露出不當修復手法對於畫作的嚴重性，並呼籲修復前先瞭解藝術家的創作理念及修復倫理，將可使藝術品擁有更好的保存環境。

一、前言

　　「修復」是一項相當複雜的工作，必須以遵守修復倫理為前提進行，以防任何藝術品的品質降低；進行再微小的介入之前皆須深思熟慮，否則將會嚴重危及藝術品的穩定性與外觀。

　　義大利學者Cesare Chirici曾說：「以不認同藝術家創作理念的觀念下進行修復，皆不能被稱作修復。」（原文：An intervention that does not recognize the artistic values of an artwork, it should not be considered a restoration".）。[2]藝術家的創作理念如美學觀、歷史觀、創作目的、真實性及意義等觀念，皆是修復師在面對亟待修復的藝術品時所要瞭解的重點；深入理解這些觀念與否，將是決定修復是否成功的關鍵。

　　陳澄波先生的作品中有九件曾被不當修復，該批畫作的物理結構完全被破壞殆盡，而結構的改變不僅影響了畫作的健康狀況，也影響了顏料的色彩，使畫作外觀不如以往般美麗；瞭解了上述的情形後，陳澄波文化基金會決定著手進行二度修復的研究。

該批畫作的蠟托裱形式極為粗糙，在畫作的正反兩面都可明顯看見使用過量的蠟，畫框非常脆弱且畫布已失去原有的彈性，許多不當的填補影響畫作品質，甚至直接在原作上進行補筆並覆蓋了作者的原跡；另外也在畫作的表面上了一層厚厚的凡尼斯，導致陳澄波先生當初所創作出的美麗畫作已不如往常。

二、蠟托裱

「蠟托裱」係由一位名為尼可拉斯‧霍普曼（Nicolaas Hopman，1794-1870）的藝術品修復師於十九世紀中期所發明，目的是為了防止畫作因受潮而損壞。當時，霍普曼得知埃及人們保存畫作的方式為將畫作浸泡在蠟中或是將畫作漆上蠟，[3]因而決定使用蜜蠟；後來「蠟托裱」這個方式即在二十世紀時被廣泛使用，直到70年代中期。西元1974年，一場「托裱技術之比較」的研討會於格林威治盛大舉行，該研討會上，有許多修復師與科學家對「蠟托裱」提出質疑且廣泛討論，甚至發表許多演說呼籲藝術家們應避免使用這種托裱方式；從那時候開始，便有許多專家學者一直在研究蠟托裱，直到現在仍有許多大量文獻。

西元1983年，藝術史學家約翰‧理查德森（John Richardson）在他的文章〈Crimes Against the Cubists〉中亦對蠟托裱技術提出負面評論，理查德森甚至以「連梵谷的皺紋都變得像美耐桌板一樣光滑了（原文：More than one rugose Van Gogh has ended up as sleek as a Formica tabletop.）」[4]來隱喻蠟托裱技術的缺點。理查德森的文章內容不斷強調該托裱技術是如何影響畫作且厚塗顏料繪畫法的脆弱程度，他提及，即使該技術最初目的是為了保存畫作不龜裂，卻仍然對畫作造成了致命性的傷害。

另一個有關蠟托裱的故事；西元1957年時，荷蘭阿姆斯特丹市立博物館決定將蠟托裱技術用在其珍藏的25件畫作上，該25件畫作即是著名的俄羅斯藝術家—馬列維奇的作品；且不光使用蠟托裱，甚至將畫作上了環己酮樹脂凡尼斯。[5]三十餘年後，阿姆斯特丹市立博物館計畫籌辦「馬列維奇世界巡迴回顧展」，且將於聖彼得堡、莫斯科、阿姆斯特丹、洛杉磯⋯⋯等各大城市舉行，因此向俄羅斯聖彼得堡借了更多馬列維奇的作品；而當那些作品抵達阿姆斯特丹時，卻發現了令人震懾的狀況，那些作品與先前使用蠟托裱的25件作品相比，不論是顏色或是狀況皆好上許多，而另外那25件作品則黃化嚴重且看起來極不自然；原來，來自聖彼得堡的那批作品的保存方式大不相同，修復師們使用魚膠加固及水彩進行補筆，都是不會危害畫作的修復方式。

三、移除蠟托裱

首先，針對使用了蠟托裱技術的陳澄波先生的作品進行了不同化學試驗分析；透過傅立葉紅外線譜分析（FTIR），確認了該批畫作使用油為黏合媒材，同時，也利用掃描式電子顯微鏡X光能量散佈分析（SEM-EDX）、X射線螢光光譜分析（XRF）和跨領域的檢測作業以獲得更多資料。

所有檢測作業完成後，我們對畫作則有了更進一步的瞭解，隨即著手進行移除蠟托裱作業。決定不使用化學溶劑是為了避免溶劑流到畫作表面，也因為已經發現化學溶劑並沒有辦法清潔畫布線上頭的蠟；[6]在另一項研究中提到，將乙基纖維素T-200分解於石油溶劑油中，再與二甲苯混合後的液體可以將蠟移除，但色差值會變為$\triangle E = 2.55$，[7]這樣的色差在畫作表面會非常明顯，因此也證實使用化學溶劑是不適當的。

瞭解到石蠟的熔點介於46-68℃之間後，便可以加熱方式將蠟移除。然而，使用加熱的方式會使蠟滲透到畫作表面，並使顏色暗化，[8]因此，我們進行了色度研究，以驗證使用真空加熱桌對於移除蠟托裱的適用性。首先，我們與宏明科技股份有限公司一起針對了多處的顏料進行比色研究後，再將畫作表面以日本紙和魚膠保護加固，接著使用小頭熨斗和吸油紙將內襯與原畫布分離，由於大量的蠟分布在畫作背面不同的區域，因此將內襯移除後，即可知道原畫布的重量以及多少克的蠟將被移除。

圖1. 真空加熱桌除蠟方法示意圖

1. 紙鎮
2. Foam board（發泡芯板）
3. 吸水紙
4. 吸油紙（一層）
5. 作品（正面朝上）

6. Hollytex（棉紙）
7. 吸油紙（五層）
8. Mylar polyester film（聚酯薄膜）
9. 真空加熱桌

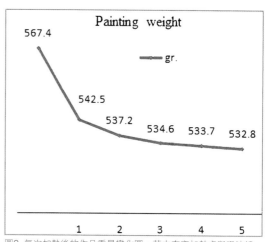

圖2. 每次加熱後的作品重量變化圖。藉由真空加熱桌與吸油紙，總共移除了34.6的蠟。

當真空加熱桌達到68℃後，放上聚酯薄膜避免畫作與桌面直接接觸，接著再聚酯薄膜上放上五層吸油紙，然後放一層棉紙將畫布和吸油紙分開，棉紙可以使融化的蠟淡化且容易被底下的五層吸油紙所吸收；畫作正面朝上放置後，再蓋上另一層吸油紙和吸水紙，最後放上發泡芯板再以少量紙鎮輕微加壓，使移除工作進行更順利。（圖1）以此步驟加熱20分鐘，重複5次，每次都必須換上新的材料且秤重，最後總共移除了34.6克的蠟。（圖2）

重複該步驟5次後，殘留下的蠟非常微量；而畫布變得非常弱脆，因為蠟托裱的使用完全改變了畫布的物理結構，因此也必須將內襯換新。然而，在最初時所進行的比色分析，主要為的是研究在長時間加熱移除蠟的過程中是否會改變作品原來的顏色和外觀，以及研究此方法是否適用於移除蠟托裱；根據比色分析後發現，此方法相當成功且其色差無法以肉眼察覺，色差值平均為△E =0.298787。（圖3-4）

小弟弟	Average BA	Average BB	Average BC	Average BD	Average BE
L*	47.04351	37.74142	45.98049	33.16437	30.37303
a*	15.01233	-5.73784	26.99447	-0.21841	-0.6847
b*	35.35518	-13.8239	13.42916	22.6431	20.22965
△C*	0.051583	0.063639	0.330958	0.048484	0.389774
△E*	0.052023	0.24781	0.540337	0.104165	0.549602

圖3. 以〔小弟弟〕為例，該作品進行真空加熱移除蠟托裱後的比色數據。

色差等級	色差值（△E）
第一級色差（極微）	0.0 - 0.5
第二級色差（微小）	0.5 - 1.5
第三級色差（可感）	1.5 - 3.0
第四級色差（明顯）	3.0 - 6.0
第五級色差（頗大）	6.0 - 12.0
第六級色差（極大）	12.0 - +

圖4. 國際照明委員會認定之色差等級參考表

畫布的纖維和線嚴重暗化，亦已無法恢復其原貌。此外，即使再將剩餘在畫布上的蠟加熱方法移除，蠟也會因為長年附著而成為畫布物理結構的一部分，已無法100%完全移除。在這個過程中蠟會被吸油紙所吸收，並不會移動到作品表面，但早在移處內襯之前，作品表面即存在一些少量的蠟，因此需要另外使用手術刀和化學溶劑來移除。（圖5）

由於作品結構相當脆弱，且支撐度不足，所以必須使用新的內襯；而我們使用BEVA371作為黏合劑。

圖5. 以加熱方法與吸油紙除蠟的前後對照圖（左：移除前，右：移除後）

四、清潔

當修復藝術品進行到清潔步驟時，瞭解「什麼該清潔」比知道「如何清潔」來得更重要，也就是説，有別於傳統一開始使用較淡的化學溶劑然後漸漸調高劑量的清洗方法，應該先從瞭解藝術家的價值觀與對該作品材質的熟悉度著手，才能知道什麼地方適合被清潔。

在現代和當代藝術中，凡尼斯已失去它原本的保護功能，轉而成為藝術家創作的材料；在傳統藝術中，使用凡尼斯是為了保護畫作和色彩飽和度，然而在現代和當代藝術中，凡尼斯則變成藝術品創作的材料之一。

在沒有經過任何修復的陳澄波先生的作品上，都找不到凡尼斯的身影，與陳澄波先生為同期藝術家的作品上亦然。陳澄波先生與其他同期藝術家們是早期留學於日本東京美術學校的學生，當時因受到法國印象派的影響，奠定了他們重要的創作習慣；印象派是第一個拒絕使用凡尼斯且倡導一次性畫法的藝術運動，因此，陳澄波先生從未在他的作品上使用凡尼斯；由此可知，畫作上的凡尼斯並非陳澄波先生本人所為。

很多時候，修復師堅持著自己的修復習慣，如加固、清潔、補筆和上凡尼斯……等，並且忘記或忽略了現代和當代藝術是抱著不使用任何保護層的想法而進行創作的。不屬於畫作本身的物質介入，都會改變藝術品的外觀與藝術家的繪畫結構，如質地和光亮度；不帶修復倫理的修復手法，導致整體的美觀性產生極大改變。另外需要強調的是，凡尼斯是無法完全可逆的，因此必須事先瞭解作品材質會出現什麼變數。

凡尼斯的使用許多修復師認為是一個不太重要的過程，在一些出版的文獻中我們可以看到許多不同的觀點，如：「在一幅油畫中，只要表面亮度一致，極有可能是在表面上了一層凡尼斯，表面亮度會因此而提升，但最終會隨著時間而流逝。」[9]或是：「因為凡尼斯，這幅畫而擁有均勻的外表，相同的亮度。」，[10]另外，享負盛名的修復師Gustav Berger也以荷蘭籍畫家蒙德里安（Piet Cornelies Mondrian，1872-1944）的作品舉例，而提到：「為了保護畫作，在畫作表面上了一層由MS2A凡尼斯、微晶蠟（2%）和塑化劑Kraton G-1726（4%）混合而成的物質。」[11]

上述提及的作者皆了解凡尼斯對於畫作的概念，然而，這仍然不尊重藝術家對於作品外觀的想法，即使凡尼斯是為了保護畫作。應該説，所有形式的凡尼斯都使畫作有了輕微的光澤，所以光亮度和表現特性皆產生改變；此外，當修復師聲稱「凡尼斯是隱形的」時，理查德森則斷言且正確地説出：「凡尼斯是由人造樹脂所製成的，它在人類的眼睛與作品之間形成了一道隔閡。」[12]添加異物到藝術品而產生不同的光亮感並非藝術家當初在創作時所希望的美感。

圖6：移除其他修復師之前所用的藍色凡尼斯

回到前文所提及的，在本研究中，所有陳澄波先生的作品上都有凡尼斯的存在，尤其在得知陳澄波先生從未有使用凡尼斯的習慣後，作品的外觀更顯得完全不同，誇張的凡尼斯使得作品看起來極度不自然。同時，拙劣的補筆傷害了畫作的品質，許多補筆超過缺損的部分甚至蓋過了原畫作的顏料。除此之外，更令人不解的是，前修復師是因為什麼理由而將兩幅裸女作品漆上藍色凡尼斯？該兩幅畫作曾被存放在不同的地方且畫作背景和身形都不相同，卻同樣被漆上藍色凡尼斯。藍色凡尼斯不僅嚴重影響了畫作的外觀，也改變了畫作色澤的飽和度，實在令人無法理解。（圖6）

清楚瞭解哪些部分應該被清潔後，便開始進行清潔步驟。經過許多測試後，最後使用的化學溶劑是以不同比例的白酒精和異丙醇之混合溶劑。清潔步驟完成後，本研究也就此告一段落，二度修復後的畫作並沒有塗上凡尼斯，而畫作的原貌則得以示人。

五、結論

本文已揭露出在不帶著修復倫理下所進行的修復將如何損害畫作，修復師們都應該理解及認同藝術家的想法和藝術品的價值，以避免畫作結構和外觀改變。

蠟托裱技術會改變畫作的所有特性，並可能導致顏色暗化。因此，在不傷害畫作的前提下，研究出了不使用化學溶劑便可移除蠟托裱的替代方法，並且成功的驗證在陳澄波先生的畫作上。如何進行真空加熱移除蠟托裱的步驟以及比色研究都完整地紀錄下來，且修復後的色差值也證實僅有些微差距。然而，畫布的性能卻因蠟托裱產生永久性變化，已無法回復原狀。

修復師們在使用任何凡尼斯之前都應該記住，許多現代及當代藝術品並不會使用凡尼斯作為保護層，只要想以凡尼斯保護作品，那都會明顯改變畫作外觀。

【註釋】

1. 本文曾於2015年11月25日正修科技大學主辦之「第四屆亞太地區熱帶氣候藝術保存研究組織（APTCCARN）年會──面對熱帶地區文物材保存的挑戰」中發表。

2. Chirici, Cesare, (1994), *Critica e restauro dal secondo ottocento ai nostri giorni*, Carte Segrete, Roma, p.90.

3. Hill Stoner, Joyce; Rushfield, Rebecca, (2012), *Conservation of easel painting*, Routledge, New York, p.425.

4. Richardson, John, (1983), *Crimes against the Cubists*, New York Review of Books 30, no.10, p.32-34. AAVV, (1996), "Historical and philosophical issues in the conservation of cultural heritage", edited by Nicholas Stanley, Mansfield Talley and Alessandra Melucco, The Getty Conservation Institute, Los Angeles, p.187.

5. Wijnberg, Louise; Bracht, Elisabeth, (1995), *L'oeuvre de Malevich àtravers le monde: non restaurée, restaurée, de-restaurée*, Colloque de A.R.A.A.F.U., Paris, p.44.

6. Berger, G. A.; Zeiliger, H. J. (1973), *Effects of consolidation measures on fibrous materials*, Bulleting, IIG-AC, 14, no.1, p.43-65, AAVV, (1974), "Conference on comparative lining techniques", National Maritime Museum, Greenwich, p.11.

7. Heydenreich, Gunnar, (1994), *Removal of a wax-resin lining and colour changes: a case study*, The Conservator, 18, p.25.

8. Bomford, David; Staniforth, Sarah, (1981), *Wax-resin lining and colour change: an evaluation*, National Gallery Technical Bulletin, vol. 5, p.58-65.

9. Castellano, Marie Grazie, (1993), *Problematiche di conservazione e restauro alla Galleria Nazionale d'Arte Moderna*, Kermes – La rivista del restauro, no.18, Firenze, p.24.

10. Schinzel, Hiltrud, "*La intención artística y las posibilidades de la restauración*", ed. by Heinz Althöfer, *La restauración de pintura contemporánea. Tendencias, materiales, técnicas*, Itmos, Madrid, 2003, p.54. Translated from the german, Restaurierung moderner malerei : Tendenzen, material, technik, Callwey, Munchen, 1985.

11. Berger, Gustav, (2000), *Conservation of paintings. Research and innovations*, Archetype Publications, London, p.72.

12. Richardson, John, p.190.

【參考文獻】

1. Berger, Gustav, (2000), *Conservation of paintings. Research and innovations*, Archetype Publications, London.

2. Bomford, David; Staniforth, Sarah, (1981), *Wax-resin lining and colour change: an evaluation*, National Gallery Technical Bulletin, vol. 5, p.58-65.

3. Berger, Gustav; Zeliger, Harold. (1973), *Effects of consolidation measures on fibrous materials*, Bulleting, IIG-AC, 14, no.1, p.43-65, AAVV, (1974), "Conference on comparative lining techniques", National Maritime Museum, Greenwich.

4. Berger, Gustav; Zeliger, (1975), *Detrimental and irreversible effects of wax impregnation on easel paintings*, Proceedings of ICOM-CC, venice, p.75/11/2-1-5.

5. Bomford, D. ; Staniforth, S., (1981), *Wax-resin lining and colour change: An evaluation*, National Gallery Technical Bulletin, 5, p.58-65.

6. Chirici, Cesare, (1994), *Critica e restauro dal secondo ottocento ai nostri giorni*, Carte Segrete, Rome.

7. Castellano, Marie Grazie, (1993), *Problematiche di conservazione e restauro alla Galleria Nazionale d'Arte Moderna*, Kermes – La rivista del restauro, no.18, Firenze, p.23-28.

8. Heydenreich, Gunnar, (1994), *Removal of a wax-resin lining and colour changes: a case study*, The Conservator, 18, p.23-27.

9. Hill Stoner, Joyce; Rushfield, Rebecca, (2012), *Conservation of easel painting*, Routledge, New York.

10. Richardson, John, (1983), *Crimes against the Cubists*, New York Review of Books 30, no.10, p.32-34. AAVV, (1996), "Historical and philosophical issues in the conservation of cultural heritage", edited by Nicholas Stanley, Mansfield Talley and Alessandra Melucco, The Getty Conservation Institute, Los Angeles, p.185-192.

11. Schinzel, Hiltrud, "*La intención artística y las posibilidades de la restauración*", ed. by Heinz Althöfer, *La restauración de pintura contemporánea. Tendencias, materiales, técnicas*, Itmos, Madrid, 2003. Translated from the german, Restaurierung moderner malerei :Tendenzen, material, technik, Callwey, Munchen, 1985.

12. Wijnberg, Louise; Bracht, Elisabeth, (1995), *L'oeuvre de Malevich à travers le monde: non restaurée, restaurée, de-restaurée*, Colloque de A.R.A.A.F.U., Paris, p.41-48.

Re-restoration of Chen Cheng-po's Paintings and the Conservation Field[1]

Dr. Ioseba I. Soraluze, Li I-chen

Abstract

This paper will discuss the complex process of conservation and how malpractice could affect paintings and alter the physical structure and aesthetic of the art works. Negligent conservation is what happened to a group of Chen Cheng-po's paintings when the treatments that were carried out were not correct. The wax-resin lining done to the canvases and retouching on original surfaces completely damaged and altered the paintings. For that reason the re-restoration project of Chen Cheng-po's paintings began with the aim to remove damage and changes incurred by the art works. Chemical tests such as X-ray fluorescence (XRF), Scanning electron microscopy with energy dispersive X-ray spectroscopy (SEM-EDX), Fourier transform infrared spectroscopy (FTIR) and cross-sections were done in order to gain a complete understanding of the paintings. A new way to remove the wax-resin lining was developed by the use of the hot-vacuum table without the need of solvents. Every time that the treatment was applied to the canvas the quantity of wax removed was calculated in grams. Furthermore, colorimetric studies were carried out to understand and evaluate how the hot treatment could affect the colours.

The retouching and varnish applied to the paintings in the first restoration totally modified the aesthetic of Chen Cheng-po's work. Large areas of original paint were covered by retouching and the lack of technique also provoked a loss in the quality of the paintings. The re-restoration had to remove all the filling and retouching without affecting the original paint; at the same time the re-restoration was required to rediscover the original colours and the artist's intention.

This project has been able to show how negligent restoration treatment can alter paintings. Critical thinking together with an understanding of the artist's intention could avoid damage to the art works and preserve them in a better way.

I. Introduction

The conservation of paintings is a complex activity that requires critical thinking to preserve them from any kind of degradation. The restoration methodology involved should take into account the necessity of respect and minimal intervention. Restorers that do not proceed with conservation standards could compromise the structural stability and aesthetic of the artwork; in this way the Italian scholar Cesare Chirici tells us that "an intervention that does not recognise the artistic values of an

artwork, it should not be considered a restoration" [2]. The artistic values such as aesthetic, historicity, artist's intention, authenticity, meanings··· are key points when an artwork faces a restoration process, and the preservation and recognition of these complete values determine a successful restoration.

A group of 9 paintings of Chen Cheng-po were restored years ago without respect to the values of the artworks and they were entirely denatured and physically modified. These structural changes were affecting the support and the colours, and the artist's aesthetic was not able to be appreciated anymore. Realising this situation, the Chen Cheng-po Cultural Foundation decided to intervene and a project of re-restoration re-restoration began.

The paintings presented wax-linings that were not carefully done. Big deposits of excess wax could be found on the painting's surface and in the back of the canvas. The supports were extremely brittle and hard, and the flexibility and good tension of the canvases were completely gone. Many bad in-paintings were carried out that affected the quality of the images; the retouching was done even on the original surfaces covering the artist's colours. A thick layer of glossy varnish was also applied to the paintings in the restoration process and the expected matte surface of an untouched Chen's aesthetic disappeared.

II. Wax-lining

The wax-resin lining was invented in the mid-nineteenth century by the artist-restorer Nicolaas Hopman (1794-1870) to prevent paintings from moisture damage. Hopman decided to use beeswax inspired by Egyptian discoveries paintings that were immersed in wax or painted with wax-based paint. The objects were in a good state of preservation.[3] During the twentieth century the wax-lining was frequently employed until the mid seventies. In 1974 at the "Conference on Comparative Lining Technique" in Greenwich was the effects of wax-lining widely discussed and several inputs were addressed to avoid using this kind of lining. Since then many restorers and scientists have been studying the results of applying wax-resin lining and there is now extensive literature about the matter.

The negativity of the wax-lining technique was also strongly reported by John Richardson in his article Crimes against the Cubits in 1983 where he declared that "more than one rugose van Gogh has ended up as sleek as a Formica tabletop" [4]. His comments were based on how the technique affected the paintings and how the paint impasto was particularly vulnerable. He suggested even if the intention is to preserve the paintings from present or future disintegration, the result was still a "waxwork, a dead thing" .

Continuing along this line, conservators from the Stedelijk Museum in Amsterdam are perfectly aware of the damage and changes wax-lining may do to paintings. In 1957 the museum decided to apply a wax based lining to twenty-five paintings of Malevich and then a cyclohexanone resin varnish with addition of wax was also added.[5] After thirty years and being showcased in many exhibitions, in 1988 a great retrospective was organized in San Petersburg, Moscow, Amsterdam and Los Angeles. The paintings were compared again once the exhibition arrived to the Stedelijk and a big shock occurred when presented with them. The paintings that had wax-lining showed different textures and colours compared to the paintings that came from Russia. The Malevich paintings restored in San Petersburg were slightly intervened by local consolidation with sturgeon glue and retouching made by watercolours. The paint surfaces of the artworks maintained an authentic appearance and a certain

gray tone while the Stedlejick's looked more yellow and denatured.

III. Removing wax-lining

All the paintings of Chen Cheng-po that suffered a wax-lining treatment were analyzed with different chemical tests. The Fourier transform infrared spectroscopy (FTIR) was done to confirm that binding media was oil. At the same time, scanning electron microscopy with energy dispersive X-ray spectroscopy (SEM-EDX), X-ray fluorescence (XRF) and cross-sections were applied to gain more understanding of the paintings compounds.

Once all the tests were done and a better understating of the paintings was achieved, the process of removing the wax based lining began. The use of solvents was rejected to avoid the migration of solvents to the painting surface as it has been found that wax impregnation of canvas threads cannot be reversed even with washing by solvents.[6] In another study the use of a mixture of ethylcellulose T-200 dissolved in white spirit and xylene was used for extracting the wax medium but a colour change of $\triangle E = 2.55$ was registered.[7] This colour change of the painting surface is very noticeable, so the inappropriateness of using solvents was also confirmed.

Knowing that the paraffin wax has a melting point between 46-68°C, the extraction of wax lining could be based using heat. However, it could increase the penetration of wax to the painting surface and produce a degree of colour darkening.[8] In that way, a colorimetric study was implemented to verify the suitability of removing wax based lining by the use of a hot table. Before facing the painting with Japanese paper and fish glue to protect and consolidate the surface, several points of colours were checked with a colorimetric customized by Hong-Ming Technology Co. Ltd. Once the painting was protected the process itself of removing the lining started. First, a small hot iron with oil-absorbing paper was used to separate the lining from the original canvas. Huge amounts of wax were located in different areas in the back of the painting. After the lining was removed the original canvas was weighed to know how many gr. of wax the process would be extracting.

When the vacuum hot table reached 68°C a mylar polyester film was placed to isolate the table,

Fig. 1: Graphic of wax extracting process by a vacuum hot table.

1. Weights
2. Foam board
3. Blotting paper
4. Oil-Absorbing paper (one layers)
5. Artwork (Face up)
6. Hollytex
7. Oil-Absorbing paper (five layers)
8. Mylar polyester film
9. Vacuum Hot Table

Fig. 2: Graphic of wax removed measured by gr. A total 34.6 gr. of wax was removed using a vacuum hot table and oil-absorbing paper.

and onto it five layers of oil-absorbent paper were also placed. Then, a hollytex was put to separate the canvas from the oil-absorbing paper; the hollytex also helped the melted wax recede and be absorbed by five layers of oil-absorbing papers. With the painting face-side up, it is then covered with another oil-absorbing paper and a blotting paper. And finally, a foam board is laid with a light weight to press the painting and allow the process to work better. (Fig. 1) This process was run for 20 minutes and then repeated 5 times. Each time the papers were changed and the painting was weighed; a total of 34.6 gr. of wax was removed. (Fig. 2)

After the process was repeated 5 times a very small amount of wax was able to be taken out and no more was extracted. The canvases were very weak and brittle because the wax completely altered the physical structure, and another lining needed to be replaced. However, colorimetric analyses were first done to compare any colour change of the paintings. The study was focused on whether the long term affects of applying heat to extract the wax may alter the artist's colours and appearance, and to address if this process was suitable for removing a wax lining. The data of the colour study was successful and the colour difference was limited to traces which are not able to be perceived by the

Little Boy	Average BA	Average BB	Average BC	Average BD	Average BE
L*	47.04351	37.74142	45.98049	33.16437	30.37303
a*	15.01233	-5.73784	26.99447	-0.21841	-0.6847
b*	35.35518	-13.8239	13.42916	22.6431	20.22965
△C*	0.051583	0.063639	0.330958	0.048484	0.389774
△E*	0.052023	0.24781	0.540337	0.104165	0.549602

Fig. 3: Graphic of the colorimetric study done to the painting *Little boy* to know the colour changes after being applied the lining removing process.

Critical remarks of color difference	△E NBS unit
Traces	0.0 - 0.5
Slight	0.5 - 1.5
Noticeable	1.5 - 3.0
Appreciable	3.0 - 6.0
Much	6.0 - 12.0
Very much	12.0 - +

Fig. 4: Graphic of the National Bureau of Standars (NBS) system of expressing color differences, △E.

eye. The average of colour change $\triangle E = 0.298787$ was registered. (Fig. 3-4)

The fibers and threads of the canvases were severely darkened and there was no possibility to recover their original appearance. Furthermore, even if any more wax could be extracted using heat, the wax is still part of the physical structure of the threads and it was not 100% completely removed. During the process the wax did not migrate to the painting surface but everything was absorbed by the different layers of oil-absorbing papers. However, before removing the lining, the surface already had some wax spots and they needed to be eliminated with a scalpel and solvents. (Fig. 5)

Due to the brittle structure of the canvases and their vulnerability, another lining process had to be undertaken. The supports were not strong enough to stretch them so new linings were performed. The adhesive selected was Beva 371.

Fig. 5: Before and after of wax extraction using heat and oil-absorbent papers.

IV. Cleaning

When approaching a cleaning of a restored painting, more important than how to clean is knowing what to clean, that is to say, unlike a traditional cleaning process which starts with a very light solvent and increases to other stronger ones, the cleaning methodology of restored paintings begins with recognizing the artistic values and the object's intellectual universe to assure what is suitable to be removed.

The controversy of the varnish that is presented in modern and contemporary works is the loss of its protection functionality in order to become an aesthetic element used by the artist. In traditional art the varnish keeps a clear protection function and the intention of saturate colours as an aesthetic process. However, modern and contemporary art use the varnish exclusively as an aesthetic resource and not as a protective coating.

All unrestored Chen Cheng-po paintings do not have any varnished layers and neither do the paintings of his peers. The first generation of oil painting Taiwanese artists that studied at the University of Tokyo were under the influence of their art academy by the French Impressionism, and it was crucial for the students' development. Impressionism was the first art movement that avoided using varnish and starting painting alla prima due to aesthetic reasons. In that way, Chen never applied varnish to his artworks and they were all matte, so the paintings that actually have a protective coating have been done by others.

Many times the restorers persist with habits like consolidation, cleaning, retouching and coating, and they forget or omit that the modern and contemporary works were conceived without any coating. The intrusion of a substance that is not part of the work changes and alters the formal aspect of the pictorial construction, that means texture, brightness and luminosity. The aesthetic unity is transformed without consideration by the restorers that do not follow critical judgment. It should also be noted that the coating of a painting is never completely reversible, so a transformation of the artwork's intellectual universe must be considered.

Applying varnish to a matte painting is regarded for many restorers as a less important process

deducted by their interventions. In several publications we are able to read different restorations as the following: "On oil paintings, as long as they have a uniform brightness, it may apply a light coat of diluted retouching varnish with a protective finality that rise very few surface brilliance and reward the opacity due the time" [9]. Or such as, "with the varnish, the painting has obtained a uniform surface, homogenous and slightly lighter" [10]. Continuing this way, the well-known restorer Gustav Berger explains an intervention done in a matte Mondrian (1872-1944), "for protection, the painting was given a coat of MS2A varnish with a small addition of microcrystalline wax (2%) and plasticizer Kraton G-1726 – 4% to achieve a slightly matte finish" [11].

All the authors mentioned understand what the notion of the matte painting concept is. However, it is still not respecting the artist's intention about the matte aspect even if the varnish is matte. It should be added that any matte varnish still provides a slight glossy finish, so the optical and expressive properties of the painting are changed. Furthermore, when a restorer claims that the varnish is invisible Richardson asserts rightly that "varnishes made from synthetic resins, inevitable form a membrane between one's eyes and the picture" [12]. Adding a foreign material to an artwork varies the refractive index creating an aesthetic not wished by the artist.

Coming back to Chen's paintings, all the artworks re-restored in this project had varnish. Knowing that the artist never applied a coating by himself, the visual appearance was completely different. The varnishes were really thick and glossy and the paintings looked visibly denatured. At the same time, all retouching areas were so poorly done and the quality of the paintings was harmed. Many losses were retouched outside of the paintings and the original surface colours were often covered. However, it was incomprehensible to know why in a couple of paintings the restorer decided to add a colour to the varnish. Two female nude works had in different places, background and body, a blue varnish. The blue was visibly affecting the aesthetic and the formal aspects of the paintings. The blue varnish varied in thickness and intensity and the presence of it could not be understood.

Once knowing which elements should be removed, the cleaning process started. Many tests were done and finally the solvents used were a mix of white spirit and isopropanol in diverse proportions. With the cleaning done the re-restoration project finished and no coating was applied, in that way the original matte aspect of the paintings were recovered.

V. Conclusions

Restoration treatments without critical thinking have shown how paintings can be damaged. Understanding the artist's idea and the values of the artworks should be taken into account to avoid structural and aesthetic alterations.

The wax-lining can alter all the paintings characteristics and could result in a darkening of colours. An alternative treatment of removing wax-lining without using solvents was undertaken and

Fig. 6: Removing a blue coloured varnish applied by another restorer.

successfully achieved with Chen Cheng-po's paintings. How the application of heat for extracting wax and the subsequent colour changes was also studied, and a minimal colour-trace difference was registered. However, the wax did alter mechanical properties of the canvas.

Restorers before applying any varnish should keep in mind that many modern and contemporary paintings do not have any coating and they are intended to be matte. The idea of any glossy-layer protection provokes evident formal aspect modifications.

1. This paper was presented at 4th meeting of APTCCARN (Asia Pacific Tropical Climate Conservation Art Research Network), *Embracing cultural materials conservation in the tropics, Cheng Shiu University, 2015.*

2. Chirici, Cesare, (1994), *Critica e restauro dal secondo ottocento ai nostri giorni*, Carte Segrete, Roma, p.90.

3. Hill Stoner, Joyce; Rushfield, Rebecca, (2012), *Conservation of easel painting*, Routledge, New York, p.425.

4. Richardson, John, (1983), *Crimes against the Cubists*, New York Review of Books 30, no.10, p.32-34. AAVV, (1996), "Historical and philosophical issues in the conservation of cultural heritage", edited by Nicholas Stanley, Mansfield Talley and Alessandra Melucco, The Getty Conservation Institute, Los Angeles, p.187.

5. Wijnberg, Louise; Bracht, Elisabeth, (1995), *L'oeuvre de Malevich à travers le monde: non restaurée, restaurée, de-restaurée*, Colloque de A.R.A.A.F.U., Paris, p.44.

6. Berger, G. A.; Zeiliger, H. J. (1973), *Effects of consolidation measures on fibrous materials*, Bulleting, IIG-AC, 14, no.1, p.43-65, AAVV, (1974), "Conference on comparative lining techniques", National Maritime Museum, Greenwich, p.11.

7. Heydenreich, Gunnar, (1994), *Removal of a wax-resin lining and colour changes: a case study*, The Conservator, 18, p.25.

8. Bomford, David; Staniforth, Sarah, (1981), *Wax-resin lining and colour change: an evaluation*, National Gallery Technical Bulletin, vol. 5, p.58-65.

9. Castellano, Marie Grazie, (1993), *Problematiche di conservazione e restauro alla Galleria Nazionale d' Arte Moderna*, Kermes – La rivista del restauro, no.18, Firenze, p.24.

10. Schinzel, Hiltrud, "*La intención artística y las posibilidades de la restauración*", ed. by Heinz Althöfer, *La restauración de pintura contemporánea. Tendencias, materiales, técnicas*, Itmos, Madrid, 2003, p.54. Translated from the german, Restaurierung moderner malerei : Tendenzen, material, technik, Callwey, Munchen, 1985.

11. Berger, Gustav, (2000), *Conservation of paintings. Research and innovations*, Archetype Publications, London, p.72.

12. Richardson, John, p.190.

[References]

1. Berger, Gustav, (2000), *Conservation of paintings. Research and innovations*, Archetype Publications, London.

2. Bomford, David; Staniforth, Sarah, (1981), *Wax-resin lining and colour change: an evaluation*, National Gallery Technical Bulletin, vol. 5, p.58-65.

3. Berger, Gustav; Zeliger, Harold. (1973), *Effects of consolidation measures on fibrous materials*, Bulleting, IIG-AC, 14, no.1, p.43-65, AAVV, (1974), "Conference on comparative lining techniques", National Maritime Museum, Greenwich.

4. Berger, Gustav; Zeliger, (1975), *Detrimental and irreversible effects of wax impregnation on easel paintings*, Proceedings of ICOM-CC, venice, p.75/11/2-1-5.

5. Bomford, D. ; Staniforth, S., (1981), *Wax-resin lining and colour change: An evaluation*, National Gallery Technical Bulletin, 5, p.58-65.

6. Chirici, Cesare, (1994), *Critica e restauro dal secondo ottocento ai nostri giorni*, Carte Segrete, Rome.

7. Castellano, Marie Grazie, (1993), *Problematiche di conservazione e restauro alla Galleria Nazionale d'Arte Moderna*, Kermes – La rivista del restauro, no.18, Firenze, p.23-28.

8. Heydenreich, Gunnar, (1994), *Removal of a wax-resin lining and colour changes: a case study*, The Conservator, 18, p.23-27.

9. Hill Stoner, Joyce; Rushfield, Rebecca, (2012), *Conservation of easel painting*, Routledge, New York.

10. Richardson, John, (1983), *Crimes against the Cubists*, New York Review of Books 30, no.10, p.32-34. AAVV, (1996), "Historical and philosophical issues in the conservation of cultural heritage", edited by Nicholas Stanley, Mansfield Talley and Alessandra Melucco, The Getty Conservation Institute, Los Angeles, p.185-192.

11. Schinzel, Hiltrud, "*La intención artística y las posibilidades de la restauración*", ed. by Heinz Althöfer, *La restauración de pintura contemporánea. Tendencias, materiales, técnicas*, Itmos, Madrid, 2003. Translated from the german, Restaurierung moderner malerei :Tendenzen, material, technik, Callwey, Munchen, 1985.

12. Wijnberg, Louise; Bracht, Elisabeth, (1995), *L'oeuvre de Malevich à travers le monde: non restaurée, restaurée, de-restaurée*, Colloque de A.R.A.A.F.U., Paris, p.41-48.

油畫作品
Oil Paintings

修復報告
Selected Treatment Reports

正修科技大學文物修護中心
Cheng Shiu University Conservation Center

前言 Introduction

　　正修科技大學文物修護中心設立於2005年，致力於推廣藝術教育與文化資產的維護工作，有幸於2011年起至2013年承接財團法人陳澄波文化基金會委託進行臺灣國寶陳澄波老師的畫作修復工作，此修復計畫共計35件為期3年，由修復博士Ioseba Soraluze領導跨領域的專業團隊執行。針對這個計畫，文物修護中心與基金會榮譽董事長陳重光先生及現任董事長陳立栢先生多次開會討論修復步驟及保存方式。

　　The Conservation Center of Cheng Shiu University was established in 2005, and had the promotion of arts education and cultural heritage preservation as its goals. The Conservation Center was honored to carry out the conservation of the paintings of Chen Cheng-po by Chen Cheng-po Cultural Foundation from 2011 to 2013. The conservation project lasted for 3-years and 35 paintings were restored with the interdisciplinary team led by Dr. Ioseba Soraluze. The Conservation Center had several discussions with foundation's Honorary Chairman Mr. Chen Tsung-kuang and Chairman Mr. Chen Li-po about the restoration treatments and conservation procedures.

　　正修文物修護中心貫以科學儀器進行媒材的檢測及分析，例如；紫外線譜儀、X光射線機、X射線螢光光譜儀、傅立葉紅外線光譜儀、測色儀等設備進行檢測。藉由這些儀器，可以深入的分析及研究畫作。2010

年間文物修護中心參與高雄市立美術館舉辦的「切切故鄉情：陳澄波紀念展」。接著於2011年正修科技大學主辦「再現澄波萬里——陳澄波作品保存修復特展」與相關之國際學術研討會；之後，於2013年受亞太地區熱帶氣候藝術保存研究組織（APTCCARN）邀請，至泰國於其第3屆年會中發表修復研究成果。並於2014年受邀到北京中國美術館舉辦的「南方豔陽——陳澄波（1895-1947）藝術大展」中展出修復成果。此外，2015年第4屆亞太地區熱帶氣候藝術保存研究年會於正修科技大學舉行，在文物修護中心與墨爾本大學合辦的國際研討會中發表了幾篇關於陳澄波畫作的論文。

The Conservation Center is used to analyze and examine materials with scientific instruments, such as UV light, X-Ray generator, XRF Spectrometer, FTIR and colorimeter studies. With these instruments the paintings may be studied and deeply researched. In 2010, the Conservation Center participated in "Nostalgia in the vast universe: Commemorative exhibition of Chen Cheng-po" held by Kaohsiung Museum of Fine Arts. In 2011, Cheng Shiu University held "The conservation Exhibition and Conference of Chen Cheng-po's Artworks". In 2013, the Conservation Center was invited to publish its discoveries in Thailand in the APTCCARN 3th Meeting and in 2014, organized the exhibition "The Bright Sunshine of the South – The Grand Art Exhibition of Chen Cheng-po (1895-1947)" held by the National Art Museum of China in Beijing. In 2015, APTCCARN 4th Meeting was held by Cheng Shiu University and the conference was organized by the Conservation Center and the University of Melbourne. Several papers about Chen Cheng-po were presented.

從此次委託油畫修復案中擇選其中的八件修復作品作為本書出版範例，主要目的是作品各有其特殊狀況且具代表性，如：畫作在需要托裱時因背面具藝術家之簽名筆跡，此時則需考量進行修復之方式，以不覆蓋重要簽名並穩定畫作健康兩全其美的方法作為優先考量。另外，曾被不當修復之作品也在此次修復範例中進行介紹，因被修復過的作品再次被修復是非常艱鉅的。此外也藉由此修復過程之介紹與說明，呈現本校修復團隊對於修護保存之重視，並能重現作品對於臺灣藝術史上之意義與畫作原始風貌所展現的使命。

From this painting conservation project we have selected 8 pieces as case studies to be published in this book. Due to these cases have their own special conservation conditions, we think they are good examples to explain the conservation treatments we carried out. In this way, we have considered what kind of treatment can be applied when the painting has the artist's signature or handwriting on its back. In this situation a transparent lining may be used for both consolidate the painting and allow the signature be read. In addition, we have also introduced examples of previous inaccurate restorations through these cases. It should be noted that restore a painting that has been restored before is a very difficult task. Furthermore, these restoration processes show the importance of our team gives to conservation standards. We value the meaning the artworks have for Taiwanese art history and we recover their original esthetic as our mission and preserve them for future generations.

綠�0裸女
Nude Female Against Green Curtain

I. 修復前狀態 Before treatment condition

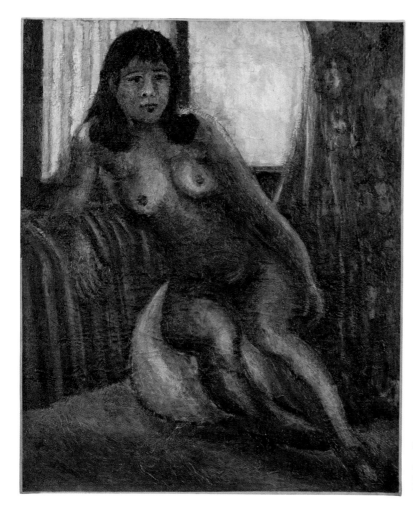

綠0裸女
Nude Female Against Green Curtain
年代不詳 Date unknown
畫布油彩 Oil on canvas
72×60cm

修復紀錄 Conservation history
　　□未曾修復Not treated before ■曾修復 Previously restored

修復項目 Treatments
　　■畫面保護 Facing □更換固定調整器 Metal adjustors □畫面加固 Consolidation ■畫布托裱 Lining
　　■基底材加固 Support consolidation □調整式內框 New stretcher ■繪畫層清潔 Cleaning
　　■填補缺洞及全色 Filling and retouching ■X光檢測 X- Ray study ■紅外線檢視 IR study ■紫外線檢視 UV study

◎狀況圖 Mapping
　　每張畫作從其狀況分析圖中，可深入完整的判讀及了解畫作所具有的各種損壞和劣化情況。狀況圖是一個很有用的輔助工具，可以更明瞭修復時所需要處理的損壞狀況有哪些，同時亦可得知畫作目前的保存狀

況。

Every painting is deeply studied and noted in a mapping with all different damages the work has. The mapping is a very useful tool because it lets us know which damages the restoration needs to face. The mapping also tells us the real condition of the painting.

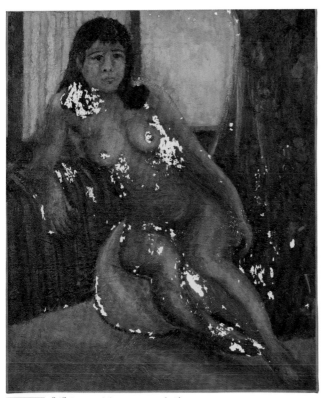

殘蠟 Areas with wax accumulation
無填補石膏，有全色 Retouching areas without filling

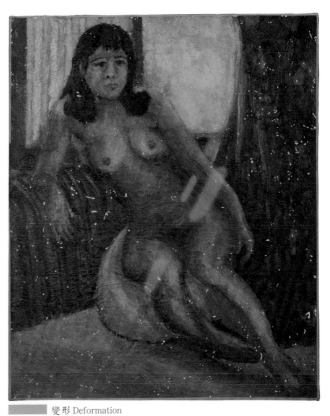

變形 Deformation
繪畫層缺失（前修復師無修復工序）
Paint loss（No treatment during previous restoration）

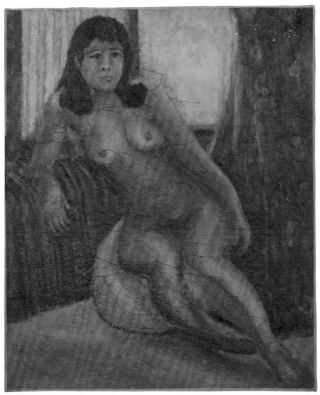

有填石膏無全色 Areas with filling but without being retouched
空鼓型龜裂 Blister with crack
全面龜裂 Cracking

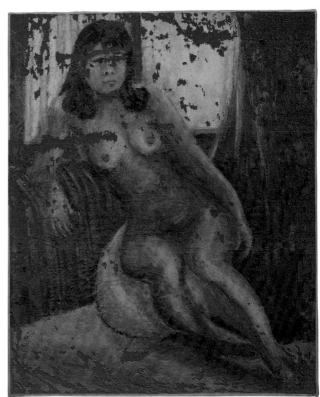

前修復師的補筆 Previous retouching

II. 修復前檢視登錄與分析 Documentation and analysis

1. 畫作狀況研讀分析 Painting condition study

　　作品在修復前先以非破壞性XRF光譜儀檢測以深入了解藝術家的創作媒材，在X光檢視下也發現此幅作品畫面下隱藏著另一幅畫：一位裸女斜坐著雙手環抱膝蓋。此外，利用不同類型的光源檢視分析畫作，藉此觀察龜裂、變形及繪畫層肌理等狀況。

　　Before doing any conservation treatment, the painting was checked with XRF to go deeper in knowledge of the artist's materials. The X-Ray revealed an underneath painting of another nude seated with the hand on her knee. Different kinds of light examination are applied to the painting to observe cracking, deformation and paint textures.

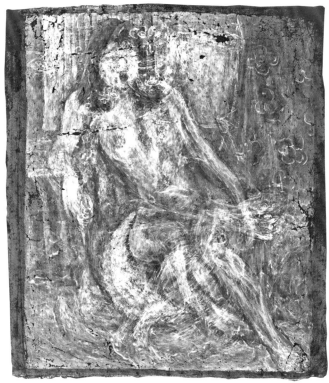 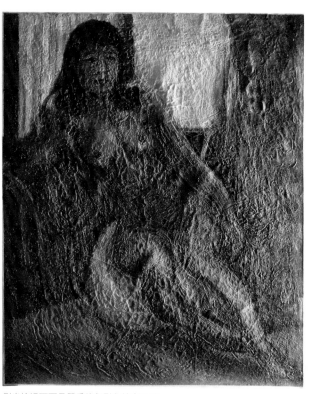

X光檢視下發現畫面下隱藏著另一幅畫
The image obtained by X-Ray light has revealed there is an underneath painting

側光檢視下可見嚴重的龜裂與繪畫肌理
View of the painting using raking light. It may observe a severe cracking and texture

　　紫外線檢視下察覺到多處不當修復補筆，這些補筆畫到缺失處周圍的原有繪畫層上。從修復前後對照的照片中清楚可視不當修復補筆遠超出繪畫層缺失範圍，覆蓋到陳澄波畫作原有的顏料上。紅色箭頭處為前人與此次修復後的全色範圍差異。

　　UV light analysis tells us that there are many inappropriate retouching which have been done on the original paint layer around the lacunas. In the comparative images can be seen how the retouching were much bigger than the original losses, covering Chen Cheng-po's colors. The red arrows show the differences between the retouching areas.

2. 修復前局部狀況 Painting condition

　　為了判斷分析畫作的狀況，必須以拍照作記錄。以此畫作而言，之前的修復並沒有完全遵守修復原則及標準。由下面的照片可察覺有些缺失處石膏漿填補不全，有些則是補色範圍過大，覆蓋到周圍繪畫層。同時，先前修復填補石膏漿時並無塑造相似於原有繪畫層的肌理，補筆也畫到原有繪畫層上。也可看見不完善

紫外線檢視：紅色箭頭處顯示出大範圍的舊補筆痕跡
UV light analysis before being restored. The red arrows show the big areas of previous retouching

修復後紫外線檢視：補筆面積小於舊補筆
UV light analysis after being restored. The loss areas are smaller than previous retouching

紫外線檢視 UV light analysis

的修復補筆及一些龜裂紋。修復是非常多樣性的工作，需要謹慎精密的進行。此外，此幅作品中也清晰可見過度及不完全的填補。再者，收邊紙膠帶沒有被正確的黏貼，因而遮蓋到畫面。

The photograph documentation is essential to determine the condition of the painting. In this case the previous restoration did not follow the conservation standards to achieve a well-done restoration. In different images below are able to see how the paint losses were not filled completely with stucco, while other retouching covered the original surface. At the same time, the restorer didn't imitate the artist oil texture and still was keeping retouching on Chen's colors. The image also shows the bad quality retouching and several cracking. The restoration is a very complex work that requires delicacy. Moreover, filler compounds and irregularities can be seen in the filling. Furthermore, the paper tape was placed incorrectly on the paint surface because was covering original painting.

缺失處石膏漿填補不完全 Losses weren't filled completely

不當補筆 Inappropriate retouching

補筆範圍大於缺失處
The retouching was bigger than paint loss

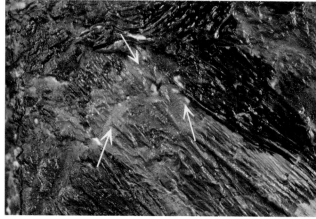

填補石膏無塑造肌理
The filling didn't imitate the original paint texture surface

龜裂與不完善修復補筆
Cracks and bad quality retouching

收邊紙膠帶黏貼不當，並覆蓋到局部畫面
The paper tape that was placed incorrectly and was covering original painting

3. 修復前基底材局部狀況 Detail of the support condition

因曾受到前人蠟托裱修復的緣故，畫布變得剛硬且缺乏彈性，也失去了它原本的結構機能性，此外大量的蠟殘留在畫作背面，甚至在畫作正面也可見到蠟殘留的痕跡。

Owing to the former wax-lining, the canvas became rigid, lacked of elasticity and losing its structural properties. Huge amount of wax remained on the back of the painting as well as on the color surface.

畫作背面可見大量殘留的蠟
Huge deposits of wax in the back of the canvas

未清除的殘蠟
The remaining wax was not removed out

III. 修復作業內容 Conservation and restoration treatments

1. 畫面保護 Facing

在揭除蠟托裱前，首先需要先保護畫面。這步驟是將日本紙以魚膠塗佈在畫作正面，藉此保護繪畫層安全性，不因後續施作於畫布背面的修復程序而受到損害。

Before removing the former wax-lining, the facing should be applied first. It was an application of Japanese paper and fish glue to the front of the painting to secure the paint layer prior to the structural procedures on the back of the painting.

畫面保護施作 Facing process

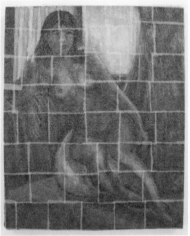

畫面保護施作完成後全貌
View of the painting when the facing is completed

2. 移除蠟托裱 Removing wax-lining

畫面保護完成後，把畫布從內框上拆解下，接著開始移除蠟托裱。過程中，不使用任何溶劑以避免溶劑滲透到畫面。而是以加熱桌配合吸油紙進行除蠟，並且對畫作進行除蠟托裱前後的色彩分析研究，檢測後原有的色彩並無加深或改變的現象。

After facing, the painting was dismounted from the stretcher and the process of removing the wax-lining started. It was not used any kind of solvents to avoid its migration to the surface. The hot table was employed with oil-absorbent papers and colorimetric studies were also done to prevent any darkening of the colors.

除蠟過程對照 The process of removing wax

去除蠟托裱及殘蠟後 After removing wax- lining

3. 基底材加固 Support consolidation

在除蠟工作進行完成後，畫布周邊破裂處以特製熱塑黏合細線將裂縫黏合。

After removing wax, broken and tears areas were sewn with thermoplastic adhesive threads.

4. 畫布托裱 New lining

畫布因之前被蠟托裱過變得非常脆弱，因此必須以熱塑性黏合劑重新托裱。此過程利用加熱吸附桌加熱至約攝氏70度來進行。

Due to the wax lining, the canvas was so brittle and a new lining had to be done with thermoplastic adhesive. This application was carried out by using the vacuum hot table at about 70 degrees.

 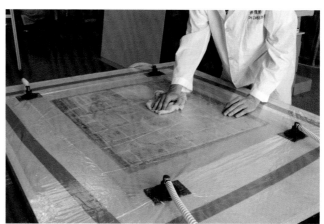

畫布局部裂痕以熱塑性膠線黏合
Fixed tears with thermoplastic adhesive threads.

畫布托裱程序 The lining process

5. 繃框 Remounting

這次修復並無換掉之前修復所做的新內框，因為它是活動式內框且狀況良好，故與予以沿用，並將畫作再次重繃於內框上。

The re-restoration project didn't remove the new stretcher because it was expandable and in good condition, and the canvas was remounted again.

6. 畫面清潔 Cleaning

清潔是任何修復步驟中最重要的過程之一，所以必須謹慎實行。應用不同的測試以選擇最適當且不會傷害到畫面顏色的清潔溶劑。因為舊的修復補筆覆蓋到原有的畫面上，所以必須仔細地將之移除。照片中原有藝術家創作的色彩在移除舊補筆後顯露出來，圖示中黃線下方完全呈現出創作者原始的美學。

The cleaning is one of the most important processes of any restoration, so the treatments are very carefully done. Different tests were applied to know the best cleaning solution. Due to old retouching were painted on original surface, it was delicate to remove all of them. In images are shown how the artist original colors appear once it has been cleaned the retouching. Under the yellow lines emerge the aesthetic colors.

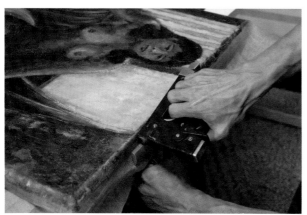

畫布繃框 Remounting the canvas

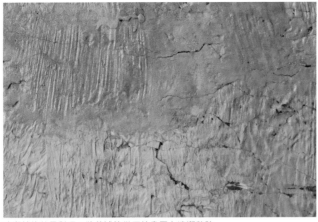

清潔前後差異對照：將舊補筆從原繪畫層上清潔移除
Different details of the cleaning process: the retouching have been done on original surface

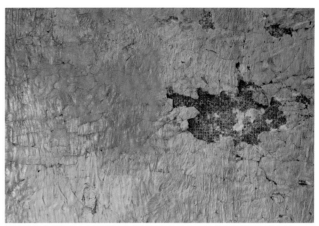

清潔前後差異對照：舊補筆清除後呈現出的缺失處比前人的舊補筆範圍小
Different details of the cleaning process: a smaller loss than the retouching has appeared

清潔前後差異對照：舊補筆顏色暗沉並覆蓋到周圍原始的繪畫層
Different details of the cleaning process: the previous retouching beside covered the color surface was darker

清潔前後差異對照：前人修復時添加的凡尼斯以及舊補筆改變了畫作原來的色彩
Different details of the cleaning process: the varnish and previous retouching changed the original colors

　　此畫作上有一層前修復師所添加的厚重凡尼斯層。由於陳澄波先生創作完後並無增添任何保護層的習慣，且他的畫作一般呈現無光澤的質感。因此，選擇將凡尼斯層移除，以還原畫家所創造的霧面美感。

　　The painting also had a very thick varnish applied by the restorer. Chen Cheng-po never used any kind of coating and all his paintings were matte. For this reason, the varnish was removed and it was respected the original matte surface.

清潔前後差異對照：清潔後呈現出作品無光澤的霧面美感
Different details of the cleaning process: recovering the original artist's matte surface

清潔前後差異對照：凡尼斯層移除後，呈現並恢復了藝術家的美學
Different details of the cleaning process: after the removal of the varnish, the artist's aesthetics were presented and restored

清潔前後差異對照：上方顯示過去修復不當的補筆
Different details of the cleaning process: the upper side show
inappropriate color retouching

清潔前後差異對照：右側方明顯可見色彩恢復後的原貌
Different details of the cleaning process: the right side has recovered
the original colors

7. 繪畫層缺損處補土全色 Filling and retouching

　　在遵守修護原則及可逆性下，於繪畫缺損處填入動物膠與硫酸鈣製成的石膏漿，並模擬塑造出畫作肌理使之與原有畫面相連貫；接著，以水性顏料於缺失處進行全色，全色範圍並不能覆蓋到周圍的畫面。修復程序於全色後結束，並沒有增添凡尼斯，因為陳澄波的所有作品皆呈現霧面無光澤感，沒有上保護層。

　　The paint losses were filled with stucco, made of gesso and animal glue. The filling was imitating the paint surface to reach the original textures. Then, the lacunas were retouched with water based color, following the conservation

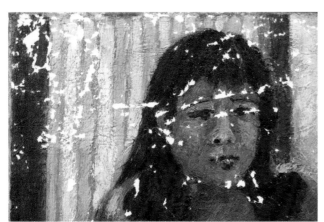

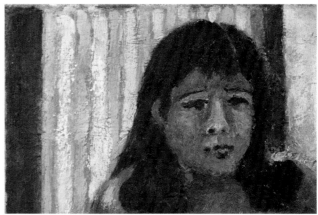

填補石膏漿 Filling process

全色完成後 After retouching

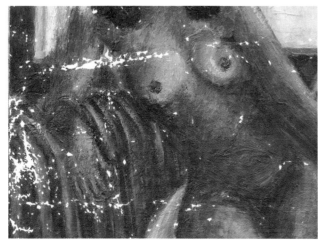

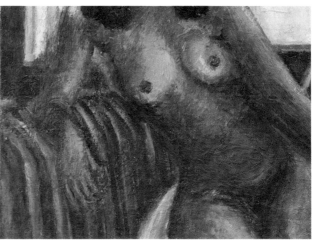

填補石膏漿 Filling process

全色完成後 After retouching

standards and its reversibility. No retouching was done on the original painting surface. The restoration process finished with the retouching and it was not apply any kind of varnish because Chen Cheng-po conceived all his works matte and free of coatings.

填補石膏漿 Filling process

全色完成後 After retouching

IV. 修復前後對照 Before and after treatment

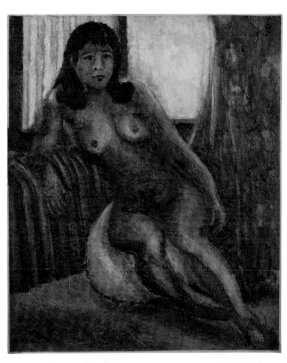

修復前
Before treatment

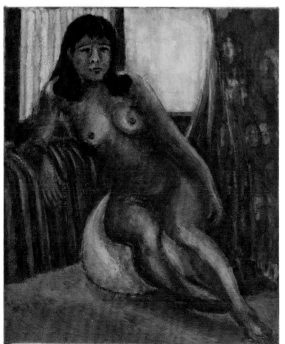

修復後
After treatment

臥躺裸女 Nude in Lying Posture

I. 修復前狀態 Before treatment condition

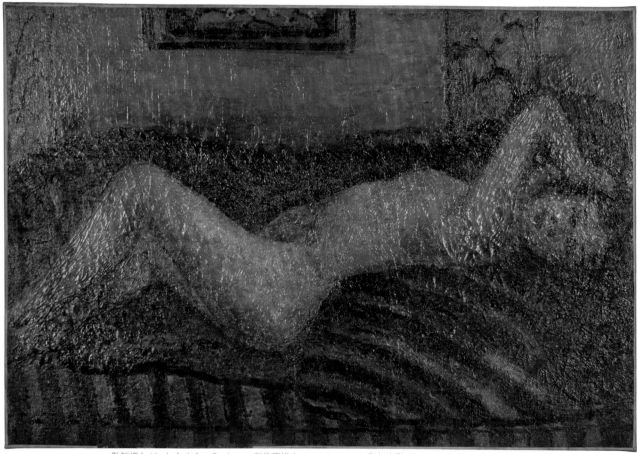

臥躺裸女 Nude in Lying Posture　年代不詳 Date unknown　畫布油彩 Oil on canvas　52.5×77cm

修復紀錄 Conservation history

　　□未曾修復 Not treated before ■曾修復 Previously restored

修復項目 Treatments

　　■畫面保護 Facing □更換固定調整器 Metal adjustors □畫面加固 Consolidation ■畫布托裱 Lining
　　■基底材加固 Support consolidation □調整式內框 New stretcher ■繪畫層清潔 Cleaning
　　■填補缺洞及全色 Filling and retouching ■X光檢測 X- Ray study ■紅外線檢視 IR study ■紫外線檢視 UV study

◎狀況圖 Mapping

　　對於了解畫作整體保存狀態而言，狀況圖是非常實用的工具。在修復進行之前須深入研究作品所呈現的各種病變情形並註明於狀況圖中。透過下面圖示可得知，畫作全面佈滿嚴重的龜裂紋，且多處具有曾與其它畫布或木板重疊放置所造成的壓印痕，還呈現沒有完整填補的繪畫層缺失和前人舊補筆。

　　The mapping is a very useful tool to know about the real condition of the painting. Thus it is fundamental to study every painting deeply and note it in a mapping all different damages the work has before treatment. The below

mappings show there were serious cracks all over the painting, texture imprints caused by being overlapped with other canvas and boards, imperfect filled paint losses and previous retouching.

全面龜裂 Cracking
布的壓痕 Texture imprints
繪畫層沾黏 Attached paint

繪畫層缺失（前修復師無修復工序）
Paint losses（No treatment during previous restoration）

繪畫層缺失（經清潔後，於補筆下的缺失）Paint losses（After cleaning）

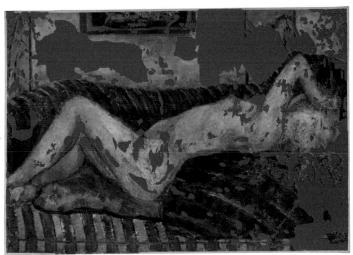

補筆 Previous retouching

II. 修復前檢視登錄與分析 Documentation and analysis

1. 畫作狀況研讀分析 Painting condition study

　　拍照檢視紀錄是也是重要的一環，不同光源的檢測和科學的分析通常運用在記錄細節以及分析作品狀況和使用媒材。就此件畫作而言，X光檢測中發現畫面上綠色毯子區域的構圖曾經有所修改。除此之外，畫面在紫外線的檢測下察覺出許多覆蓋到原始繪畫層上的不當舊補筆。由下面對照的圖示中可觀察出之前的修復補筆比缺失本身的面積還大。

　　Photography documentation is also an important part. Different light examinations and scientific studies are used to record details and analyze the condition and the painting's materials. As for this painting, the X-rays revealed a composition change in the green cover or blanket. Moreover, UV light analysis told us that there were many inappropriate retouching which had been done on the original paint layer. In the comparative images below it can be noted the previous retouching were bigger than the paint losses themselves.

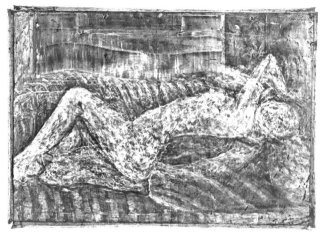

X光檢視顯示構圖曾被改變
The X-ray light shows that the composition was changed

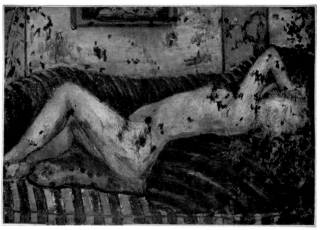

從紫外線照片中可清楚觀察出畫布上顏色較深處為前人舊補筆
Photograph done with UV light. It may see clearly in dark colors all the overpainting the canvas had

以紫外線拍攝舊補筆處
Detail with UV light of previous retouching

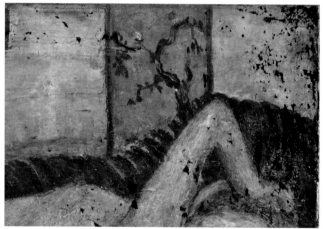

修復後以紫外線拍攝同區域作對照。顯示（左圖）前人舊補筆全色覆蓋面積範圍較大，且舊補筆覆蓋了原有畫面。
Same area under UV light after the painting has been restored. The previous retouching were bigger and they were done covering original surface

而在側光檢視下，則清楚可見嚴重的龜裂痕佈滿整個畫面。此外，在畫面右下方有一斜角的摺痕。

With raking light examination serious cracks were very visible. They presented various forms of cracks. Furthermore, a sign of the canvas being folded showed on the lower right corner of the painting.

側光檢視 Raking light

以側光檢視明顯可見畫作的肌理及裂痕狀況
Detail of the painting texture and cracks using raking light

側光檢視局部可見畫作嚴重的龜裂痕
Detail of severe cracks shown by ranking light

2. 修復前局部狀況 Detail of painting condition

此案例中，之前所做的修復，並未遵守修復標準來達成最佳的修復。從下面不同圖示中可清楚看到繪畫層缺失處，雖已有填補石膏漿，但部分區域全色不完全，且畫面多處呈現不適當的舊補筆，且當時修復人員並沒有模擬畫作肌理，加上有些地方補土與全色顏料覆蓋至畫作原始表面。而畫面上並可見過量的蠟殘留和未填補的繪畫層缺失。

繪畫層缺失處有填補石膏但無全色
Paint losses were filled with stucco but were not retouched

繪畫層剝落與蠟殘留
Unfilled paint losses and wax excess

石膏填補與全色不當
Inappropriate filling and retouching

補色不當之舊補筆覆蓋於畫作繪畫層上
Inappropriate color retouching covering original surface

In this case the previous restoration did not follow the conservation standards to achieve a well-done restoration. In different images below are able to see how the paint losses were filled but not retouched completely, while other previous retouching were applied inappropriately. At the same time, the restorer did not imitate the artist oil texture and also filled and retouched on the original surface. There were wax excess and unfilled paint losses as well.

III. 修復作業內容 Conservation and restoration treatments

1. 畫面保護 Facing

在移除舊的蠟托裱之前，首先需就之後將進行的程序，於畫作上施予繪畫層保護。此步驟是以備好的日本紙及魚膠進行。

Before removing the wax- lining, the facing should be applied first to protect the paint layer from the following procedures. It was done with a treatment of Japanese paper and fish glue.

畫面保護施作完成後全貌
View of the painting when the facing is completed

2. 移除蠟托裱 Removing wax-lining

一旦畫作從內框上卸下後，就開始進行蠟托裱的移除，而這步驟中並沒有使用任何溶劑，以避免溶劑滲入至畫作表面。故採用加熱桌及吸油紙移除蠟，並進行顏色分析來確認過程中並無加深畫作顏色。從下面圖示中可清楚看出畫布上移除殘蠟前後明顯的不同，而所移除的蠟總量頗多。

Once the painting was dismounted from the stretcher, the process of removing the wax-lining started. The procedure was not done with any kind of solvents to avoid its migration to the surface. The hot table was employed with oil-absorbent papers, and colorimetric studies were also done to control any darkening of the colors. The images below show the differences between before and after cleaning. Great amounts of wax were removed.

除蠟過程差異對照
Comparison of removing wax process differences

除蠟過程差異對照局部特寫
Close-up of removing wax process

3. 畫布托裱 Lining

畫布因之前被蠟托裱過，變得非常脆弱，因此需重新以熱塑性黏合劑在加熱吸附桌上，於約70度的溫度下，重新托裱畫作。

Due to the wax lining, the canvas was so brittle and a new lining had to be done with thermoplastic adhesive. This application was carried out by using the vacuum hot able at about 70 degree.

4. 繃內框 Remounting

由於原本的內框是可調整式且狀況良好，所以在托裱後，將畫布重新繃回原有的內框。

After lining, the canvas was remounted back to the stretcher that was expandable and in a good condition.

5. 畫面清潔 Cleaning

清潔是修復中最精密且複雜的一環，因為它是不可復原的步驟，所以過程中不能改變到原始彩繪層。所以需進行不同的測試，為了調配出最佳且安全的清潔溶劑。從圖示中顯示，一旦將厚重且光亮的凡尼斯清除後，藝術家原始的霧面色彩重新看見，在黃線右側方為原有色調。除此之外，基於不明理由，畫作局部塗刷了一層混合藍色墨料的凡尼斯。而且從同區域相對照的圖示可觀察出大於缺失本身範圍的舊補筆。

畫布托裱過程 The lining process

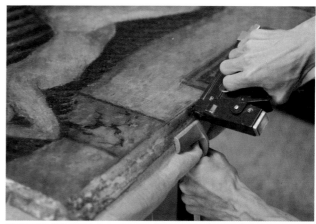

將畫作再次繃於畫框上 Remounting the canvas to the stretcher

The cleaning is one of the most delicate and complicate restoration treatments. Because it is irreversible, thus it can't affect the original colors. Different tests were necessary done to know the best cleaning solution. In images are observed how the artist original matte colors appear once it has been cleaned the heavy and gloss varnish. On the right side of the yellow lines emerge the original colors. In addition, it was noted that previous restoration added blue ink in the varnish by an unknown reason. Moreover, may see that the previous retouching was bigger than the original losses from the comparative images below.

清潔前後差異對照：經畫面清潔與移除舊補筆後呈現畫作原本的色彩
Different details of the cleaning process: original colors appeared after removing previous retouching

清潔前後差異對照：將光亮凡尼斯層清除後恢復藝術家原始美學
Different details of the cleaning process: the glossy varnish was removed and recovered the artist's aesthetic

清潔前後差異對照：由於陳澄波先生從未使用凡尼斯，故將這些在被修復時所添加的凡尼斯塗層清潔移除
Different details of the cleaning process: Chen Cheng-po never conceived his paintings with varnish and the coating applied by a previous restoration was completely removed.

清潔前後差異對照：恢復畫作原始霧面無光澤的特性
Different details of the cleaning process: the characteristic matte surface was possible to recover

清潔前後差異對照：前人修復時在凡尼斯加上藍色顏料，完全改變了畫作原始的色彩 Different details of the cleaning process: the previous restoration added a blue pigment to the varnish. This blue varnish changed and altered the original colors

清潔前後差異對照：前人修復時添加藍色凡尼斯，其動機至今仍不明
Different details of the cleaning process: the use of a blue pigment varnish was a decision made by a previous restorer. The motive of why using it is still unknown

舊補筆已覆蓋住原始畫面（左圖）
Detail of a retouching that was covering original surface

清潔後在畫面缺失處下方可見綠色顏料，藝術家創作的風貌原始呈現（右圖）
After cleaning, the green pigment is visible below the screen. The artist matte surface was recovered

6. 繪畫層缺損處補土全色 Filling and retouching

在畫面清潔後，於繪畫層缺失處，以動物膠及石膏調製而成的石膏漿模擬仿造周圍原始的紋理予以填補，使之與畫面整體肌理連貫一致。之後，遵循修復準則在填補處以修復專業用水性顏料進行全色。此計畫中的所有畫作皆於全色後，完成修復工序，並無增添任何凡尼斯層，因為陳澄波先生創作概念是維持霧面無光澤的色調，不添加任何塗層於作品表面。

After cleaning, the paint losses were filled with stucco, made of gesso and animal glue. The filling imitated the paint surface to reach the original textures. Then, the retouching was applied with reversible water based color on the lacunas, following conservation standards. As all the paintings of this project, the restoration process finished with the retouching without adding varnish because Chen Cheng-po conceived all his works matte and free of coatings.

填補石膏漿 Filling process　　　　　　全色完成後 After retouching

填補石膏漿 Filling process　　　　　　全色完成後 After retouching

填補石膏漿 Filling process　　　　　　全色完成後 After retouching

129

IV. 修復前後對照 Before and after treatment

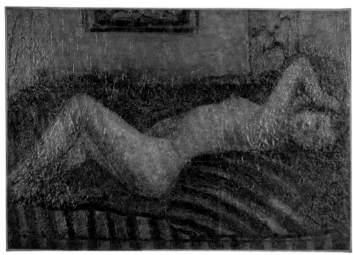

修復前 Before treatment

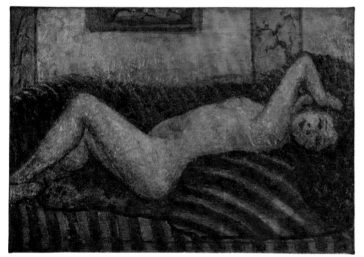

修復後 After treatment

貯木場 A Lumberyard

I. 修復前狀態 Before treatment condition

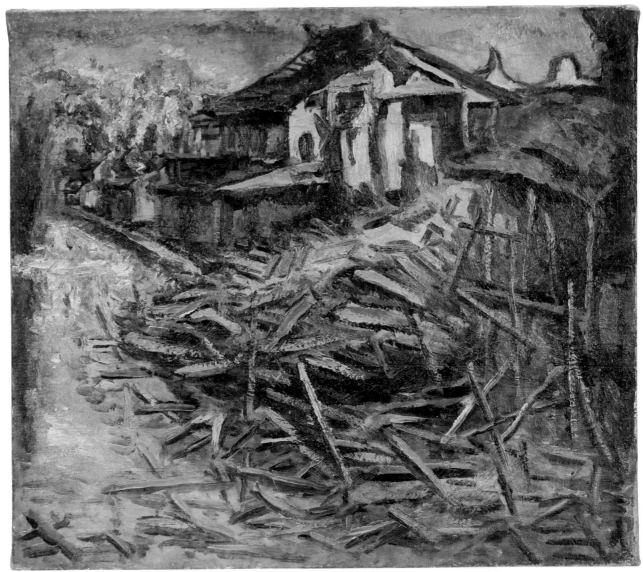

貯木場 A Lumberyard　年代不詳 Date unknown　畫布油彩 Oil on canvas　45×52.5cm

修復紀錄 Conservation history

□未曾修復 Not treated before ■曾修復 Previously restored

修復項目 Treatments

■畫面保護 Facing □更換固定調整器 Metal adjustors □畫面加固 Consolidation ■畫布接邊 Strip-lining

■基底材加固 Support consolidation □調整式內框 New stretcher ■繪畫層清潔 Cleaning

■填補缺洞及全色 Filling and retouching ■X光檢測 X- Ray study ■紅外線檢視 IR study ■紫外線檢視 UV study

　　修復前的狀況圖是用來協助修復人員明瞭有可能會面臨的畫作受損情形，且能全面性的顯示畫作的狀況。就此案例，從狀況圖中可見畫作整體保存狀態不佳，遍佈嚴重的龜裂紋及山型裂痕，以及先前修復過填補不完整的繪畫層缺失處及不完善的補筆，和許多顏料層被壓扁的壓痕，及其他畫布疊放其上而留下的印痕。此外，厚重光亮的凡尼斯塗層也明顯可見。

　　The mapping is a useful tool to aware of all kinds of damages the painting's conservator may face. It shows the condition of the canvas integrally. In this case, it can be seen that the artwork was general in a bad condition from the mappings below. There were serious cracks and tenting cracks, imperfect filling and retouching from the previous restoration, and also many crushed impasto and texture imprints. Moreover it presented a gloss layer of varnish.

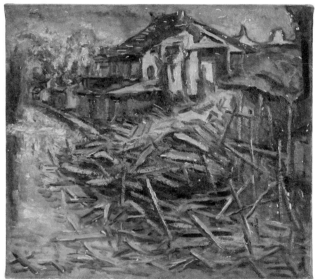

壓痕（顏料遭擠壓）Crushed impasto
壓痕（布壓印）Texture imprints
蠟殘留 Areas with wax accumulation
指紋痕 Finger-prints

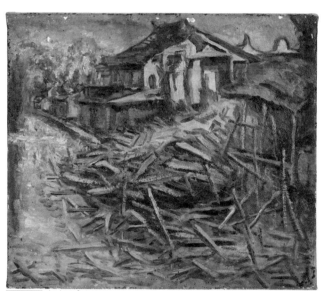

有填石膏無全色
Areas with filling but without being retouched
繪畫層缺失（前修復師無修復工序）
Paint losses (No treatment during previous restoration)
補色範圍過大，明顯覆蓋周圍繪畫層
Previous retouching applied on original paint layer

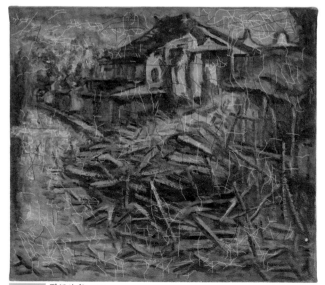

髒汙沾黏 Dirt
空鼓型裂痕 Tenting cracks
裂痕 Cracking

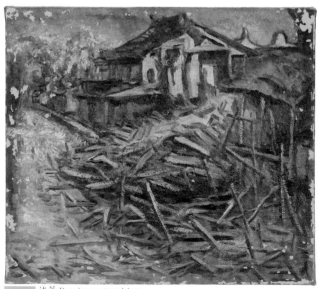

補筆 Previous retouching

II. 修復前檢視登錄與分析 Documentation and analysis

1. 畫作狀況研讀分析 Painting condition study

藉由科學儀器的協助，可用非破壞性方式來深入分析研究所有畫作。這幅作品以X光檢測後而察覺畫面底下，另有一半身的裸女繪畫層。再者，紫外線照射下則可清楚地觀察到畫作多處呈現先前修復補筆的痕跡及凡尼斯塗層。

With the help of scientific instruments, every painting can be studied deeply by a non-destructive way. It was revealed that there is an underneath painting, a half portrait of a nude woman with X-Ray examination. Besides, previous retouching and varnish can be observed clearly under UV light.

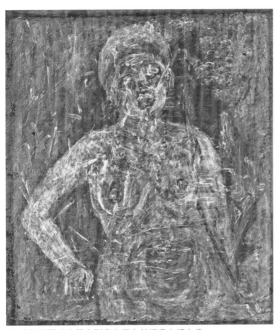

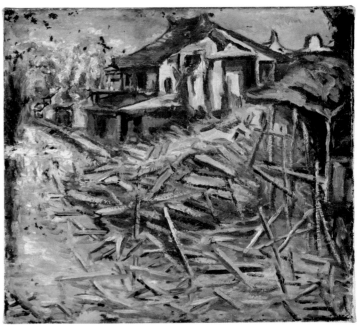

從X光檢視圖片中觀察到畫布下方曾經畫有裸女像
Image of X-Ray photography. The canvas was used before to paint a nude female.

紫外線檢視：從顏色較深處可見一些舊補筆
View of the painting using UV light. Several retouching may be seen in darker color

對照在自然光下及紫外線下所拍攝的照片，能清楚的辨別出之前修復舊補筆的所在位置。

It can determine the location of previous retouching precisely by comparing the photos taken with nature light and UV light.

以自然光拍攝舊補筆處
Detail of a retouching using nature light

在同位置以紫外線拍攝舊補筆
Detail of the same retouching using UV light

133

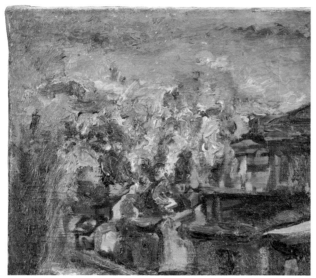
以自然光拍攝舊補筆處
Detail of a retouching using nature light

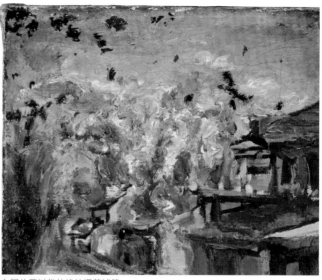
在同位置以紫外線拍攝舊補筆
Detail of the same retouching using UV light

而使用不同擺放位置的光源拍攝也能助於瞭解作品的各種類型的病變問題。如在正面光照射下，可清楚地觀察到髒污和繪畫層剝落，而山型裂痕則在側光檢視下清晰可見。

It is useful to observe the painting by setting up lights in different positions. In front light examination, it was note a deposit of dirt and paint losses. And with raking-light, the tenting cracks were seen clearly.

以正面光檢視可見畫面上堆積的灰塵及光亮的凡尼斯
The use of front light tells us the painting surface condition as deposit of dirt and glossy varnish

以側光檢視清楚可見高隆的肌理及山型龜裂痕
View of high texture and cracks using raking light

2. 修復前局部狀況 Detail of painting condition

近距離拍攝的照片則呈現紀錄畫面各種不同的劣化情形，例如積存的污垢、繪畫層缺失和裂痕。同時也清楚地觀察到沒有遵循修復原則且顏色與原始色調不相似的不完善舊補筆。這些先前的補筆不只有些超出缺失範圍之外，有些還未完全覆蓋住填補處。

The close photos showed various damages the painting had, such as a deposit of dirt, paint losses and cracks. It was also noted that previous inappropriate retouching did not follow conservation standards, they presented in different tone of color without reaching the original one. The previous retouching was either painted over the losses areas or did not cover the filler completely.

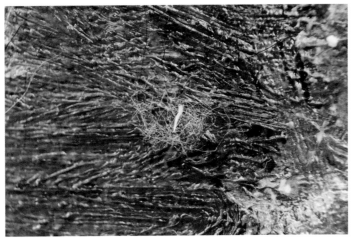

繪畫層髒污 Dirt

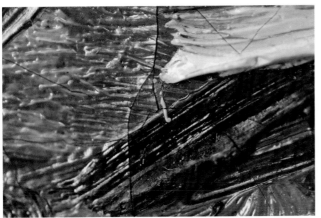

繪畫層缺失 Paint losses

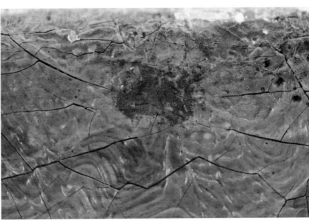

補色不當 Inappropriate retouching

補色不完全
Imperfect retouching

補色不當：與原始色彩不吻合
Inappropriate retouching. The colors do not match the original

III. 修復作業內容 Conservation and restoration treatments

1. 畫面保護 Facing

以日本紙及適當比例魚膠保護繪畫層避免在接下來的修復過程中受到損害。

For protecting the paint layer from the following procedures, a facing was applied to the paint surface with Japanese paper and fish glue.

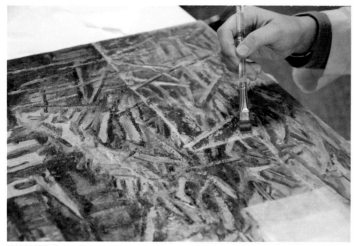

畫面保護施作 Facing process

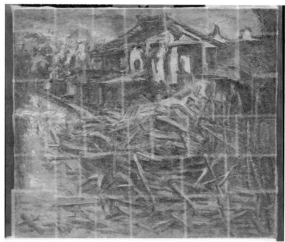

畫面保護施作完成後全貌
View of the painting when the facing is completed

2. 拆除內框 Dismounting

一旦畫面保護完成且乾燥後，即可將畫作從畫框上拆卸下。經檢視畫布狀況良好，且發現到畫作背面有藝術家的姓氏及一些草圖，然而，在舊接邊的畫布邊緣有大量的膠殘留。

Once the facing was done and dried, the painting was dismounted from the stretcher. The canvas was in a fair condition. Besides, some drafts and artist's family name were noted on its back. However there were huge amount of glue left on the edges of the previous strip-lining.

畫布背面 The back of the canvas

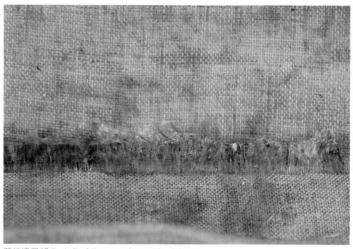

舊接邊局部 Detail of the previous strip-lining

揭除畫布舊接邊 Removing the previous strip-lining

3. 移除舊接邊 Removing the previous strip-lining

以小平頭熨斗加熱，輔以鉗子及修復專用小刮刀將舊接邊緩緩移除。並將畫布邊緣處所殘留的蠟完全清除。

After adding heat with the small iron, the previous strip-lining was removed by using pliers and small spatula for conservation. The remaining adhesive on the edges of the painting was removed as well.

4. 背面清潔
Cleaning the back of the painting

以物理性乾式清潔及修復專用吸塵器去除畫作背面髒污及塵埃。

A physical dry cleaning was applied on the back of the painting with a special vacuum cleaner for conservation to eliminate the dirt and dust.

清潔畫布背面 Cleaning of the back of the canvas

5. 畫布接邊 New strip-lining

因畫作背面有藝術家的手稿且畫布狀況尚佳，因此選擇增加布邊方式來強化畫布的支撐力。故以熨斗及熱塑性黏合劑來進行畫布接邊。

Having the artist's sign on the back of the painting and knowing the condition of the canvas was good enough, the strip-lining was chosen to provide additional support to the canvas. The strip-lining was done with thermoplastic adhesive applied by an iron.

畫布接邊過程 During the process of applying strip-lining

6. 護紙清除 Removing the facing

在完成畫布接邊步驟後，以溫水將保護畫面用的日本紙緩緩且仔細地清除，然後再次將畫作繃回原本狀況良好的內框上。

After finishing the strip-lining, the Japanese paper facing was removed from the surface gradually and carefully with warm water. Then, the painting was remounted back on the stretcher which was still in good condition.

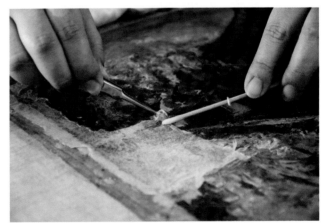

護紙清除 Removing the facing

7. 畫面清潔 Cleaning

畫面清潔是非常重要且須小心的程序，以不影響原始顏色為原則。因此，不同的測試可以讓我們清楚何種清潔溶劑對畫作是安全的。畫作上全面堆積了污垢及具有油亮反光的凡尼斯層。清潔後，畫作重新顯露出原有的霧面色彩。且在清潔過程中，可發現之前修復的全色範圍大於既有的繪畫層剝落範圍。

The cleaning is a delicate process that should be done without affecting the original colors. For this reason, different tests were applied to know the best cleaning solution. This painting had deposits of dirt and gloss varnish. The original matte colors were recovered after the cleaning . During this process, it was also observed that the previous retouching was bigger than the original paint losses.

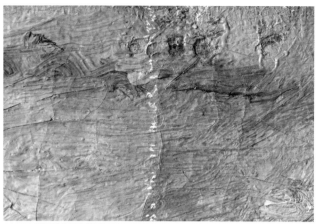

清潔前後差異對照 Different details of the cleaning process

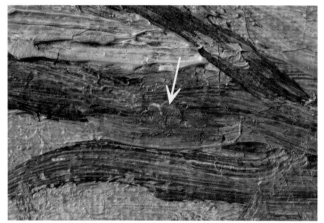

清潔前細部：明顯看出與原始顏色不吻合
Detail Before cleaning. The retouching did not match the original colors

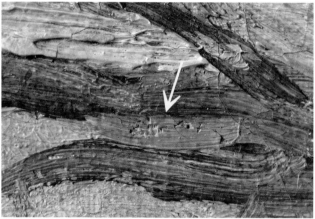

清潔後細部：缺損處面積比前修復者舊補筆範圍小
Detail after cleaning. The losses were smaller than the retouching done by a previous restoration

清潔前細部：舊補筆已超出於畫作的缺失範圍並直接覆蓋在畫面上，且缺損處填補覆蓋並不完全 Detail before cleaning. The retouching beside being on original surface, it did not cover properly the filling

清潔後細部：較小範圍的缺失及原始色彩完全呈現
Smaller losses and original colors appeared after the cleaning process

8. 繪畫層缺損處補土全色 Filling and retouching

繪畫層缺失處以石膏及動物膠調合的石膏漿進行填補，填補時需模擬仿製畫面以吻合作品本身的表面肌理，然後以可逆性水性顏料進行全色。全色之後，修復即告完成。因尊重藝術家想表現的美感，所以並無添加任何保護層。

The paint losses were filled with stucco, made of gesso and animal glue. The fillings were imitating the paint surface to match the original textures. Then, the retouching was applied with water based reversible colors. After retouching, the restoration process was ended without adding any coating, respecting the original artist's aesthetic.

填補石膏漿 Filling process

全色完成後 After retouching

填補石膏漿 Filling process

全色完成後 After retouching

填補石膏漿 Filling process

全色完成後 After retouching

填補石膏漿 Filling process

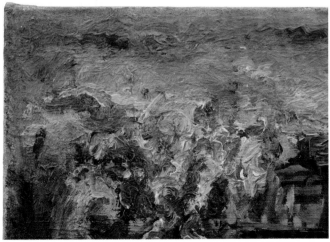

全色完成後 After retouching

IV. 修復前後對照 Before and after treatment

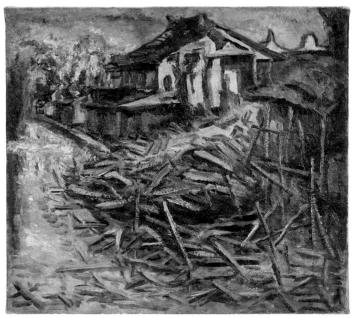

修復前 Before treatment

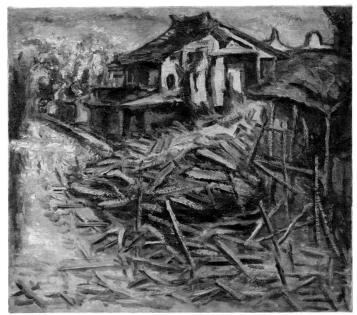

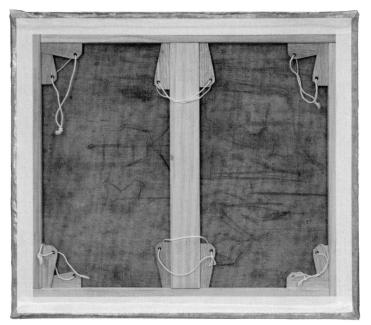

修復後 After treatment

上海碼頭 Shanghai Dock

I. 修復前狀態 Before treatment condition

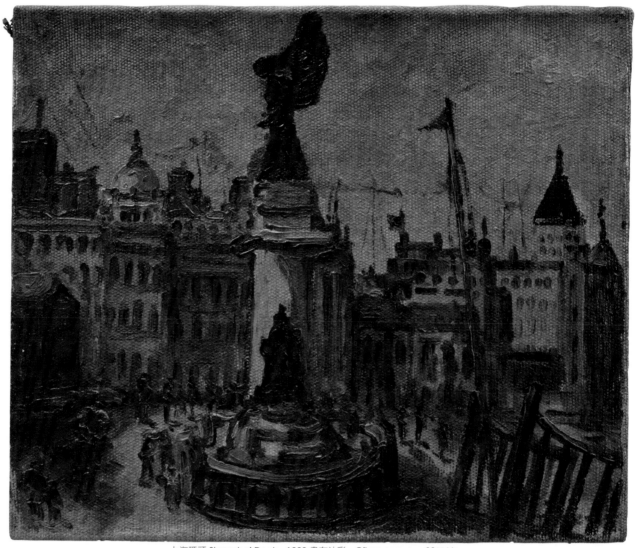

上海碼頭 Shanghai Dock　1933 畫布油彩　Oil on canvas　38×46cm

修復紀錄 Conservation history

　　□未曾修復 Not treated before ■曾修復 Previously restored

修復項目 Treatments

　　■畫面加濕攤平 Flattening ■畫面保護 Facing ■畫面加固 Consolidation ■畫布接邊 Strip-lining

　　□基底材加固 Support consolidation □調整式內框 New stretcher ■繪畫層清潔 Cleaning

　　■填補缺洞及全色 Filling and retouching ■更換固定調整器 Metal adjustors ■X光檢測 X-Ray study

　　■紅外線檢視 IR study ■紫外線檢視 UV study

II. 修復前檢視登錄與分析 Documentation and analysis

1. 畫作狀況研讀分析 Painting condition study

　　在進行任何修復之前，必需要檢視登錄畫作狀況，以協助我們更進一步的了解作品，而修復全程的紀錄也可以幫助我們清楚知道修復前後的差異。根據不同光源的檢視，塗佈於繪畫層表面的黃化厚重凡尼斯清晰可見，且其上堆積著灰塵及污垢。進一步，則從紫外線照射下觀察到許多不完善的舊補筆。

　　Before applying any treatment, it needs to document the painting's condition to help us to know better the artwork. It is also useful to record the difference between before and after restoration. According to the use of several light examinations, it was able to see a heavy varnish layer applied on the painting, besides it was also covered with dirt and smoke. With UV light, a previous retouching was revealed.

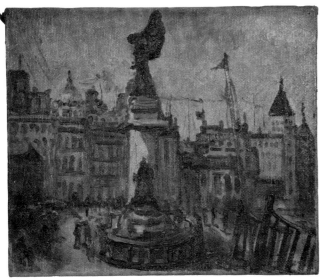

正面光拍攝，可見過量凡尼斯塗佈，引起明顯反光
View of the painting using front light. Huge reflection caused by an excess varnish may be seen

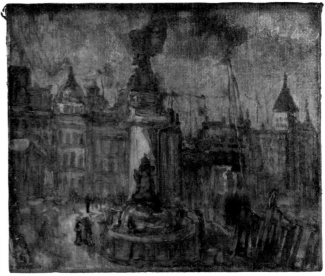

經紫外線檢視可見多處補筆
View of the painting using UV light. Some retouching were detected

正常光下拍攝的補筆
View of a retouching area under front light

同位置紫外線下拍攝的舊補筆
View of the same retouching using UV light

2. 修復前局部狀況 Detail of painting condition

　　該畫作呈現因基底材織紋老化所造成的裂痕，但是這些裂痕非常的細小需近距離觀察才能察覺。且堆積了大量的塵埃及髒污，經仔細觀察後得知畫作的基底材是以一經二緯的方式織成的畫布，這並非陳澄波先生常使用的類型。除此之外，畫作曾經於顏料還未乾時與其他畫作重疊置放，因此作品彩繪層上有被其他畫布

壓印上的痕跡。之外，添加於畫面上的不均勻凡尼斯層可明顯觀察出。

The painting had cracks caused by the aging and weave of the support, but they were thin and only visible upon close inspection. Huge deposits of dust and smoke were noted as well. It was seen that the support is made in 1 welt - 2 warps weave and it was not a common canvas used by Chen Cheng-po. In addition, the painting was placed with other painting, one next another, while the colors weren't dried completely, thus some texture imprints of other canvas left on the paint layer. The varnish applied on the painting was not homogeneous as well.

因特殊基底材所導致紋理的裂痕
Close-up of cracks caused by the specificity of the support

裂痕及污垢 Cracks and dirt

筆觸上的布紋肌理是與另一塊畫布接觸造成的印記
Detail of Texture imprints made by being in contact with another canvas

嚴重髒污沾黏 Heavy deposit of dirt

所支撐的畫布屬一經二緯特殊織法
Detail of the support weaving using 1welt-2warps.

凡尼斯塗佈不均 Not homogeneous Varnish

III. 修復作業內容 Conservation and restoration treatments

1. 畫面保護與加固 Facing and consolidation

　　為保護繪畫層因接下來的修復程序免於受損，需以日本紙及魚膠覆蓋於畫作表面進行畫面保護程序。接著，當保護用紙靜置待乾後，使用小型平頭式修復用熨斗於其上適當加熱使魚膠滲入畫作中以加固穩定彩繪層。

　　Facing was applied to protect the paint layer from the successive procedures. It was an application of Japanese paper and fish glue to the paint surface. Once the facing dried, consolidation was carried out by adding heat with a small iron delicately to make the fish glue permeate into the painting to consolidate color layer.

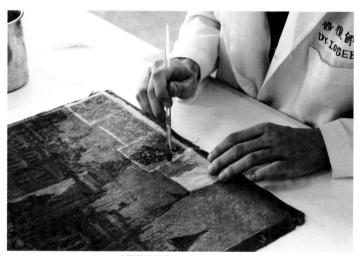

畫面保護施作 Facing process

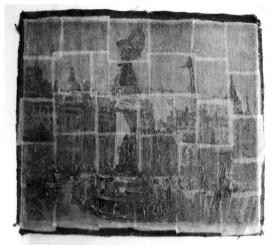

畫面保護施作完成後全貌
View of the painting when the facing is completed

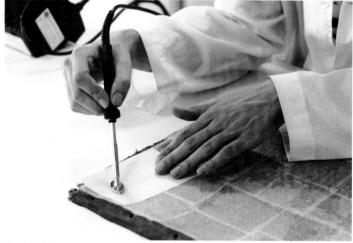

畫面保護後加固過程
View while the painting is being consolidated

2. 背面清潔 Cleaning of the back of the painting

　　以修復專用吸塵器，針對畫作背面進行物理性乾式除塵，圖示中黃線下方為清潔後的畫布。

　　A physical dry cleaning was done on the back of the painting with the special vacuum for conservation. In the image, the area below the yellow lines showed the canvas after cleaning.

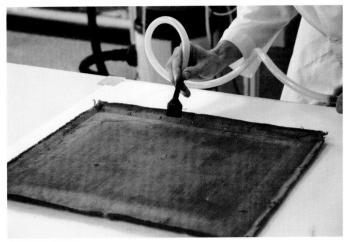

畫布背面清潔過程
Cleaning the back of the painting

畫布背面清潔前後對照
View of the canvas before and after the cleaning

3. 畫布接邊 Strip-lining

　　當畫作基底材安全穩定及繪畫層牢固後，將四周畫布進行接邊使畫布再次延伸。

　　Due to the painting support that was in good condition and the paint layers were also stable, a strip-lining was chosen to be able to stretch it again.

4. 護紙清除 Removing facing

　　當所有施加於畫布背面的結構性修復步驟完成後，可將畫作表面暫時性保護移除，利用適當溫度的溫水緩緩將貼覆於畫作表面的日本紙移除。

　　After the structural treatments on the back of the painting were done, the facing could be removed from the surface of the painting. It was used warm water to remove the Japanese paper gradually and carefully.

畫布接邊 Strip-lining

5. 重繃畫布 Remounting

　　除了畫作原始內框已為可調整式且狀況尚佳之外，內框背面上有畫作名稱書寫於其上，

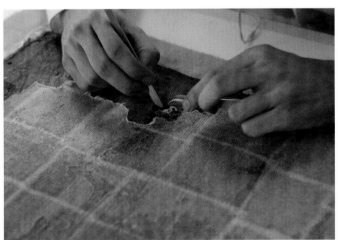

護紙清除過程 Detail while removing the facing

因此我們保留延用原始的內框，但首先需針對內框進行一些修復程序，例如填補鐵釘拔起後的孔洞，同時也加固黏合原木裂開處。

　　The original expandable stretcher was in fair condition, and also the title of the painting was written on the back. As this reason, the canvas was remounted again on the original stretcher. But some treatments needed to be done on the stretcher first, such as filling the holds left after taking off the nails. At the same time, some wood breaks were also consolidated.

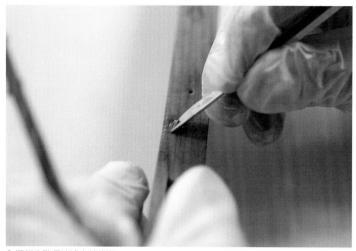

內框釘痕孔洞填補木料填泥
Filling the holes of the stretcher

內框木條開裂處加固
View of the consolidation process to recover its functionality

將畫布重新繃於內框上
Image while stretching the canvas

背面修復前細部
View of back of the canvas
before treatments

背面修復後細部
View of back of the canvas
after treatments

6. 作品背面修復前後局部比較 Detail of the back of the painting before and after treatment

在內框背面有以中文書寫的「上海外灘碼头」字樣，因此在以無酸背膠帶進行畫布收邊時，需避開此區域，使之顯露出。

There is a handwriting "The Bund, Shanghai Dock" in Chinese on the back of the stretcher, so an acid-free tape was fixed in a way to avoid covering it.

7. 畫面清潔 Cleaning

在經多次測試後，以擇選適當安全且不影響繪畫層表面的清潔溶劑。畫作原有明亮色調在移除黃化凡尼斯之後，重新顯露出來。從下面各張的圖示中皆可察覺清潔前後明顯的差異。

After several tests, the most appropriate solvent was chosen without affecting the paint surface. After removing

清潔前後差異對照：泛黃凡尼斯完全被移除
Different details of the cleaning process: the yellowing varnish was completely removed

the yellowing varnish, the original colors were revealed again. The differences between before and after cleaning are obvious in the images below.

8. 繪畫層缺損處補土全色 Filling and retouching

　　繪畫層缺失處則以兔膠及硫酸鈣進行填補，而填石膏漿時需模擬塑造畫作表面肌理使之與周圍畫面接連，並以水性顏料在遵循修復規範下進行全色。此外，對照下面的兩張圖片，可看出先前修復的補筆與此次修復的全色，二者之間的差異性，補色時應模擬仿照周圍原始的色彩。最後，由於藝術家並沒有將其畫作塗佈凡尼斯的習慣，因此修復後保留作品原有的霧面無光澤色調。

The losses on the paint layer were filled with stucco which was made of rabbit glue and gesso. The filler imitated the surface texture of the painting to connect with the surrounding original one. Then, the retouching was done with water based colors following conservation standards. Moreover comparing the two images below, it was noted the difference between the previous retouching and the new one. The retouching is supposed to respect the original colors. In the end, since the artist hadn't used to add varnish coating, this painting was kept its matte color texture.

未修復前畫作表面狀況
Painting surface before being restored

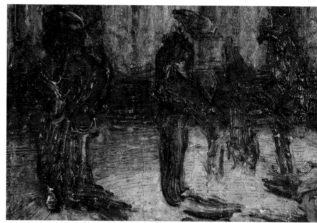

同位置修復後表面狀況
The same painting surface after being restored

填補石膏漿 Filling process

全色完成後 After retouching

填補石膏漿 Filling process

全色完成後 After retouching

IV. 修復前後對照 Before and after treatment

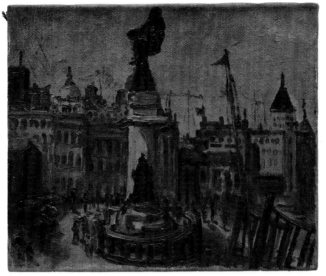

修復前 Before treatment

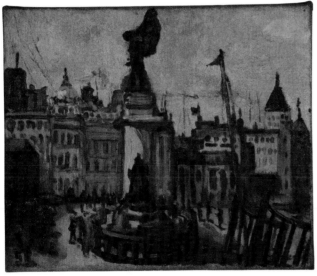

修復後 After treatment

淑女像 Portrait of a Lady

I. 修復前狀態 Before treatment condition

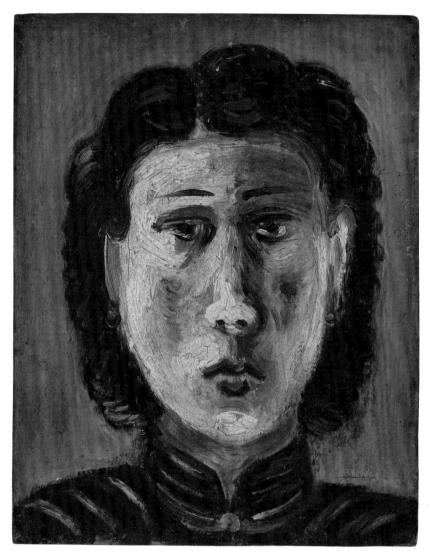

淑女像 Portrait of a Lady
年代不詳 Date unknown
木板油彩 Oil on wood
26.9×21.3cm

修復紀錄 Conservation history

■未曾修復 Not treated before
□曾修復 Previously restored

修復項目 Treatments

□畫面保護 Facing
□更換固定調整器 Metal adjustors
□畫面加固 Consolidation
□畫布托裱 Lining
□基底材加固 Support consolidation
□調整式內框 New stretcher
■繪畫層清潔 Cleaning
■填補缺洞及全色 Filling and retouching
■X光檢測 X- Ray study
■紅外線檢視 IR study
■紫外線檢視 UV study

II. 修復前檢視登錄與分析 Documentation and analysis

1. 畫作狀況研讀分析 Painting condition study

　　畫作經X光拍攝鑑識，基底材上並無任何跡象顯示曾被重繪過。而且藉由紫外線拍攝檢測後，也無前人舊補筆反映跡象。

　　According to the X-Ray examination of the painting, there is no sign of the support that has been revealed. The UV light did not show any previous inpainting either.

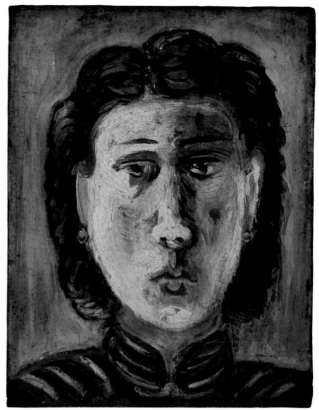

X光檢視：無其他底層畫作
X-Ray light: there is no underneath painting

紫外線檢視：無舊補筆
UV light: the painting doesn't have any retouching

2. 修復前局部狀況 Detail of painting condition

　　畫作全面呈現嚴重髒污，且因為藝術家的創作技法導致些許裂痕。作品整體狀況良好，畫面呈現毫無光澤的色調，可見多處昆蟲排遺的現象。

　　The painting was so dirty and had some cracking due to artist's technique. However, the painting condition was good and presented a very matte surface, but it was found many insect excrements on the painting.

昆蟲排遺（顆粒狀）Insect excrements（granules）

昆蟲排遺（顆粒狀）Insect excrements（granules）

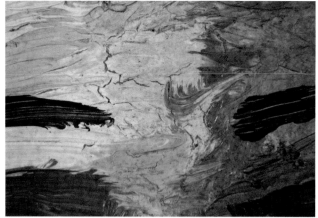

灰塵髒污及裂痕 Dirt and cracks

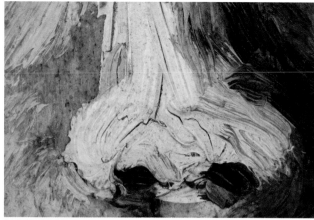

灰塵髒污及裂痕 Dirt and cracks

灰塵髒污、裂痕及昆蟲排遺 Dirt, cracks and insect excrements

壓痕、裂痕與髒污 Crushed impasto, cracks and dirt

各種不同狀況的昆蟲排遺（稀軟狀）Different details of insect excrements（clay-like）

III. 修復作業內容 Conservation and restoration treatments

1. 畫面清潔 Cleaning

利用修復專業用泡棉以物理性方式清潔背面，將堆積於木板上的污垢移除，並使用經測試後所調配之安全溶劑來清潔正面繪畫層，使之還原乾淨色彩。且於清潔後保留作品原有的無光澤色調。

A physical dry cleaning was chosen to remove the dust from the back of the painting with a conservation sponge. After several tests a special soap was used to clean the surface and recover the colors. After the cleaning, the matte surface of the painting was kept.

以修復專業用橡皮泡棉輕輕去除畫作背面灰塵髒污
Detail while cleaning the back of the painting with a conservation sponge

清潔前後差異對照 Different details of the cleaning process.

2. 繪畫層缺損處補土全色 Filling and retouching

　　於畫面左方及右上方缺失處填入以兔膠與硫酸鈣調和而成石膏漿，並塑造出畫作原有的肌理狀態。全色則以水性可逆專業顏料進行，並秉持著保留古色最高準則進行全色，修復工作於此完成。

　　The losses on the left, right and upper sides of the painting were filled with stucco made of rabbit glue and calcium sulfate. The texture of the surface was imitated to reach the original one. The retouching was applied with water based conservation colors. The restoration finished with the retouching and the patina of the painting may be observed.

填補石膏漿 Filling process

全色完成後 After retouching

填補石膏漿 Filling process

全色完成後 After retouching

IV. 修復前後對照 Before and after treatment

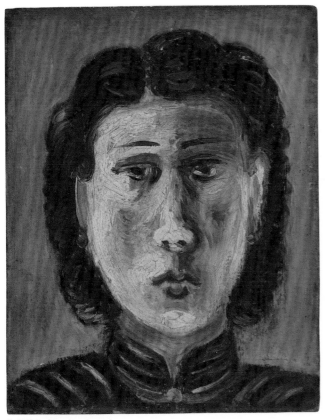

修復前 Before treatment

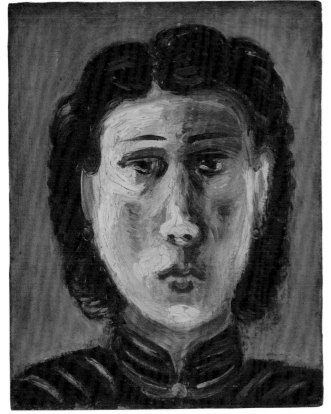

修復後 After treatment

船艙內 Inside the Cabin

I. 修復前狀態 Before treatment condition

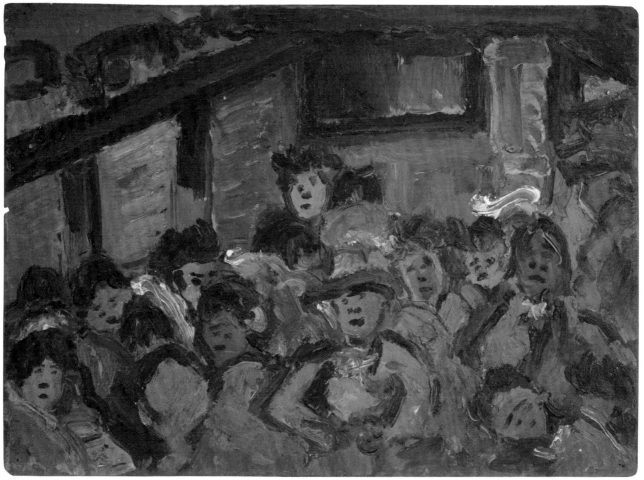

船艙內 Inside the Cabin　年代不詳 Date unknown　木板油彩 Oil on wood　23.8×33cm

修復紀錄 Conservation history

■未曾修復 Not treated before □曾修復 Previously restored

修復項目 Treatments

□畫面保護 Facing □更換固定調整器 Metal adjustors □畫面加固 Consolidation □畫布托裱 Lining

■基底材加固 Support consolidation □調整式內框 New stretcher ■繪畫層清潔 Cleaning

■填補缺洞及全色 Filling and retouching ■X光檢測 X-Ray study ■紅外線檢視 IR study ■紫外線檢視 UV study

II. 修復前檢視登錄與分析 Documentation and analysis

1. 畫作狀況研讀分析 Painting condition study

透過不同的檢測與分析對畫作的判讀是有幫助的，根據紅外線、紫外線及X光拍攝檢視下，從中發現畫

作並無底稿、舊補筆、凡尼斯或隱藏的繪畫層的反應，由此可知此畫作並沒有被修復過。

Different examinations were useful to research and determine the painting deeply. According to infrared light (IR), ultraviolet light (UV) and X-Ray studies, there were no manuscript, retouching, varnish or underneath painting. The painting was not restored before.

X光檢視：無其他底層畫作
X-Ray light: there is no underneath painting

紫外線檢視：無任何補筆
UV light: the painting doesn't have any retouching

紅外線檢視：無底稿
IR light: the painting doesn't have any manuscript

2. 修復前局部狀況 Detail of painting condition

該畫作是繪製於木板上的油畫，其狀況尚佳。明顯的劣化狀況是沉積的髒污及塵埃，且畫作左方區域有一不明的繪畫層及基底材缺失狀況。在畫面左右方角落上方有些許昆蟲的排遺。除此之外，因為在繪畫層未完全乾燥時曾經與其他木板疊放，導致厚塗處顏料部分有被壓扁的狀況。

This painting is an oil color on wooden board. The condition was generally good. The obvious degradation was serious deposit of dirt and smoke. On left area of the painting, an unknown loss of paint and support was noted. There were insect excrements on the upper left and right corner. In addition, there were some crushed impastos as result of being placed under some flat board while the colors didn't dried completely.

昆蟲排遺 Insect excrements

不明鑿痕 Unknown mark

灰塵髒污與壓痕 Dirt and crushed impasto

灰塵髒污與裂痕 Dirt and cracks

3. 修復前基底材局部狀況 Detail of the support condition

畫作基底材是木製板，其背面顯現裂縫及破損狀況明顯可見，且上面堆積著厚重的灰塵。

The support of the painting is wooden board. It showed breaks and cracks on the back and it was covered with heavy dust as well.

基底材破裂與灰塵沾黏 Fractures and dirt

基底材破裂與灰塵沾黏 Fractures and dirt

III. 修復作業內容 Conservation and restoration treatments

1. 畫面清潔 Cleaning

　　畫作背面進行物理性的乾式清潔，以修復專業用海綿移除畫作背面污垢。至於畫作表面清潔，在經多種不同的溶劑溶解度測試後，選擇使用修復專業用皂性溶劑移除污垢，從圖示中可看出繪畫層清潔前後的明顯差異。在清潔完全後，曾經被厚重的髒污給覆蓋住的美麗色彩重新顯露出來。

　　A physical dry cleaning was applied on the back of the support. This procedure was done with a conservation sponge to remove the dirt from the back of the painting. As for the cleaning of the paint surface, a special soap was chosen to clean the surface after different tests. The difference between before and after cleaning was obvious. The original beautiful colors appeared after cleaning, which had been altered by deposit of dirt.

以修復專用橡皮海綿輕輕去除畫作背面灰塵髒污
View of the process of cleaning the back of the painting with a conservation sponge

清潔前後差異對照：髒污及昆蟲排遺已完全清除
Detail of the cleaning process: all the dirt and insect excrements were removed

清潔前後差異對照：清潔後恢復畫作原有顏色和古色
Detail of the cleaning process: the colors and patina were recover

2. 基底材填補 Filling support losses

　　而基底材缺失處則以木質修復專用環氧樹脂填補。然後再以兔膠及石膏製成的石膏漿填補於其上，並塑造畫作表面肌理。接著，以修復專用水性顏料模擬周圍顏色進行全色，也注意到此畫作四角有曾經使用畫布針所留下的圓形印痕和孔洞。

The losses of support were filled with a special epoxy resin paste for wood. Then, it was filled with stucco made with rabbit glue and gesso. The filling imitated the paint texture and it was retouched with conservation colors to reach the support surrounding. There is also a canvas pin printed on the paint surface and its corresponded hole.

基底材缺失處填補修復專用環氧樹脂填料
Filling the support losses with epoxy resin paste

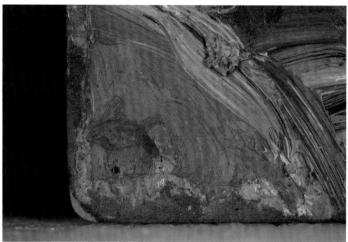

左下方基底材缺失處填補修復專用環氧樹脂填料
The corner of the board that has been filled with epoxy resin paste

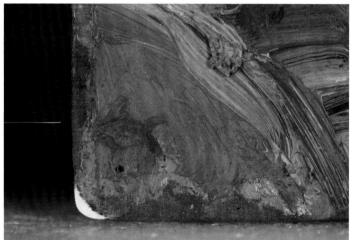

於修復專用環氧樹脂填料填補處覆上石膏漿
The stucco filling on the epoxy resin paste

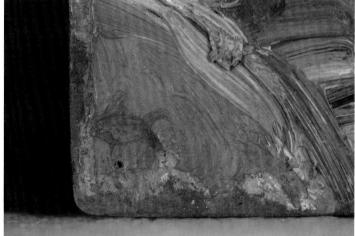

於圓形印痕及孔洞周圍處完成全色
View once the filling has been retouched around the printed canvas pin

　　此外，針對於畫作的修復分析及研究，有助於了解關於藝術家技術上與組織上的特色。在畫作的各角落有一圓狀壓印痕跡且其中間有一孔洞，這損傷揭露出陳澄波先生將畫作從創作處攜回工作室時所用的方法。由於藝術家習慣在戶外創作，因此，須盡可能地使用最安全的運送方式或攜帶畫作的器具將未乾的畫作搬回工作室。而剛完成的作品需要使用工具以避免因攜帶運送時可能造成的毀壞，因此開始使用畫布針。而這金屬畫布針的型式是把6公厘的2端頭針釘入畫框當作撐具，將二件畫作正面對正面的固定，使之能一起運送，然而這類型的設備則會在畫作上形成孔洞且擦傷到畫作表面。

　　In addition, the restoration study carried out on the paintings let us know technical and organizational aspects of the artist. At the corner it is printed a circle with a hole. These damages demonstrate how Chen Cheng-po moved the painting from the place he painted to his studio. The artist had the habit to paint outdoor, so he needed to bring the

paintings back to the workshop when it was still damp. He had to use a transportation system or a painting carrier to be able to move them as safely as possible. Transporting a freshly painted canvas required a tool to make it portable without mess, and the artist started to use canvas pins. The metallic canvas pin had two nails of 6mm to drive into the stretchers to be able to move two paintings at the same time placed face to face, so it is a system that drills the paintings and scratches the surfaces.

畫布針 Canvas pin

3. 繪畫層缺損處補土全色 Filling and retouching

　　繪畫層缺失處則以兔膠及硫酸鈣所調和的石膏漿進行填補，然後在其上全色。石膏漿需塑造畫作肌理，全色則以具可逆性修復專業用水性顏料進行，修復工作即告完成。

　　The paint losses were filled with stucco made of rabbit glue and gesso, and retouched. The texture of the filling imitated the original one. Then the retouching was done with water-based reversible colors. After retouching, the restoration treatments were completed.

填補石膏漿 Filling process

全色完成後 After retouching

填補石膏漿（左圖）Filling process
全色完成後（右圖）After retouching

IV. 修復前後對照 Before and after treatment

修復前 Before treatment

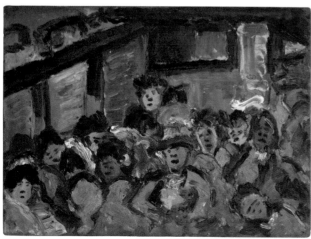

修復後 After treatment

運河 Canal

I. 修復前狀態 Before treatment condition

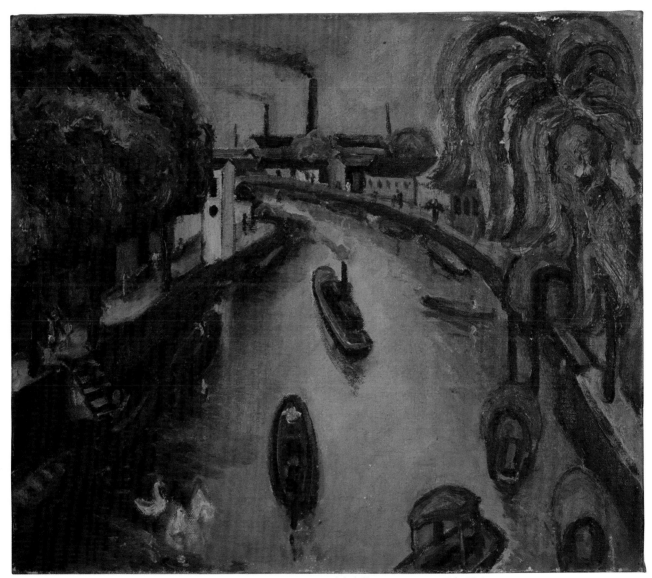

運河 Canal　年代不詳 Date unknown　畫布油彩 Oil on canvas　45.8×53.4cm

修復紀錄 Conservation history

　　□未曾修復 Not treated before ■曾修復 Previously treated

修復項目 Treatments

　　■畫面保護 Facing ■更換固定調整器 Metal adjustors □畫面加固 Consolidation ■畫布托裱 Lining

　　■基底材加固 Support consolidation ■調整式內框 New stretcher ■繪畫層清潔 Cleaning

　　■填補缺洞及全色 Filling and retouching ■X光檢測 X-Ray study ■紅外線檢視 IR study ■紫外線檢視 UV study

◎狀況圖 Mapping

　　狀況圖的製作有助於觀察畫作不同的劣化情形。除此之外，也可以讓修復師全面性地瞭解到所有關於畫作的保存狀況和可能要處理的損壞。在此案例，其狀況大致上不佳，由於畫布曾經被捲曲著收藏，所以畫面上佈滿大量同方向的裂痕。當初，在陳澄波先生遭受當權者迫害而死亡後，其家人認為畫作應該保護藏匿起來避免被發現，因為被發現後作品勢必會被沒收並破壞。陳家人因此決心保護藝術家的遺物，而展現出來的勇氣讓臺灣人能保有這些珍貴資產。因此，畫面上的捲曲裂痕展現出的是勇氣和文物保存的象徵，並告知世人這幅畫作的生命歷史和傷痕。

　　Mapping is used to observe different kinds of painting degradation. It helps conservators to know about the complete conservation condition and what kind the damages they need to face. In this case, the general condition was not good. Due to the canvas was rolled, there were plenty of directional cracks. As Chen Cheng-Po was killed by the authorities, his family thought that the paintings had to be protected and hidden from the government. If they had found the paintings they would have probably confiscated and destroyed them. In this way, The Chen's family had determination to preserve the artist's legacy and they showed courage to avoid the loss of this Taiwanese heritage. So the rolling cracking is a symbol of bravery and preservation that display to us the wound of history that the painting lived.

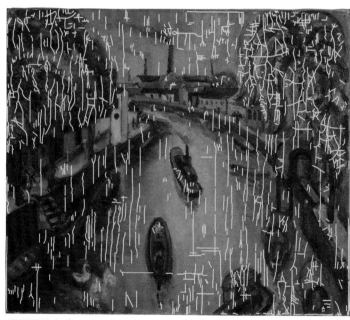

龜裂 Cracking

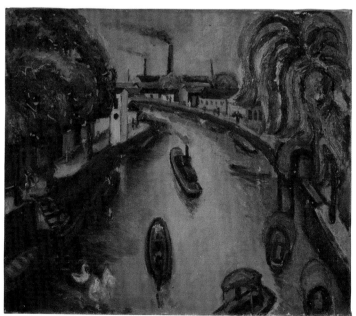

壓痕 Texture imprints

II. 修復前檢視登錄與分析 Documentation and analysis

1. 畫作狀況研讀分析 Painting condition study

　　在進行修復之前，畫作狀況的拍照記錄是必需的，主要是檢視並記錄畫作的所有狀況。而不同光源的檢視可以協助修復師清楚且深入的判讀畫作，並幫助判別不同型態的受損及畫作的構成。就此案例而言，可經紫外線照射觀察到些許位置曾經全色過，因為全色補筆會呈現比原始顏料較深的色彩。藉由不同擺放位置的光源，例如背面透光，可讓修復師清楚地得知繪畫層的裂痕及缺失訊息。

　　Before treatment, the photography documentation needs to be done to survey and record the condition of the

painting. Different light examinations serve to study the painting clearly and deeply, and help conservators to determine the different kinds of damages or components of a painting. As for this case, it presented few small previous retouching which was distinguishable from the original paint as a darker material under ultraviolet light. The placement of the light source, such as the transmitted light, allowed conservators to see the cracks and paint losses clearly.

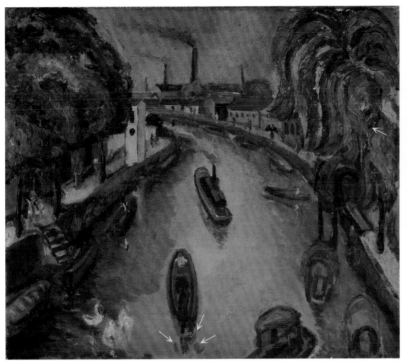

紫外線檢視：黃色箭頭處顯示出多處補筆
UV light: the yellow arrows show the places where retouching are

背光檢視下可見因捲曲而導致的同方向龜裂紋
Directional cracks for being rolled visible by transmitted light

再者，在側光下檢視，則顯現出畫面有全面積、同方向的變形狀況，這是當初為了要躲避政府的搜查而將畫作捲曲收藏所造成的結果。

Furthermore, according to the raking light examination, it was noted there were plenty of directional deformations over all the painting as a result of having been rolled to avoid the government's search.

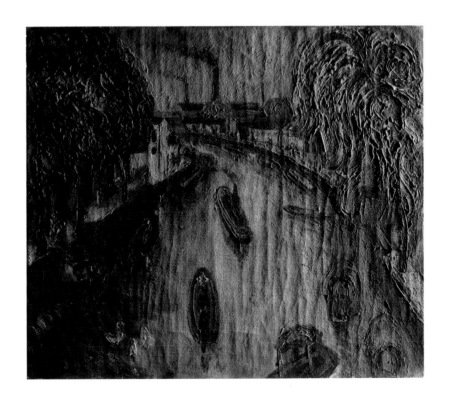

以側光檢視可見定向條狀裂紋，畫作表面肌理也清晰可見（右圖）
Image of the painting using raking light. Beside the directional cracks, texture of the surface may be seen

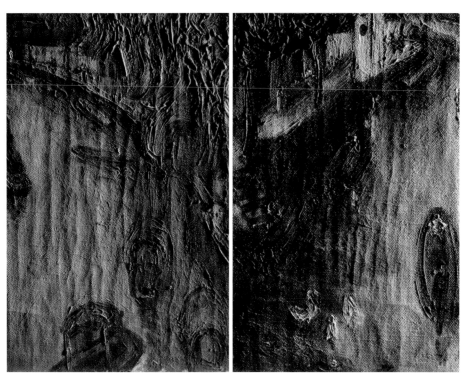

以側光檢視畫作，定向條狀裂紋顯而易見
Detail of the painting using raking light. The directional cracks are very noticeable

2. 修復前局部狀況 Detail of painting condition

　　畫面變形及大量的裂痕是該幅畫作主要的劣化狀況，並具有繪畫層剝落、起翹以及堆積的污垢等情形。除此之外，畫面上有發現昆蟲的排遺物。從陳澄波先生多張畫作上觀察到，其畫面各角落皆留有一個細小孔洞，這是由於他慣於使用釘入至內框的畫布針來運送畫作的緣故。

　　It was seen that deformations and cracks were the major issues of this painting. It also presented paint losses, lifting and deposits of dirt. In addition, insect excrements were found as well on the painting. As some other Chen Cheng-po's paintings, we observed there were holes on each corner as the result of using the canvas pin for transport. He used to carry the paintings with them which were driven into the stretchers.

繪畫層缺失與龜裂紋 Paint losses and cracks as pin

繪畫層起翹、缺失與龜裂 Lifting, losses and cracks

昆蟲排遺與裂痕 Insect excrements and cracks

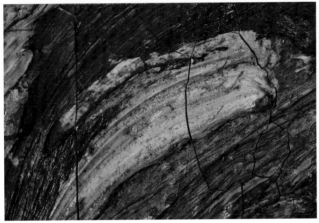

灰塵髒污沾黏與裂痕 Dirt and cracks

因畫布針形成的孔洞 A hole made by a canvas pin

III. 修復作業內容 Conservation and restoration treatments

1. 畫面保護 Facing

　　首先施以日本紙及魚膠進行畫作表面保護，此步驟有助於加固，使用小型修復專用熨斗謹慎地加熱使魚膠滲入畫作表層以加固繪畫層。

The protection should be the first procedure and was done with Japanese paper and fish glue. The facing also

畫面保護施作
Facing process

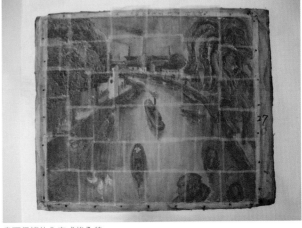

畫面保護施作完成後全貌
View of the painting when the facing is completed

serves for the consolidation of the painting. It was added heat with small iron delicately to make fish glue permeate into the surface to consolidate the color layers.

2. 基底材加固 Support consolidation

畫布邊脫線鬆散處以甲基纖維素（CMC），進行加固。

Due to some threads that were off the edges of the canvas, they were attached back to it with carboxymethyl cellulose (CMC).

布邊脫線處加固前
View of the threads before being fixed

布邊脫線處加固後
View of the threads after being fixed

3. 背面清潔 Cleaning the back of the painting

畫作背面以修復用吸塵器來實行物理性乾式清潔，就下面的圖例可清楚看到清潔前後的差異性。

A physical dry cleaning was applied on the back of the painting. This process was done with a special vacuum for conservation. In the image below, may see the difference between clean and dirty areas.

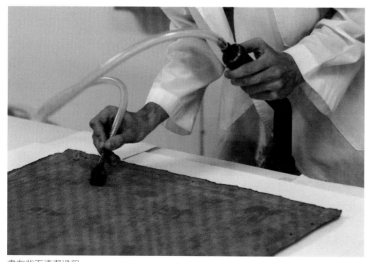

畫布背面清潔過程
Cleaning the back of the canvas

清潔前後差異對照
Different details of the cleaning process

4. 護紙清除 Removing facing

一旦施作於畫布背面的修復程序完成後，則以溫水小心地逐步移除畫作表面暫時性保護層。

Once treatments on the back of the painting were done, the facing could be removed from the surface of the painting gradually and carefully with warm water.

護紙移除 Removing facing

5. 重繃畫布 Remounting

由於舊的木製內框對畫作保存而言不佳，將之替換。所以將畫布繃於新的可調整式榫接木製內框。

Due to the old stretcher was not good enough for its conservation, it was better to replace it with a new expandable one to be able to stretch the canvas.

將畫布繃於內框 Stretching the canvas

6. 畫面清潔 Cleaning

多種不同的清潔溶劑測試是為了瞭解何種是對畫作清潔最佳且安全的，這步驟需要謹慎的處理，原有的顏料色彩絕不能產生任何變化。在清潔畫面髒污後，畫面上天空及河流清晰顯露出原有明亮的色彩。

Different tests were applied to know the best cleaning solution. The cleaning is a delicate process that should be done without affecting the original colors. Once deposits of dirt were removed, the original colors of sky and river revealed.

清潔前後差異對照：污垢、昆蟲排泄物及其他污漬完全移除
Different details of the cleaning process. Dirt, insect excrements and other stains were completely removed

7. 繪畫層缺損處補土全色 Filling and retouching

　　細小的繪畫層剝落處以動物膠及硫酸鈣所調和的石膏漿進行填補，並塑造出相似且與缺失周圍一致的表面肌理，而最後的修復程序則是以修復專業用水性顏料，模擬色彩筆觸及光澤度於填補處上全色。

Tiny areas of paint loss were filled with a reversible material made from gesso and animal glue. It was applied to achieve a texture that matched the surface of the painting. The final stage of the treatments was retouching. Water based conservation colors were used for the lacunas.

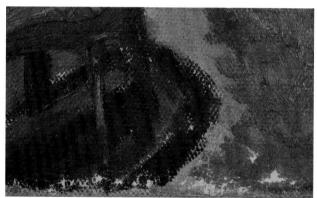

填補石膏漿 Filling process

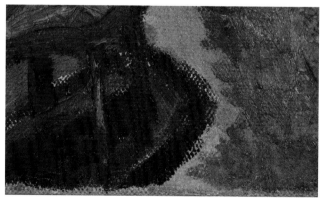

全色完成後 After retouching

填補石膏漿 Filling process

全色完成後 After retouching

填補石膏漿 Filling process

全色完成後 After retouching

IV. 修復前後對照 Before and after treatment

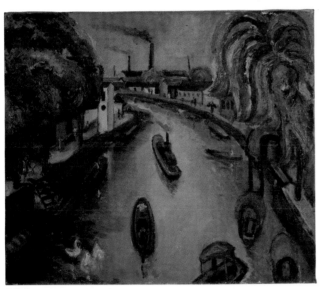

修復前 Before treatment

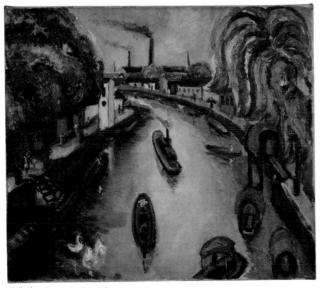

修復後 After treatment

含羞裸女 A Bashful Nude

I. 修復前狀態 Before treatment condition

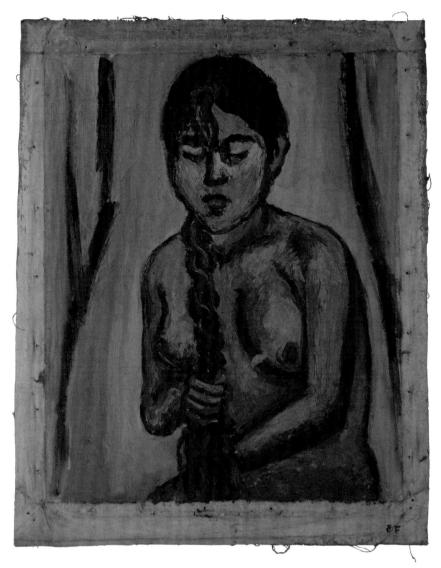

修復紀錄 Conservation history
■未曾修復 Not treated before
□曾修復 Previously restored

修復項目 Treatments
■畫面保護 Facing
■更換固定調整器 Metal adjustors
■畫面加固 Consolidation
■畫布托裱 Lining
■基底材加固 Support consolidation
■調整式內框 New stretcher
■繪畫層清潔 Cleaning
■填補缺洞及全色 Filling and retouching
■X光檢測 X-Ray study
■紅外線檢視 IR study
■紫外線檢視 UV study

含羞裸女 A Bashful Nude
年代不詳 Date unknown
畫布油彩 Oil on canvas
45×37.3cm

II. 修復前檢視登錄與分析 Documentation and analysis

1. 畫作狀況研讀分析 Painting condition study

　　畫作修復前的狀況拍攝紀錄是必需的，透過科學儀器分析畫作更能清楚了解其狀況。針對這張畫作進行了X光及紫外線檢測，發現畫作沒有被重複繪製或補色，意謂未曾被修復過，但其保存狀態不佳。在此可使用不同擺放位置的光源協助我們辦別畫作狀況，圖示中察覺作品全面呈現嚴重龜裂紋、髒污及可見一處面積不小的繪畫層缺失。

　　The photography documentation is necessary to determine the condition of the painting. With scientific instruments, the painting can be examined better. In this case, through the X-Ray and the UV light studies, it was noted

there was no sign of reusing canvas or any retouching. Thus it might say this painting haven't been restored before, however the conservation condition of this painting wasn't good. Different light resources can help us to verify the conservation state of the painting, and they show serious cracks, dirt and also a big paint loss.

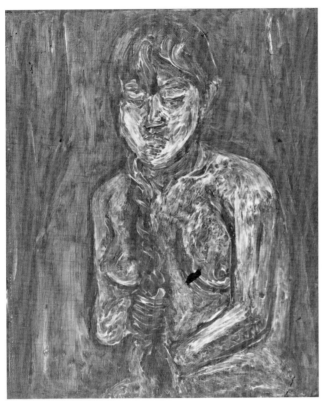

X光檢視：無其他底層畫作
X-Ray light: there is no underneath painting

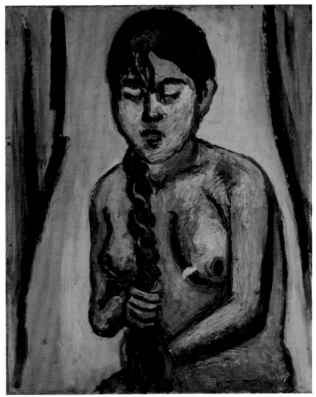

紫外線檢視 UV light

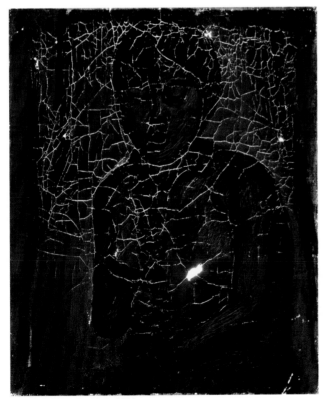

背光檢視清楚可見裂痕及破損處
Image of the painting using transmitted light. The cracks and
the loss are clearly visible

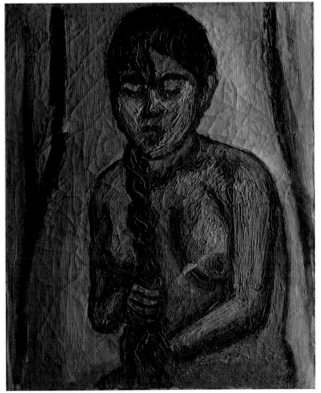

側光檢視下嚴重的裂痕顯而易見
The Raking light show us the severe cracking the painting has

2. 修復前局部狀況 The painting condition

從圖示中可以清楚得知，幾乎佈滿整張畫面的嚴重龜裂紋是該畫作主要的劣化狀況，並伴隨嚴重的髒污及一些繪畫層缺失等情況。

From the images, it can be known the major problem of this painting was the heavy cracks it had almost all over the painting. There were also deposits of dirt and several paint losses.

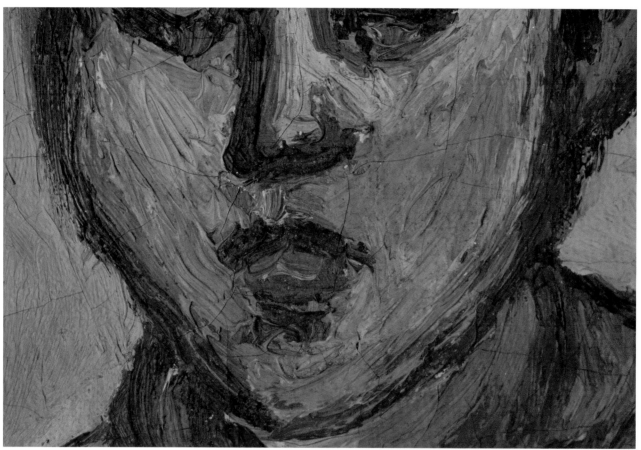

裂痕及灰塵沾黏細部圖示 Detail of cracks and dirt

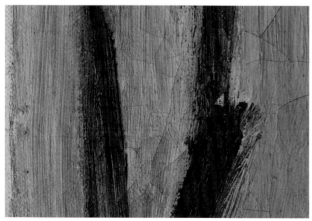

繪畫層缺失及裂痕 Paint losses and cracks

灰塵沾黏、繪畫層缺失與裂痕 Dirt, paint losses and cracks

III. 修復作業內容 Conservation and restoration treatments

1. 基底材加固 Support consolidation

畫布邊脫線處以甲基纖維素（CMC）進行加固，將之黏回布邊。

Due to some threads that were off the edges of the canvas, they were attached back to it with carboxymethyl cellulose.

2. 畫面保護 Facing

在畫作托裱之前，首先需進行繪畫層暫時保護的步驟，以防止繪畫層因接下來將施作於畫作背面的修復程序而受損。此步驟使用日本紙及魚膠作暫時性表面保護。

Before lining, the facing should be applied first to protect the paint layer from the following procedures on the back of painting. It was a treatment of Japanese paper and fish glue.

基底材加固過程 During the process of the support consolidation

畫面保護施作 Facing process

3. 背面清潔 Cleaning

選擇以物理性乾式法清潔畫作背面，以修復專用吸塵器除塵，從照片中可見畫布清潔前與清潔後的差異。

A physical dry cleaning was applied on the back of the painting. This process was done with the special vacuum for conservation. From the image, may see the difference between clean and dirty areas.

畫作背面清潔中
During the process of cleaning the back of the painting

清潔前後差異對照：黃線左側已清潔完成
Different details of the cleaning process. The left side of yellow line is already cleaned

4. 畫布托裱 Lining

　　畫作有許多龜裂痕及媒材不穩定的狀況，因此必需對畫作施行全面性托裱以加固繪畫層，同時也可幫助畫作基底材更平整。但考慮到畫作背面有畫家的親筆簽名，所以透明托裱為最佳選擇，並於攝氏70度的加熱吸附桌上進行托裱。以透明材質進行托裱方式是維持藝術家簽名處可見的唯一方法，可讓畫作整體結構更加穩定且保留畫布的歷史。

　　Having many cracks and unstable condition, a lining was essential to consolidate the paint layer. At the same time, it also helped to flatten the support. Considering the support had the artist signature on the back of the painting, a transparent lining was the best choice. This process was carried out using the vacuum hot table at 70 degree. Doing a transparent lining is the only way to keep the signature still visible; it is a method of preserving the paint structure while maintains the historicity of the canvas.

畫布托裱過程
During the process of making the lining

背面修復前
The back before treatment

背面完成托裱後，畫家的簽名筆跡仍清晰可見
After the lining has been done, the artist's signature is still visible

5. 畫面清潔 Cleaning

　　清潔畫面需要小心謹慎處理，因為過程中不能影響到畫作原本的色彩。基於此原因，需進行不同清潔溶解度的測試以擇定最佳且安全適當的清潔溶劑。此作品表面髒污程度嚴重，下面不同的圖例中，可清楚看見畫面清潔後的樣貌，佈滿黑色髒污的區域，於清潔後呈現出畫作原本鮮明的色彩。

　　The cleaning is a delicate process that should be done without affecting the original colors. For this reason, different tests were applied to know the best cleaning solution. This painting was so dirty, in different images below, the cleaned surface are clearly seen. In the black smoke areas, the original vibrant colors appeared after cleaning.

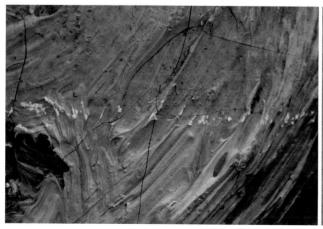
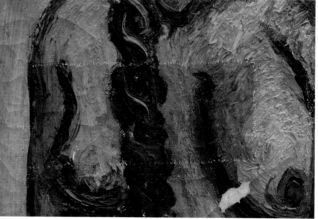

清潔前後差異對照：畫作顏色完全呈現並保留原有古色
Details of the cleaning process: the colors were recovered and patina was kept

清潔前後差異對照：黑色髒汙完全被移除
Details of the cleaning process: the black smoke areas and dust were completely removed

6. 繪畫層加固 Fixing

在修復過程中，可發現畫面裸女左胸的大面積彩繪層缺失色塊，沾黏於另一張靜物畫作〔早餐〕的背面，這是因為在顏料未完全乾透時，將兩張畫布疊壓存放所造成。要將黏於靜物畫背面的易碎彩繪層色塊從畫布上完整的分離並拼合黏回原處是一項精細的步驟。在將色塊跟畫布分離之前，需先以日本紙及膠黏附於色塊背面將之固定，預防色塊在剝離及復原修復中碎裂，然後小心取下，再以動物膠將色塊黏回〔含羞裸女〕上原缺失處。

During the treatments, it was found that the big loss paint of the left breast of the nude was fixed on the back of other Chen Cheng-po's painting—*Breakfast*. This was a consequence of placing the canvases together, one over another, while the colors hadn't dried completely. Recovering the missing paint and fix it back to the original position was a delicate process. Thus the missing paint had to be detached carefully from the back of still-life painting. Before detaching it, a Japanese paper was applied with animal glue on the back of the paint layer first to prevent it from breaking in pieces during the treatment. Afterwards, it was fixed to the *A Bashful Nude* with animal glue.

〔含羞裸女〕胸前局部色塊缺失
Detail of paint loss on *A Bashful Nude*

〔早餐〕 *Breakfast*

〔含羞裸女〕缺失的色塊沾黏於〔早餐〕背面（黃色圓圈處）
In the yellow circle the paint loss of *A Bashful Nude* is attached to the back of the *Breakfast*

缺失的色塊 The loss painting

以修復專用日本紙保護缺失色塊
The loss painting has been protected with Japanese paper

缺失色塊從畫布背面轉移並貼回原處
The loss painting was removed from the back of the canvas and fixed to the original position

7. 繪畫層缺損處補土全色 Filling and retouching

於顏料層剝落部分，以動物膠與硫酸鈣調和成的石膏漿填補，並模擬塑造出與畫面連貫一致的肌理。最後以具有可逆性的水性修復用顏料進行全色。鑒於藝術家原始畫作即為非亮面的彩繪層表面，全色後不施加任何光亮塗層於繪畫層上。

The paint losses were filled with stucco, made of gesso and animal glue. The fillings imitated the paint surface to match the original textures. Then the retouching was applied with water based reversible colors. After retouching, it wasn't applied any coating to the painting surface respecting the matte surface of the artist.

填補石膏漿 Filling process

全色完成後 After retouching

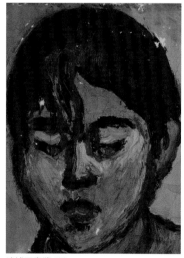
填補石膏漿 Filling process

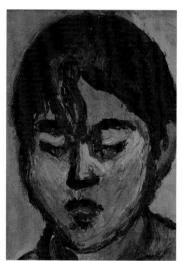
全色完成後 After retouching

填補石膏漿 Filling process

全色完成後 After retouching

IV. 修復前後對照 Before and after treatment

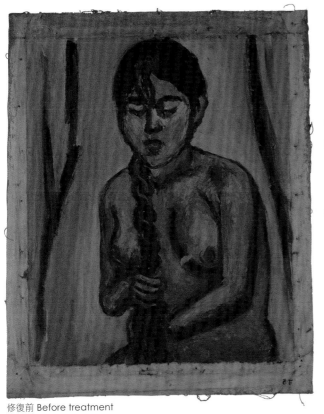

修復前 Before treatment

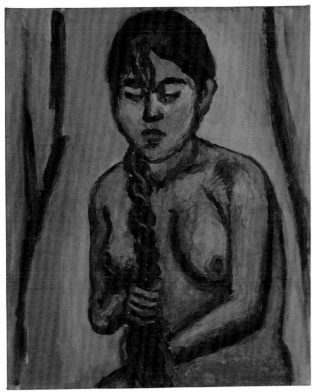

修復後 After treatment

油畫作品
Oil Paintings

修復前後對照
Before and After Treatment

正修科技大學文物修護中心
Cheng Shiu University Conservation Center

油畫 Oil Paintings

每件作品以修復前和修復後做為對照，共四張圖。
修復前置於上方、修復後置於下方。

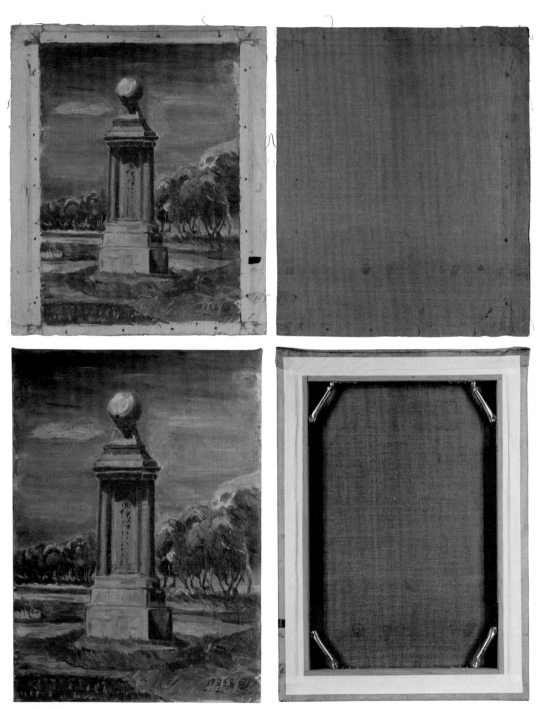

北回歸線地標 Tropic of Cancer Landmark

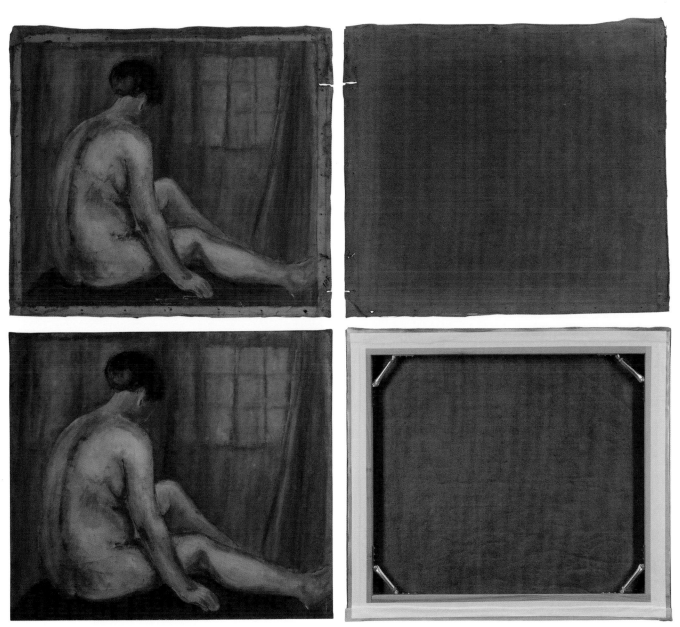

背向坐姿裸女 Back of Sitting Nude Female

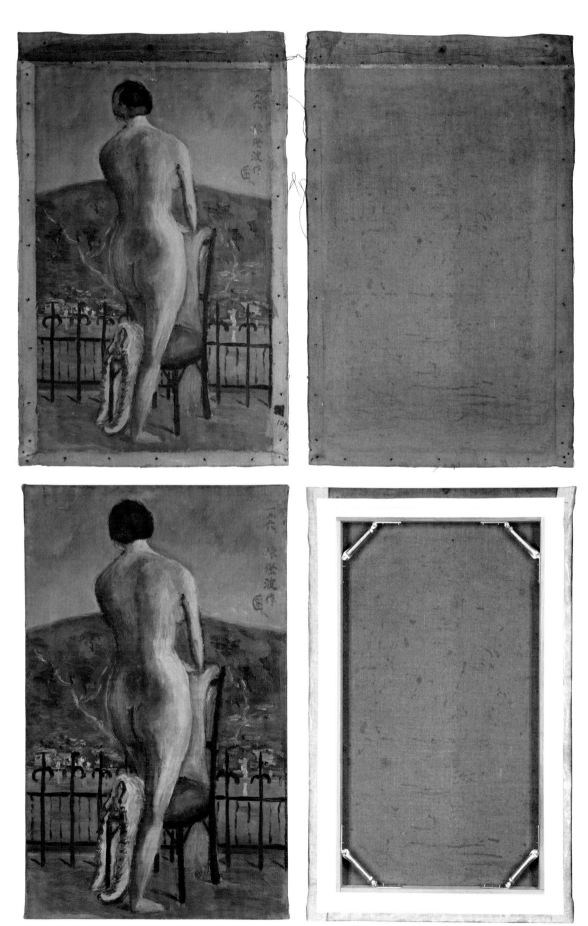

陽台上的裸女 Nude on a Balcony

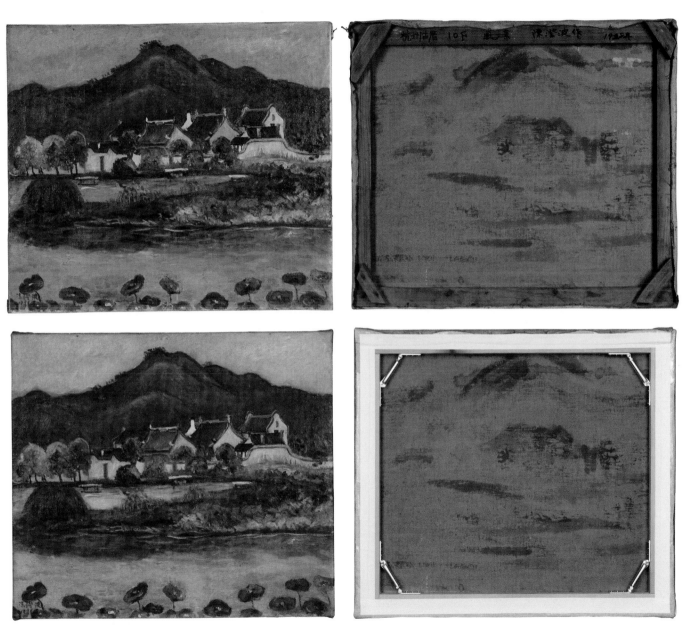

杭州古厝 Ancient Houses in Hangzhou

小弟弟 Little Boy

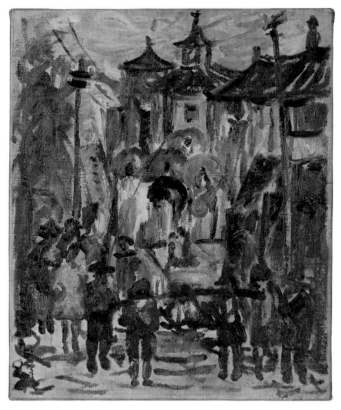

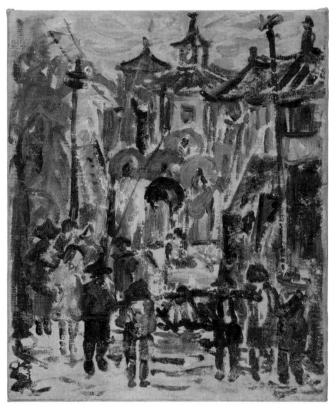

八月城隍祭典 Town God Sacrificial Rites in August

林中戲水裸女 Nude Female Kicking Water in Forest

簷上遠望 Looking out on Top of the Eaves

玉山暖冬 Mild Winter at Mt. Jade Mountain

抱肘裸女 Nude Female Holding Elbow

橋畔 Bridge Side

屋頂 Rooftop

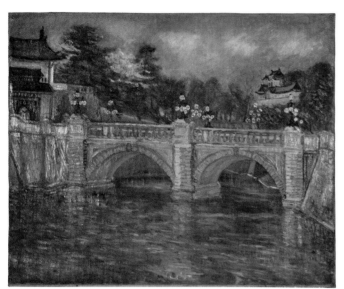

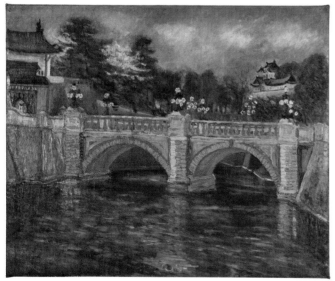

二重橋 Nijibashi Bridge

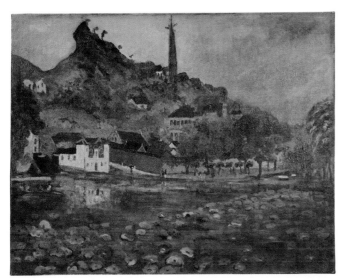

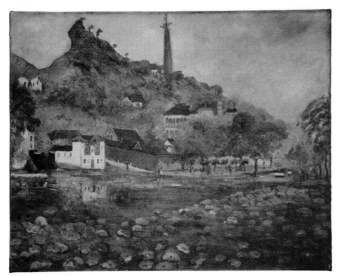

西湖塔景 Tower Scene at West Lake

上海郊外 Shanghai Outskirts

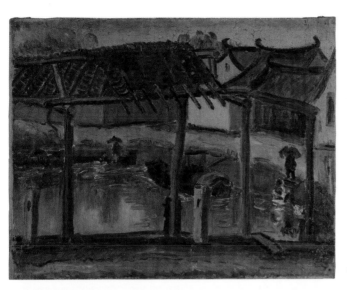

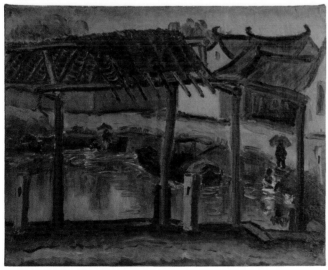

厝後池邊 Pondside at the back of Houses

有芭蕉樹的人家 Houses with a Banana Tree

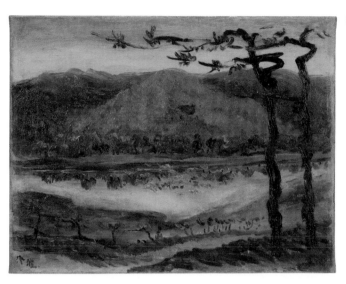

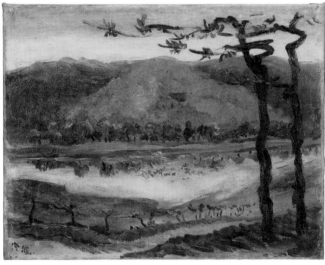

潭前山景 Mountain View in Front of a Pond

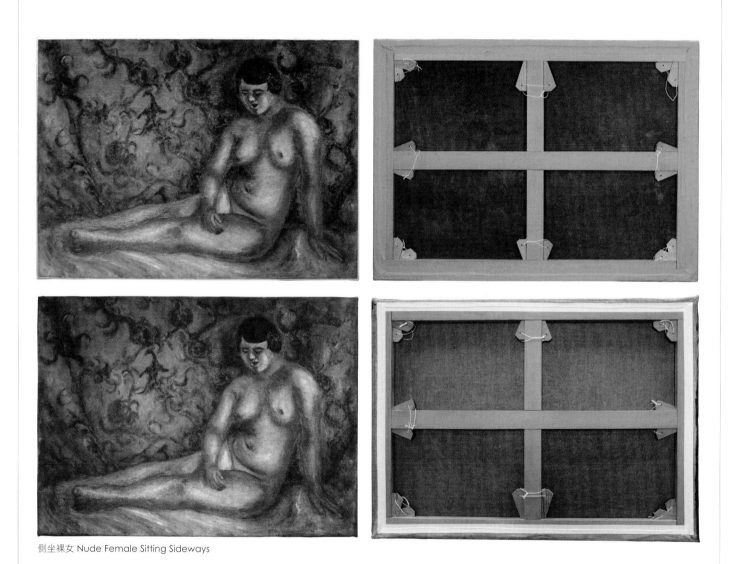

側坐裸女 Nude Female Sitting Sideways

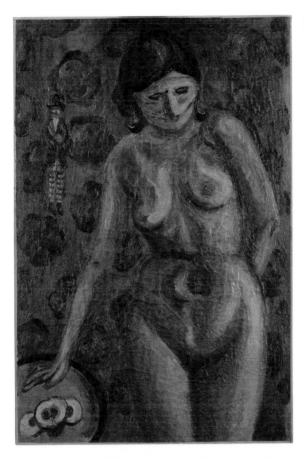

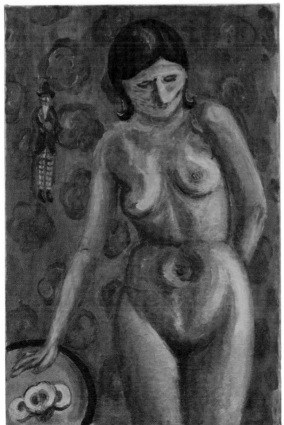

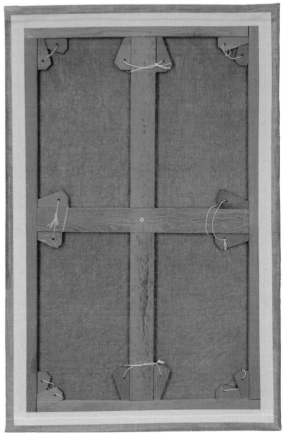

綠面具裸女 Nude Female with a Green Mask

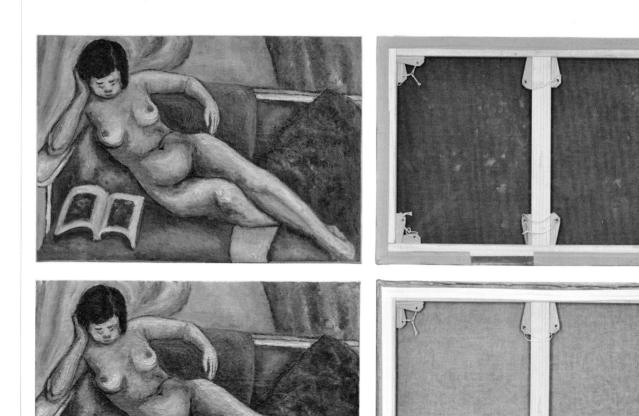

側臥閱讀裸女 Reclining Nude Reading Book

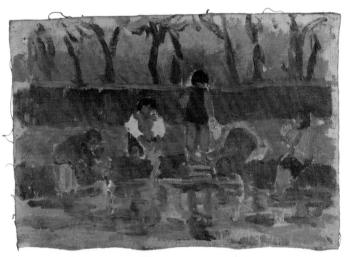

修復後為夾裱，無法拍攝背面。

洗衣 Doing Washing

甕 Jug

酒瓶與水果盤 Wine Bottles and Fruit Plates

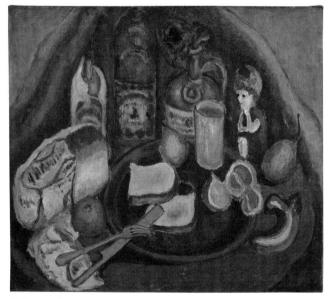

早餐 Breakfast

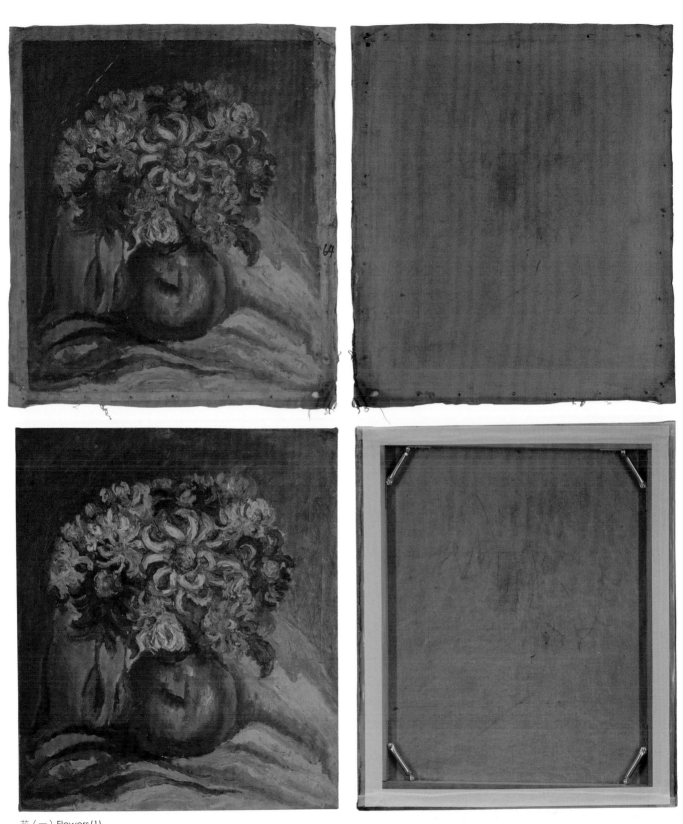

花（一）Flowers（1）

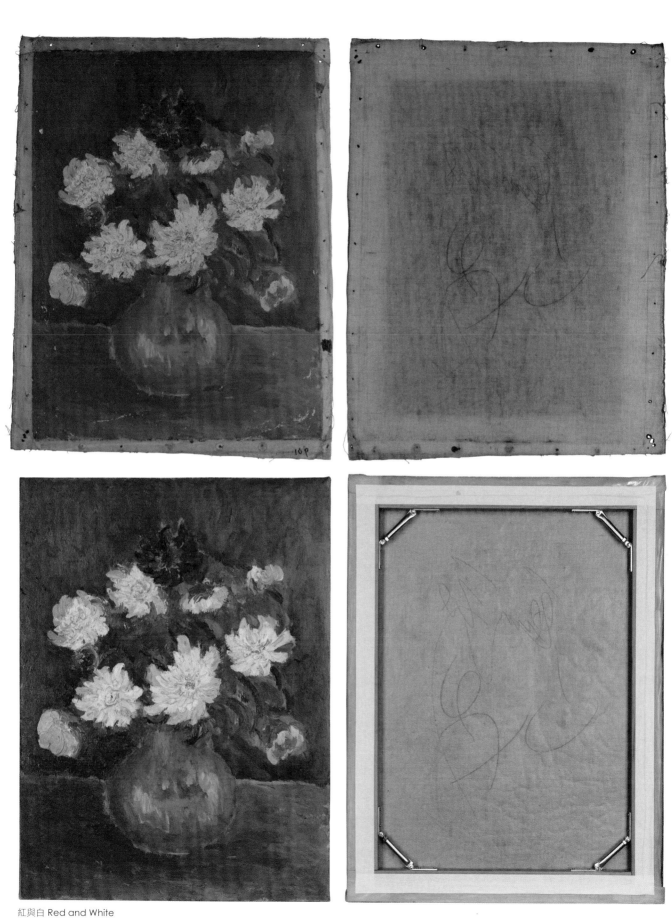

紅與白 Red and White

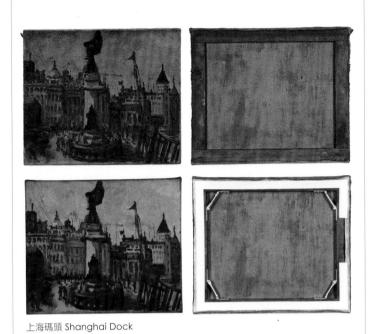

上海碼頭 Shanghai Dock

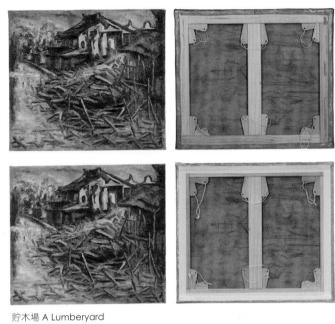

貯木場 A Lumberyard

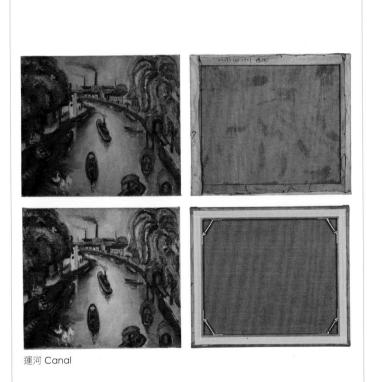

運河 Canal

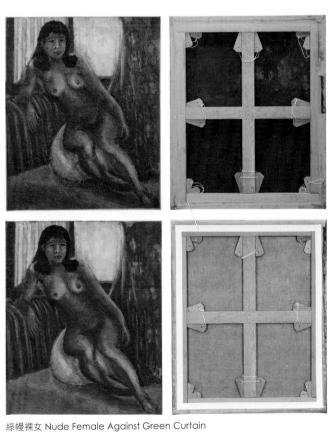

綠幔裸女 Nude Female Against Green Curtain

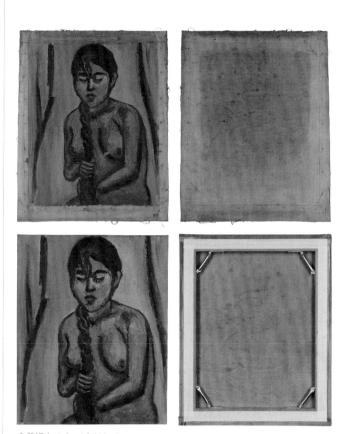

含羞裸女 A Bashful Nude

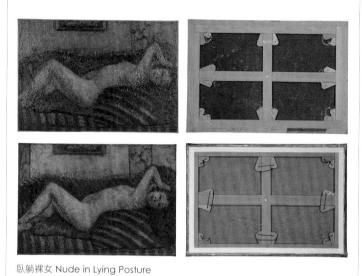

臥躺裸女 Nude in Lying Posture

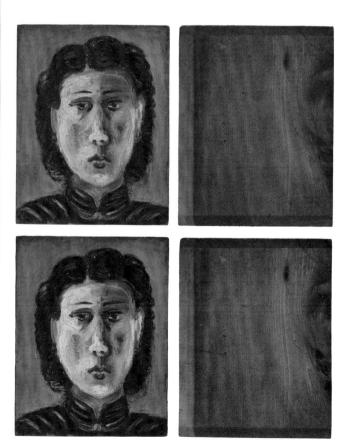

淑女像 Portrait of a Lady

船艙內 Inside the Cabin

紙質作品
Works on Paper

修復報告
Selected Treatment Reports

正修科技大學文物修護中心
Cheng Shiu University Conservation Center

前言 Introduction

　　紙質作品又分為東方與西方紙質作品，東方紙質作品的基底材主要構成原料為樹皮之韌皮纖維、大麻、藤類與禾本科的竹類、草類等。主要媒材以水墨、彩墨、書法、膠彩作品為大宗。財團法人陳澄波文化基金會（以下簡稱基金會）自2011起至2015年以來，共分三階段，委託正修科技大學文物修護中心紙質修護工作室，陸續修復膠彩鏡片[1] 1件、水墨鏡片1件、彩墨鏡片1件、彩墨掛軸4件、水墨掛軸1件、書法對聯一組2件，以及扇面一件，共計11件。

　　Works on paper can be basically divided into Eastern and Western works. The main materials of the paper substrate in East Asian painting that are the Bast fibers such as Hemp (cannabis sativa), Rattan (calamus rotang), and the Grass fiber as the Bamboo, Straw. Those papers are usually made by hand. The main media of the artworks in East Asian painting are inks, ink and colors, calligraphies and gouaches. Since 2011 to 2015, the Chen Cheng-po Cultural Foundation (hereinafter referred to as the "the Foundation") entrust the Paper Conservation Studio of Cheng Shiu University Conservation Center divided into three stages to restore their collections. Total have 11 artworks in this case, that include 1 glue color painting in framing,[1] 1 ink painting in framing, 1 ink and color painting in framing, 4 ink and color paintings in scroll, 1 ink painting in scroll, a pair of calligraphy couplet and a folding fan in framing.

　　東方紙質作品常見的劣化狀況有環境因素所造成的紙張黃化、褐斑。若是存放環境有蟲害汙染則可能會有昆蟲啃蝕痕跡、作品缺失破洞或昆蟲排泄物的殘留等。另外，存放環境若是漏水、返潮則會造成作品有水漬（潮痕）、暈開或滲移的狀況發生。

　　The common paper deterioration in East Asian painting works are yellowing and foxing that usually caused by the environment. If the storage or housing place is polluted by insects will cause Biological Deterioration like insect hole, flyspeck and accretion. In addition, if the environments have water damage, like leaking or getting damp, it may cause liquid stain (or called tide line), bleeding or offset.

　　在西式紙材作品的部分，主要以機製紙[2] 為基底材，藝術家通常使用炭筆或鉛筆畫素描，亦有鋼筆速寫或色鉛筆速寫參於其中。自2011-2015年，共分三階段，陸續修復炭筆素描12張、素描簿3本、地圖1張、水彩1張，26張散頁山景速寫，259張散頁人物與靜物速寫。

　　In the works which painted on western paper, the main constituents of the paper substrate is machine-made paper.[2] The artist usually use charcoal or pencil to do sketches, there are some pen sketch and color-pencil sketch works. The conservation work are also in three stages, start from 2011 to 2015.In this case, a stack of western-paper collections are entrusted , including 12 charcoalsketches, 3 sketchbooks, 1 printing map, 1 watercolor, 26 pieces of them are mountain scenery, 259 pieces are portrait and still life drawings.

　　西式紙張由於其製造方式的關係，若是存放環境溫濕度過高或光線直射，紙張容易黃化、焦脆、斷裂，並產生褐斑。存放環境若陰暗潮濕，甚至於漏水，將導致作品著生黴菌與水漬；另外，生物所造成的危害，如蟲蛀、昆蟲排遺，甚至昆蟲屍體等，都是必須預防與杜絕的。

　　Due to the manufacturing methods, the machine-made papers stored under a high temperature and high humidity environment or exposure under the light that will easy to cause yellowing, foxing, breaks and brittle. If stored in a dark place with high humidity or leaking that will get mold and mold stain. Water damages, like stain (tide line) may caused

by leakage. Biological Deterioration such as insect damage, insect hole, flyspeck and frass should all be prevented.

　　本次修復計畫中紙質作品主要的修復流程順序如下圖所示。其中，修復計畫擬定後，修復建議以及執行的細節內容因文物狀況不盡相同，將於後段章節逐一單篇說明。

　　In this project, the order of the conservation treatment process of the arts on paper is prescribed as the following figure, in a restoration flow chart. The damaged condition of each art work is different, therefore, after planning the generally treatment proposal, the detail of the conservation suggestion and treatment process of each item will be mentioned bellow.

作品出庫／取件 Check and bring out the artworks

檢視登錄 Documentation

修復前攝影 Photos before treatment

擬定修復計畫書 Treatment proposal

呈核 Authentication

修復執行 conservation treatment

修復後攝影 Photos after treatments

撰寫修復報告 Treatment report

修復完成 Finish the treatment

修復作業流程圖
The restoration flow chart for the paper substrate works.

【註釋】

1. 鏡片，裝裱型式的一種。有橫豎二種，多為一色裱。又稱鏡心、框裱。
 Framing, is one kind of mounting style, mostly designed in one color . It can be horizontal or vertical.
2. 指從蒸煮、打漿至烘乾等造紙程序中，以機械為造紙之主要動力者稱之。
 It refers to the steam boiling, beating to drying paper program to machinery as the main driving force of those who called machine-made paper.

水墨 Ink Painting

此次修復的水墨作品計有水墨畫八件和書法對聯共一件，其中僅〔牽牛花〕為陳澄波畫作，另一件〔淡水寫生合畫〕是陳澄波與友人合畫的，其餘均是友人贈送給陳澄波之畫作。以下列舉〔牽牛花〕和〔淡水寫生合畫〕做為修復的範例。

There are 8 pieces of ink paintings and a pair of couplet of calligraphy in this conservation project. Of all these paintings, the *Morning Glory* is painted by Chen Cheng-po. The artist and his friends worked together on this work, *Tamsui Collaboration*. The rest of these paintings are all painted by his friends, as gifts to the artist. *Morning Glory* and *Tamsui Collaboration* will be introduced.

• 牽牛花 Morning Glory

此作為陳澄波少見之水墨作品，作品完成後未曾裝裱。畫心紙張邊緣不齊，多處摺痕，邊緣帶些許裂痕，褐斑嚴重干擾畫意，但紙張結構尚屬穩定。由於此畫未曾經過裝裱，邊緣大小不一。

This artwork is one of Chen Cheng-po's ink painting which is not often to see. Before treatment, this painting did not have any mounting. In addition, this painting was unequal-sided. The main condition includes yellowing and foxing which seriously distract visual effects. Fortunately, the structure of this painting is strong and stable, only some light crease on the surface and small splits around edges.

修復處理上，建議全面清洗與淡化褐斑，另外，為保留原畫的完整性與欣賞時的協調性，命紙將先行染色後再進行小托，以延展邊緣的方式全色，補足缺失的部分，使畫心在視覺上較為方正。並選擇無酸蜂巢板作為背板，以框裱作為日後保存維護與展示的形式。

In conservation treatment, overall washing and lightening the foxing were suggested in this case. The color of the first lining paper was dyed closed to the painting. In order to harmonize the visual effects while watching and to maintain the integrity of the painting, retouching would be applied on the lining paper around the painting to adjust the unequal-sided edges. For further preservation, storage and display, instead of using wooden board, acid-free honeycomb panel was chosen as backing in framing.

I. 修復前狀態 Before treatment condition

修復紀錄 Conservation history
■未曾修復 Not treated before
□曾修復 Previously restored

修復項目 Treatments
□畫作解體 Decomposition
■表面清潔 Surface cleaning
■顏料暈染測試 Spot test
■顏料加固 Consolidation
■黃化與褐斑清洗 Washing
□揭除舊命紙 Lining removal
■隱補缺洞 Compensation
■重托命紙 lining
□重新裝裱 Remounting
■無酸蜂巢板 Tycore® mounting panel
■補彩 Inpainting
□紫外線檢視 UV study

牽牛花 Morning Glory
1924-1925
紙本水墨 Ink on paper
33.5×31.5cm

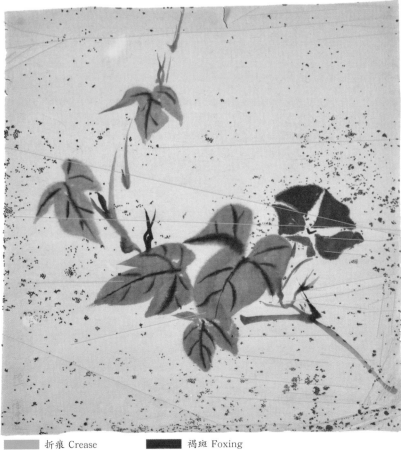

作品劣化狀況分析 Condition mapping

折痕 Crease
斷裂 Break
褐斑 Foxing
髒汙 Dirt

215

II. 修復作業內容 Conservation and restoration treatments

1. 修護前檢視登錄 Documentation

修護進行前，記錄畫作劣化狀況，並以正光、側光、透光攝影記錄。

Before conservation treatment, documentation of the painting is necessary. It consists of written and pictorial records. The deterioration of the painting will be examined. Photographic documentation which includes normal light, raking light and transmitted light will also be recorded.

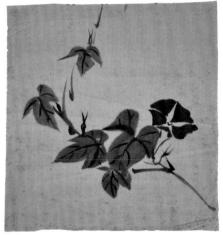
正光攝影 Front light

側光攝影 Raking light

透光攝影 Transmitted light

2. 表面除塵 Surface cleaning

用軟毛刷及吸塵器將畫心表面的灰塵清除。

Using soft wool brush and HEPA vacuum cleaner to clean the dust and dirt on the painting's surface.

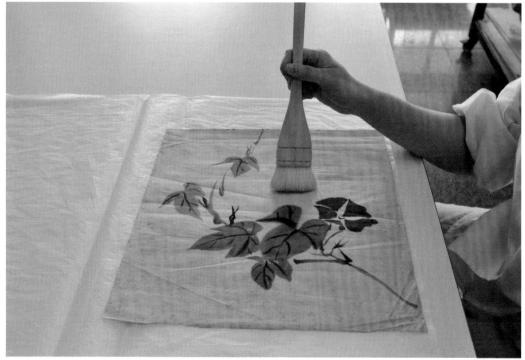
作品表面除塵 Surface cleaning

3. 顏料暈染測試與顏料加固
Spot test and media consolidation

　　使用棉花棒沾少許RO純水，測試顏料暈染狀態，若發現易掉色之處，則需進行顏料加固。此幅畫作顏料穩定不需加固。

　　Testing the media is sensitivity to water or not with cotton swab slightly wetted with pure water. Consolidation will be given to strengthen the media if the color-painting area is water soluble. The ink of this painting is very stable, thus it is unnecessary to consolidate the color.

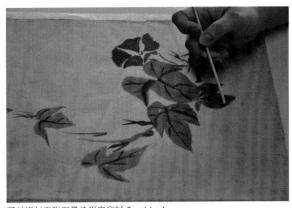

顏料媒材牢附與暈染程度測試 Spot test

4. 褐斑淡化 Bleaching the foxing area

　　溫水清洗，不易去除的褐斑則使用稀釋後的過氧化氫進行淡化清潔。

　　Wash the painting with warm water. After overall washing, some foxing which are difficult to remove will be bleached by diluted Hydrogen peroxide.

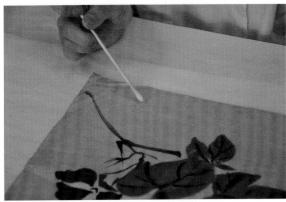

以稀釋後的過氧化氫水溶液淡化紙張表面的褐斑
Bleachingthe foxing area by diluted Hydrogen peroxide solution

5. 純水清潔 Pure water washing

　　使用過氧化氫淡化褐斑後，需用純水再次清洗畫作，以避免藥劑殘留在基底材及顏料層中，之後將畫心放於羊毛毯上晾乾。

　　After bleaching with hydrogen peroxide, it is necessary to wash the painting by pure water again. Avoiding the chemical solvent keep effecting the paper substrate and pigment layer. After that, put the painting on the woolen blanket for drying.

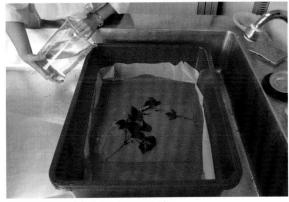

以純水作全面的清潔 Pure water washing

6. 小托紙染製 Dye the lining paper

　　選用與畫心性質較相近的中性手工紙作為小托紙（命紙），以排筆刷染的方式染好4-6張做為小托之

刷染4到6張小托紙 Dye the lining paper

將小托紙分開晾乾 Spilt the dyed paper

用，待乾後挑選顏色最適合的一張進行小托。

Choose several neutral handmade papers which the thickness and surface texture are similar to the original one for the first lining paper. Coloring the papers by brush. Usually we will dye 4 to 6 pieces of papers, then choose the best one for the first lining paper.

7. 小托 Lining

畫心加濕攤平後，將修復用小麥澱粉糊塗刷於小托紙上。

After humidifying and flattening the painting, lining the best-dyed paper with wheat starch adhesives.

小托畫心 First lining

搭邊：沿著畫作邊緣在小托紙上再搭覆紙邊
Adhere the strips on the edges

8. 加托 Additional lining

選用中性手工美栖紙作為加托紙，因紙張的成分含有碳酸鈣，可用以中和畫作的酸鹼值。

Choose the neutral handmade Misupaper as the additional lining paper. Misupaper contains calcium carbonate. This substance can neutralize the acidity in the painting substrate.

加托 Second layer lining

覆背 final lining

9. 上板繃平 Flattening on drying board

待畫心晾乾，適度潤濕畫心，在四邊塗上漿糊，上板繃平。

After the second and third layer is dried, slightly humidifying the painting again then adhere it by narrowing margins onto a wooden drying board.

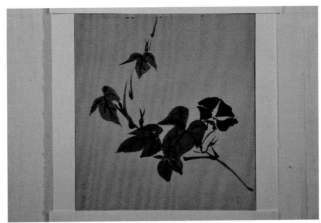

畫作上板繃平 Flattening on drying board

10. 全色 Inpainting

透過邊緣的全色以延伸畫心周圍，達到調整畫心形狀以利後續裝裱步驟。全色前先塗佈隔離層，再進行全色，避免顏料暈染到畫心。

Due to the irregular edges of painting and for the following mounting steps, extend the margin of the painting with watercolors of Schmincke. Apply the isolating layers before inpainting.

上隔離層 Apply isolating layers

全色 Inpainting

11. 下板方裁 Trimming

待紙張在板上晾乾3-4天，完全繃平穩定之後，下板方裁。

After drying for 3 to 4 days, detach the painting from the drying board by using a thin bamboo spatula. Trimming the edges of painting squared.

下板：將繃平後的畫作從乾燥版上取下
Detach the painting from the drying board

方裁：取適當的留邊距離，裁切多餘的紙邊
Trim the edges

12. 固定後裝框 Framing

　　將畫心四周塗上修護用小麥澱粉糊，固定在裁切好的蜂巢板上待乾。將蜂巢板放入製作好的畫框中，背後再鑲上無酸卡紙板調整厚度，最後以無酸導流板為最後一層取代原畫框之木板，周圍鎖上螺絲。

　　Adhere the painting by narrowing margins onto a Tycore® mounting panel. From inside to the outside, putting the objects into the frame with the order of Tycore® mounting panel, Rising Museum Board and PC board as the backing instead of the original wooden board.

將方裁好的畫作貼在蜂巢版上
Adhere the painting on Tycore® mounting panel

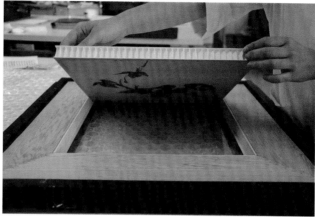

裝框 Framing

13. 修復與裝裱完成後之相關拍照及記錄 Documentation after treatment

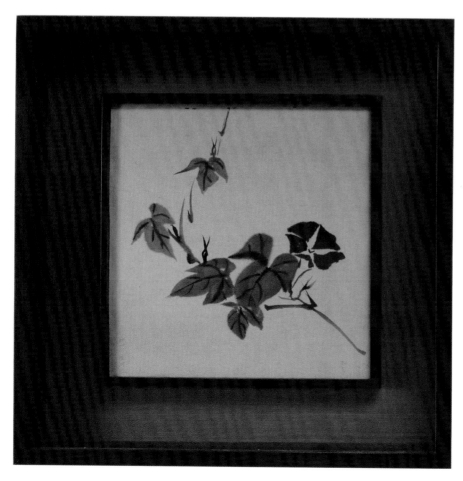

作品裝裱完成 After farming

III. 修復前後對照 Before and after treatment

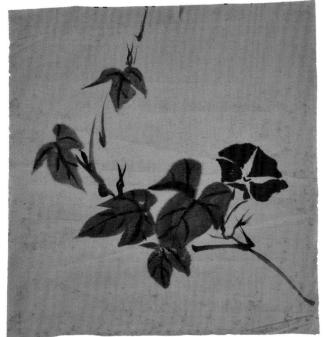

修復前 Before treatment

修復後 After treatment

修復前（局部）Before treatment（detail）

修復後（局部）After treatment（detail）

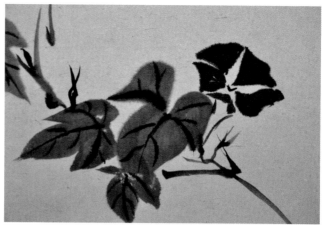

修復前（局部）Before treatment（detail）　　　　修復後（局部）After treatment（detail）

• 淡水寫生合畫 Tamsui Collaboration

　　此作品為西元1941年由陳澄波等六人共同合畫的水墨淡彩畫，從陳重光先生（陳澄波之子）的紀錄可知六位藝術家分別畫了哪些部分。陳澄波畫山腳房屋、周圍草地、小帆船與鳥群；楊三郎畫觀音山；林玉山畫大船；李梅樹畫左邊大樹；郭雪湖畫前面陸地；陳敬輝畫淡水河中沙地。

　　This painting was painted by Chen Cheng-po with six artists at 1941. It was painted with ink and light color on a Japanese paper board. A note from Chen Tsung-kuang, the son of Chen Cheng-po's, recorded every artist's painting part in this painting. Chen Cheng-po: houses and grasses at foot of the mountain, little sailing boat, and the birds. Yang San-lang: Guanyin Mountain. Lin Yu-shan: the big boat. Li Mei-shu: the tree on the left. Kuo Hsueh-hu: the land on the front river side. Chen Jing-hui: the sandy land on the river.

　　畫作基底材為日本厚紙板，正面為白色，背面為淺褐色，紙板尺寸長度27.2公分，寬度24.2公分，厚度約0.1公分，四周立邊有鑲金。畫作背面有落款「昭和十六年春初淡水寫生紀念」以及六位藝術家的簽名。修復前狀況，畫心表面有黃化現象，多處佈滿嚴重的褐斑，四周邊緣有明顯的髒汙和蟲蛀，四個邊角有摺痕。

　　The length of the paper board is about 27.2 cm, the width is about 24.2 cm and the thickness is 0.1cm. The four edges are wrapped with golden-color strips. It is worth noticing that six artists all signed on the back and some information, like the time (in Japanese era name: Shōwa) ,the season at that time (spring time) and the place (Taipei Tamsui area) were also recorded. Before treatments, the condition of this painting including overall yellowing, foxing, dirt and some obvious loses on the edges which caused by insects. Because of the top layer paper of the four corners was slightly lifted and some creases.

　　畫作的保存狀況除了肉眼的檢視登錄外，初步以實體拍攝、紫外線拍攝以及圖像狀況標色等方式，作為修復前置之檢視紀錄工作。

　　Before the treatment, conservation documentation consists with optical and photographic examination. Take photographs under normal and ultraviolet light, the condition of the deterioration will be marked with different color in the pictures.

I. 修復前狀態 Before treatment condition

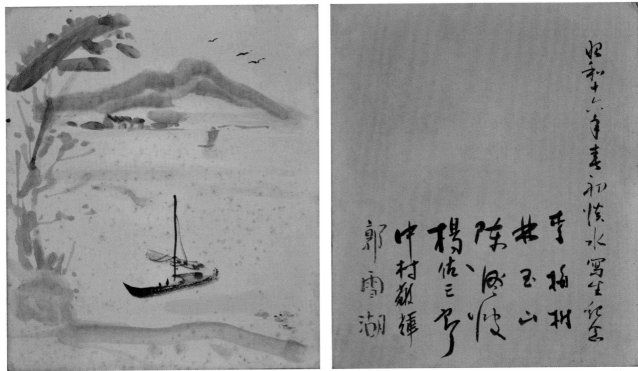

淡水寫生合畫 Tamsui Collaboration
1941　紙本彩墨 Ink and color on paper　27.2×24.2cm

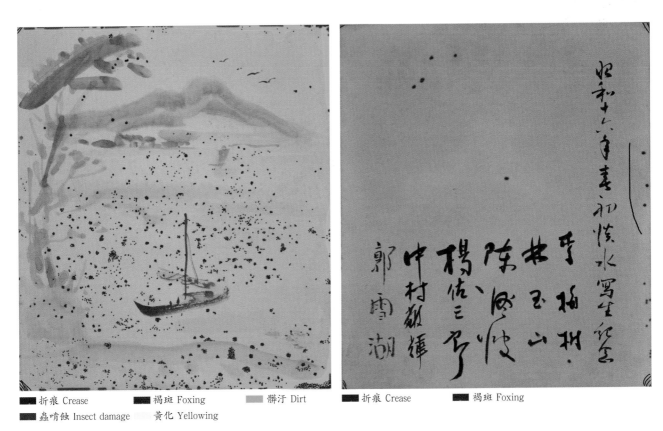

■ 折痕 Crease　　　■ 褐斑 Foxing　　　■ 髒汙 Dirt
■ 蟲啃蝕 Insect damage　　黃化 Yellowing

■ 折痕 Crease　　　■ 褐斑 Foxing

作品保存狀況圖示 Condition mapping

修復紀錄 Conservation history

■未曾修復 Not treated before □曾修復 Previously restored

修復項目 Treatments

□畫作解體 Decomposition ■表面清潔 Surface cleaning ■顏料暈染測試 Spot test ■顏料加固 Consolidation
■黃化與褐斑清洗 Washing □揭除舊命紙 Lining removal □隱補缺洞 Compensation □重托命紙 lining
■重新裝裱 Remounting □無酸蜂巢板 Tycore® mounting panel □補彩 Inpainting ■紫外線檢視 UV study

II. 修復作業內容 Conservation and restoration treatments

1. 修復前檢視登錄 Documentation

修復進行前，記錄畫作劣化狀況，並以正常光、側光、紫外線攝影記錄。

Before conservation treatment, examine the deterioration of the painting, written and pictorial records are both included. Photographic documentation which include normal light, raking light and transmitted light will also be recorded.

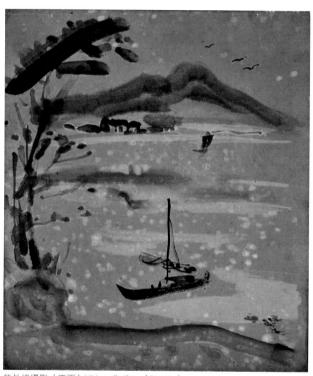

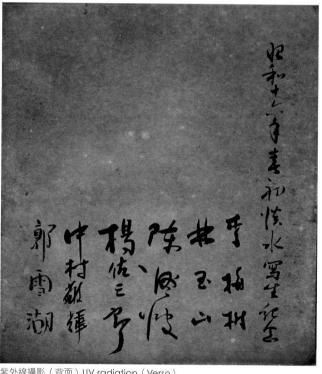

紫外線攝影（正面）UV radiation（Recto）　　紫外線攝影（背面）UV radiation（Verso）

2. 表面除塵 Surface cleaning

用軟毛刷掃除畫心表面的灰塵。

Clean the dust on the surface by soft brush.

畫作表面除塵 Surface cleaning

3. 顏料暈染測試與顏料加固 Spot test and media consolidation

　　使用棉花棒沾少許純水，測試顏料暈染狀態。這件作品使用約2-3%的明膠水溶液，以毛筆塗刷，加固易掉色的顏料。

　　Testing the media is sensitivity to water or not with cotton swab slightly wetted with pure water. In this painting, the color area were consolidate with 2-3% gelatin glue by brush.

顏料媒材對水的溶解度測試 Spot test　　　　　　　　　　　針對易掉彩的顏料以明膠加固 Consolidation

4. 褐斑淡化 Bleaching the foxing area

　　首先以40-60度的溫水清洗髒汙處，不易去除的褐斑則使用稀釋後的過氧化氫進行淡化清潔。使用過氧化氫淡化褐斑後，再用純水，以沖洗方式將紙張中髒汙及藥劑洗出，避免藥劑殘留在基底材及顏料層。

　　Wash the painting with warm water at 40-60°C first . Foxing are difficult to remove need to be bleached that used diluted Hydrogen peroxide can let the foxing easy to remove. After bleaching with hydrogen peroxide, it is necessary to wash the painting by pure water again. Avoiding the chemical solvent keep saffecting the paper substrate and pigment layer.

褐斑淡化 Bleaching the foxing　　　　　　　　　　　　以純水清洗畫作 Pure water washing

5. 攤平畫作 Flattening

　　畫作清洗完成後，以三明治加壓的方式，分別在畫作的上下各墊上一層人造纖維紙與兩張無酸吸水紙，加壓攤平的過程中須常常替換上乾的吸水紙。

The painting will be flatten with weight after washing. It is put between rayon papers, blotter papers and two acrylic sheets, the structure is just like a sandwich. The blotters need to change periodicaly to absorb the moisture while flattening by weight.

攤平清洗完的畫作 Flattening

攤平過程中更換吸水紙 Changing blotters while flatting

加壓攤平 Flattening with weight

6. 雙面無酸夾裱製作 Mounting with double-side window mat

　　畫作背面有六位藝術家的簽名，與修復人員討論後，由於畫作的前後兩面分別有圖像與文字，因此將以雙面窗框夾裱的方式，讓畫作兩面皆可觀賞。

　　這個夾裱方式有兩層窗形夾裱。首先先讓畫作嵌合在內層的2-ply無酸卡紙夾裱中。固定的方式是在雙面的窗框四周的邊緣，以無酸雙面膠貼上無酸聚酯片，使作品不需以黏著劑便能以前後夾住的方式固定在2-ply的無酸卡紙夾裱中。由於內層夾裱的支撐力沒那麼足夠，正反面將再加上同樣也是有開窗的8-ply無酸卡紙板。

There are six artists' signatures on the back side of this painting. Discuss and design by the conservators with the owner, in order to display both the painting and information on the back, it is decided to mount this painting with double-side window mat.

This design consist two layers of mat window. The inner mat window of 2-ply acid-free archival board fit the painting exactly. The painting is fixed to the 2-ply acid-free archival window mat by covering two layer of Mylar® polyester strips around the edges from the front and back side without any adhesive. The Mylar® polyester strips are adhered to the 2-ply board with acid-free double-stick tape. As the stated mat window mat is not strong enough to support, another layer of 8-ply board mat window will be added on both side.

夾裱製作：確認作品位置 Matting: fix the position

夾裱製作：固定作品至板上 Matting: adhere the painting to the board

夾裱製作：組合前後卡紙板 Matting: combine with the cover

夾裱製作完成 Matting: finish

7. 透明壓克力立式臺座裝裱 Framing with a standing acrylic pedestal

　　這件作品的框裱部分將設計一個方式使畫作兩面都能被觀賞。夾裱完成的作品放在一個4釐米厚，一體成型的U型透明壓克力板，並讓開口朝下。這個壓克力板的厚度和大小與夾裱完的作品相同。夾裱完的畫作放入以後，再將其放入一個霧面半透明的壓克力凹槽底座中固定畫作，使其能以站立的方式被觀賞。

For seeing both side of this painting, a customary framing will be designed. The matted painting will put in U-shaped, 4 mm acrylic sheet which the size is exactly in the same of the matted painting. The distance between two the two acrylic sheets also fit the thickness of the matted painting. At last, for displaying this work in a standing way, the framing will insert into a foggy acrylic pedestal, which its opening is on the bottom

將作品放入透明壓克力板中
Put the matted painting into the acrylic sheets

以壓克力凹槽底座固定畫作
Fix the sheets by inserting it into the acrylic pedestal

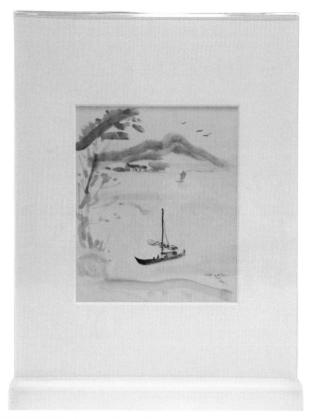

裝裱後正面 After farming（Recto）

裝裱後背面 After farming（Verso）

III. 修復前後對照 Before and after treatment

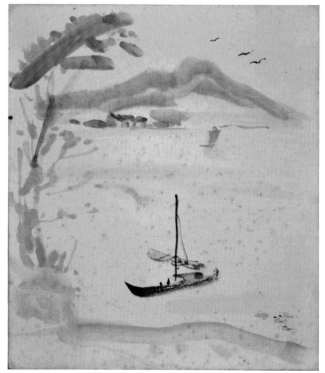

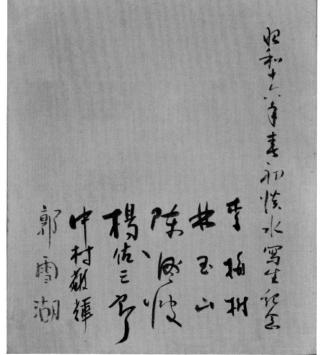

修復前 Before treatment

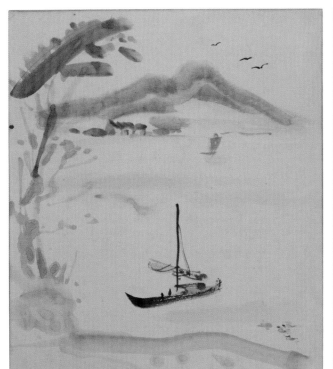
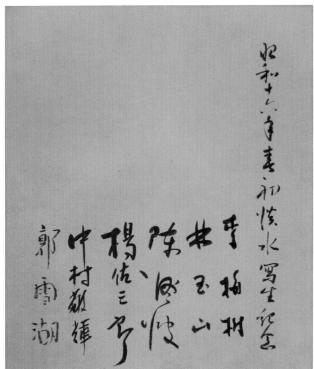

修復後 After treatment

修復前（局部）Before treatment（detail）

修復後（局部）After treatment（detail）

229

膠彩 Glue Color Painting

此次修復的膠彩畫僅〔百合花〕一件。畫作因為長期捲收，加上紙張酸化嚴重，基底材相當脆弱，需經過小心的加濕攤平與背面加固，才得以展開，一窺畫作原貌。

This painting *Lilies*, is the only one glue color painting in this conservation project. Possibly due to rolling for long time and the paper is serious acidified, the substrate and the media are very weak. Before spreading out the painting totally, it need to be wetted, flatten, and temporary consolidated from the back first.

除了畫心之外，背面還包含一層命紙與一層大小與畫心一致的加托紙。但由於長期捲曲的保存方式以及時間、環境的變化，整幅作品狀況不佳。畫心紙張嚴重黃化、脆化。表面髒汙且有漬痕和缺失。原裝裱的紙力也不勝負荷，且由於長期捲曲收藏，造成橫向、縱向多處摺痕，甚至伴隨斷裂，特別是在紙張中間和邊緣處。雖然紙張基底材劣化嚴重，但百合花畫意保留相當完整，甚至從背面黃化情況可以發現該作品中的白色顏料降低紙張酸化黃化狀況，起了保護紙張的作用。

By examination, there are two lining layers under the painting, include the first backing paper and the outer layer backing paper which in the same size with the painting. However, both the inappropriate way of storage in a long time and changing of the environment speed up the deterioration of this painting. It was in poor condition. The paper substrate of the painting was badly yellowed and brittle. There were dirt, stains and loses on the surface. The original mounting was not able to give enough supporting to the painting. It is because the painting was rolled while storage, there were overall creases which parallel to the direction of the rolling-paper. What's worse, some creases accompanied with breaks, especially on the center and edges. The lily flowers still remains quite well. Despite that the paper substrate was badly acid , the white color seemed to provide protection to the paper substrate. It was obviously to see that the paper was less yellow in that area.

為了讓畫作能長久保存，首先要先改善紙力脆弱的問題。藉由移除原有的背紙，降低紙張中酸性物質，並針對裂痕、摺痕處進行加固，最後選用性質較佳的修復級紙張加托，並且改善日後的保存方式與環境。

For maintaining the painting in good condition, to improve the strength of the paper will be the priority. By removing the original backing paper to reduce the acid materials in the paper. After that, joining the splits then reinforcing the creases to stronger the structure. Last, choosing a better quality of paper for additional lining. The housing environment and storage also need to be improved.

• 百合花 Lilies

I. 修復前狀態 **Before treatment condition**

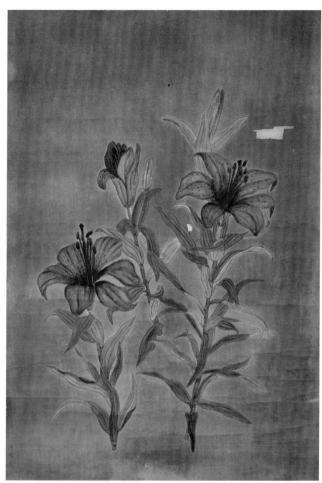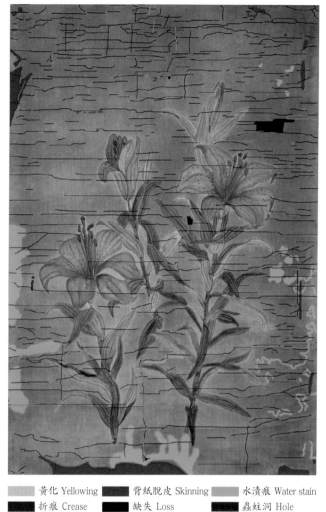

百合花 Lilies 1924-1925
紙本膠彩 Glue color on paper
65.8×44.9cm

黃化 Yellowing	背紙脫皮 Skinning	水漬痕 Water stain
折痕 Crease	缺失 Loss	蟲蛀洞 Hole
起翹 Flaking	斷裂 Break	

作品保存狀況圖示 Condition mapping

修復紀錄 Conservation history

■未曾修復 Not treated before □曾修復 Previously treated

修復項目 Treatments

■畫作解體 Decomposition ■表面清潔 Surface cleaning ■顏料暈染測試 Spot test ■顏料加固 Consolidation
■黃化與褐斑清洗 Washing ■揭除舊命紙 Lining removal ■隱補缺洞 Compensation ■重托命紙 Lining
■重新裝裱 Remounting ■無酸蜂巢板 Tycore® mounting panel ■補彩 Inpainting ■紫外線檢視 UV study

II. 修復作業內容 **Conservation and restoration treatments**

1. 修復前檢視登錄 Documentation

　　畫作修復前必須先進行劣化狀況檢視登錄，透過文字及圖像攝影紀錄將畫作劣化狀況進行檢視。攝影紀錄包括正光、側光、透光等方式。

Before conservation treatment, documentation of the painting is necessary. It consists of written and pictorial records. The deterioration of the painting will be examined. Photographic documentation which includes front light, raking light and transmitting light will also be recorded.

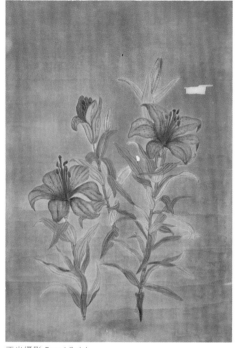
正光攝影 Front light

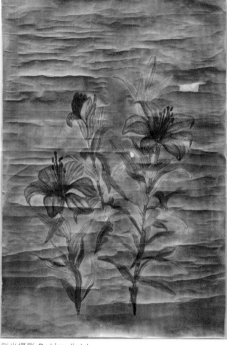
側光攝影 Raking light

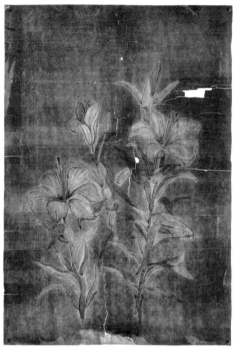
透光攝影 Transmitted light

2. 畫作加濕攤平 Wet and flatten the painting

　　畫作長期捲曲收藏，變形嚴重，紙張劣化後已失去彈性與韌性，容易脆裂，因此在攤平的過程需要格外謹慎，藉由輕微的水氣讓紙張纖維舒展，逐一攤平。

The paper substrate became brittle and inflexible because the painting was rolled storage for a long time. Therefore, the process of flatten need to be careful. Moist the paper slightly to extent the fibers of paper, then flatten it partially.

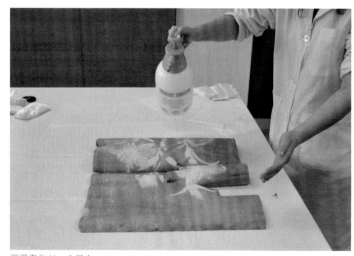
潤濕畫作 Humidifying

以適量的重物加濕後加壓，舒緩紙張嚴重摺痕處
Flattening the hard creases with appropriate weight after humidifying

3. 背面暫時性加固 Temporary consolidation from the backside

　　為維持畫面正面的完整性以利相關檢視登錄，並支撐紙張斷裂、摺痕處以利持拿與後續清洗與媒材加固等修復步驟，將使用濃度3-5%之甲基纖維素與人造纖維不織布從背面進行暫時性加固。

　　In order to maintain the integrity of the front image for documentation and to provide additional support to the breaks and creases during subsequent conservation treatments, like washing and media temporary consolidation from the backside is considered. The material will use 3-5%MC and rayon paper.

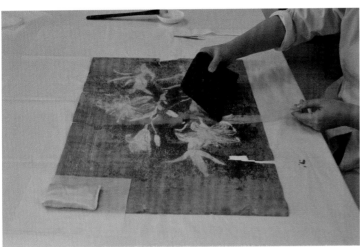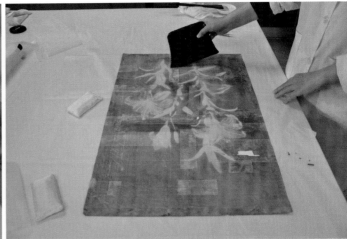

背面暫時性加固 Temporary facing from the back

4. 表面除塵 Surface cleaning

　　用軟毛刷及吸塵器將畫心表面的灰塵清除。

　　Using soft wool brush and HEPA vacuum cleaner to clean the dust and dirt on the painting's surface.

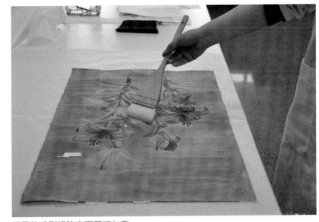

使用軟毛刷掃除表面髒汙灰塵
Using soft wool brush clean the painting's surface

5. 顏料暈染測試與顏料加固
Spot test and media consolidation

　　使用棉花棒沾少許純水，測試顏料暈染狀態，若發現易掉色之處，則需進行顏料加固。這件作品使用約1.5%的三千本膠水溶液，以毛筆塗刷，加固百合花的顏料。

　　Testing the media with slightly wetted cotton swab. Consolidation will be given to strengthen the media if it is water soluble. In this painting the flower part are consolidated with 1.5% animal glue by brush.

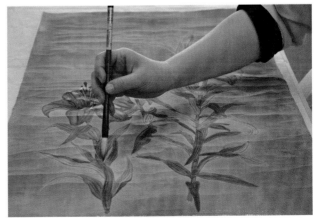

針對易掉彩的顏料進行加固 Consolidation the pigment

6. 清洗與褐斑淡化 Lighten the foxing

　　首先以棉花棒沾取微量的溫水清洗髒汙處，不易去除的褐斑則使用稀釋後的過氧化氫進行淡化清潔。經過清潔溶劑的處理後，再將畫作以純水洗淨，避免藥劑殘留。

　　Clean the dirt area with cotton swab wetted with pure water first. After that, foxing area will be bleached by diluted hydrogen peroxide. Avoiding the chemical solvent keep affecting the paper substrate and pigment layer, it is necessary to wash the painting with pure water.

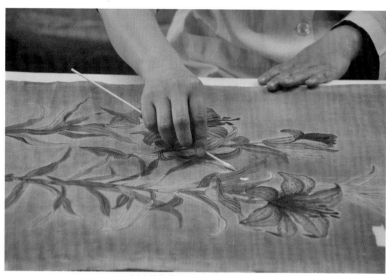

以自捲棉花棒針對局部髒汙清潔
Cleaning the dirt part with wetted cotton swab by pure water

7. 全面淋洗 Overall washing

　　以人造纖維紙襯住畫心並放置於壓克力板上，將RO純水以淋洗方式緩緩將紙張髒汙洗出，待清洗完畢直接以人造纖維紙將畫心提起，放於壓克力板上。

　　The painting is supported with a rayon paper. Drench the painting by floating water and brush the surface which protected with rayon paper at the meantime to wash away the inner dirt and dust. After washing, lift the painting with the rayon paper and put it on another acrylic sheet.

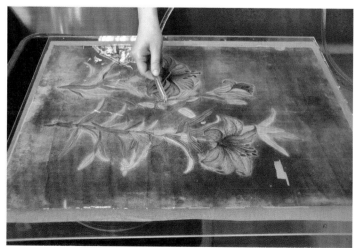

全面淋洗 Overall washing

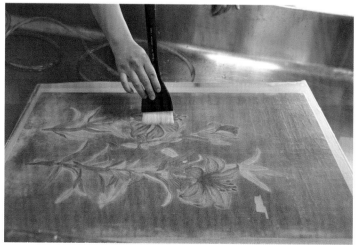

隔著人造纖維紙將汙水刷出
Brush the dirty water out from the painting from a protected rayon paper sheet

8. 表面暫時性加固 Facing

　　淋洗後在紙張仍潮濕時，將破碎分離的紙張位置稍作調整拼接，確定畫作表面的潔淨與平整後將吸去多餘的水分，以刷上濃度約5-8％的甲基纖維素的15公分大小方型人造纖維紙，進行畫面的暫時性加固。為防止人造纖維紙脫落，最後將再加托一層皮料紙，以穩固畫作的安全。

　　Fix the separated area while the painting still float above the water. Absorb the water after confirming the imagery position is all correct. Applied rayon paper in 15×15cm square with 5-8%MC on the surface for facing. Avoid the rayon papers shedding accidentally, second layer of mulberry paper will be applied for a stable support.

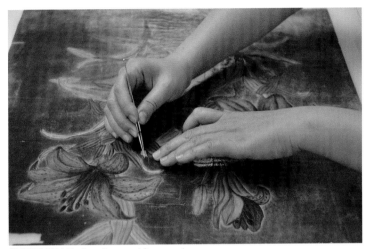
拼接畫作碎片 Fix the dispersed fragment

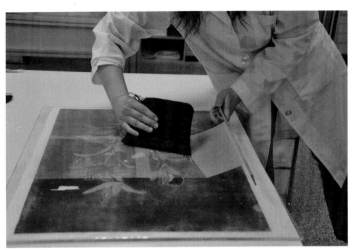
表面暫時性加固 Temporary facing

9. 揭除舊背紙與命紙 Remove original backing and first lining paper

　　畫心晾乾，移除背面暫時性加固紙後依序揭除舊背紙與舊命紙。揭除時托拉的方向儘量與畫心摺痕、裂痕保持平行，防止不慎將破損處掀起。命紙直接與畫心黏合，因此在揭除時須格外小心，微量施加水分，以小片面積用乾揭法輕搓除去。

　　After the temporary facing layer dried, remove the original back and the first lining paper. Avoid pulling the damage area accidently while removing, the direction of taking off the paper is better to be parallel to the direction of the creases and splits on the painting. Minor moisture is added and gently rub the original lining paper little by little. The first lining paper directly attach the painting, hence it needs more attention when detaching.

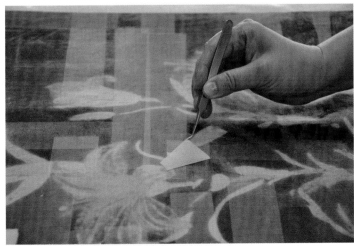
移除畫作背面的暫時性加固紙 Remove the temporary facing on the back

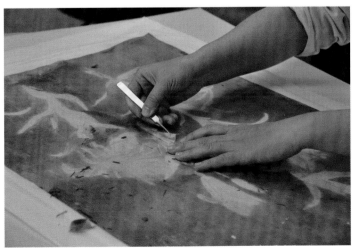
揭除畫作的舊命紙 Remove the original first lining paper

10. 染紙 Dye the lining paper

選用與畫心相似性較高的中性手工紙作為命紙,以排筆刷染紙張方式染4-6張做為小托之用,待乾後挑選顏色最適合的一張進行小托。

Choose several neutral handmade papers which the thickness and surface texture are similar to the original of the first lining paper. Color the paper with brush. 4 to 6 sheets will be prepared at the same time in order to choose the best one.

將染料預熱 Heat the dying material　　染命紙 Dying the papers

11. 補紙 Compensation

利用光桌,在補紙上描繪畫心缺失處的形狀,周圍預留1-1.5mm,切割下來後在周圍塗小麥澱粉糊,黏貼至畫心破損處。

Draw the shape of the loss area of the painting on the insert paper under the light table, and cut it bigger than the outline about 1 to 1.5mm. Adhere the insert paper with starch around the edge to the loss area of the painting.

裁切補紙 Cutting compensation paper

12. 小托後揭除表面暫時性加固紙 Lining and taking off the temporary facing paper

第一層命紙選用染色後與畫心相似性較高的紙張;第2層加托紙選用含有碳酸鈣的日本中性手工美栖紙,內含的鹼性物質可中和畫作酸性物質。完成後翻至正面移除表面暫時性加固的人造纖維紙,並檢視畫心狀況。

Lining the best-dyed paper with wheat starch. On account of containing calcium carbonate, choose the neutral Japanese handmade Misupaper as the second layer. The acidity in the painting can be neutralized by the alkaline content in the Misupaper. Take off the temporary facing paper when finish lining and check the condition of the painting.

小托命紙 First lining

加托第二層美栖紙 Second lining

移除第二層的表面暫時性加固紙
Take off the first layer facing rayon paper

移除第一層的表面暫時性加固人造纖維紙
Take off the second layer facing rayon papers

13. 頂條加固 Mending

以寬度約5mm，帶有毛邊的長纖維楮皮紙，塗佈漿糊後在原有摺痕、裂痕處進行加固，加強支撐力。

Tear mulberry paper strips in 5mm wide with feathered edges. The reinforcing paper strips mend the breaks and creases with wheat starch, strengthen the weak area of the painting, provide better support.

以頂條黏貼在摺痕處，加強該處的支撐力
Apply mending strips to the creases for giving more support.

14. 加托背紙 3ʳᵈ layer lining

再次加托一層染好的楮皮紙，讓畫作更穩固平整。

For a more stable supporting to the painting, line another toned mulberry paper as third layer lining.

15. 全色補彩 Inpainting

為調整畫心不規則邊緣以利後續裝裱，將延伸畫心周圍的顏色至命紙。全色前先塗佈隔離層，避免顏料暈染到畫心。

Due to the irregular edges of painting, the color of the painting will be extend with watercolors on the first lining paper. It is also for the following mounting steps. Apply an isolating layer before inpainting.

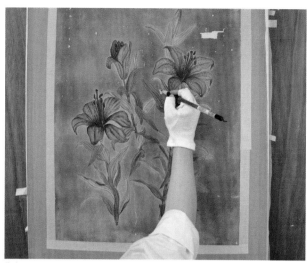

全色 Inpainting

16. 下板方裁 Trimming

待紙張在板上晾乾3-4天，完全繃平穩定之後，下板方裁。

After flattening on a drying board for 3 to 4 days , detach the painting by using a bamboo spatula. Trimming the edges of painting squared.

方裁，將裝裱完成且繃平後的畫作取下後裁切方正
Trim the edges

將方裁好的畫作繃平在無酸蜂巢板
Adhere thepainting on Tycore® mounting panel

17. 固定後裝框 Framing

方裁完畢，以小麥澱粉糊黏貼四邊，固定在裁切好的蜂巢板上待乾。依序放入蜂巢板與無酸卡紙板，最後以無酸導流板為最後一層，取代原畫框之木板。

Adhere the painting by narrowing margins onto a Tycore® mounting panel. From inside to outside, putting the objects into the frame with the order of Tycore® mounting panel, Rising Museum Board 4ply and PC board as the backing instead of the original wooden board.

18. 修復與裝裱完成後之相關拍照及記錄 Documentation after treatment

III. 修復前後對照 Before and after treatment

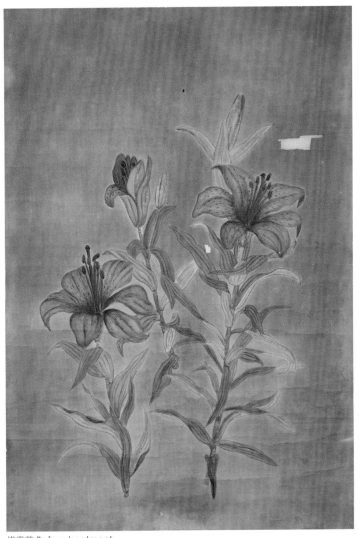

修復前 Before treatment

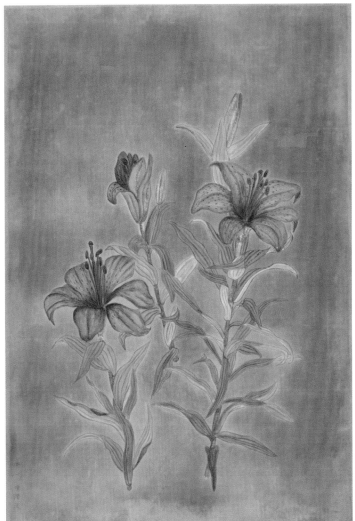

修復後 After treatment

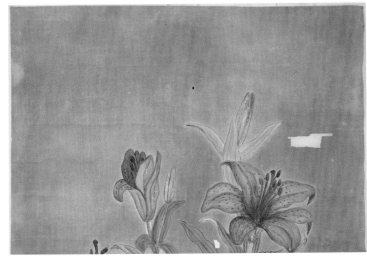

修復前（局部）Before treatment（detail）

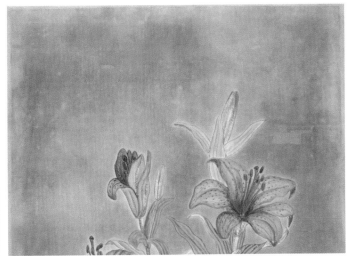

修復後（局部）After treatment（detail）

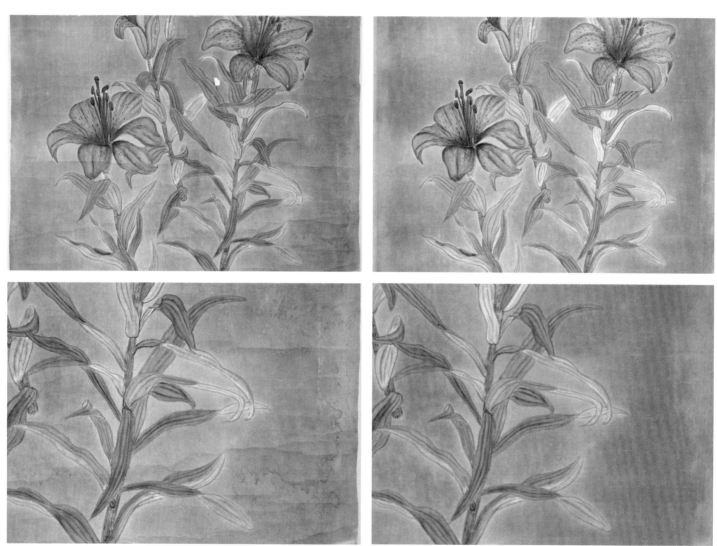

修復前（局部）Before treatment（detail）　　　　修復後（局部）After treatment（detail）

炭筆素描 Charcoal Sketches

此批修復的12張裸體人物炭筆素描，大約在1925年到1930年間完成。這批作品都有藝術家紀錄完成的年代和日期。經由透光檢視可看出紋路清晰的浮水印，且每張基底材的厚薄、紋路、質地皆不盡相同。

These works are 12 nude model charcoal sketches, finished in 1925 to 1930. All of these works were recorded the finishing year and date by the artist. When viewed by transmitted light, the paper substrate of these 12 sheet of sketches can examine watermark on it. The thickness and texture of each of these papers are different.

畫作之原始狀態無任何裝裱，以重疊捲曲方式收藏。畫作基底材方面，多數作品紙張表面黃化嚴重且顏色不均勻，帶有輕微髒汙及些許異物或昆蟲排遺；紙張邊緣焦脆、缺損。這些作品劣化之情形描述如下。

These works are stored by rolling, without any mounting. The damages basically include unevenly overall yellowing, dirt, attached accretion and flyspeck. The edges are brittle and burned with some losses. Following are some descriptions of the deterioration of these works.

作品〔坐姿裸女素描-27.2（16）〕、〔坐姿裸女素描-27.11.24（26）〕、〔立姿裸女素描-27.10.20（25）〕三張在左下角同一位置有一形狀、大小相同的缺失，應是收藏時重疊而同時造成的缺損。

On these three works: *Seated Female Nude Sketch-27.2 (16), Seated Female Nude Sketch-27.11.24 (26), Standing Female Nude Sketch-27.10.20 (25)*, there is a loss almost in the same size and shape on the lower left corner. Putting together whiles storage is the main reason to cause the similar damages.

作品〔坐姿裸女素描-30.5.3（30）〕人物及簽名部分皆有明顯黃化，下方則有兩處方型較白的痕跡，推測黃化嚴重部分可能是噴膠變質導致，白色部分則可能曾被紙膠或是其他膠帶遮蔽，沒有沾染到噴膠因此沒有變色現象。

On *Seated Female Nude Sketch-30.5.3 (30)*, it is obviously to see part of the paper condition is more aged, especially on the figure and the artist's sign. It is suspected that the deteriorated drawing fixative resulted in this ageing condition. On the other hand, there are two less yellowed square shaped area on the bottom of the paper. These places might be covered by something like tapes so that the fixative did not spray on them.

作品〔立姿裸女素描-28.10.19（32）〕紙張較薄，下方有兩條大範圍橫向折痕，一處垂直裂痕，紙纖維脆弱，需要進行嵌折處理以強化紙力。

The paper substrate of *Standing Female Nude Sketch-28.10.19 (32)* is thinner than others. There are two large creases and one break which is vertical to the painting. These weak places of paper need to be strengthen by mending.

作品〔坐姿裸女素描-25.6.11（4）〕因為紙張形狀為上窄下寬且邊緣不齊，為保留邊緣的簽名與印章，在製作夾裱時以邊緣外加紙張方式讓畫心往外延伸，以便展示簽名的部份。

The paper of *Seated Female Nude Sketch-25.6.11 (4)* was not square, the upper side was narrower than the lower side and the edges were not straight. In order to display the artist's written record and the sealing, additional paper will be added to extend the painting while matting.

I. 修復前狀態 Before treatment condition

不明漬痕 Unknown stains

不明漬痕 Unknown stains

不明漬痕 Unknown stains

缺失 Lost

撕裂 Tears

撕裂與皺摺 Tears and creases

褐斑 Foxing

脆化 Brittle

脆化 Brittle

修復紀錄 Conservation history

　　■未曾修復 Not treated before □曾修復 Previously restored

修復項目 Treatments

　　■表面清潔 Surface cleaning ■顏料暈染測試 Spot test ■加濕攤平 Wet and flatten ■顏料加固 Consolidation
　　■黃化清洗與褐斑清洗 Washing □重托命紙 Lining ■隱補缺洞 Compensation □頂條加固 Mending
　　■補彩 Inpainting ■紫外線檢視 UV study ■透光檢視 Transmitted light study □無酸蜂巢板 Tycore® mounting panel
　　■重新製作夾裱 Matting ■重新裝框 Framing

II. 修復作業內容
Conservation and restoration treatments

1. 修復前檢視登錄 Documentation

　　修復進行前，記錄畫作劣化狀況，並以正光、透光、紫外線攝影記錄。

Examine and record the deteriorations of the painting before conservation treatments. Photo records include normal lighting, transmitted light and UV radiation.

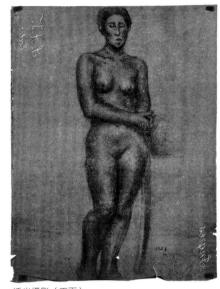

透光攝影（正面）
Transmitted light（Recto）

透光攝影下可以看到紙張的不同浮水印
Different watermarks showed up under transmitted light

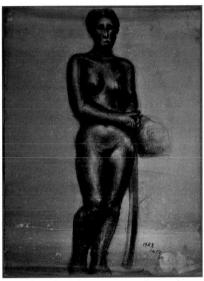

紫外線攝影（正面）UV radiation（Recto）

紫外線攝影下的褐斑以及漬痕處的螢光反應
Foxing spots and stain fluoresce under UV radiation

2. 表面除塵 Surface cleaning

　　使用吸塵器及橡皮擦粉末將畫心表面的灰塵清除。

Use the vacuum and eraser powder to clean the dust on the surface.

使用吸塵器吸除表面灰塵
Use vacuum to clean the surface dust

使用橡皮擦粉以畫圓方式清除表面較頑固的髒汙
Use erase powder to clean the dust on the surface

3. 顏料暈染測試與顏料加固
Spot test and media consolidation

　　使用棉花棒沾少許RO純水，測試顏料暈染狀態。此批畫作因年代久遠，噴膠老化導致碳粉容易脫落，因此需再進行加固處理。

　　Use the cotton swab with pure water to test sensitivity of the media. The fixative layer has been aged, therefore, consolidation is necessary to strengthen the structure of the media.

顏料暈染測試 Spot test

4. 剔除昆蟲排遺 Remove flyspeck

　　以手術刀尖端清除畫作邊緣之異物與昆蟲排遺。

　　Thin and crush the flyspeck into smaller pieces with scalpel. Some area which attached deeper in the paper can be picked off with the pointed tip of the scalpel.

清除畫作邊緣異物 Accretion removal on the edge

5. 局部攤平與表面暫時性加固
Partially flatten and temporary consolidation

　　畫作邊緣翻摺處，先使用純水潤濕，再用鑷子進行攤平。攤平後，由於該處脆弱易斷，使用甲基纖維素作為黏著劑塗佈於人造纖維紙上，於紙力脆弱處進行局部暫時性加固。

　　Wet the small folded area and flat with tweezers. The paper structure will become weaker when it is flattened. Those area will be temporary consolidated with methyl cellulose and rayon paper

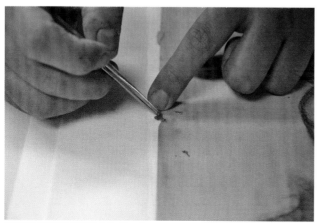

使用鑷子攤平紙張翻摺處 Flatten the creases with tweezers

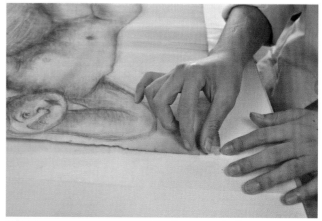

針對畫作邊緣脆弱處進行正面暫時性加固 Temporary facing

6. 媒材加固 Media consolidation

　　為避免碳粉在後續修護處理中暈開與脫落，以無酸聚酯片遮蔽畫作空白處，調製濃度0.1-0.3%的照片級明膠，利用超音波加濕器將明膠以霧狀方式加固炭粉。

　　For preventing the media loosing and bleeding during the afterward conservation treatment, the charcoal part will be consolidated with 0.1-0.3% gelatin mist by spraying with an ultrasonic humidifier. The rest area of the painting will be protected by Mylar® sheet.

使用超音波加濕器進行媒材加固處理
Using ultrasonic humidifier to consolidate fragile media

7. 淡化褐斑與純水清潔 Bleaching and pure water washing

　　使用3%過氧化氫（H$_2$O$_2$）淡化褐斑後，以浸泡清水的方式將紙張中髒汙及藥劑洗出，避免藥劑殘留在基底材及顏料層中。由於炭筆素描的作品在紙張完全濕潤時若直接重壓攤平，碳粉媒材容易脫落，進而被帶起，所以必須先將畫心晾乾後再進行攤平。

　　After bleaching by 3% hydrogen peroxide solution, immerse the painting in pure water to remove the Hydrogen peroxide residual and wash out inner dirt. However, while the paper is wet through, the charcoal particles is easy to drop off from the surface. It is recommended to flatten with slightly moisture again then with weight after the paper is dry. Therefore, before flattening the paper, put the painting on the woolen blanket for drying first.

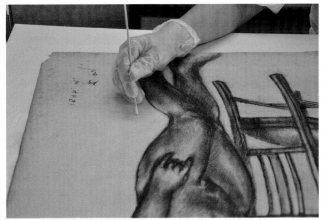

使用稀釋後的過氧化氫水溶液局部漂白褐斑處
Bleach the foxing with diluted hydrogen peroxide solutinn

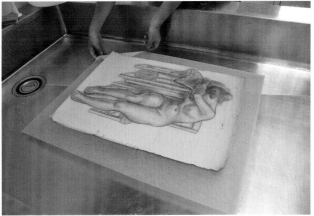

漂白後置入水槽浸泡清洗
After bleaching, put the painting in pure water to wash out the bleaching agent

8. 全面加濕攤平 Humidification and flatten

　　將晾乾的作品置入透明遮罩內，以超音波加濕器將濕度控制在約60%-80%相對溼度，潤濕作品約5-6分鐘，使作品全面微微的潤濕後即可取出，取出後上下放置人造化纖紙與吸水紙，並蓋上壓克力板及紙鎮重壓待乾。

　　After bleaching and overall washing, the paper is not flat when it is dry. Enable to humidify the paper slightly, gently and evenly, use ultrasonic humidifier to mist the paper in a chamber in about 5 to 6 minutes. The relative humidity (RH) will be consolled around 60% to 80%. As the paper is slightly wetted, put it between two sheet of rayon paper and blotters then weigh it to flatten.

使用超音波加濕器潤濕作品
Use ultrasonic humidifier to humidify the paper

作品重壓待乾
Flatten the paper by weight

9. 染製補紙 Toning the filling paper

　　由於多件作品有大範圍缺失，因此需挑選厚薄、肌理相似之素描紙製作補紙，並選用壓克力顏料進行染製，補洞後畫面視覺上會較為協調。染紙方式可分為浸染與刷染方式，對照作品本身基底材色調進行顏料調製，並製作多張不同色階之補紙供不同缺失區域使用。

　　There are several large loses in these sketches. For filling the missing area of the paper substrate, choose sketch paper which the thickness and texture is similar to the original one. Adjust the color of the filling paper close to the original paper with acrylic color by brush or by immersing. A level of color of the toned paper will be prepared for using. The visual integrity will be improved after filling the loses.

調製補紙染色顏料 Toning material

將紙張置於染色盆中浸泡上色 Toning the paper by immersing

使用排筆沾取顏料塗刷上色 Tone the paper by brush

選擇適合之補紙顏色 Chose the best color

10. 缺失處補洞 Filling the loses

　　將補紙與作品之間放置聚酯片隔離，在光桌上以針錐打點描繪缺失處輪廓，補紙製作完成後鑲嵌於作品缺失處，使用修復用皮料紙製作頂條，以修復用小麥澱粉糊作為黏著劑將頂條固定於作品背面。

　　For protecting, insert a MYLAR sheet between the painting and filling paper then puncture the shape of the loss area of the painting on the filling paper by a needle under a light table. The filling paper will be inserting to the missing area and will be mended with feathered mulberry paper strips and starch from the back.

於光桌上打點描繪補紙輪廓
Puncture the shape of losing area on a filling paper under a light table

使用頂條沿補紙邊緣黏貼，以固定補紙
Mend the filling paper with paper strips.

11. 撕裂處嵌折 Mending

　　多件作品邊緣有長短不一之撕裂痕，在此使用修復用皮料紙製作頂條，以修復用小麥澱粉糊作為黏著劑於光桌上進行嵌折。

　　There are many tears in different lengths along the edges. Use mulberry paper strips to mend those damage places with starch under a light table.

使用頂條固定紙張撕裂處 Mend the tears with paper strips

12. 全色 Inpainting

選用修復級粉彩顏料於補紙上進行顏色上的細節調整，使補紙色調與作品更為協調。

To harmonize the overall toning and to make the color closer to the original painting, adjust the color and detail of the filling paper with pastel.

使用棉花棒沾取粉彩進行調色 Fix the pastel color by a cotton swab

顏色確認後於補紙上進行全色 Inpaint the fixed color on the filling paper

13. 夾裱製作 Matting

選用厚度8Ply無酸白色卡紙板製作活動式窗型夾裱，並使用無酸聚酯片與卡紙板製作壓條，將作品固定於夾裱背板上。

Chose 8Ply white acid-free paper board to make active window matting. Fix the painting on the matting with MYLAR sheet strips and card board strips.

使用開窗機製作窗型夾裱 Use a mat cutter to do the window matting

使用壓條固定畫作 Cut strips to fix the painting

III. 修復前後對照 Before and after treatment

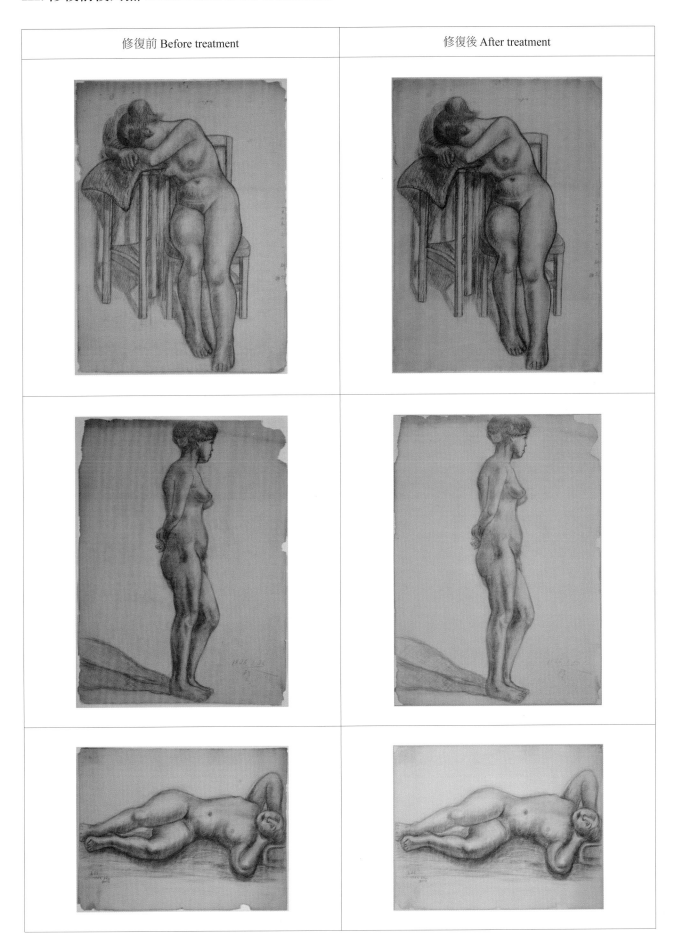

修復前 Before treatment	修復後 After treatment

修復前 Before treatment 修復後 After treatment

修復前 Before treatment	修復後 After treatment
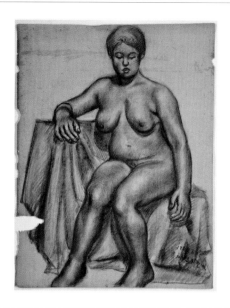	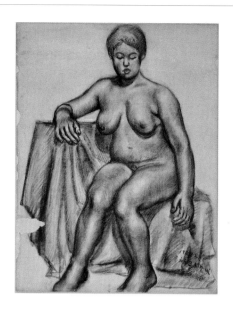
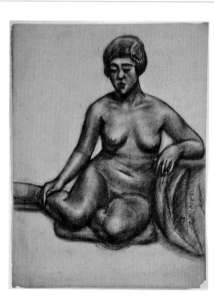	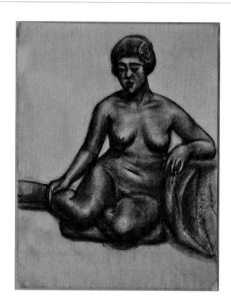
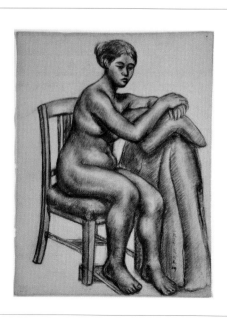	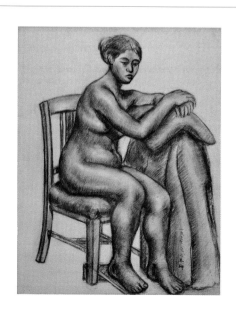

修復前 Before treatment	修復後 After treatment
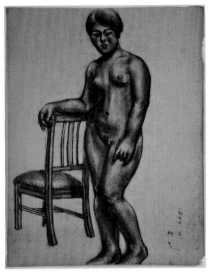	
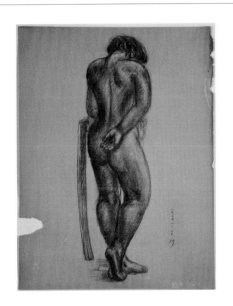	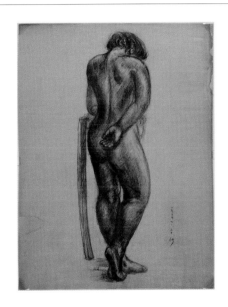
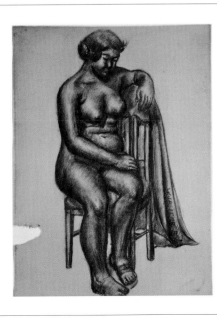	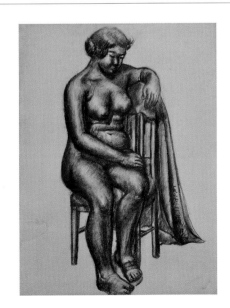

修復前 Before treatment	修復後 After treatment
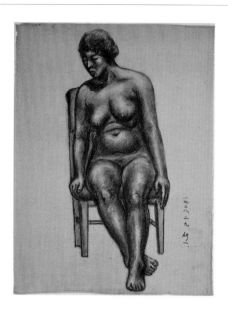	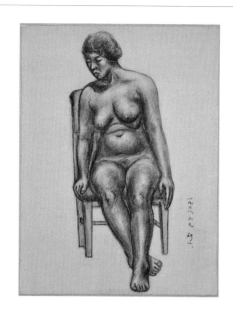
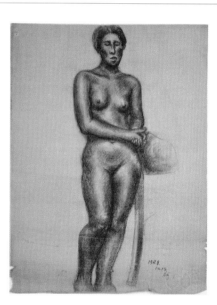	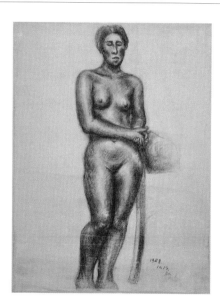
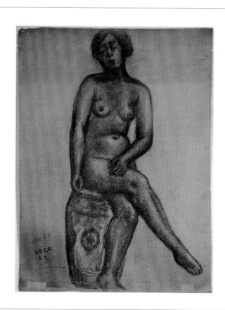	

水彩 Watercolor

　　此次修復之水彩畫作名為〔水源地附近〕，為西元1915年9月19日所繪之風景寫生，左下方有簽名、印章、文字註記共六處，背面亦有以中日文書寫之文字，但因前人以較厚的長纖維紙張從背後托裱，致使字跡難以辨認。畫心全面黃化，邊緣顏色暗沉、髒汙嚴重，褐斑顏色較深，上方一處缺口較大，缺口邊緣有許多昆蟲排遺。全幅畫意完整，紙力穩固，為保留紙張背面文字可辨識性，將揭掉原托裱紙張，並移除夾紙內的膠帶，以加濕壓平方式恢復紙張原貌。裝裱時複製背面文字與畫心共同展示於無酸夾裱中，讓觀眾在欣賞畫作的同時，能閱讀藝術家當時在背後所註記之文字。

　　This landscape watercolor painting is named *Near the Water Source*, painted at September 19, 1915. There are six marks on the front side, including the artist's signature, stamp and some records. Some Chinese and Japanese letters were written on the backside, however, the additional lining made those letters difficult to read. The paper substrate was overall yellowing, foxing but stable. The four edges were all darken and dirty. There were also some loses around the edges, especially on the top and corners of the paper and with flyspeck. In conservation treatment, in order to let the information which written on the back can be clearly recognized, it is suggested to remove all the lining papers. By the meantime, taking off the aged tapes which in the first and last lining. After that, it would be humidifying and flattening with weight. For limiting potential damage, preservation matting and framing will be applied. In this case, a reproduction of the letters which on the back would be made for later exhibition.

• 水源地附近 Near the Water Source

I. 修復前狀態 Before treatment condition

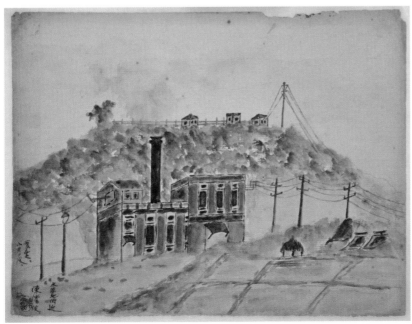

水源地附近 Near the Water Source　1915　紙本水彩 Watercolor on paper　23.5×31cm

修復紀錄 Conservation history
■未曾修復 Not treated before
□曾修復 Previously restored

修復項目 Treatments
■加濕攤平 Wet and flatten
■顏料暈染測試 Spot test
■黃化與褐斑清洗 Washing
■隱補缺洞 Compensation
■重新裝框 Frame
■補彩 Inpainting
■表面清潔 Surface cleaning
■顏料加固 Consolidation
■揭除舊命紙 Lining removal
■頂條加固 Mending
■無酸夾裱 Mat board
■無酸蜂巢板 Tycore® mounting panel

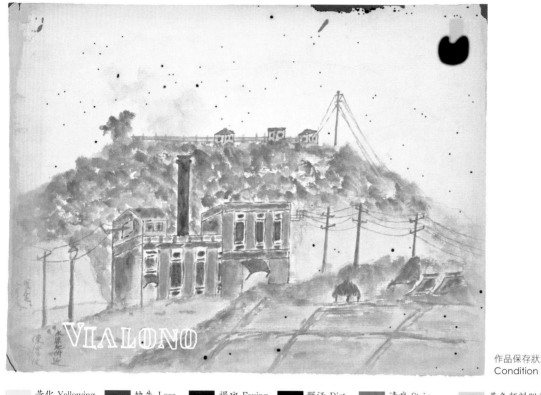

黃化 Yellowing		缺失 Loss		褐斑 Foxing		髒汙 Dirt		漬痕 Stain	黃色顏料附著 Color attached
折痕 Crease		斷裂 Break		破洞 Hole		膠帶 Tape		脫皮 Skinning	浮水印 Watermark

II. 修復作業內容 Conservation and restoration treatments

1. 修復前檢視登錄 Documentation

　　畫作修復處理前必須先進行劣化狀況檢視登錄，透過文字及圖像攝影紀錄將畫作劣化狀況進行檢視。攝影紀錄包括正光、側光、透光等方式。

Before conservation treatment, documentation of the painting is necessary. It consists of written and pictorial records. The deterioration of the painting will be examined. Photographic documentation which includes front light, raking light and transmitting light will also be recorded.

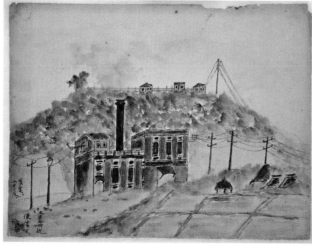

正光攝影 Normal light

透光攝影 Transmitted light

2. 表面除塵 Surface cleaning

以指腹輕搓橡皮擦粉末清除畫心表面的灰塵。

Clean the foreign media with eraser powder by gently applying to the surface of the painting.

使用橡皮擦粉末進行表面除塵 Surface cleaning with eraser powder

3. 顏料暈染試與顏料加固
Spot test and media consolidation

使用棉花棒沾少許純水，測試顏料暈染狀態，若發現易掉色之處，則需進行顏料加固。這件作品約使用1%到3%的明膠水溶液，以毛筆塗刷，加固易掉彩的顏料。

Test the solubility of the media with slightly wetted cotton swab. Consolidation will be given to strengthen the media if it is water soluble. In this painting, the fragile pigments are consolidated with 1-3% gelatin glue by brush.

以1-3%濃度的明膠水溶液加固易掉彩的顏料
Consolidation by 1-3 % gelatin solution

4. 昆蟲排遺移除 Remove flyspeck

使用手術刀將昆蟲排遺硬塊輕敲擊碎，附著較深部位則以手術刀尖端輕輕挑起，再以軟毛刷掃除清潔。

Thin and crush the flyspeck into smaller pieces with scalpel. Some area which attached deeper in the paper can be picked up with the pointed tip of the scalpel.

輕敲擊碎紙張表面的昆蟲排泄物
Thin and crush the flyspeck on the paper surface

5. 清洗與褐斑淡化
Washing and lighten the foxing

首先以棉花棒沾取微量的溫水清洗髒汙處，不易去除的褐斑則使用稀釋後的過氧化氫進行淡化清潔。經過清潔溶劑的處理後，再將畫作以純水洗淨，避免藥劑殘留。

Clean the dirt area with cotton swab wetted with pure water first. After that, foxing area will be bleached by diluted hydrogen peroxide. Avoiding the chemical solvent keep affecting the paper substrate and pigment layer, it is necessary to wash the painting with pure water.

局部淡化褐斑 Partially lighten the foxing

移除舊托紙 Lining removal

移除膠帶 Tape removal

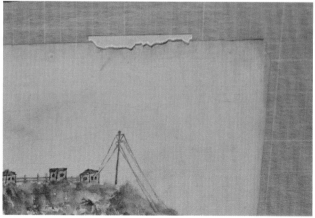

補紙 Filling the losses

嵌摺：以撕毛邊的楮皮紙條從背面加固基底材斷裂處 Mending

6. 移除舊托紙
Remove the original lining paper

將舊托紙局部加濕後，使用鑷子小面積逐一揭除。

Humidify the original lining paper partially, remove the backing paper piece by piece with tweezers.

7. 移除背面膠帶與膠漬
Tape residual and stain removal

畫作背面左上角之紙膠帶用鑷子揭除，再使用豬皮橡膠，去除所遺留之殘膠。

Remove the tape and tape residual on the left corner on the back of the painting. Use tweezers to take off the tape first then erase the residual in a very gently way by rubber.

8. 補紙 Compensation

透過光桌在無酸聚酯片上描繪缺口形狀，再以針錐打點方式將形狀點繪在質地顏色相似的舊紙上，比對確認無誤後，將紙張鑲入畫心，背後再以帶有毛邊的楮皮紙頂條加固以加強結構。

Draw the shape of the loss area of the painting on the MYLAR sheet under the light table. Transfer the shape and cut to the insert paper by puncturing the insert paper with needle. The compensation paper will be mended with feathered mulberry paper strips to strength the structure for a better support.

9. 嵌摺 Mending

撕楮皮毛邊作為頂條，塗佈修復用小麥澱粉糊，從畫心背面加固基底材斷裂區域。

Tear mulberry paper strips with feathered edges. The paper strips mend the paper breaks with wheat starch, strengthen the weak area of the painting.

10. 全色 Inpainting

待畫心壓乾穩定之後，調整補紙的顏色。

After the painting is flattened, adjust the color of the compensation paper.

11. 無酸夾裱 Matting

使用8Ply無酸卡紙板挖鑲夾裱，上方開窗展示畫心、下方開窗展示複製文字。

Choose acid-free 8Ply board as matting material. This matting will have two windows for displaying the reproduction of the characters on the back and the painting at the same time.

夾裱製作：組合前後卡紙板
Matting: combine with the cover

夾裱製作：固定畫心
Matting: adhere the painting to the matting board with hinges

12. 裝框 Framing

將畫心與無酸夾裱放入製作好的畫框中，依序放入無酸蜂巢板、無酸瓦楞紙板，最後以聚丙烯背板為最後一層取代原畫框之木板。

Put the matted painting into the frame. From inside to outside, putting the objects into the frame with the order of Tycore® mounting panel, Rising Museum Board 4P and Polypropylene board as the backing instead of the original wooden board.

畫框放入聚丙烯背板 Putting the pp board as the backing board

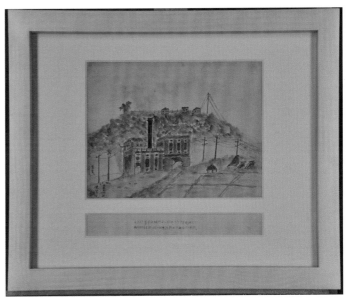

裝框完成 After framing

III. 修復前後對照 Before and after treatment

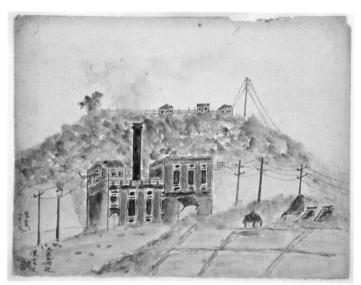

修復前 Before treatment

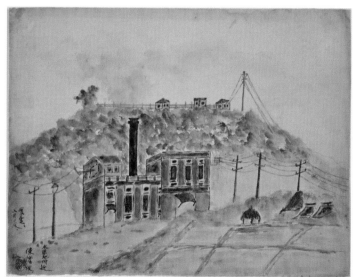

修復後 After treatment

修復前（局部）Before treatment（detail）　　　　　修復後（局部）After treatment（detail）

單頁速寫 Single-sheet Sketches

此批陳澄波先生所繪之單頁速寫，共285張。其中有25張風景、260張人物與靜物速寫。手稿之保存狀況不佳，原始保存狀態為一整大疊收藏，以牛皮紙袋簡易包覆。紙張嚴重黃化，其邊緣焦黃脆化，部份手稿有成塊狀的暗化情形。另外，紙張普遍有褐斑著生，並有皺摺、髒汙、破損、缺失、撕裂、不明漬痕、水漬、蟲蛀、白點、昆蟲排遺等，並發現兩隻昆蟲屍體。

These 285 single-sheet sketches are depicted by Mr. Chen Cheng-po. There are 25 landscape sketches and the rest of the 260 sketches involve portraits and still life drawing. They were stacked up in kraft paper bags originally, and in poor condition. The sketches were yellowing severely, the edges of paper were very brittle and fragile, and some of the sketches had darkening aggregately. In addition, most of sketches had condition of foxing, creases, dirt, losses, tears, unknown stain, tide line, insect damage, white spots and flyspecks. Two of insect bodies are found during documentation.

修復過程中，每件作品之處理程序雖依照其個別狀況制訂修復處理細節，但在清洗、除漬痕、褐斑或補紙時，其程序必須統一。

Each treatment procedures are carried out depending on the different condition, yet some of procedures have the SOP such as washing, stain or foxing alleviation and filling losses.

I. 修復前狀態 Before treatment condition

1. 人物與靜物速寫 Figures and still life sketches

水漬與摺痕 Tide line and creases

水漬與摺痕 Tide line and creases

水漬 Tide line

水漬 Tide line

昆蟲屍體 Insect damage

昆蟲屍體 Insect damage

不明漬痕 Unknown stain

不明漬痕 Unknown stain

髒汙與褐斑 Dirts and foxing

褐斑 Foxing

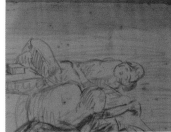

塊狀暗化 Darking

昆蟲排遺 Flyspecks

蛀洞 Insect hole

脆化 Brittle

皺褶 Creases

邊緣撕裂 Tears

修復紀錄 Conservation history

■未曾修復 Not treated before □曾修復 Previously restored

修復項目 Treatments

■加濕攤平 Wet and flatten ■顏料暈染測試 Spot test ■表面除塵 Surface cleaning ■黃化清洗 Washing

□頂條加固 Mending □揭除舊命紙 Lining removal ■重托命紙 Lining □隱補缺洞 Compensation

□無酸蜂巢板 Tycore® mounting panel □重新夾裱 Framing □重新裝幀 Rebinding ■無酸保護盒製作 Acid-free box

2. 風景速寫 Landscape sketches

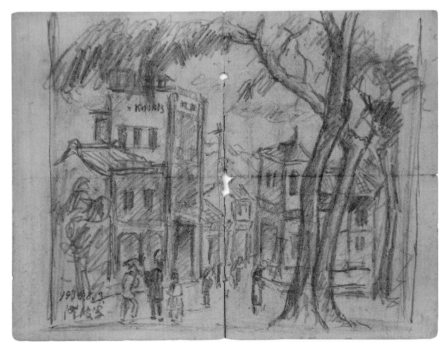

修復紀錄 Conservation history

■未曾修復 Not treated before
□曾修復 Previously restored

修復項目 Treatments

■加濕攤平 Wet and flatten
■顏料暈染測試 Spot test
■表面除塵 Surface cleaning
■黃化清洗 Washing
■頂條加固 Mending
□揭除舊命紙 Lining removal
■重托命紙 Lining
■隱補缺洞 Compensation
□無酸蜂巢板 Tycore® mounting panel
■無酸夾裱 Matting
□重新裝幀 Rebinding
■無酸保護盒製作 Acid-free box

II. 修復作業內容 Conservation and restoration treatments

此批速寫雖個別狀況有些許差異，但主要劣化狀況大同小異，處理步驟與說明如下：

The sketches have some individual condition, but the main deteriorations are similar. The treatments and procedures are described below.

1. 修復前檢視登錄 Documentation

作品修復處理前須先進行劣化狀況檢視登錄，透過文字及圖像攝影紀錄將畫作劣化狀況詳實紀錄以作為修復處理的依據，攝影紀錄包括正光與側光。

Before treatment, documentation of the each sketch is necessary. It consists of written and pictorial records. The deterioration of the sketches will be examined. Photographic documentation which includes front light and raking light will also be carried out.

2. 表面清潔除塵與移除異物 Surface cleaning and accretion removal

以羊毛刷與附有高效空氣濾網（HEPA）的專業級吸塵器相互搭配，進行初步除塵作業，再以自製橡皮擦粉末進行清潔。若是作品上有異物或昆蟲排遺則使用手術刀或抹刀等適當工具以挑、刮、分解等方式清除。

Use wool soft brush and professional vacuum with HEPA filter to clean the surface of sketches. Furthermore clean ith eraser powders. Strike off the flyspecks and frass with applicable tools such as spatula and scalpel.

以橡皮擦粉末移除表面髒汙
Surface cleaning by eraser powder

以手術刀挑除紙纖維中的昆蟲排遺
Strike off the flyspecks and frass with scalpel

3. 顏料暈染測試與顏料加固 Spot test and media consolidation

使用棉花棒沾少許RO純水，於顏料上停留約5-15秒，檢視媒材是否有暈染或掉色的情形。經測試後不穩定的媒材須進行固色處理。

Use cotton swabs with pure water to test the stability of media. If the media is water sensitive, consolidate with applicable adhesive before water treatment.

4. 攤摺痕 Unfolding

此批作品之畫心邊緣或內部皆有多處摺痕，施作時以小號水彩筆沾取純水潤濕摺痕處纖維，並上下夾覆不織布與吸水紙重壓待乾。

Due to many creases and handling dents on sketches, use water brush with pure water to moisturize and swell the cellulose. Furthermore, cover with Hollytex and blotters, and then dry with the pressures.

顏料暈染測試 Spot test

5. 褐斑淡化處理 Foxing alleviation

在測試過後，以小號水彩筆沾取適當藥劑將褐斑或黃斑淡化。

After spot tests, alleviate the foxing and yellowing with applicable solution.

以純水潤溼摺痕處紙張纖維
Use a brush with pure water to moisturize and swell the cellulose

6. 作品清洗與除酸
Washing and deacidification

此批作品在清洗前，預先測試紙張的酸鹼度（pH值）做為參考比較之依據。在清洗時，使用斜板固定角度，將作品置於斜板上清洗以確保作品的安全性。由於添加藥劑進行清洗，可能造成作品紙張顏色變化過大，為保持作品原始狀況，故本批作品在清洗時僅使用純水，並無添加額外的藥劑。透過清洗步驟將紙張纖維內部的有害物質與色素帶離，當清洗過的餘液漸趨透明時，即可將作品提起並置於羊毛毯待乾。而清洗的時間、水溫與相關資訊，將依照測試結果以相同條件下進行並記錄。由於此批作品紙張的原始顏色並不相同，老化後顏色差異變大，清洗過後雖可輕微縮小彼此間顏色的差異，但實無法將整批作品調整至完全相同，在此特為說明。

以適當藥劑淡化褐斑 Alleviating foxing and yellowing

Test the pH value of each sketch before washing. Use a screen printing board to support the sketch when it is washed. Use the pure water to wash out the deteriorating ingredients from paper, dry it out on woolen blanket. Record the washing time and temperature of every washing procedure. The original colors of sketches are different, so the colors after aging are different certainly. Even though these different colors became closer to each other after washing, but there are slightly variations which are inevitable.

測試作品清洗前的酸鹼值
Test pH value of the paper before washing

以絹框與不織布撐托作品進行清洗
The paper sheets were held and supported with rayon paper and framed net while washing.

7. 畫心小托與補洞 Lining and lining

　　清洗且乾燥後，使用修復級皮料紙與小麥澱粉糊將作品小托，而後進行補洞。待缺失填補完成後，上板繃平即完成修復。修復完成之作品則不需修邊。

　　After washing and drying, use Japanese paper and wheat starch to line the sketches. Fill the losses after lining, and adhere it by narrowing margins onto a wooden drying board.

以皮料紙與小麥澱粉糊將作品小托
use Japanese paper and wheat starch to line the sketches

染製顏色相近的補紙進行補洞
Filling the loss by colored paper

作品上板繃平 Adhere the works onto a wooden drying board

8. 修復後攝影記錄並撰寫報告 Documentation after treatment

透過攝影詳實記錄作品修復前、中與後的狀況，並將修復過程完整紀錄，做為了解作品狀況的依據。

For understanding the condition of sketches, photo documentation and reports are necessary.

9. 無酸夾裱與保護措施製作 Acid-free matting and boxes

在與基金會討論過後，決議將25張風景速寫與1張人物速寫以8Ply厚度的無酸卡紙板製作活動式的窗型夾裱存放，背板以風扣襯托以減輕整體重量；其餘259張作品則訂製無酸瓦楞紙板製的保護盒存放，除了便於收藏，其輕便與穩固的特性也提高持拿的便利性。

After treatments, make the 8Ply acid-free matting for restoring 25 pieces of landscape sketches and 1 figure sketch, and choose the lightening form core as back board. Boxes which made by B-Flute acid-free corrugated boards are for restoring other 259 pieces of sketches.

開窗製作無酸夾裱
Making 8Ply acid-free matting for the sketches

整理作品並放入無酸保護盒
Putting the works into the acid-free storage box

III. 修復前後對照 Before and after treatment

修復前 Before treatment	修復後 After treatment

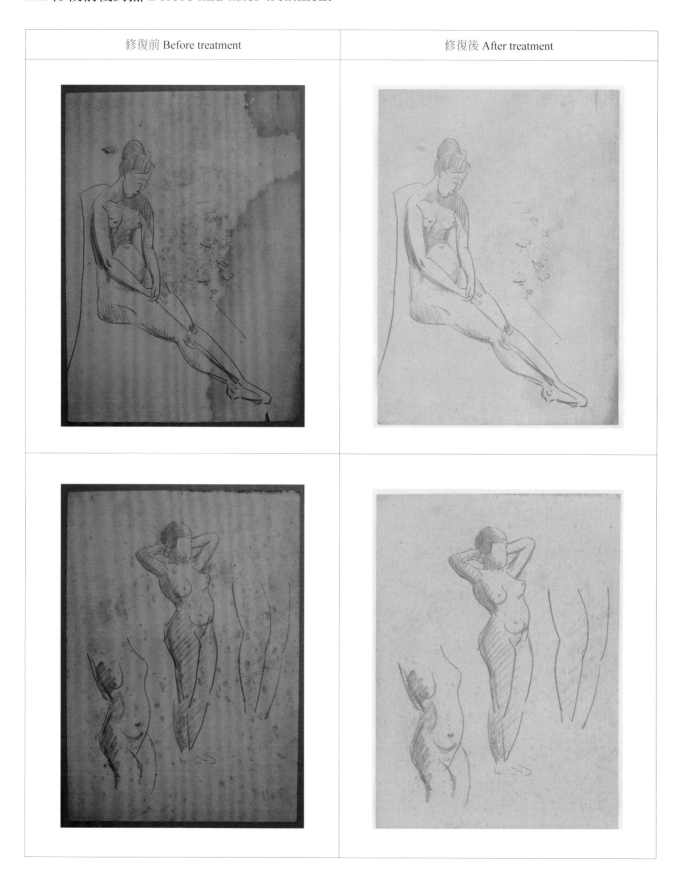

修復前 Before treatment	修復後 After treatment
	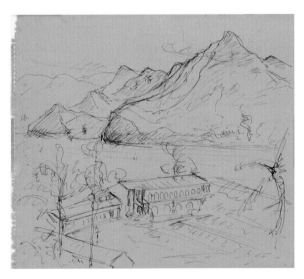

素描簿 Sketchbooks

此次修復的三本素描簿編號為SB13、SB18和SB25。素描簿為陳澄波先生所繪的寫生草圖、內容包括各地實景描繪、練習、記錄。雖然只是鉛筆與鋼筆的簡單線條，但透過圖畫和部分的文字記錄，仍能了解當時陳澄波先生的生活情景與感受。從藝術者的視野與創作邏輯，也可以尋找完整作品的前身；因此，藝術家的素描簿常是學者專家所珍愛的文史資料。

In this project, the numbers of the three sketchbooks are SB13, SB18 and SB25. These sketchbooks are belonging to Chen Cheng-po, the content includes the depiction of sceneries. The artist also wrote down his observation. Although the painting is only composed of simple lines by pen and pencil, viewers still can be perceived about his living and life experience from it and from the recorded text. The idea of the complete painting sometimes can be found from that information, like the artist's vision and the logic of those rough out. As important historical information, that's the reason why the artist's sketchbooks are often cherished by scholars and experts.

SB13與SB18素描簿，頁數分別為109與64頁，以棉繩裝幀而成。書身與書皮已脫開分離，但縫線完整，不需重新裝幀。計畫將書身與書皮在經過書頁的加固與嵌摺後將其回貼，以維持書本的完整性。最後製作無酸掀貝式保護盒妥善保存。

SB13 and SB18 are 109 pages and 64 pages respectively, both binding with cotton ropes. Though the book covers and the book blocks are separated, the stitches are intact so rebinding work is unnecessary. After leaves consolidated and mended, the book covers and the book blocks are pasted together for the completeness. After treatments, the Clam shell box has been designed for the sketchbooks.

SB25以金屬釘針裝幀，但因為年代已久，原先的金屬釘已鏽蝕，鐵鏽不僅成為紙張的汙染源，也無法穩定的固定書頁而失去原本的功能，因此決定將原本的金屬釘移除，使用楮皮紙製作紙釘取代，原書籍則製做無酸四折翼保護盒收藏。

SB25 is in side-stitch binding, however, the staples rusted with ages. Rust not only become the source of pollution but also lose the original function, couldn't join the paper together. It was decided to remove the original side stitch and replace it with paper-stitch which is made out of Japanese long fiber paper. For housing, the sketchbooks will be collected in an acid-free four-flap box.

I. 修復前狀態 Before treatment condition

1. SB13

SB13　1938　12.5×18.5cm

修復紀錄 Conservation history

■未曾修復 Not treated before
□曾修復 Previously restored

修復項目 Treatments

□加濕攤平 Wet and flatten
□顏料暈染測試 Spot test
■表面除塵 Surface cleaning
□黃化清洗 Washing
■頂條加固 Mending
□揭除舊命紙 Lining removal
□重托命紙 Lining
□隱補缺洞 Compensation
□回貼書板 Reattach cover board
■重新裝幀 Rebinding
■無酸保護盒製作 Acid-free box

2. SB18

SB18　1938　12.5×18.5cm

修復紀錄 Conservation history

■未曾修復 Not treated before
□曾修復 Previously restored

修復項目 Treatments

□加濕攤平 Wet and flatten
□顏料暈染測試 Spot test
■表面除塵 Surface cleaning
□黃化清洗 Washing
■頂條加固 Mending
□揭除舊命紙 Lining removal
□重托命紙 Lining
□隱補缺洞 Compensation
□回貼書板 Reattach cover board
■重新裝幀 Rebinding
■無酸保護盒製作 Acid-free box

3. SB25

SB25　1938　29×24.8cm

修復紀錄 Conservation history

■未曾修復 Not treated before
□曾修復 Previously restored

修復項目 Treatments
□加濕攤平 Wet and flatten
□顏料暈染測試 Spot test
■表面除塵 Surface cleaning
□黃化清洗 Washing
■頂條加固 Mending
□揭除舊命紙 Lining removal
□重托命紙 Lining
□隱補缺洞 Compensation
□回貼書板 Reattach cover board
■重新裝幀 Rebinding
■無酸保護盒製作 Acid-free box

II. 修復作業內容 Conservation and restoration treatments

1. 修復前檢視登錄 Documentation

修復處理前必須先進行劣化狀況檢視登錄，透過文字及圖像攝影紀錄將劣化狀況進行檢視。

Before conservation treatment, documentation of the painting is necessary. It consists of written and pictorial records. The deterioration of the sketchbooks and the photograph record will be examined.

2. 表面除塵 Surface cleaning

用手指輕搓聚乙烯橡皮粉末，清理表面灰塵和髒汙處，再配合軟羊毛刷及吸塵器將灰塵與髒汙的粉屑清除乾淨。

Use polyethylene eraser powder with finger and HEPA vacuum cleaner with soft wool brush to clean the dust and dirt on the surface.

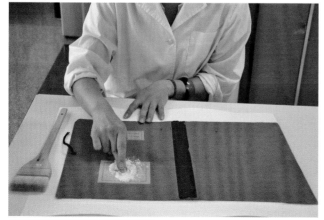

以手指輕搓橡皮擦粉末進行表面除塵
Use eraser powder to do surface cleaning

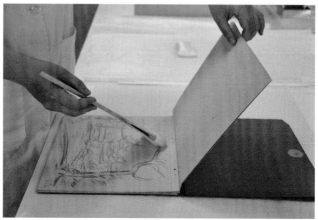

以羊毛刷清理橡皮擦粉末髒汙碎屑
Use soft wool brush to swap the dirty eraser powder

3. 移除生鏽金屬釘針
Removing the rusty staples in side-stitch binding

使用鑷子挑除生鏽的釘針後，再以羊毛刷和吸塵器將細屑粉末清除。

Pick up all of the rusty staples by tweezers. Using HEPA vacuum cleaner and soft wool brush to clean the residual rust after removing staples.

以鑷子挑除生鏽釘針 Remove the rusty stitches by tweezers

4. 頂條加固 Mending

將楮皮紙1-2cm兩邊撕毛邊後作為頂條，塗佈修復用小麥澱粉糊，加固基底材斷裂區域，黏合後用吸水紙及紙鎮吸濕加壓。

For strength the structure of breaking area of the painting, use feathered mulberry paper strips in 1 to 2 centimeter width to mend those damage places with starch then flatten with blotter and weight after mending.

頂條加固黑色扉頁 Mending the black endpaper

5. 書皮填補與全色 Filling the loses of cover and inpainting

書皮封面以厚紙板製成，部分蟲蛀需要填補。用小麥澱粉糊、無酸白膠調合楮皮纖維紙漿，填補缺洞，再黏貼一層顏色與書皮相近之紙張，最後以水彩調整顏色。

The cover of the sketchbook is made of card board. It was damaged by insects, with several small loses on it. The loses will be insert with mulberry paper fiber which mixed with starch and PVA glue. A sheet of paper in a similar color of the cover will be applied and the fix the overall toning with watercolor.

填補與全色（修復前）
Filling and inpainting（before treatment）

填補與全色（修復後）
Filling and inpainting（after treatment）

6. 重新裝幀 Rebinding

SB25移除金屬釘後，以重新製作的楮皮紙紙釘取代之，清潔並且調整好原先的金屬釘孔洞，將紙釘穿好固定，打結後敲扁，最後再用楮皮紙撕好毛邊作為固定書皮與內頁之用。

After removing the rusty staples chose paper-stitch to replace the original rusted metal one. Clean and adjust the original perforation before pass through the paper-stitch. Knot the paper-stitch then punch it to flat. Last, combine the cover and all pages with feathered mulberry paper to give a better structure.

以楮皮毛邊紙固定書皮和內頁
Join the cover and inner pages with feathered paper

將紙釘穿過原本的釘孔
Pass through the paper-stitch to the original perforation

紙釘打結後敲扁 Knotting and punching the paper-stitch to flat

調整紙釘打結的位置 Adjust the place of knotting

7. 無酸保護盒製作 Making acid-free four flap box

以無酸檔案夾紙與無酸聚酯片製作四折翼。四折翼保護盒是四面開頁形式，可以將書籍置中保護，盒外的無酸聚酯片扣帶，可確實固定書頁並方便拿取。

Make the acid-free four flap box by folder stock and Mylar® sheets for housing the object. A four flap box can be full-opened in four directions. The object is placed in the middle. The Mylar® strip which wrapped the box can ensure the object is well-protected by the four flap and easy to take.

四折翼保護盒 The four flap box

以無酸聚酯片扣帶固定保護盒 Wrap the box with Mylar strip

紙質作品
Works on Paper

修復前後對照
Before and After Treatment

正修科技大學文物修護中心
Cheng Shiu University Conservation Center

水墨 Ink Paintings

每件作品以修復前和修復後做為對照。
修復前置於左側、修復後置於右側。

IW002
牽牛花 Morning Glory

IW008
淡水寫生合畫
Tamsui Collaboration

膠彩 Glue Color Painting

作品以修復前和修復後做為對照。
修復前置於左側、修復後置於右側。

GC004
百合花 Lilies

炭筆素描 Charcoal Sketches

每件作品以修復前和修復後做為對照。
修復前置於左側、修復後置於右側。

CS012
坐姿裸女素描-25.6.11（4）Seated Female Nude Sketch-25.6.11（4）

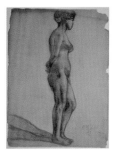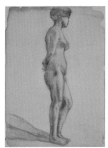

CS025
立姿裸女素描-26.1.22（12）Standing Female Nude Sketch-26.1.22（12）

CS035
臥姿裸女素描-26.6.26（2）Reclining Female Nude Sketch-26.6.26（2）

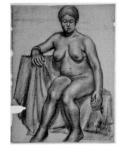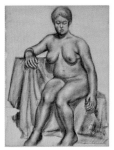

CS052
坐姿裸女素描-27.2（16）Seated Female Nude Sketch-27.2（16）

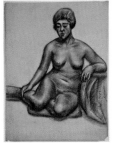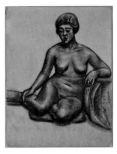

CS053
坐姿裸女素描-27.3.11（17）Seated Female Nude Sketch-27.3.11（17）

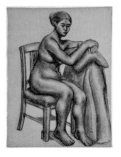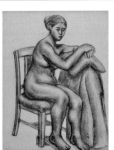

CS056
坐姿裸女素描-27.3.25（18）Seated Female Nude Sketch-27.3.25（18）

CS059
立姿裸女素描-27.3（23）Standing Female Nude Sketch-27.3（23）

CS069
立姿裸女素描-27.10.20（25）Standing Female Nude Sketch-27.10.20（25）

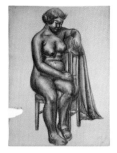
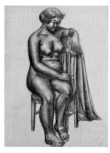

CS073
坐姿裸女素描-27.11.24（26）Seated Female Nude Sketch-27.11.24（26）

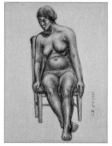
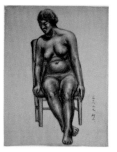

CS077
坐姿裸女素描-28.2.9（27）Seated Female Nude Sketch-28.2.9（27）

CS083
立姿裸女素描-28.10.19（32）Standing Female Nude Sketch-28.10.19（32）

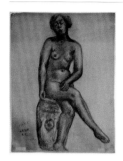
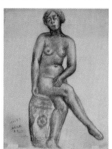

CS089
坐姿裸女素描-30.5.3（30）Seated Female Nude Sketch-30.5.3（30）

水彩 Watercolor

作品以修復前和修復後做為對照。
修復前置於左側、修復後置於右側。

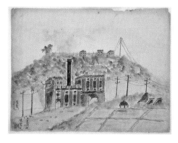

WA013
水源地附近 Near The Water Source

單頁速寫 Single-sheet Sketches

每件作品以修復前和修復後做為對照。
修復前置於左側、修復後置於右側。

SK0267
立姿裸女速寫（123）Standing Female Nude Sketch（123）

SK0269
立姿裸女速寫（124）Standing Female Nude Sketch（124）

SK0270
蹲姿裸女速寫（9）Squatting Female Nude Sketch（9）

SK0271
蹲姿裸女速寫（10）Squatting Female Nude Sketch（10）

SK0272
臥姿裸女速寫（10）Reclining Female Nude Sketch（10）

SK0273
臥姿裸女速寫（11）Reclining Female Nude Sketch（11）

SK0274
臥姿裸女速寫（12）Reclining Female Nude Sketch（12）

SK0275
人物速寫（6）Figure Sketch（6）

SK0276
坐姿裸女速寫（107）Seated Female Nude Sketch（107）

SK0277
坐姿裸女速寫（108）Seated Female Nude Sketch（108）

SK0278
坐姿裸女速寫（109）Seated Female Nude Sketch（109）

SK0279
坐姿裸女速寫（110）Seated Female Nude Sketch（110）

SK0280
坐姿裸女速寫（111）Seated Female Nude Sketch（111）

SK0281
坐姿裸女速寫（112）Seated Female Nude Sketch（112）

SK0282
立姿裸女速寫（125）Standing Female Nude Sketch（125）

SK0283
女體速寫（4）Female Body Sketch（4）

SK0284
立姿裸女速寫（126）Standing Female Nude Sketch（126）

SK0285
立姿裸女速寫（127）Standing Female Nude Sketch（127）

SK0286
立姿裸女速寫（128）Standing Female Nude Sketch（128）

SK0287
立姿裸女速寫（129）Standing Female Nude Sketch（129）

SK0288
女體速寫（5）Female Body Sketch（5）

SK0289
女體速寫（6）Female Body Sketch（6）

SK0290
坐姿裸女速寫（113）Seated Female Nude Sketch（113）

SK0291
坐姿裸女速寫（114）Seated Female Nude Sketch（114）

SK0292
坐姿裸女速寫（115）Seated Female Nude Sketch（115）

SK0293
坐姿裸女速寫（116）Seated Female Nude Sketch（116）

SK0294
立姿裸女速寫（130）Standing Female Nude Sketch（130）

SK0295
立姿裸女速寫（131）Standing Female Nude Sketch（131）

SK0296
立姿裸女速寫（132）Standing Female Nude Sketch（132）

SK0297
坐姿裸女速寫（117）Seated Female Nude Sketch（117）

SK0298
坐姿裸女速寫（118）Seated Female Nude Sketch（118）

SK0299
坐姿裸女速寫（119）Seated Female Nude Sketch（119）

SK0300
坐姿裸女速寫（120）Seated Female Nude Sketch（120）

SK0301
坐姿裸女速寫（121）Seated Female Nude Sketch（121）

SK0302
坐姿裸女速寫（122）Seated Female Nude Sketch（122）

SK0303
立姿裸女速寫（133）Standing Female Nude Sketch（133）

SK0304
立姿裸女速寫（134）Standing Female Nude Sketch（134）

SK0305
立姿裸女速寫（135）Standing Female Nude Sketch（135）

SK0306
立姿裸女速寫（136）Standing Female Nude Sketch（136）

SK0307
人物速寫（7）Figure Sketch（7）

SK0308
坐姿裸女速寫（123）Seated Female Nude Sketch（123）

SK0309
臥姿裸女速寫（13）Reclining Female Nude Sketch（13）

SK0310
臥姿裸女速寫（14）Reclining Female Nude Sketch（14）

SK0311
立姿裸女速寫（137）Standing Female Nude Sketch（137）

SK0312
立姿裸女速寫（138）Standing Female Nude Sketch（138）

SK0313
蹲姿裸女速寫（11）Squatting Female Nude Sketch（11）

SK0314
跪姿裸女速寫（8）Kneeling Female Nude Sketch（8）

SK0315
跪姿裸女速寫（9）Kneeling Female Nude Sketch（9）

SK0316
坐姿裸女速寫（124）Seated Female Nude Sketch（124）

SK0317
坐姿裸女速寫（125）Seated Female Nude Sketch（125）

SK0318
坐姿裸女速寫（126）Seated Female Nude Sketch（126）

SK0319
坐姿裸女速寫（127）Seated Female Nude Sketch（127）

SK0320
立姿裸女速寫（139）Standing Female Nude Sketch（139）

SK0321
立姿裸女速寫（140）Standing Female Nude Sketch（140）

SK0322
坐姿裸女速寫（128）Seated Female Nude Sketch（128）

SK0323
坐姿裸女速寫（129）Seated Female Nude Sketch（129）

SK0324
坐姿裸女速寫（130）Seated Female Nude Sketch（130）

SK0325
坐姿裸女速寫（131）Seated Female Nude Sketch（131）

SK0327
坐姿裸女速寫（133）Seated Female Nude Sketch（133）

SK0328
坐姿裸女速寫（134）Seated Female Nude Sketch（134）

SK0329
坐姿裸女速寫（135）Seated Female Nude Sketch（135）

SK0330
坐姿裸女速寫（136）Seated Female Nude Sketch（136）

SK0331
跪姿裸女速寫（10）Kneeling Female Nude Sketch（10）

SK0332
立姿裸女速寫（141）Standing Female Nude Sketch（141）

SK0333
立姿裸女速寫（142）Standing Female Nude Sketch（142）

SK0334
立姿裸女速寫（143）Standing Female Nude Sketch（143）

SK0335
立姿裸女速寫（144）Standing Female Nude Sketch（144）

SK0336
立姿裸女速寫（145）Standing Female Nude Sketch（145）

SK0337
跪姿裸女速寫（11）Kneeling Female Nude Sketch（11）

SK0338
臥姿裸女速寫（15）Reclining Female Nude Sketch（15）

SK0339
立姿裸女速寫（146）Standing Female Nude Sketch（146）

SK0340
立姿裸女速寫（147）Standing Female Nude Sketch（147）

SK0341
立姿裸女速寫（148）Standing Female Nude Sketch（148）

SK0342
立姿裸女速寫（149）Standing Female Nude Sketch（149）

SK0343
立姿裸女速寫（150）Standing Female Nude Sketch（150）

SK0344
立姿裸女速寫（151）Standing Female Nude Sketch（151）

SK0345
立姿裸女速寫（152）Standing Female Nude Sketch（152）

SK0346
立姿裸女速寫（153）Standing Female Nude Sketch（153）

SK0347
立姿裸女速寫（154）Standing Female Nude Sketch（154）

SK0348
立姿裸女速寫（155）Standing Female Nude Sketch（155）

SK0349
立姿裸女速寫（156）Standing Female Nude Sketch（156）

SK0350
立姿裸女速寫（157）Standing Female Nude Sketch（157）

SK0351
立姿裸女速寫（158）Standing Female Nude Sketch（158）

SK0352
立姿裸女速寫（159）Standing Female Nude Sketch（159）

SK0353
立姿裸女速寫（160）Standing Female Nude Sketch（160）

SK0354
立姿裸女速寫（161）Standing Female Nude Sketch（161）

SK0355
立姿裸女速寫（162）Standing Female Nude Sketch（162）

SK0356
立姿裸女速寫（163）Standing Female Nude Sketch（163）

SK0357
蹲姿裸女速寫（12）Squatting Female Nude Sketch（12）

SK0358
立姿裸女速寫（164）Standing Female Nude Sketch（164）

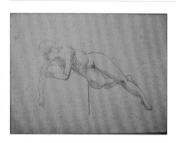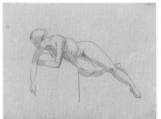

SK0359
臥姿裸女速寫（16）Reclining Female Nude Sketch（16）

SK0360
蹲姿裸女速寫（13）Squatting Female Nude Sketch（13）

SK0361
立姿裸女速寫（165）Standing Female Nude Sketch（165）

SK0363
立姿裸女速寫（167）Standing Female Nude Sketch（167）

SK0364
立姿裸女速寫（168）Standing Female Nude Sketch（168）

SK0365
立姿裸女速寫（169）Standing Female Nude Sketch（169）

SK0366
立姿裸女速寫（170）Standing Female Nude Sketch（170）

SK0367
立姿裸女速寫（171）Standing Female Nude Sketch（171）

SK0368
跪姿裸女速寫（12）Kneeling Female Nude Sketch（12）

SK0369
立姿裸女速寫（172）Standing Female Nude Sketch（172）

SK0370
立姿裸女速寫（173）Standing Female Nude Sketch（173）

SK0371
立姿裸女速寫（174）Standing Female Nude Sketch（174）

SK0372
立姿裸女速寫（175）Standing Female Nude Sketch（175）

SK0373
立姿裸女速寫（176）Standing Female Nude Sketch（176）

SK0374
女體速寫（7）Female Body Sketch（7）

SK0375
立姿裸女速寫（177）Standing Female Nude Sketch（177）

SK0376
立姿裸女速寫（178）Standing Female Nude Sketch（178）

SK0377
立姿裸女速寫（179）Standing Female Nude Sketch（179）

SK0378
立姿裸女速寫（180）Standing Female Nude Sketch（180）

SK0379
立姿裸女速寫（181）Standing Female Nude Sketch（181）

SK0380
立姿裸女速寫（182）Standing Female Nude Sketch（182）

SK0381
立姿裸女速寫（183）Standing Female Nude Sketch（183）

SK0382
立姿裸女速寫（184）Standing Female Nude Sketch（184）

SK0383
立姿裸女速寫（185）Standing Female Nude Sketch（185）

SK0384
立姿裸女速寫（186）Standing Female Nude Sketch（186）

SK0385
立姿裸女速寫（187）Standing Female Nude Sketch（187）

SK0386
立姿裸女速寫（188）Standing Female Nude Sketch（188）

SK0387
立姿裸女速寫（189）Standing Female Nude Sketch（189）

SK0388
女體速寫（8）Female Body Sketch（8）

SK0389
女體速寫（9）Female Body Sketch（9）

SK0390
立姿裸女速寫（190）Standing Female Nude Sketch（190）

SK0391
女體速寫（10）Female Body Sketch（10）

SK0392
立姿裸女速寫（191）Standing Female Nude Sketch（191）

SK0393
立姿裸女速寫（192）Standing Female Nude Sketch（192）

SK0394
立姿裸女速寫（193）Standing Female Nude Sketch（193）

SK0395
坐姿裸女速寫（137）Seated Female Nude Sketch（137）

SK0396
坐姿裸女速寫（138）Seated Female Nude Sketch（138）

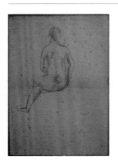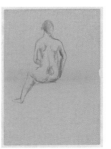

SK0397
坐姿裸女速寫（139）Seated Female Nude Sketch（139）

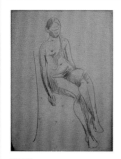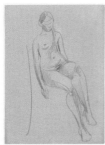

SK0398
坐姿裸女速寫（140）Seated Female Nude Sketch（140）

SK0399
立姿裸女速寫（194）Standing Female Nude Sketch（194）

SK0400
坐姿裸女速寫（141）Seated Female Nude Sketch（141）

SK0401
坐姿裸女速寫（142）Seated Female Nude Sketch（142）

SK0402
女體速寫（11）Female Body Sketch（11）

SK0403
坐姿裸女速寫（143）Seated Female Nude Sketch（143）

SK0404
坐姿裸女速寫（144）Seated Female Nude Sketch（144）

SK0405
坐姿裸女速寫（145）Seated Female Nude Sketch（145）

SK0406
坐姿裸女速寫（146）Seated Female Nude Sketch（146）

SK0407
坐姿裸女速寫（147）Seated Female Nude Sketch（147）

SK0409
坐姿裸女速寫（149）Seated Female Nude Sketch（149）

SK0410
坐姿裸女速寫（150）Seated Female Nude Sketch（150）

SK0411
坐姿裸女速寫（151）Seated Female Nude Sketch（151）

SK0412
坐姿裸女速寫（152）Seated Female Nude Sketch（152）

SK0413
坐姿裸女速寫（153）Seated Female Nude Sketch（153）

SK0414
女體速寫（12）Female Body Sketch（12）

SK0415
坐姿裸女速寫（154）Seated Female Nude Sketch（154）

SK0416
女體速寫（13）Female Body Sketch（13）

SK0417
坐姿裸女速寫（155）Seated Female Nude Sketch（155）

SK0418
坐姿裸女速寫（156）Seated Female Nude Sketch（156）

SK0419
女體速寫（14）Female Body Sketch（14）

SK0420
坐姿裸女速寫（157）Seated Female Nude Sketch（157）

SK0421
坐姿裸女速寫（158）Seated Female Nude Sketch（158）

SK0422
坐姿裸女速寫（159）Seated Female Nude Sketch（159）

SK0423
坐姿裸女速寫（160）Seated Female Nude Sketch（160）

SK0424
坐姿裸女速寫（161）Seated Female Nude Sketch（161）

SK0425
坐姿裸女速寫（162）Seated Female Nude Sketch（162）

SK0426
坐姿裸女速寫（163）Seated Female Nude Sketch（163）

SK0427
坐姿裸女速寫（164）Seated Female Nude Sketch（164）

SK0428
坐姿裸女速寫（165）Seated Female Nude Sketch（165）

SK0429
坐姿裸女速寫（166）Seated Female Nude Sketch（166）

SK0430
跪姿裸女速寫（13）Kneeling Female Nude Sketch（13）

SK0431
臥姿裸女速寫（17）Reclining Female Nude Sketch（17）

SK0432
坐姿裸女速寫（167）Seated Female Nude Sketch（167）

SK0433
坐姿裸女速寫（168）Seated Female Nude Sketch（168）

SK0434
坐姿裸女速寫（169）Seated Female Nude Sketch（169）

SK0435
坐姿裸女速寫（170）Seated Female Nude Sketch（170）

SK0436
坐姿裸女速寫（171）Seated Female Nude Sketch（171）

SK0437
坐姿裸女速寫（172）Seated Female Nude Sketch（172）

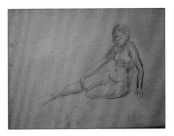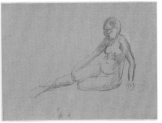

SK0438
坐姿裸女速寫（173）Seated Female Nude Sketch（173）

SK0439
坐姿裸女速寫（174）Seated Female Nude Sketch（174）

SK0440
坐姿裸女速寫（175）Seated Female Nude Sketch（175）

SK0441
坐姿裸女速寫（176）Seated Female Nude Sketch（176）

SK0442
坐姿裸女速寫（177）Seated Female Nude Sketch（177）

SK0443
坐姿裸女速寫（178）Seated Female Nude Sketch（178）

SK0444
坐姿裸女速寫（179）Seated Female Nude Sketch（179）

SK0445
坐姿裸女速寫（180）Seated Female Nude Sketch（180）

SK0446
坐姿裸女速寫（181）Seated Female Nude Sketch（181）

SK0447
坐姿裸女速寫（182）Seated Female Nude Sketch（182）

SK0448
坐姿裸女速寫（183）Seated Female Nude Sketch（183）

SK0449
坐姿裸女速寫（184）Seated Female Nude Sketch（184）

SK0450
跪姿裸女速寫（14）Kneeling Female Nude Sketch（14）

SK0451
跪姿裸女速寫（15）Kneeling Female Nude Sketch（15）

SK0452
坐姿裸女速寫（185）Seated Female Nude Sketch（185）

SK0453
跪姿裸女速寫（16）Kneeling Female Nude Sketch（16）

SK0454
坐姿裸女速寫（186）Seated Female Nude Sketch（186）

SK0455
坐姿裸女速寫（187）Seated Female Nude Sketch（187）

SK0456
坐姿裸女速寫（188）Seated Female Nude Sketch（188）

SK0457
坐姿裸女速寫（189）Seated Female Nude Sketch（189）

SK0458
坐姿裸女速寫（190）Seated Female Nude Sketch（190）

SK0459
坐姿裸女速寫（191）Seated Female Nude Sketch（191）

SK0460
坐姿裸女速寫（192）Seated Female Nude Sketch（192）

SK0461
坐姿裸女速寫（193）Seated Female Nude Sketch（193）

SK0462
坐姿裸女速寫（194）Seated Female Nude Sketch（194）

SK0463
坐姿裸女速寫（195）Seated Female Nude Sketch（195）

SK0464
坐姿裸女速寫（196）Seated Female Nude Sketch（196）

SK0465
坐姿裸女速寫（197）Seated Female Nude Sketch（197）

SK0466
坐姿裸女速寫（198）Seated Female Nude Sketch（198）

SK0481
立姿裸女速寫（204）Standing Female Nude Sketch（204）

SK0482
立姿裸女速寫（205）Standing Female Nude Sketch（205）

SK0483
蹲姿裸女速寫（14）Squatting Female Nude Sketch（14）

SK0492
女體速寫（16）Female Body Sketch（16）

SK0496
人物速寫（8）Figure Sketch（8）

SK0497
人物速寫（9）Figure Sketch（9）

SK0498
人物速寫（10）Figure Sketch（10）

SK0499
人物速寫（11）Figure Sketch（11）

SK0500
人物速寫（12）Figure Sketch（12）

SK0501
人物速寫（13）Figure Sketch（13）

SK0502
人物速寫（14）Figure Sketch（14）

SK0503
坐姿裸女與人物速寫（1）Seated Female Nude and Figure Sketch（1）

SK0504
人物速寫（15）Figure Sketch（15）

SK0505
人物速寫（16）Figure Sketch（16）

SK0507
頭像速寫（6）Portrait Sketch（6）

SK0509
頭像速寫（8）Portrait Sketch（8）

SK0511
頭像速寫（10）Portrait Sketch（10）

SK0650
立姿裸女速寫-28.3.31（271）Standing Female Nude Sketch-28.3.31（271）

SK0654
頭像速寫-28.11.8（20）Portrait Sketch-28.11.8（20）

SK0673
坐姿裸女速寫（257）Seated Female Nude Sketch（257）

SK0692
坐姿裸女速寫-29.3.23（263）Seated Female Nude Sketch-29.3.23（263）

SK0693
坐姿裸女速寫-29.3.23（264）Seated Female Nude Sketch-29.3.23（264）

SK0701
立姿裸女速寫-29.3.23（294）Standing Female Nude Sketch-29.3.23（294）

SK0703
臥姿裸女速寫-29.3.29（35）Reclining Female Nude Sketch-29.3.29（35）

SK0705
坐姿裸女速寫-29.5.13（267）Seated Female Nude Sketch-29.5.13（267）

SK0707
臥姿裸女速寫-29.6.12（36）Reclining Female Nude Sketch-29.6.12（36）

SK0708
臥姿裸女速寫-29.6.12（37）Reclining Female Nude Sketch-29.6.12（37）

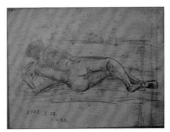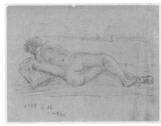

SK0709
臥姿裸女速寫-29.6.22（38）Reclining Female Nude Sketch-29.6.22（38）

SK0710
人物速寫-29.6.23（21）Figure Sketch-29.6.23（21）

SK0714
立姿裸女速寫-29.7.13（296）Standing Female Nude Sketch-29.7.13（296）

SK0716
坐姿裸女速寫-29.7.13（271）Seated Female Nude Sketch-29.7.13（271）

SK0717
坐姿裸女速寫-29.7.13（272）Seated Female Nude Sketch-29.7.13（272）

SK0720
坐姿裸女速寫-29.7.13（273）Seated Female Nude Sketch-29.7.13（273）

SK0721
坐姿裸女速寫-29.7.13（274）Seated Female Nude Sketch-29.7.13（274）

SK0722
坐姿裸女速寫-29.7.13（275）Seated Female Nude Sketch-29.7.13（275）

SK0723
坐姿裸女速寫-29.7.13（276）Seated Female Nude Sketch-29.7.13（276）

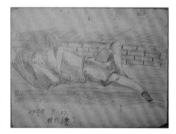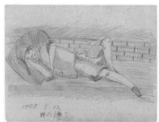

SK0725
睡於墙下-29.7.13　Sleeping Against a Wall-29.7.13

SK0727
人物速寫-29.12.27（22）Figure Sketch-29.12.27（22）

SK0728
坐姿裸女速寫（277）Seated Female Nude Sketch（277）

SK0731
坐姿裸女速寫（279）Seated Female Nude Sketch（279）

SK0732
立姿裸女速寫（299）Standing Female Nude Sketch（299）

SK0733
立姿裸女速寫（300）Standing Female Nude Sketch（300）

SK0735
人物速寫-6.27（23）Figure Sketch-6.27（23）

SK0892
風景速寫-34.8.3（2）Landscape Sketch-34.8.3（2）

SK0894
人物速寫-35.4.7（31）Figure Sketch-35.4.7（31）

SK0895
從對高岳展望開農台-35.4.7　Looking from Dueigaoyue to Kainongtai-35.4.7

SK0896
阿里山鐵軌-35.4.8　Alishan Railroad-35.4.8

SK0897
風景速寫-35.4（3）Landscape Sketch-35.4（3）

SK0898
阿里山小學校-35.4　Alishan Primary School-35.4

SK0899
阿里山區風景速寫-35.4.9（1）Alishan Landscape Sketch-35.4.9（1）

SK0900
阿里山區風景速寫-35.4.9（2）Alishan Landscape Sketch-35.4.9（2）

SK0901
阿里山區風景速寫（3）Alishan Landscape Sketch（3）

SK0902
獅子頭山 Shizaitou Mountain

SK0903
塔山 Tashan

SK0904
從祝山眺望松山-35.4.13　Looking from Chushan to Songshan-35.4.13

SK0906
在霧峯-36 Wufeng-36

SK0907
旗山街-37.8.23　Cishan Street-37.8.23

SK0908
從幼葉林眺望交力坪-38.1.6　Looking from Youyelin to Jiaoliping-38.1.6

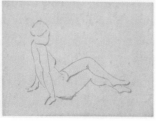

SK0912
坐姿裸女速寫（335）Seated Female Nude Sketch（335）

SK0913
坐姿裸女速寫（336）Seated Female Nude Sketch（336）

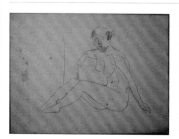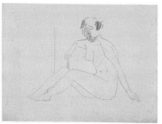

SK0914
坐姿裸女速寫（337）Seated Female Nude Sketch（337）

SK0915
坐姿裸女速寫（338）Seated Female Nude Sketch（338）

SK0918
坐姿裸女速寫（341）Seated Female Nude Sketch（341）

SK0919
坐姿裸女速寫（342）Seated Female Nude Sketch（342）

SK0952
坐姿與臥姿裸女速寫（10）Seated and Reclining Female Nude Sketch（10）

SK0953
坐姿裸女速寫（370）Seated Female Nude Sketch（370）

SK0956
立姿裸女速寫（339）Standing Female Nude Sketch（339）

SK0957
立姿裸女速寫（340）Standing Female Nude Sketch（340）

SK0958
立姿裸女速寫（341）Standing Female Nude Sketch（341）

SK0960
立姿裸女速寫（343）Standing Female Nude Sketch（343）

SK0961
跳舞的姿勢 Dancing Posture

SK0989
臥姿裸女速寫（57）Reclining Female Nude Sketch（57）

SK0996
女體速寫（27）Female Body Sketch（27）

SK1002
人物速寫（33）Figure Sketch（33）

SK1004
人物速寫（34）Figure Sketch（34）

SK1005
人物速寫（35）Figure Sketch（35）

SK1006
人物速寫（36）Figure Sketch（36）

SK1075
靜物速寫（2）Still Life Sketch（2）

SK1076
靜物速寫（3）Still Life Sketch（3）

SK1079
風景速寫（5）Landscape Sketch（5）

SK1080
風景速寫（6）Landscape Sketch（6）

SK1081
風景速寫（7）Landscape Sketch（7）

SK1082
山岳標高圖（1）Elevation Profile of Mountains（1）

SK1083
山岳標高圖（2）Elevation Profile of Mountains（2）

SK1094
風景速寫（17）Landscape Sketch（17）

SK1095
風景速寫（18）Landscape Sketch（18）

SK1096
風景速寫（19）Landscape Sketch（19）

SK1098
風景速寫（21）Landscape Sketch（21）

SK1099
風景速寫（22）Landscape Sketch（22）

友人贈送與自藏書畫 Art Collections

每件作品以修復前和修復後做為對照。
修復前置於左側、修復後置於右側。

蘇友讓 Su You-rang　七言對聯 Calligraphy couplet

諸聞韻 Zhu Wen-yun　紫藤 Chinese Wisteria

林玉山 Lin Yu-shan　竹林與水牛 Bamboo and Buffalo

徐培基 Xu Pei-ji　山水 Landscape

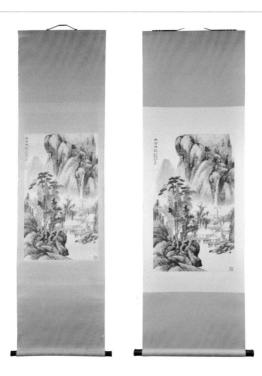

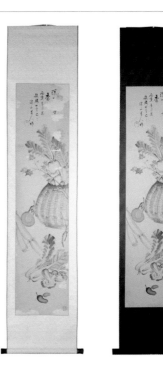

俞劍華 Yu Jian-hua　水閣清談 Chatting in a Waterside Open Hall

溪山道人 Xishandaoren　蔬果圖 Vegetables

峯仙 Fengxian　墨藤扇 Ink Vine Fan

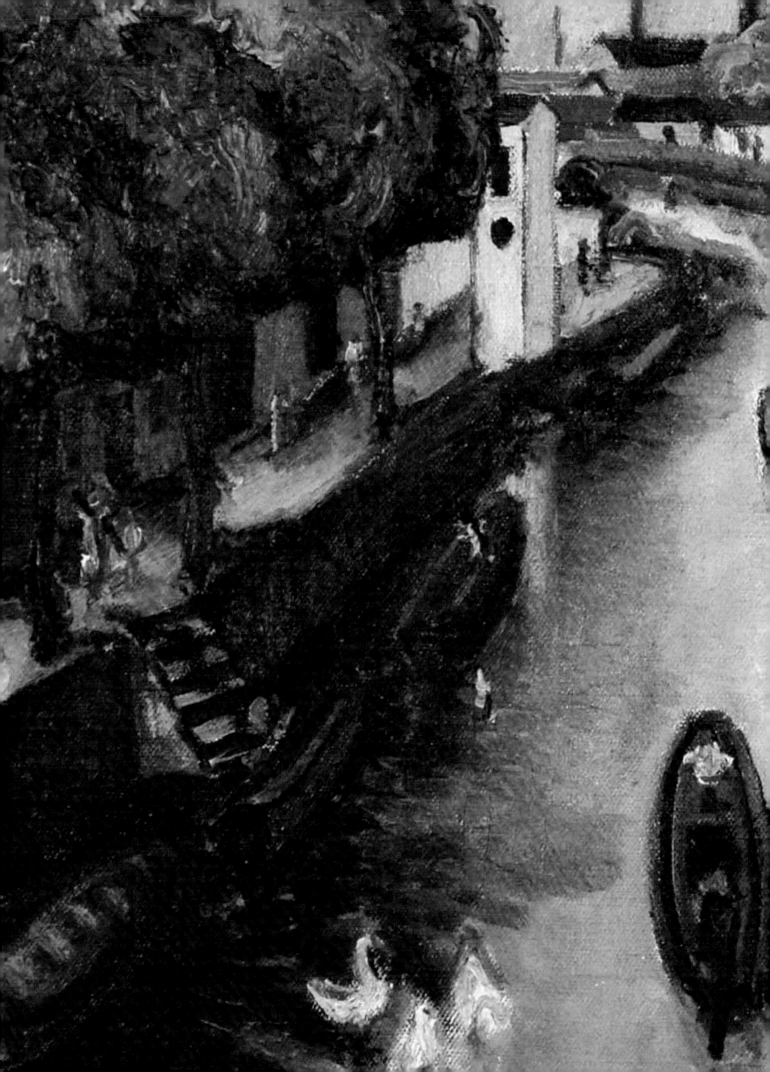

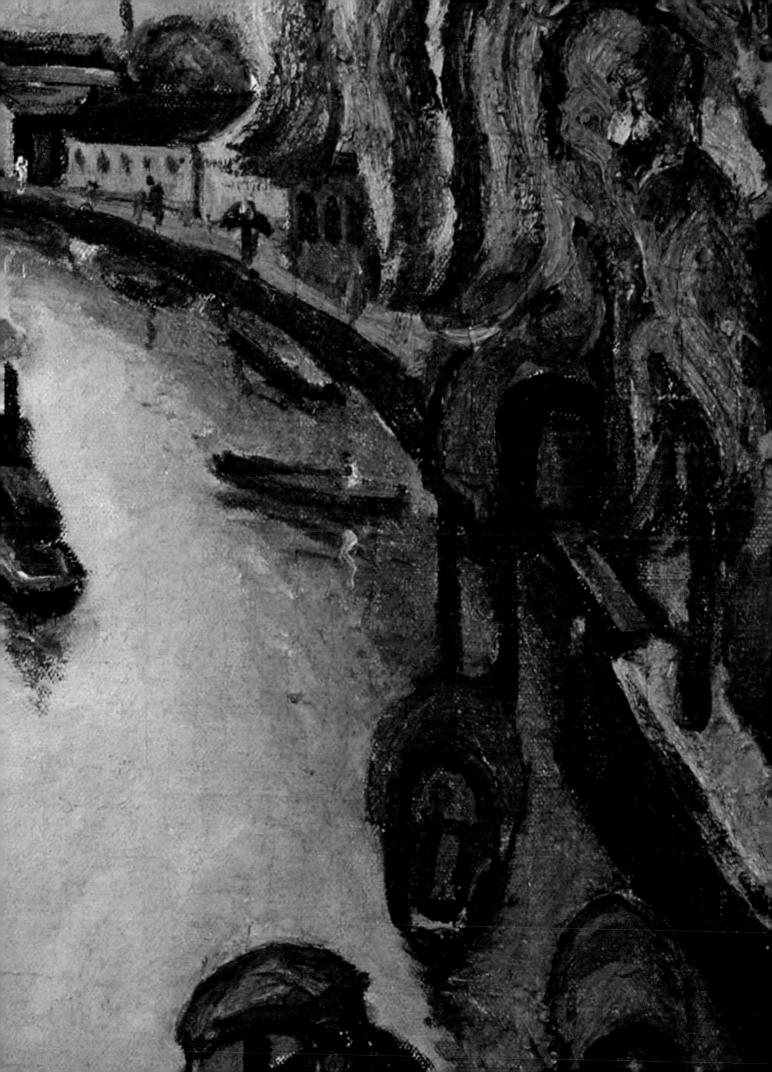

編後語

陳澄波因二二八事件罹難，使得他的名字一度成為禁忌；其遺留下來的作品與文物，家屬為避免被政府單位查禁沒收，長期密藏在住家的閣樓裡，由於保存環境不佳，使得作品與文物遭受不同程度的嚴重損壞。因應2014年「陳澄波百二誕辰東亞巡迴大展」的展出，這些作品與文物需要被全面修復；由於數量龐大加上時間壓力，因此交付三個主要的單位同步進行，分別是：國立臺灣師範大學文物保存維護研究發展中心（簡稱文保中心）、正修科技大學文物修護中心，與臺北文化財保存研究所。

《陳澄波全集》第15-17卷，主要就是呈現這三個單位的修復成果。第15卷和第16卷前半部，為張元鳳老師領導的文保中心的紙質類作品、油畫和文物的修復報告，並搭配專文，深入簡出地介紹修復的理念與過程；第16卷下半部為林煥盛老師主持的臺北文化財保存研究所的紙絹類作品修復報告；第17卷則是收錄李益成老師領導的正修科技大學文物修護中心的油畫和紙質類作品修復報告，與修復期間所發表的文章。在每個類別的最後，並收入所有作品修復前後的對照圖，將修復作品做一完整之呈現，也讓讀者可以比對修復前後之差異。此外，15-17卷特以中英文對照呈現，以期能推廣國內優秀的修復技術。

由於修復前後對照圖有數千件，當初送修復時的編號也與後來《全集》的編號不同，因此耗費相當多的時間來重新整理圖檔；然而當作品能依序完整呈現，編者亦是感到十分欣慰。而修復前後對照圖大多是修復師所攝，因為不是專業攝影或掃描，有些圖檔品質並不理想，圖檔顏色看起來也會與《全集》第1至5卷之作品圖錄有些許差異，然均為修復師工作中之紀錄，為完整呈現修復的全貌，編輯時選擇仍將其全部收錄。另有少部分素描簿圖檔，因修復後加強了騎縫處的黏合，導致攝影時靠近騎縫處會有陰影或不平整的狀況產生，實乃無法避免，尚請寬諒。

有人把修復師比喻為文物的醫生，而文物就是病人；在面對同一個病人，不同醫師所開的藥方也會不盡相同。同樣的，在面對各式各樣的文物和不一樣的修復需求時，三個單位的修復程序、方法與使用之材料，自然也會有所不同，甚至連修復報告的格式也有所差別。對於這些差異性，編輯者選擇如實保留，不強加統一，藉以呈顯各單位之修復特色。

此次陳澄波作品與文物的大量修復，應是國內創舉，目前在臺灣應還沒有其他畫家從事如此大規模的修復；這樣的工程，除需耗費龐大的金錢外，更考驗著三個單位的修復能力，不僅要在有限的時間內完成，以應付展出，最令人感動的是三個單位均嚴格遵循修復倫理，因為修復是為了延長文物的保存壽命，而非讓後人的修復介入反而毀壞了原作。

感謝三個單位的主持人與修復師，工作忙碌之餘，還抽空撰寫專文、規劃內容、整理資料，並協助校稿。若要瞭解作品與文物如何被修復，相信讀完這三卷報告書，就會有很清楚的概念。這是國內修復專業一次重大的成果；而美編處理幾千件圖檔的辛勞，在此也一併誌謝。

<div align="right">

財團法人陳澄波文化基金會
研究專員　賴鈴如

</div>

Editor's Afterword

The fact that Chen Cheng-po had fallen victim to the "228 Incident" had once made his name a taboo. For fear that his works and cultural objects might be searched for violation of ban and confiscated, his family members had them hidden for a long time in the household attic. Because of the poor conservation conditions, the works and cultural objects had undergone various degrees of serious damages. In order that they could be showcased in the 2014 "Chen Cheng-po's 120th Birthday Touring Exhibition in East Asia", there was a need to conserve these works and cultural objects comprehensively. Considering the large quantity involved and the limited time available, three institutions were charged with carrying out the conservation simultaneously, namely, Research Center for Conservation of Cultural Relics (RCCR), National Taiwan Normal University; Cheng Shiu University Conservation Center; and Taipei Conservation Center.

Volumes 15 to 17 of *Chen Cheng-po Corpus* mainly present the conservation results of these three institutions. Volume 15 and the first half of Volume 16 consist of the reports of conserving respectively paper-based works, oil paintings, and cultural objects by an RCCR team led by Chang Yuan-feng. Also included is a monograph that succinctly presents the concepts and processes of the conservation in depth. The second half of Volume 16 is a report on the conservation of paper or silk based paintings by Taipei Conservation Center run by Lin Huan-sheng. Included in Volume 17 are reports on the conservation of oil paintings and paper-based works carried out by Cheng Shiu University Conservation Center under the leadership of Li I-cheng. It also consists of a number of papers published in the course of the conservation. At the end of each category section, there are comparison photos showing the works before and after conservation. Such a complete presentation of the conserved works allows readers the chance of comparing the differences before and after conservation. Also, Volumes 15 to 17 are published in a Chinese-English bilingual format to better promote the superb conservation techniques available in Taiwan.

Since there are thousands of before and after conservation photos and that the serial numbers at the time of sending out for conservation are different than those given in the *Corpus*, considerable amount of time has been engaged in reorganizing the photo files. Yet, when all the works are finally presented in their sequential order, this editor cannot help but thrilled with satisfaction. Most of the before and after conservation photos have been taken by the conservators concerned. Since no professional photography or scanning is involved, the quality of some of the photo files is less than desirable, with the colors of the files somewhat different than those included in Volumes 1 to 5 of the *Corpus*. Nevertheless, as the entire photo files are the work records of the conservators, in compiling these three volumes, it has been decided to include all of them in order to present a full picture of the conservation efforts. In addition, in some of the sketchbook photo files, since the bonds of the sketchbook seams have been reinforced during conservation, shadows or unevenness may show up near the seams in the photos. This is unavoidable and we hope readers will understand.

Conservators have been likened to doctors of cultural objects and the cultural objects are the patients. When dealing with the same patient, the prescriptions given out by different doctors are not all the same. Likewise, in dealing with a whole range of cultural objects and different conservation needs, the procedures, methods, and materials adopted by the three conservation institutions are naturally not the same; in fact, even the formats of their conservation reports are also different. Faced with these differences, this editor has chosen to retain them as they were and has not enforced uniformity so as to present the conservation features of these institutions.

The current wholesale conservation of Chen Cheng-po's works and cultural objects is a first of its type in Taiwan. As yet, there is no other artist in Taiwan whose works have undergone conservation of such a large scale. Such an undertaking not only incurs a lot of money, it is also very taxing on the conservation capabilities of the three institutions. In addition to having to complete their respective tasks within limited time to be ready for the exhibition, what is touching is that all three of them had to abide by stringent conservation ethics. This is so because, after all, the purpose of conservation is to extend the retention life of the works of art and cultural objects, and is not to allow the intrusion of conservation to damage them.

We extend our gratitude to the directors and conservators of the three institutions for sparing time in their busy schedules to write the papers, plan the contents, and organize the materials as well as to help proofreading. If one wants to understand how art works and cultural objects are conserved, reading these three volumes would be a sure way to get a clear idea. This project is a major achievement on the part of Taiwan's conservation profession. Our thanks is also due to our art editor who had to laboriously handle thousands of photo files.

Researcher,
Judicial Person Chen Cheng-po Cultural Foundation
Lai Ling-ju

Lai Ling-ju

國家圖書館出版品預行編目資料

陳澄波全集. 第十七卷, 修復報告. Ⅲ / 蕭瓊瑞總主編. -- 初版.
-- 臺北市：藝術家出版；嘉義市：陳澄波文化基金會；
[臺北市]：中研院臺史所發行, 2018.3
312面；22×28.5公分

ISBN 978-986-282-201-2(精裝)

1.書畫 2.文物修復

941.5 106013614

陳澄波全集
CHEN CHENG-PO CORPUS
第十七卷・修復報告（Ⅲ）
Volume 17 · Selected Treatment Reports（Ⅲ）

發　　行：財團法人陳澄波文化基金會
　　　　　中央研究院臺灣史研究所
出　　版：藝術家出版社
發 行 人：陳重光、翁啟惠、何政廣
策　　劃：財團法人陳澄波文化基金會
總 策 劃：陳立栢
總 主 編：蕭瓊瑞
編輯顧問：王秀雄、吉田千鶴子、李鴻禧、李賢文、林柏亭、林保堯、林釗、張義雄
　　　　　張炎憲、陳重光、黃才郎、黃光男、潘元石、謝里法、謝國興、顏娟英
編輯委員：文貞姬、白適銘、林育淳、邱函妮、許雪姬、陳麗涓、陳水財、張元鳳、張炎憲
　　　　　黃冬富、廖瑾瑗、蔡獻友、蔣伯欣、黃姍姍、謝慧玲、蕭瓊瑞
執行編輯：賴鈴如、何冠儀
美術編輯：王孝嫈
翻　　譯：日文／潘襎（序文）、英文／陳彥名（序文）、正修科技大學文物修護中心、盧藹芹（編後語）

出 版 者：藝術家出版社
　　　　　台北市金山南路（藝術家路）二段165號6樓
　　　　　TEL：（02）23886715
　　　　　FAX：（02）23965708
　　　　　郵政劃撥：50035145 藝術家出版社帳戶

總 經 銷：時報文化出版企業股份有限公司
　　　　　桃園市龜山區萬壽路二段351號
　　　　　TEL：（02）2306-6842
南區代理：台南市西門路一段223巷10弄26號
　　　　　TEL：（06）261-7268
　　　　　FAX：（06）263-7698

製版印刷：欣佑彩色製版印刷股份有限公司
初　　版：2018年3月
定　　價：新臺幣1800元

ISBN　978-986-282-201-2（精裝）